HERKOMER

A VICTORIAN ARTIST

Lee MacCormick Edwards

Herkomer

A Victorian Artist

ASHGATE

Published by
Ashgate Publishing Limited Ashgate Publishing Company
Gower House Old Post Road
Croft Road Brookfield
Aldershot Vermont 05036-9704
Hants GU11 3HR USA
England

British Library Cataloguing-in-Publication data

Edwards, Lee MacCormick
 Herkomer a Victorian artist
 1. Herkomer, Sir Hubert von, 1849–1914 2. Painters – England
 – Biography 3. Painting, English 4. Painting, Modern – 19th
 century – England
 I. Title
 759.2

Library of Congress Cataloging-in-Publication data

Edwards, Lee M.
 Herkomer a Victorian artist / by Lee MacCormick
 Edwards.
 p. cm.
 Includes bibliographical references and index.
 ISBN 1–84014–686–9 (hardback : alk. paper)
 1. Herkomer, Hubert von, Sir, 1849–1914—Criticism and
 interpretation. I. Herkomer, Hubert von, Sir, 1849–1914.
 II. Title.
 N6797.H45E38 1999
 759.2—dc21
 [b] 98–53572
 CIP

ISBN 1 84014 686 9

Printed on acid-free paper

Typeset in Palatino by Wearset, Boldon, Tyne and
Wear. Printed in Singapore by
Kyodo Printing Co.

Contents

List of illustrations

All illustrations are the work of Hubert von Herkomer, unless otherwise stated.

Colour plates

Black and white illustrations

10 *Rabbits in a Forest*, 1862, oil on canvas, 17 × 14¼ inches (43.1 × 36.1 cm). Yale Center for British Art, Gift of Agnes and Hans Platenius.

11 *Study of a Nude* (Lorenz Herkomer), 17 September 1865, pencil on paper, 12 × 6½ inches (30.4 × 16.5 cm). Herkomerstiftung, Landsberg.

12 *Study of a Nude*, 19 October 1865, pencil and bodycolour on paper, 14½ × 10 inches (36.8 × 25.4 cm). Yale Center for British Art, Gift of Agnes and Hans Platenius.

13 Frederick Walker, *The Bathers*, 1867, oil on canvas, 36½ × 84½ inches (92.7 × 214.6 cm). Board of Trustees, National Museums and Galleries on Merseyside (Lady Lever Art Gallery).

14 Photograph of an interior view at Dyreham, Bushey, Hertfordshire, c.1883, with furnishings carved by Lorenz Herkomer. A part of Hubert Herkomer's portrait of Archibald Forbes (1882) is visible in the top right corner. Bushey Museum Trust.

15 Photograph of Hubert Herkomer and his son, Siegfried, c.1877, taken outside the studio at Dyreham, Bushey, Hertfordshire. Bushey Museum Trust.

16 Photograph of Hubert Herkomer holding his infant daughter, Elsa, 1876, taken at Dyreham, Bushey, Hertfordshire. Bushey Museum Trust.

17 Photograph of the artist's two youngest children, Gwendydd and Lawrence, c.1898, taken at Lululaund, Bushey, Hertfordshire. Bushey Museum Trust.

18 Photograph of Gwendydd Herkomer outside the *Mutterturm*, Landsberg-am-Lech, c.1912. Bushey Museum Trust.

19 *The Crucifixion* ('A Rift in the Clouds'), 1896, watercolour, 27⅞ × 20 inches (70.6 × 50.8 cm). Royal Watercolour Society. From a photograph in A.L. Baldry, *Hubert von Herkomer, R.A.* (London, 1901).

20 Photograph of Herkomer's casket in his studio at Lululaund, 1914. The wing clusters on the walls signify the personal motto on the arms Herkomer was granted with his Bavarian knighthood: 'Propriis Alis' ('By my own Wings'). Bushey Museum Trust.

21 *Murder Will Out. Fun*, 1 May 1869, p. 84. Butler Library, Columbia University, New York.

22 *A thousand times is former woe repaid by present bliss. The Quiver*, 1868, p. 73. Butler Library, Columbia University, New York.

23 *A Gipsy Encampment on Putney Common. The Graphic*, 18 June 1870, p. 680. Butler Library, Columbia University, New York.

24 *Preliminary Study of a Gypsy*, 1870, pen and ink. Bushey Museum Trust.

25 *A 'Smoking Concert' by the Wandering Minstrels. The Graphic*, 25 June 1870, p. 717. Rare Book and Manuscript Library, Columbia University, New York.

26 *A Sketch at a Concert Given to the Poor Italians in London. The Graphic*, 18 March 1871, p. 253. Butler Library, Columbia University, New York.

27 *The Sunday Trading Question – A Sketch in Petticoat Lane. The Graphic*, 6 January 1872, p. 61. Butler Library, Columbia University, New York.

28 *A Sketch in Newgate – The Garotter's Reward. The Graphic*, 9 March 1872, p. 221. Butler Library, Columbia University, New York.

29 *Divine Service for Shepherds and Herdsmen – A Study at the Berner's Hall, Islington. The Graphic*, 20 January 1872, pp. 56-57. Butler Library, Columbia University, New York.

30 *Heads of the People, Drawn from Life II – The Agricultural Labourer – Sunday. The Graphic*, 9 October 1875, p. 360. Butler Library, Columbia University, New York.

31 *Heads of the People – The Coastguardsman. The Graphic*, 20 September 1879, p. 292. Butler Library, Columbia University, New York.

32 *Prussian Spies at Tours* and *Count Kératry's Breton Army – Trying on Uniforms at St. Quimper. The Graphic*, 3 December 1870, p. 549. Sterling Memorial Library, Yale University, New Haven, Connecticut.

33 *I had grasped a pitchfork: Gredel stood behind with an axe. The Story of the Plebiscite. The Cornhill Magazine*, February 1872, p. 6. Butler Library, Columbia University, New York.

34 *Anxious Times – A Sketch at Tréport, France. The Graphic*, 26 November 1870, p. 512. Butler Library, Columbia University, New York.

35 *Rome – On the Steps of St. Peter's – 'Per Carità, Signori'. The Graphic*, 24 February 1872, p. 172. Butler Library, Columbia University, New York.

36 *Rome – The Quack Doctor. The Graphic*, 11 May 1872, p. 437. Butler Library, Columbia University, New York.

37 *A Dilemma. The Graphic*, 24 June 1876, pp. 610–611. Butler Library, Columbia University, New York.

38 *Tourists in the Bavarian Alps – The Echo. The Graphic*, 7 October 1876, p. 353. Butler Library, Columbia University, New York.

39 *Sketches in the Bavarian Alps – The 'Schuhplattl' Dance. The Graphic*, 22 March 1873, p. 276. Butler Library, Columbia University, New York.

40 *Returning from Work, A Sketch in the Tyrol. The Graphic*, 19 August 1871, p. 189. Butler Library, Columbia University, New York.

41 Original sketch of the central figure in *Returning from Work, A Sketch in the Tyrol*, 1871, pencil, 12 × 7½ inches (30 × 18.8 cm). Southampton Museums and Art Gallery.

42 *A Visit to the Berchtesgaden Salt Mine, Bavaria II – Going Down the Slide. The Graphic*, 3 April 1875, p. 352. Butler Library, Columbia University, New York.

43 *Sketches in the Bavarian Alps – The Arrest of a Poacher. The Graphic*, 17 May 1873, p. 465. Butler Library, Columbia University, New York.

44 *Choosing*, 1868, watercolour, 10 × 7 inches (25.4 × 17.7 cm). Watford Museum.

45 *Lonely Jane. Good Words for the Young*, 1 November 1868, p. 28. Rare Book and Manuscript Library, Columbia University, New York.

46 *Amy and her Doves. Good Words for the Young*, 1 January 1871, p. 176. Rare Book and Manuscript Library, Columbia University, New York.

47 *Jack and Jane. Good Words for the Young*, 1 June 1870, p. 444. Butler Library, Columbia University, New York.

48 George Pinwell, *The Gang Children. The Sunday Magazine*, 1 October 1868, p. 25. Sterling Memorial Library, Yale University, New Haven, Connecticut.

49 *Rest: Aldenham Church*, 1876, watercolour, 16 × 22 inches (40.6 × 55.8 cm). Inscribed 'November 14, 1876'. Private collection, New York.

88 *On Strike*, 1891, oil on canvas, 89½ × 49½ inches (227.3 × 125.7 cm). Royal Academy of Arts.

89 *In the Black Country*, 1891, oil on canvas, 15 × 19 inches (38.1 × 48.2 cm). Private collection.

90 Dudley Hardy, *The Dock Strike, London 1889*, 1890, oil on canvas. Untraced.

91 Robert Koehler, *The Strike*, 1886, oil on canvas, 71½ × 108½ inches (181.6 × 275.5 cm). Private collection.

92 *The Arrest of a Poacher in the Bavarian Alps*, 1874, watercolour, 20½ × 34½ inches (52 × 87.6 cm). Herkomerstiftung, Landsberg.

93 Photograph of the installation of the Herkomer commemorative exhibition in Landsberg-am-Lech, 1931, with Herkomer's portraits of Richard Wagner, 1877 (left), and Cosima Wagner, 1878 (right). Both watercolour, approx. 36 × 28 inches (91.4 × 71.1 cm). Formerly in Wahnfried, Bayreuth; missing after World War II. A lithograph of Herkomer's *The Lady in Black* (1887) hangs between the two portraits. Stadt Landsberg, Neues Stadtmuseum.

94 *John Ruskin*, 1879, watercolour, 28 × 19 inches (71.1 × 48.2 cm). By courtesy of the National Portrait Gallery, London.

95 *G.F. Watts*, 1897, watercolour, 6¾ × 4¾ inches (17.1 × 12 cm). Inscribed 'To my friend G.F. Watts'. Trustees of the Watts Gallery, Compton, Surrey.

96 *Archibald Forbes*, 1881, oil on canvas, 50¼ × 36 inches (127.6 × 91.4 cm). Kunsthalle, Hamburg.

97 *Lieutenant General Sir Robert Baden Powell*, 1903, oil on canvas, 56 × 44 inches (142.2 × 111.7 cm). By courtesy of the National Portrait Gallery, London.

98 *Stratford Canning, first Viscount de Redcliffe*, 1879, oil on canvas, 47 × 37 inches (119.3 × 93.9 cm). By kind permission of the Fellows of King's College, Cambridge.

99 *Sir Henry Tate*, 1897, oil on canvas, 55¾ × 44 inches (141.6 × 111.7 cm). Tate Gallery, London.

100 *The Painter Valentin Ruths*, 1900, oil on canvas, 55 × 43 inches (139.7 × 109.2 cm). Kunsthalle, Hamburg. Photo credit © Elke Walford, Hamburg.

101 *Emilia Frances, Lady Dilke*, 1887, oil on canvas, 55 × 43 inches (139.7 × 109.2 cm). By courtesy of the National Portrait Gallery, London.

102 *Queen Victoria on her Death Bed*, 1901, watercolour, 16¾ × 23 inches (42.5 × 58.4 cm). The Royal Collection, Her Majesty Queen Elizabeth II. Inscribed 'Painted direct from her Majesty Queen Victoria January 24, 1901'.

103 *H.R.H. the Late Duke of Clarence and Avondale, K.G., K.P.*, double-page photogravure of Herkomer's watercolour portrait. *The Graphic*, supplement, 23 January 1892, following p. 136. Butler Library, Columbia University, New York.

104 *Prince Regent Luitpold of Bavaria*, 1895–1896, oil on canvas, 55 × 44 inches (139.7 × 111.7 cm). Bayerischen Staatsgemäldesammlungen, Neue Pinakotek, Munich.

105 *The Board of Directors*, 1892, oil on canvas, 77 × 129 inches (195.5 × 327.6 cm). Private collection. Photograph Courtauld Institute of Art, London.

106 *The Burgermeister of Landsberg, Bavaria, with his Town Council (Die Magistratsitzung)*, 1891, oil on canvas, 96 × 288 inches (243.8 × 731.5 cm). Herkomersaal, Rathaus, Landsberg.

107 *A Zither Evening with my Students in my Studio*, 1901, oil on canvas, 46 × 64½ inches (124.4 × 163.8 cm). Kunsthalle, Hamburg. Photo credit © Elke Walford, Hamburg.

108 *A Zither Evening with my Students in my Studio*, detail 1.

109 *A Zither Evening with my Students in my Studio*, detail 2.

110 *The Managers and Directors of the Firm Fried. Krupp, Essen, Germany (Aufsichtsrat und Direktorium der Fried. Krupp AG im Jahre 1912)*, 1913, oil on canvas, 132 × 218 inches (335.2 × 553.7 cm). Fried. Krupp GmbH, Historisches Archiv, Villa Hügel, Essen, Germany.

111 *Whitelaw Reid*, 1883, oil on canvas, 52 × 35 inches (132 × 88.9 cm). Lotos Club, New York.

112 *Jay Gould*, 1883, oil on canvas, 47 × 36¾ inches (119.3 × 93.3 cm). National Trust for Historical Preservation, Lyndhurst, Tarrytown, New York.

113 *Pressing to the West: A Scene in Castle Garden, New York*, 1884, oil on canvas, 57 × 84½ inches (144.7 × 214.6 cm). Museum der Bildenden Künste, Leipzig.

114 Charles Frederick Ulrich, *In the Land of Promise – Castle Garden*, 1884, oil on canvas, 28⅜ × 35¾ inches (72 × 90.8 cm). Corcoran Gallery of Art, Washington DC.

115 Henry Hobson Richardson, architect, 'Lululaund': *Professor Herkomer's House at Bushey Now in Course of Erection. The American Architect and Building News*, 26 November 1892, no. 883. Avery Architectural and Fine Arts Library, Columbia University, New York.

116 *Robert Treat Paine*, 1884, oil on canvas. Stonehurst, Waltham, Massachusetts.

117 *The Lady in Black ('Entranced in Some Diviner Mood of Self-Oblivious Solitude')*, 1887, oil on canvas, 55¼ × 44 inches (140.3 × 117.8 cm). Leeds City Art Galleries.

118 Photograph of Lululaund, c.1900. Bushey Museum Trust. Located at 43 Melbourne Road, Bushey, Hertfordshire, the house was destroyed in 1939.

119 Photograph of an interior at Lululaund, c.1900. Herkomer Archive, Yale Center for British Art.

120 Photograph of the plaster frieze, *Human Sympathy*, in the dining room at Lululaund, Bushey, Hertfordshire, c.1900. Bushey Museum Trust.

121 Photograph of the front entrance of Lululaund, Bushey, Hertfordshire, c.1900. Bushey Museum Trust. The entrance portal with its curved archway is all that survives today.

122 *The First Born*, 1887, oil on canvas, 44 × 57 inches (111.7 × 144.7 cm). The FORBES Magazine Collection, New York. © All rights reserved.

123 *Our Village*, 1890, oil on canvas, 68 × 92½ inches (172.7 × 234.9 cm). City of Aberdeen Art Gallery.

124 *'This here stooping do fairly make my back open and shut'*, exclaimed the dairyman. Illustration for Thomas Hardy's *Tess of the D'Urbervilles. The Graphic*, 29 August 1891, p. 245. Butler Library, Columbia University, New York.

125 *On going up to the fire* ... Illustration to Thomas Hardy's *Tess of the D'Urbervilles. The Graphic*, 5 December 1891, pp. 670–671. Butler Library, Columbia University, New York.

126 *There stood her mother, amid the group of children* ... Illustration to Thomas Hardy's *Tess of the D'Urbervilles. The Graphic*, 4 July 1891, pp. 12–13. Butler Library, Columbia University, New York.

For Alison, who watched the beginning,
and Michael, who gave me the impetus to finish

Acknowledgements

I am deeply grateful to all who have helped me with this project. I owe special thanks to Hubert von Herkomer's American relatives, the late Agnes Platenius and the late Dr Francis Herrick, for making available to me their archive of family papers, drawings, paintings and decorative objects, which are now housed in the Herkomer Archive, Yale Center for British Art; to Sir David and Lady Mary Mansel Lewis; and to Verner and Fiona Wylie for sharing their Herkomer material with me and for their gracious hospitality. In England I have benefited enormously from the advice and assistance of the Curators of the Bushey Museum Trust, Grant Longman and Bryen Wood; and of Nicholas Browne, Celina Fox, Nicholas Harris, Alan Hobart, Kenneth McConkey, the late Jeremy Maas, Rupert Maas, Philip McEvansoneya, David Messum, Richard Ormond, Michael Pritchard, Duncan Robinson, David Setford, Mary-Anne Stevens, Rosemary Treble, Julian Treuherz and William Vaughan. In Landsberg, Konrad Büglmeier, Franz Huschka and Hartfrid Neunzert generously made available to me the holdings of the Herkomer-stiftung. Many museums, libraries and institutions provided information and made their facilities available, which I acknowledge with heartiest thanks.

I would also like to thank Kevin Avery, Janet Balmforth, Annette Blaugrund, Gerald Carr, Susan P. Casteras, Constance Clements, Linda Ferber, Barbara Gallatti, Marcia Goldberg, the late Dale Harris, Maria Makela, Katherine Manthorne, Herbert Paulus, Inez and Peter Platenius, Henry H. Richardson, Terez and Peter Rowley, Gerald Silk, Kay Sperling and Sarah Weiner.

A very special note of gratitude must go to Allen Staley for his continuous support and unwavering enthusiasm for this project; to Robert Bardin for his brilliant assistance and photographic skills; to Michael Crane for solving all my computer glitches; and finally to Marie Busco and Lucy Oakley.

Parts of Chapters 5 and 6 were previously published in different form in Lee M. Edwards, ' "Sympathy for the Old and for Suffering Mankind": Hubert von Herkomer', in Julian Trenherz, *Hard Times: Social Realism in Victorian Art*, exhibition catalogue, Manchester City Art Galleries (Manchester, 1988), 90–104. Parts of Chapter 8 were previously published in different form in Lee M. Edwards, 'Herkomer in America', *American Art Journal* 21, 3 (1989), 48–73.

Preface

Hubert von Herkomer (1849–1914) was one of those Victorian personalities whose productivity and passion for work send the modern mind reeling. Best known today for his portraits of the privileged and his genre subjects, which document the sufferings of the poor, Herkomer first achieved prominence in the 1870s with his illustrations of contemporary urban life for the *Graphic* magazine. His published engravings, like those of his colleagues Luke Fildes and Frank Holl, portrayed the plight of the poorer classes with grim realism, in contrast to the more common picturesque or idealized forms of representation. Herkomer worked up several of these engravings into exhibited paintings, the most celebrated being *The Last Muster* (see Colour plate XVII), which depicts a group of Chelsea Pensioners, one of whom has quietly died, seated at Sunday service in the Chelsea Hospital Chapel.

Herkomer's sympathy for the poor was fostered in part by his own humble origins. The son of impoverished German immigrants, he eventually amassed an immense fortune through his practice as a portrait painter. His residence 'Lululaund' (named for his second wife) in Bushey, designed for him by the American architect Henry Hobson Richardson, was often the scene of fashionable 'afternoons' attended by the most talented and powerful figures of the day. There the actors Sarah Bernhardt, Ellen Terry and Henry Irving and the writers Thomas Hardy and Edmund Gosse mingled with industrialists and politicians whose portraits the artist had painted. In his attempts to represent all levels of society – the disadvantaged in his subject pictures, the eminent and glamorous in his portraits – Herkomer's ultimate goal was to document all aspects of contemporary life (much as Baudelaire had suggested to artists in the 1840s), to tell history via the painter's craft. 'Be it remembered that we paint and write for future generations to dream over and wonder', he told students in a Royal Academy lecture in 1900.

Nevertheless, in the light of his own spectacular rise from poverty to affluence, and the wider perspective of Victorian middle-class social attitudes, which towards the end of the century viewed the poor less as objects of charity and more as an ominous threat, Herkomer's later subject pictures, such as *On Strike* (see Figure 88) assume different levels of meaning.

His last important commission, the immense group portrait *The Managers and Directors of the Firm Fried.*

Krupp, Essen, Germany (see Figure 110), painted in 1913, appears to make no judgements but manages to impart the spirit of the solemn, calculating men. Ironically, in his self-appointed role as the artist who depicted the 'true' history of his generation, Herkomer had, in this final great work, memorialized those who helped bring about the destruction of the epoch he had so faithfully recorded.

Herkomer's considerable talents in a number of fields, his vital personality and his genius for self-publicity propelled him to the heights of renown. He lectured tirelessly on numerous social issues and art-related topics, and he succeeded John Ruskin (at Ruskin's own suggestion) as Slade Professor at Oxford University, a position he held from 1885 to 1894. He was also a noted instrumentalist and composer, and the author of several books; a playwright and theatre-set designer who influenced the groundbreaking theatrical innovations of Edward Gordon Craig; and an early film-maker who pioneered the technology of this new art form in Great Britain. His art school in Bushey drew students from the Continent, as well as from America, Australia and South Africa.

Herkomer's international reputation was bolstered by his stature in Germany. While he remained outspokenly loyal to his adopted homeland, and was a powerful force in the Royal Academy after his election to membership, he maintained a residence in his native Bavaria to which he returned almost annually. His involvement with the Munich Secession in the 1890s and his use of Symbolist imagery during that period provide fresh insights into his artistic temperament and the forces that informed it.

That Herkomer's work looked different from that of his Victorian contemporaries from the outset of his career in England is already obvious in his early images of Bavarian peasant life (which incorporated borrowings from his German contemporaries Wilhelm Leibl and Adolph von Menzel) and his illustrations for the *Graphic* magazine. His vigorous and idiosyncratic style helped prepare the way for the critical acceptance of foreign tendencies in the next generation of English artists. Perhaps more importantly, Herkomer's expressive illustrations for the *Graphic*, which in turn sparked his most inventive subject pictures, left their mark on one of the greatest figures of emerging modernism, Vincent van Gogh.

Herkomer's achievements on the broader cultural

front have long been neglected. The victim in part of the ongoing Anglo-German tensions that marked the first half of our century, his reputation was also damaged by the pervasive antipathy to all things Victorian in the wake of the First World War. Even the artist's skilful self-promotion (he was the subject of several contemporary monographs and the author of a two-volume autobiography) caused a backlash against him when he was no longer around to prod, proclaim and enthuse. His body of work both serves as an eloquent expression of a Victorian artist's personal vision and offers insights into the aspirations and fears of a society in upheaval and transition, one that anticipates the complexity and unrest of our own times.

Herkomer's life: a path to success

The small house (Figure 1) in the Bavarian village of Waal, about 40 miles from Munich, Germany, where Hubert Herkomer was born and where he lived for the first two years of his life, is now marked with two wall plaques dedicated to his memory. One of them, decorated with baroque shells and other flourishes, notes in elegant Gothic script his birthdate as well as his profession as an artist. The other, a plain rectangle bearing block letters, states that Herkomer introduced automobile racing to the German public. Donated by a group of car enthusiasts, it was inserted in the wall in 1974, the sixtieth anniversary of his death.

These contrasting markers hint at the contradictions in Herkomer's professional and personal life. While his most inventive paintings and illustrations derive from the early years of his career, the creative endeavours of his later life were often experimental in nature and underscored his fascination with the possibilities of modern technology. His outspoken enthusiasm for everything he undertook, as well as his populist tendencies, sometimes alienated his English peers, who perceived an unpleasant mixture of arrogance and smugness in his personal make-up. His German counterparts, on the other hand, were more tolerant of his diverse interests and personal quirks, and tended to focus on his versatility and generosity of spirit.

Hubert Herkomer (Figure 2) was born on 26 May 1849, in a house built by his father in Waal. He was the only child of Lorenz Herkomer (1825–1888) (Figure 3), a builder and woodcarver, and Josephine Niggl (1826–1879), a gifted pianist and music teacher from the nearby village of Denklingen. An old Bavarian family whose presence in Waal extended back to the early years of the seventeenth century, the Herkomers had long been engaged in traditional craft trades.[1] Herkomer's paternal grandfather, Mathias (1770–1843), was locally renowned for his carvings and labour-saving tools. A product of the onerous apprentice system then in effect in Munich, Mathias became a master mason. His wife, also named Josephine, was a strong and resourceful woman who trained as a midwife.[2] Nine children were born of this marriage, of whom four sons and two daughters survived into adulthood.[3] Herkomer's father, Lorenz, was the third son.

As a master mason, Mathias Herkomer fashioned hundreds of carved and gilded religious figures and nativity scenes for church displays in Bavaria and he passed his craft skills and love of art on to three of his

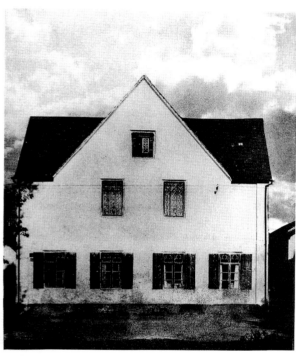

1 The house where Hubert Herkomer was born in 1849 in Waal, Bavaria

sons: Lorenz and Hans (1821–1913) (later known as John [Figure 4]) trained as woodcarvers and carpenters; and Anton (1806–1901) was apprenticed to a weaver (Figure 5).

Herkomer's mother, Josephine, was the daughter of a schoolmaster and church organist. She received a good education and became a gifted pianist. Her skills as a piano teacher were to become an important source of family income after her marriage. Other maternal relatives also had musical talent – Josephine Herkomer's two nieces, Marie and Mathilde Wurm (Mathilde later anglicized her name to Verne), went on to enjoy distinguished careers as musicians in England.[4]

After completing his apprenticeship as a woodcarver in Munich and taking the obligatory *Wanderjahr*, Herkomer's father, Lorenz, settled with his bride in Waal; here their only child Hubert was born.[5] A few months later, in 1850, Lorenz completed his most important commission, an elaborately carved and gilded wooden altar in the Gothic style for the church in Waal.

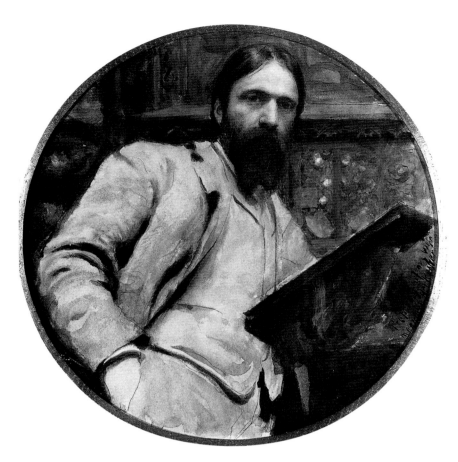

2 *Self-portrait*, c.1888,
watercolour.
Inscribed 'Property of
my wife, Maggie B.
Herkomer'

and 'sifted' half across the floor – a grim contrast to the comfort that all classes have at their command in modern America.[8]

One particularly poignant family souvenir from this period is Josephine Herkomer's carefully annotated account book of music lessons. As the principal wage earner in the family, she gave more than 3 000 lessons as well as two concerts during three years in Cleveland, earning a little more than $1 000.[9]

Discouraged by the lack of work available to someone with his old-fashioned craft skills – he found that elaborately carved furnishings and objects were not in much demand in the New World – Lorenz Herkomer, with his wife and son, decided to leave Cleveland and emigrate to England. In May 1857, their trip financed by the dowry money of John Herkomer's new German-born bride, they sailed for Southampton. A brief visit to London convinced them that the metropolis was too overwhelming, and after returning to Southampton they soon settled in a semi-detached house on Windsor Terrace. John Herkomer for the time being remained in Cleveland, where he eventually started an art school and also taught woodcarving at the Western Reserve School of Design.[10] Among his later American commissions were carvings for Booth's Theater in New York City and the Detroit Opera House, all now destroyed.[11]

During the Herkomers' first years in Southampton, lack of money was a continual problem and indeed they might have starved but for the generosity of a neighbour.[12] Their foreign origin was often the butt of ridicule, though Mrs Herkomer, whose English had become serviceable during the years in America, soon attracted piano pupils. In fact the family later enjoyed a certain celebrity. The following excerpt from a Southampton newspaper attests to the esteem Josephine Herkomer had attained by the time of her retirement in 1874:

An advertisement has announced to our readers that Madame Herkomer, who has so successfully laboured in the town during the past seventeen years as a professor of music, is about to leave Southampton in order to take up residence with her son (Mr. Hubert Herkomer) near London. While here she has gained the respect and love of her pupils and a large circle of friends . . . Mr. Hubert Herkomer has already attained high honours as an artist, and they hope he will shine still further and become one of the stars in the art of painting.[13]

Hubert often performed in his mother's concerts in Southampton. The legendary stage presence of his later years, whether lecturing or performing in his plays, was nurtured during these childhood soirées. Among the instruments he played with a high degree of competence as a youngster were the piano, violin and zither.[14] Indeed, his gifts were such that he could have pursued a career as a musician, and in the leaner times of his art-student days he attempted to become a zither player with a Christy-minstrel troupe in

In 1851 Lorenz Herkomer, now 26 years old, decided to emigrate to America with his wife and two-year-old son, citing family and political reasons. Lorenz's brothers, Anton and Hans (John), had already emigrated there shortly after 1848, the year of revolution in Europe, when many German families came to the United States to seek greater freedom. Increasingly constrained by the autocracy of the local Bavarian authorities, Lorenz found his commissions curtailed in the wake of disagreements with village and church elders about his work.[6] In order to raise money for the voyage, the house in Waal was sold, and the Herkomers sailed to New York. After barely surviving the crossing, they remained in New York City for two years. From August 1853 to January 1854 the family tried to make a home in Syracuse in upstate New York. Sadly disillusioned, they moved again, this time to Cleveland, Ohio, where they shared lodgings with John Herkomer.[7] 'I have a distinct recollection of our home in Cleveland', Herkomer wrote more than 50 years later:

My father and uncle had one room for their work – the largest in the flat, and my mother established herself in one of the smaller rooms for music teaching . . . My recollection is of sparsely furnished rooms; of terrible heat on summer nights when we slept on the bare floor in the vain hope of getting a little coolness; of exasperating bites of stinking bugs (the more aristocratic flea, not being indigenous, was hardly ever met with); of the terrible cold in winter – when we slept between straw mattresses to get warm; of the snow that beat in through the imperfectly made window sashes,

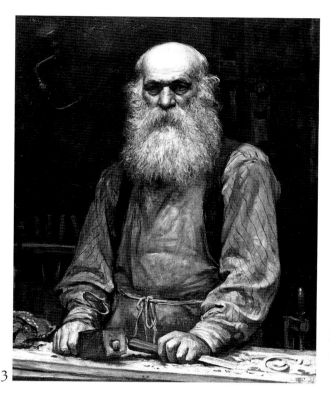

3

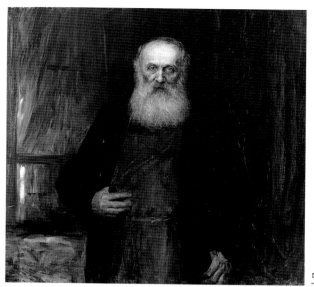

5

3 *Lorenz Herkomer*, 1882, oil on canvas

4 *John (Hans) Herkomer*, 1891, oil on canvas

5 *Anton Herkomer*, 1886, oil on canvas. This and the portraits of Lorenz and John Herkomer were often exhibited as a triptych, *The Makers of my House*

eyes. His grief at her death in 1879 inspired him to build a memorial castle, the *Mutterturm* ('Mother Tower') (Figure 6) in Landsberg-am-Lech near Waal, which became his summer residence after its completion in 1885.

Soon after the Herkomers arrived in Southampton in 1857, the education of their eight-year-old son became imperative. Although Hubert could already speak English, he first learned to read and write his adopted language under the instruction of one of his mother's piano pupils.[16] His only formal schooling began shortly thereafter, but although he was a lively, active child, ill-health dogged his adolescence, and his attendance at school terminated after six months. Thereafter, he was taught at home by his father: 'To this education my father devoted his life, and it was his duty (as he felt it) rather than his pride (as people thought) that prevented him from seeking a position as an ordinary workman.'[17] Lorenz Herkomer, who was a gruff and silent man, found few customers in Southampton for his elaborately carved woodwork, though he made a little money as a frame-maker and picture-restorer.[18] A dreamer who thought of art as a spiritual calling, he lacked the basic skills to function in a businesslike way, and never seemed to adapt to life in his new homeland.

Despite Hubert's lack of formal education, his capacity for learning was astonishing. A teacher at heart, he soaked up information and enthusiastically tried to impart it to others. He became an articulate and entertaining lecturer and in his later years wrote several books and many articles on various disciplines in the applied arts.[19] He sought literary advice from such eminent authors as his friends Edmund Gosse and Thomas Hardy, and on art matters from Marion H. Spielmann, the editor of the *Magazine of Art*, and Alfred Lys Baldry, a well-known late-nineteenth-century art critic and Herkomer's

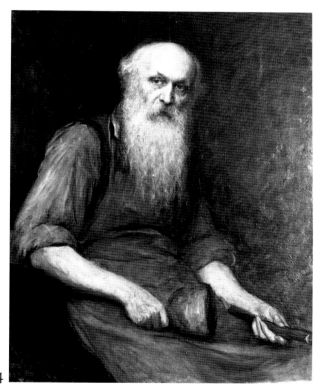

4

London.[15] In later years he published music for both zither and violin, and also composed and scored the orchestral accompaniment for the 'pictorial-music-plays' he produced in the 1890s. His unflagging energy and passion for work were inherited from his musical mother, whom he deeply loved and respected. Her portrait, which he painted in 1877, two years before her death, captures her attractive appearance – firm mouth and chin and wistful, expressive

6 *The Mutterturm*, Landsberg-am-Lech, Bavaria, etching. Completed in 1885, the *Mutterturm* was the artist's summer residence

English and German subjects, a pattern he continued throughout his career. An example of these teaching exercises survives: *The Bagpiper* (1860, Figure 7), inscribed in Herkomer's hand 'copied from a woodcut and colour added on the advice of my father', made when the artist was eleven years old (Figure 8). The crudely drawn hands in this youthful effort betray his inexperience though, curiously, the delineation of hands was to remain difficult to Herkomer: at the height of his career, the *Art Journal* sarcastically observed of Herkomer's hugely successful portrait of Archibald Forbes, painted in 1881 (see Figure 96), 'The hands, over which Mr. Herkomer too often blunders, are prudently hidden.'[25] An even earlier pencil drawing, *King David* (1857; Figure 9), was probably copied from a child's history text. A depiction of the patron saint of Wales dressed in Druidic costume and plucking at a lyre, it is inscribed in his father's hand: 'Hubert Herkomer mit 8 Jahren gezeichnet.' It is significant that Herkomer's father preserved a Welsh subject from these juvenile exercises, for Welsh culture later made a strong impact on the artist. In addition, these two early drawings depict music-making, one of the artist's lifelong favourite activities. Other art activities, supervised by his father, included toymaking and sketching outdoors, and the boy was also encouraged to create purely imaginary scenes.[26] A more finished piece of juvenilia is the artist's first oil painting, *Rabbits in a Forest* (Figure 10). Painted in 1862 when he was thirteen years old, it is surrounded by one of Lorenz's carved frames.

In 1863 Herkomer enrolled in the Southampton School of Art, where he studied for two years. This introduction to formal training was a disaster, and in later life he often criticized the crippling academic methods to which he was exposed as a young art student.[27] Despite his impatience with teaching methods at Southampton, however, he found lifelong friendship with a fellow art student, George Sandell, who kept alive Herkomer's involvement with the school and, indeed, his fondness for the city of his youth. Sandell, who remained involved in the arts while pursuing a successful career as a ship's broker, was able to persuade Herkomer to lecture at the school as late as 1913; the artist also donated his favourite palette to the Southampton Art Gallery.[28]

In 1865, Lorenz Herkomer received a commission from his brother John in Cleveland to carve six copies of Peter Vischer's apostle statuettes on the St Sebaldus monument in Nuremburg.[29] For Lorenz, the commission provided an excuse to begin his son's art education in Munich – 'the place best suited as he thought for the purpose'.[30] Father and son left Southampton in April 1865, and Herkomer was accepted at the Munich Academy after submitting the competitive drawing required. Because they arrived near the end

biographer. Herkomer amassed an extensive private library and when, after his death, his widow auctioned his books, among them were William James's *Principles of Psychology* (2 volumes, 1910); Charles Darwin's *Life and Letters* (3 volumes, 1887); a first edition of Swinburne's *Poems* (1886); a complete set of Lord Macaulay's *Works* (12 volumes, 1898–1910), and books by John Ruskin, G. B. Shaw, Thomas Hardy and other leading writers of the time.[20] Herkomer maintained an easy rapport with such crusty literary figures as John Ruskin (see Figure 94) and Alfred, Lord Tennyson (whose portrait painted by Herkomer in 1879 is now in the Lady Lever Art Gallery, Port Sunlight), and wrote illuminating letters about their personal idiosyncracies.[21] Interestingly, although he spoke German fluently he had difficulty reading and writing it.[22] According to a younger relative, his English accent was immaculate and he spoke in the clipped tones of the educated upper classes.[23]

Lorenz Herkomer taught his son how to carve simple figures and set him to copying engravings and filling them in with watercolours. The engravings were usually woodcut illustrations from the *Illustrated London News* or German picture sheets[24] and thus Herkomer began early to make images of both

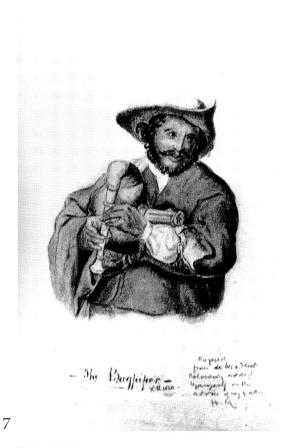

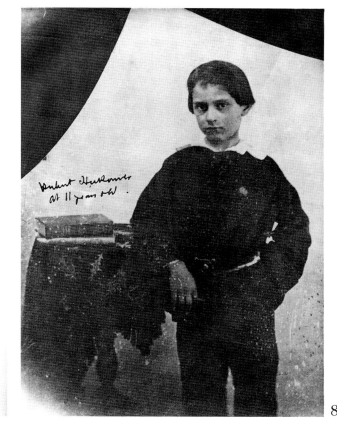

7 *The Bagpiper*, 1860, pencil on paper

8 Photograph of Hubert von Herkomer at eleven years old

9 *King David*, 1857, pencil on paper

7

9

8

(1805–1874), Echter had helped his master execute a series of frescoes in the stairwell of the Berlin Museum, *The Apotheosis of the Evolution of Human Culture*, completed in 1865. The Munich Academy attracted students from all over Europe and the United States, and the period between 1860 and 1890 saw the Academy at its most distinctive and influential. The 'ban on realism' of which Herkomer complained may have been relieved somewhat by his exposure to the work of Wilhelm Leibl (1844–1900), a student (he was five years older than Herkomer) at the Academy during the time the Herkomers were in Munich.[32] Leibl's realism was much admired by many of the students at the Academy and Herkomer would have been aware of this artist's impact among his contemporaries.

Academy instruction in Munich followed a traditional structured mode: students were expected to spend two years drawing from classical casts – heads, hands, feet and so on – before graduating to the life class, a system already abhorrent to Herkomer, who thought that drawing from casts was unnecessary and tedious.[33] Five drawings that survive from the period record the young Herkomer's progress as he worked from the nude model. They also testify to his father's patience and desire to see his son succeed as an artist:

We rose at 6 o'clock every morning . . . and whilst I dressed, my father made a fire in the stove, and put the water on to boil. During that time my father remained undressed, and in the intervals of his domestic work posed for me. When the water boiled, it was time to lay aside the sketch, to be renewed the next morning.[34]

of the term (Lorenz Herkomer never seemed to think ahead), however, Herkomer only attended Academy classes for a short time. He received some drawing instruction from Professor Michael Echter (1812–1879) who, according to Herkomer, felt that 'realism should be banished from the arts'.[31] A former pupil of the Academy's Director, Wilhelm von Kaulbach

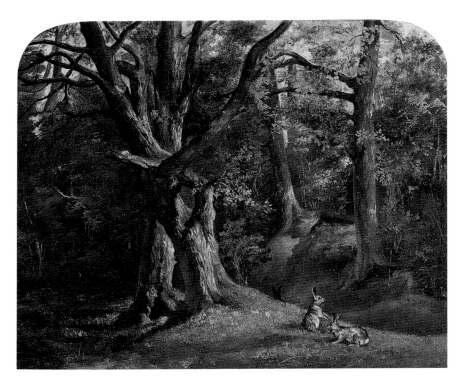

10 *Rabbits in a Forest*, 1862, oil on canvas

In addition, he and his father joined an evening life class which was privately organized by a group of painters and sculptors,[35] though there remains no record of the participants. A comparison of Herkomer's study of his father, sketched during their early morning sessions (Figure 11), with his drawing of a model, made in the private life class (Figure 12) in Munich a month later, is revealing: the simple outlines and flattened masses in the first study have given way in the second to a more sophisticated image with rubbed-in shading, rounded volume and bodycolour highlights.[36]

Because naturalized British citizens could stay abroad no longer than six months (and because, had the Herkomers decided to stay, German military service would have been mandatory for the boy), father and son returned to Southampton in November 1865, bringing Lorenz's unfinished sculptures along with them. With his habitual forthrightness, Herkomer later recorded that 'Southampton after Munich seemed arid and stupid. I missed the galleries of pictures by the greatest past masters; I longed for the whole art atmosphere that had surrounded us in the Bavarian capital.'[37]

In 1866 and 1867 Herkomer spent two summer terms at the National Art Training School (later the Royal College of Art) in South Kensington, London, which was attached to what would become the Victoria and Albert Museum. Again he found the teaching intolerable – 'aimless and undirected'.[38] Determined to skip the dreaded preliminary class, he offered his Munich drawings as proof of proficiency and was immediately promoted to the life class. At South Kensington he met and formed a lifelong friendship with his classmate Luke Fildes (1843–1927), who, like Herkomer, was soon to become known for expressive depictions of the poor. Fildes had already gained celebrity among the students because his drawings on wood had been published as woodcuts in a number of periodicals.[39] Fildes encouraged Herkomer in his own black-and-white work,[40] and in 1868 his illustrations began to appear in such popular periodicals as *Good Words for the Young* (see Figure 45) and the *Quiver* (see Figure 22). Over parental objection, Herkomer, now 19 years old, moved from Southampton into rented rooms on Smith Street in Chelsea, and in the summer of 1869 two of his works were selected for exhibition: a watercolour, *Leisure Hours* (untraced) at the Royal Academy, where he was to exhibit almost every year until his death; and another watercolour, *Choosing* (see Figure 44), at the Dudley Gallery, a popular venue for young watercolour artists of the time, who showed there before progressing to membership in the venerable Royal Watercolour Society.

In 1870 Herkomer's most celebrated black-and-white work, which often depicted scenes of urban poverty, began to appear in the *Graphic* magazine. His life in art had begun in earnest, and he never again lacked work. Using the money he earned from illustrating, Herkomer and his father returned to Germany in May 1871, spending six months in Garmisch in the Bavarian Alps. Here Herkomer sketched and painted the activities and colourful costumes of the local peasants, absorbing stimuli for future works of art. For the rest of his life, he visited Germany frequently, often staying for months at a time.

In 1867, during his second term at South Kensington, Herkomer saw *The Bathers* (Figure 13), an oil painting by Frederick Walker (1840–1875) exhibited at the Royal Academy. The painting was a revelation to him, 'a new direction ... a new light', as he later wrote.[41] He was particularly excited by the shallow frieze-like composition, the poetic realism of the subject matter and the oil painting technique with its chalk-like surface.[42] Herkomer acknowledged the inspiration of Walker's art throughout his career: as late as 1893, in an article on another of his heroes, the landscape painter and close friend of Walker, John W. North (1842–1924),[43] Herkomer eulogized Walker as 'the creator of the English Renaissance', and he referred to him in a lecture in Birmingham as the apogee of English watercolourists.[44] In the same year he purchased at auction Walker's exquisite watercolour *The First Swallow* (1868; British Museum).[45]

Herkomer's adulation of Walker was hardly an isolated phenomenon: a number of later Victorian artists and critics admired Walker's art with what amounted to cult-like reverence. This reached its apotheosis in George du Maurier's hugely popular novel *Trilby*

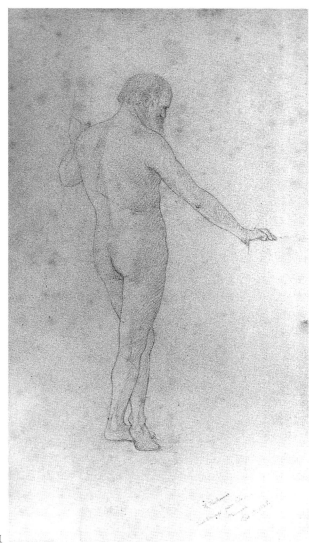

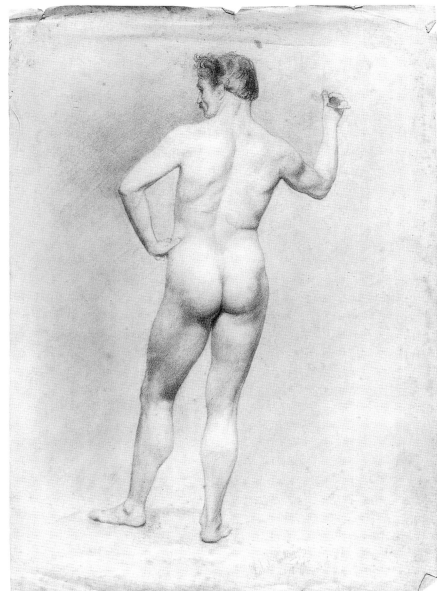

11

12

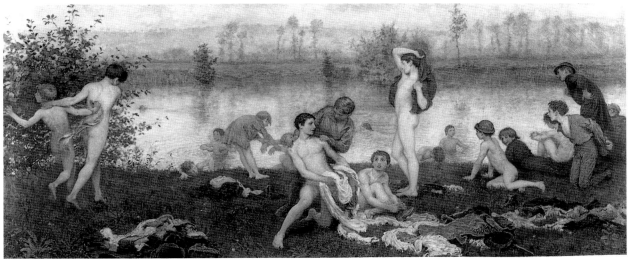

13

11 *Study of a Nude*
(Lorenz Herkomer),
17 September 1865,
pencil on paper

12 *Study of a Nude*, 19
October 1865, pencil
and bodycolour on
paper

13 Frederick Walker,
The Bathers, 1867, oil
on canvas

(1894), in which the character of the delicate young artist Little Billee is modelled on Walker.[46]

In his earliest work, Herkomer clearly emulated Walker's style though George Pinwell (1842–1875) was another obvious influence. Herkomer's contemporaries often commented on this stylistic dependency. Two watercolours exhibited by Herkomer in 1872, *A Chat on the Way* and *A Boating Party* (both untraced), were criticized for being 'in so many respects ... a mere echo of Walker'.[47] Even Herkomer's first major oil painting, *After the Toil of the Day* (Colour plate VIII), a scene in the Bavarian Alps, elicited one viewer's response, 'Oh, here's a Walker!', when it was exhibited in 1873 at the Royal Academy.[48] Although he did know members of Walker's circle, Herkomer wrote many years later in his memoirs that he never met Walker and 'only saw him at a distance on two occasions'.[49] This seems hard to believe, especially considering Herkomer's close friendship with Pinwell during his first years in London. Illustrations by Pinwell and Walker often appeared together in publications of the 1860s, in such volumes as *Wayside Posies: Original Poems of the Country Life* (1867), and they certainly knew each other. An edgy distance, however, seemed to prevail, possibly arising from their different social backgrounds. Pinwell's education was limited, and he did not circulate in the musically gifted and fashionably Bohemian art crowd in which Walker felt comfortable.[50] J. Comyns Carr, a Victorian author and critic who was acquainted with Walker, recalled that he was a melancholic and shy soul who was difficult to know.[51] Walker was nine years older than Herkomer, and the latter's youthful vigour and noisy enthusiasm would surely have unnerved the frail and sickly older artist, who died of tuberculosis in 1875 at the age of 35. Compounding that tragedy, Pinwell died in the same year, also from tuberculosis. Although we must accept that Herkomer and Walker never met, we know that word reached Herkomer that Walker was displeased by public reaction to the man he perceived as his imitator.[52]

Along with his admiration for the art of Walker and the other artists of what is now known as the Idyllic School, by the mid-1870s Herkomer's exhibited watercolours and oil paintings revealed his absorption of the peasant realism of his German contemporaries Wilhelm Leibl (1844–1900) and Franz von Defregger (1835–1921).[53] This assimilation of Continental styles, conjoined with Walker's poetic naturalism, helped guide Herkomer in the creation of his own provocative and formally innovative work.

In 1873 Herkomer persuaded his mother to give up her piano teaching in Southampton so that his parents could settle with him in a pair of cottages he named Dyreham (a play on the words 'dear home')[54] in the High Street in Bushey, Hertfordshire, a village 15 miles from London. Lorenz Herkomer's beautiful hand-carved furniture soon filled the little house (Figure 14), while the Smith Street rooms in Chelsea were kept as a studio. Bushey had attracted artists ever since Dr Thomas Monro, a prominent physician (he attended George III in his final illness) and amateur watercolour painter and collector, purchased Merry Hill House in 1805.[55] There Monro ran a painting academy similar to an earlier one located at his London residence on Adelphi Terrace, where artists in his circle included J. M. W. Turner and Thomas Girtin. A frequent visitor to Monro's Bushey establishment was William Henry Hunt (1790–1864), whose watercolours were much admired by John Ruskin and Walker. Like Hunt, Herkomer would use the rural poor of Bushey as models for many of his later subject pictures.

Why did Herkomer choose to reside for the rest of his life in the quaint village of Bushey? It is possible he knew of Bushey's significance as an artists' haven, and, still at this early stage in the 'thralldom of Walker',[56] who also preferred village life (at Cookham in Berkshire) to London, he must have thought it comparably rustic.

Perhaps most significantly, the artist's first important patron, Clarence Fry, lived in the neighbouring town of Watford. Fry was a partner in the photography firm of Elliott and Fry, of Baker Street in London, which had been founded by his father. One of the earliest photographic studios of the day, it did primarily portrait work and attracted a celebrity clientele. Clarence Fry bought Herkomer's earliest exhibited watercolours and was the first owner of the artist's most famous painting, *The Last Muster* (Colour plate XVII), painted in 1875. These works were prominently displayed in the Baker Street studio,[57] and Fry's collection at one time numbered more than 50 drawings, prints and oil paintings by Herkomer. Fry enjoyed bicycling and fly-fishing in Germany with Herkomer and visited him there on numerous occasions. Herkomer's spontaneous watercolour sketch of Clarence Fry (Colour plate I) was painted at the Schluch See in the Black Forest in the summer of 1873, while they were on a fishing expedition to the area. It was through Fry that Herkomer met his first wife, the German-born Anna Weise, who was residing in the Frys' house in Watford, Little Elms, by 1873. They were married in December of that year in the parish church in Bushey with Sophie Fry, Clarence's wife, acting as a witness.[58]

Herkomer's son Siegfried (d.1939), who later served as his father's secretary, was born in Bushey in 1874, and his daughter Elsa (d.1938) was born in 1877. The marriage was unhappy, exacerbated by Anna Herkomer's chronic ill-health. Because of tension in the household, Herkomer's parents resettled in Bavaria in 1877 in a house Herkomer bought for them in Landsberg-am-Lech, near Waal. After the death of

Herkomer's mother two years later, his father returned to Bushey and served as his son's constant companion till his own death in 1888.

In May 1883 Herkomer's wife Anna died of consumption in Vienna.[59] They had separated the previous year, after living intermittently apart since 1877, and Herkomer made no secret of the difficulties in the marriage. His memoirs, written years later, paint a bitter, one-sided picture of their relationship.[60] On the other hand, his poignant image of her listlessly resting in a hammock (painted in 1876 for their children) forecasts the terminal nature of her illness (see Colour plate II). Some years older than her husband, Anna Herkomer was the well-educated daughter of Albert Weise, a lawyer from Berlin.[61] A surviving letter written in her elegant hand tells of her love for her husband.[62] The author Edmund Gosse (1849–1928), who was Herkomer's age and knew the couple well, was appalled by the artist's cruel appraisal of his wife in his several autobiographies. Gosse noted in a *Sunday Times* article that

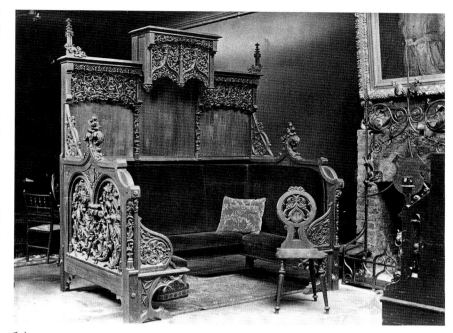

14

The first Mrs. Herkomer was a lady of charm and refinement, in social cultivation considerably superior to her husband when she married him. She was devoted to his interests, and although she was delicate it was not until near her end that she became what he ungraciously called 'a burden' to him. The 'severity of his domestic trials,' which he thought it becoming to so repeatedly bewail in public, was all moonshine.[63]

One factor in the mounting domestic stress was undoubtedly Herkomer's burgeoning passion for a Welsh nurse, Lulu Griffiths (1849–1885), who joined his household in 1874 to care for Anna and to help with little Siegfried.

Convinced of his powers as a mesmerist, which he said would help him in his painting,[64] though in what capacity is not clear, Herkomer could have served as a model for the character Svengali in George du Maurier's novel *Trilby*. He practised his 'curative' hypnosis on the long-suffering Anna, and, when his wife was away, on Lulu. She too suffered from ill-health – her heart had been weakened by rheumatic fever when she was a child – and severe headaches, and the artist occasionally placed her in sinister trance-like states that went on for days.[65] He may have had other reasons for initiating these curative sessions, for he enjoyed the calming effect that resulted from 'a power of concentrating myself beyond my natural tendencies'.[66] Herkomer was always fascinated by the occult and the mysteries of the mind. Surrounded by serious illness at home, he may have thought the 'mind over matter' discipline that he found useful for himself could be helpful to those closest to him. By the mid-1870s he was also a follower of the fashionable American phrenologist Lorenzo Niles Fowler (1811–1896), who gave a lecture on health regimes at Herkomer's invitation.[67] Herkomer himself had matured from a sickly little

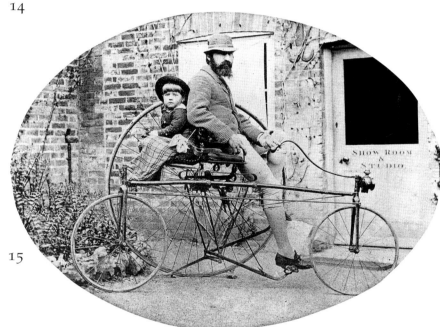

15

boy into a sturdy muscular man of middle height, who was an early advocate of fitness machines. He particularly enjoyed such outdoor pursuits as bicycling (Figure 15) and mountain hiking, adhered to a primarily vegetarian diet and neither drank nor smoked. Until 1890, after which he remained clean-shaven, his face was covered in a lustrous black beard which, combined with his piercing eyes, attenuated nose and humourless demeanour, produced a rather menacing appearance.

On 14 August 1884 Hubert married Lulu at her birthplace, Ruthin in Wales. Her sudden death in November 1885, three months after their child was born dead, devastated him. He struggled for the rest of his life with the pain of losing her. Herkomer's only known painting of her (see Colour plate III) remained

unfinished at her death but a wonderful close-up pencil drawing (now lost) of her quizzical face with its enquiring gaze is reproduced in his memoirs.[68] From all accounts she was a popular and kind person whose tiny frame belied the strength of her character.

In 1888 Herkomer married Lulu's sister Margaret Griffiths (1857–1934) (see Colour plate VI), also a nurse, who had joined the Herkomer household in 1878. The marriage took place in Landsberg-am-Lech, Bavaria, and Herkomer had to renounce his British citizenship, it being illegal in England at that time to marry a deceased wife's sister (he was renaturalized in 1897).[69] Their children, Lorenz (later Lawrence, who was nicknamed 'Tutti') and Gwendydd, were born in 1889 and 1893. As a father, Herkomer could be tender (Figure 16), but the chaotic early years of his first marriage and the early deaths of both Anna and Lulu Herkomer often threw the lives of the two eldest children, Siegfried and Elsa, into a state of upheaval. Although Margaret had been a member of the household for many years before her marriage, the children were slow to bond with their new stepmother. In his memoirs Herkomer claimed they adored her[70] but, distracted by her own two children (Figure 17), Margaret was emotionally distant with her stepchildren and neglectful of even their basic needs.[71] Herkomer's passion and energy were mostly devoted to his work, though his father Lorenz was an affectionate grandparent until his death in 1888. Elsa escaped by marrying young and spent most of her life abroad as did Gwendydd, who grew into a strong-willed beauty (Figure 18). The two boys, who led unfulfilled lives, never emerged from their father's shadow.[72]

Herkomer's first critical and popular success was *The Last Muster* (see Colour plate XVII). The painting, which depicts Chelsea Pensioners at chapel, was the sensation of the Royal Academy at its exhibition in 1875 and was awarded a medal of honour at the Universal Exhibition in Paris in 1878. For the next four decades it remained one of the most popular Victorian pictures. Other genre paintings (scenes of everyday life) exhibited by Herkomer during the 1870s and 1880s include *Eventide: A Scene in Westminster Union* (1878; see Colour plate XV) and *Pressing to the West* (1884; see Figure 113), both focusing on specific social themes, and a number of scenes of everyday Bavarian peasant life, such as *At Death's Door* (1876; see Colour plate IX) and *Der Bittgang* (1877; see Colour plate X). During these early years he also exhibited decorative pieces, such as the two wooden panels with seminude male and female figures called *Legend, Oracle* (1875; Laing Art Gallery, Newcastle), and fantasy subjects such as *A Fairy Symphony* (1873; now in a private collection, a watercolour of nude figures surrounded by symbolical creatures), which were precursors of a Symbolist phase in his art of the 1890s.

Although Herkomer painted genre subjects

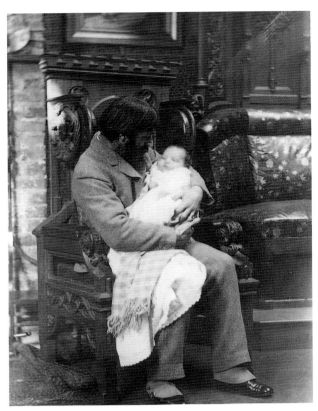

16

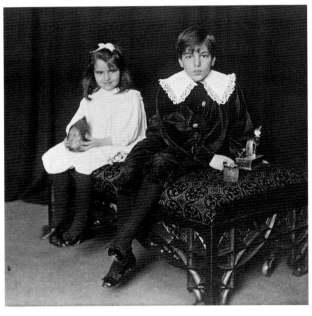

17

throughout his career, including such works as *The Chapel of the Charterhouse* (1889; see Figure 78), *Our Village* (1889; see Figure 123), *On Strike* (1891; see Figure 88) and *The Guards' Cheer* (1898; see Figure 80), his principal focus after 1880 was portraiture. There is no question that, like his fellow *Graphic* illustrators, Luke Fildes and Frank Holl (1845–1888), he turned to portrait painting to make money. The bulk of his income, while providing for increasingly burdensome family needs, was channelled into supporting his other artistic enterprises. These included the building of his Arts and Crafts castle-home Lululaund (named after his second wife), in Bushey; experiments in

printmaking and enamelling; theatrical productions of his music-plays; film-making; and the founding of the Herkomer Art School in Bushey. These diversions detracted from the time he could devote to his painting, but they also point up Herkomer's didactic impulses and fascination with the technical inventions of art. Ultimately, his goal was to define all of the arts as one conjunctive whole or *Gesamtkunstwerk*, a continuation in England of the aims of the composer Richard Wagner (1813–1883), whom Herkomer greatly admired.

In the spring months between 1879 and 1884 Herkomer and his close friend and patron Charles W. Mansel Lewis (1845–1931), a Welsh landowner and amateur painter, camped in the vicinity of Lake Idwal in North Wales. Here they experimented with photography, and Herkomer produced several large landscape paintings that were exhibited at the Royal Academy and at the Grosvenor Gallery, the latter the most progressive and fashionable exhibition venue of the 1880s.

By 1879, when Herkomer was elected an Associate of the Royal Academy, his place in the pantheon of London's artistic life was assured. He became a full Academician in 1890. In the 1880s he also branched out into lecturing and writing, beginning a career in the public eye that continued until his death. His lectures cut across social boundaries to reach very different audiences. For example, in the 1890s he gave lectures to the poor who attended the art exhibitions organized by Samuel Barnett at the Whitechapel Gallery,[73] and from 1885 to 1894, while Slade Professor of Art at Oxford University, he focused primarily on technical solutions to engraving and painting problems in lecture-demonstrations to students and faculty. Herkomer succeeded John Ruskin (see Figure 94) to the Slade professorship on Ruskin's recommendation. They had met for the first time in November 1878, when both were guests in the same house in Liverpool. After reading a lecture Herkomer was preparing, Ruskin (according to Herkomer) was 'full of glee' and 'was heart and soul with all I said'. Ruskin promptly suggested that Herkomer succeed him as Slade Professor, although Herkomer was not appointed for another seven years.[74] A series of lectures at the Royal Academy in 1900 was another high point of his career.[75] In 1907 he could boast to his biographer A. L. Baldry that he had lectured to over 40 000 people in that year alone.[76] In his lectures he stressed the importance of all of the arts and their relationship to the public, a means of bridging the gulf between all classes.[77]

Despite Herkomer's diversified interests, his exhibition record is staggering. Throughout the 1880s and 1890s, he exhibited in several London venues besides the Royal Academy. He was an inaugural exhibitor at the Grosvenor Gallery summer exhibitions, showing

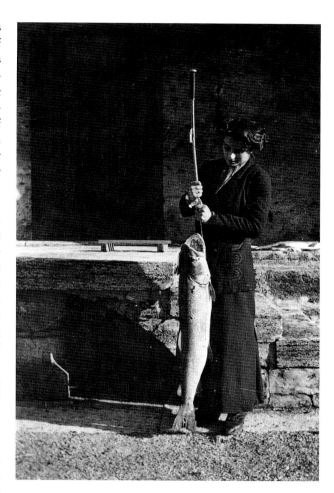

18 Photograph of Gwendydd Herkomer outside the *Mutterturm*, Landsberg-am-Lech, c.1912

peasant subjects such as *Light, Life, and Melody* (1877–1879; see Colour plate XI), as well as portraits, from 1877 to 1887. From 1888 to 1894, Herkomer exhibited portraits at the New Gallery[78] (a breakaway venue that, like the Grosvenor, challenged the conservatism of the Royal Academy), which was founded by the former managers of the Grosvenor Gallery, Charles Hallé and J. W. Comyns Carr. Herkomer served on the Consulting Committee of the New Gallery with other important Victorian artists such as Edward Burne-Jones, Lawrence Alma-Tadema and William Holman Hunt. Carr was Herkomer's first biographer, publishing an early account of his life and work in 1882. The Dudley Gallery, the Old Watercolour Society, the Fine Art Society and the German Athenaeum were among the other exhibition venues where Herkomer showed his work. In 1892, in London alone, he exhibited a total of 55 works in a variety of media.[79]

At the same time his international exposure kept pace with that in Britain. His paintings were shown intermittently at the Paris Salon from 1879 to 1898, in Vienna, and on several occasions in America, to cite just a few examples.[80] As he matured, his stature in his birthplace, Germany, became increasingly significant. After 1870 Herkomer spent several months of almost every year in Germany, residing there after 1885 in his own residence, the *Mutterturm* (see Figure

artist to be hung in the Landsberg Town Hall; and *The Managers and Directors of the Firm of Fried. Krupp, Essen* (1913; see Figure 110) made for the Krupp family. In September 1899 Kaiser Wilhelm II awarded the artist a Prussian Order of Merit, and two months later he received the Order of Maximilien from Prince Regent Luitpold of Bavaria, which entitled him to add the prefix 'von' to his name. Afraid that such an honour might be misinterpreted, he informed the editor of the *Magazine of Art*, Marion Spielmann, that it was awarded to him as 'an English artist'.[86]

Herkomer had actively lobbied for his Bavarian knighthood, however, explaining in May 1899 in a letter to the Director of the Munich Secession, Hofrat Adolf Paulus, who had become a good friend, that 'my whole social ambition is to get the word "von" attached to my name! Most of the German artists have been honoured in this way and I would like to feel that I have, through my labours, been able to raise the family name to this degree.' Paulus had helped the artist regain his German citizenship so that he could marry his sister-in-law Margaret Griffiths in Landsberg in 1888. Although Herkomer was renaturalized an English citizen in 1897, he made it clear to Paulus that 'the special certificate of naturalisation here [i.e. England] ... leaves me the full German privileges when I am in Germany'.[87] Clearly the issue of Herkomer's citizenship was a murky one, and it would continue to haunt him from this point onward.

Though he was in increasingly poor health during his last years, Herkomer's work and travel continued unabated. He visited Italy twice, for the first time in 1890 and again in 1898, and Spain in 1905. He was active in the affairs of the Royal Academy and served on its Hanging Committee; his group portrait, *The Council of the Royal Academy*, painted in 1908 (now in the Tate Gallery), commemorates his dedication. Among his late honours were an English knighthood in 1907 from King Edward VII and an honorary Doctorate of Letters from Oxford University, also in 1907.

While his self-publicity, outspoken enthusiasm and no-nonsense personality often made him an annoying presence in English artistic life, Herkomer's controversial persona may also have felt the effects of the growing anti-German bias that surfaced in the British press at the turn of the century.[88] In 1897, after several Royal Academicians questioned Herkomer's citizenship, he filed a copy of his renaturalization papers in the Royal Academy archives. A bitter disappointment to him was his failed bid for the presidency of the Royal Watercolour Society in 1897, losing out by one vote after having served as Deputy President the year before. His strange Symbolist diploma work, *The Crucifixion ('A Rift in the Clouds')* (Figure 19), in which Herkomer himself posed as the figure of Christ, may have had something to do with his defeat for the presidency, for the watercolour was poorly received.[89] Picturing himself as a Christ-figure was not entirely out

6), in Landsberg, Bavaria.[81] His first German success came in the Munich International Exhibition of 1879, where his watercolour portrait of Wagner (1877; see Figure 93) won a gold medal.[82] In the decade of the 1880s, he exhibited at the Munich Glaspalast, showing in 1883, for example, portraits as well as *The Last Muster* (see Colour plate XVII).[83] At the Munich Secession from 1893 to 1899 his exhibited pieces included Symbolist nudes such as *'All Beautiful in Naked Purity'* (see Figure 137); social realist subjects such as *Pressing to the West* (see Figure 113), and a number of portraits of both English and German sitters.[84] He also exhibited frequently in Berlin and Hamburg. With his growing German reputation came friendships with artists such as Adolph von Menzel, the portrait painter Franz von Lenbach and Franz von Stuck.[85] Interestingly, Herkomer's Bavarian peasant paintings of the 1870s and 1880s, which he exhibited to much critical comment in England and which connect his work stylistically and thematically to that of several of his German contemporaries, were infrequently shown in Germany.

As in England, Herkomer's German portrait commissions came from prominent academics, businessmen, and members of the nobility, for example *H.R.H. Prince Regent Luitpold of Bavaria* (1895–1896; see Figure 104). He also painted huge group portraits such as *The Burgermeister of Landsberg, Bavaria, with his Town Council* (1891; see Figure 106), which was given by the

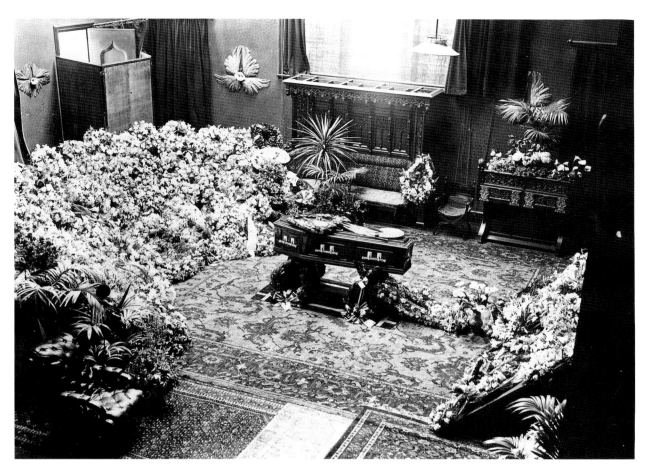

20 Photograph of Herkomer's casket in his studio at Lululaund, 1914. The wing clusters on the walls signify the personal motto on the arms Herkomer was granted with his Bavarian knighthood: 'Propriis Alis' ('By my own Wings')

of character; anyone who could publish a book with the title *My School and my Gospel* (as Herkomer did in 1908) obviously had an enlarged view of himself, whether as martyr or leader. He and his son Siegfried, who served as the Society's secretary during his father's tenure as Deputy President, also alienated members with their efficiency drive to 'wake up' the fusty Society.[90] In 1896, Herkomer designed and executed a beautiful president's badge made of gold, ivory and diamonds, which he gave to the Society, perhaps in anticipation of his wearing this official insignia himself. As he explained to M. H. Spielmann, editor of the *Magazine of Art*, his defeat came about because he was perceived as a 'forriner'.[91] Particularly galling to Herkomer was the disloyalty of the landscape painter John W. North. Herkomer had essentially revived this artist's career by writing a laudatory article in 1893, but North turned several of Herkomer's friends at the Society against him in the final voting by informing them that Herkomer 'was autocratic and that Englishmen don't like this trait'.[92]

Nevertheless, his association with the Royal Watercolour Society brought him into close contact with the British royal family, in particular with Princess Louise (1848–1939).[93] A gifted amateur watercolourist (and Queen Victoria's sixth child), she was active in the Society's affairs and introduced the artist to other royal family members. When Queen Victoria died, Edward VII asked Herkomer to paint a portrait of her on her deathbed (see Figure 102), which the artist gave to the family.

In 1910 Herkomer published his memoirs in two volumes. Plagued by stomach ulcers and serious illness throughout his last decade, he survived critical stomach surgery in 1912. His health continued to decline and on 31 March 1914 he died suddenly at Budleigh Salterton in Devon, where his family had taken him for a seaside cure. He was 65 years old. His elaborate funeral at Lululaund was attended by many Victorian luminaries; the pallbearers included the President of the Royal Academy, Sir Edward Poynter, as well as Herkomer's longtime friends and fellow Academicians, Luke Fildes, Briton Rivière and George Dunlop Leslie (see Figure 20). Among the German contingent was the Lord Mayor of Landsberg.[94] Herkomer was buried in the Bushey parish churchyard, his simple grave marked with the words: 'Hubert Herkomer Painter and Teacher. Artum Magister'.

Herkomer as illustrator and the *Graphic* magazine

Herkomer first became involved with the *Graphic* in 1870, six months after it began publication on 4 December 1869. He designed some 55 illustrations for the paper (9 of them were double-page spreads) and at least 16 of these formed the basis for later exhibited works in other media or were reproduced as illustrations from paintings (see Appendix 1). Most of Herkomer's engravings for the *Graphic* appeared in the 1870s, and they covered a wide range of subjects: 16 are urban scenes; 19 show contemporary life in Bavaria; 7 represent military subjects, including scenes of the Franco-Prussian War; and 3 belong to a series of 'Heads of the People'. Other illustrations include 2 for Victor Hugo's novel *Ninety-Three*, serialized in the *Graphic* in 1874, and 6 for Thomas Hardy's *Tess of the D'Urbervilles*, serialized from June to December, 1891.[1]

The *Graphic* magazine was founded by William Luson Thomas (1830–1900), a wood engraver who had, with his brother George Thomas (1824–1868), studied and worked in Paris, Rome and New York prior to resettling in his birthplace, London.[2] The brothers then worked as illustrators and wood engravers for the *Illustrated London News*, founded by Herbert Ingram in 1842. George Thomas went on to a successful career as a painter, exhibiting at the Royal Academy annually from 1851 till his death. William prospered as a wood engraver and illustrator, organizing a firm of young artists and wood engravers to supply illustrations for books and journals during the 1860s; for example, Luke Fildes and Henry Woods, two of Herkomer's friends at South Kensington, were among Thomas's 'stable'.[3]

Herkomer, who was one of the paper's most prolific contributors of images of the urban poor,[4] became a close friend of William Thomas. When he chaired an elaborate dinner given in 1890 to honour the *Graphic* and its founder, Herkomer praised Thomas's insistence that his artists 'go out into life and humanity' for their subject matter.[5] Clearly, Thomas's interests along with the demands of *Graphic* journalism were an important factor in establishing the direction of Herkomer's art.

In 1868, even before his foray into illustrated journalism, Herkomer's drawings were appearing in illustrated literary magazines such as the *Quiver* and the *Sunday Magazine*, uplifting publications that were considered suitable for reading on the Sabbath; in *Good Words for the Young*, which published stories and

poems for children; in the *Cornhill Magazine*, where three of his illustrations were published to accompany a serialized novella, *The Story of the Plebiscite*; and in *Fun*, a comic publication that imitated the hugely popular *Punch*. Between February 1869 and April 1870 Herkomer made five drawings for *Fun* that already reveal his flair for unusual spatial organization and theatrical narrative (Figure 21). In this series of illustrations, Herkomer repeated the same figures, a conservation of artistic energy that he would later employ in his multiple renderings in a variety of media – oil, watercolour, black-and-white – of some of his most celebrated works. Examples of his work for the *Quiver*[6] (Figure 22) and the *Sunday Magazine* were more conventional and rather crudely rendered. Luke Fildes and George Pinwell, who as we have seen were close friends of Herkomer's in these early years, were frequent contributors to these periodicals (as was the *Graphic*'s founder W. L. Thomas), and with their encouragement, his career as an illustrator was off to a good start.

During the early days of English illustration, the wood engraving was the most common reproductive medium. In the 1860s it became more significant as an art form and indeed often functioned as a stepping-stone to a significant career in the fine arts. Its artistic revival is generally ascribed to the Pre-Raphaelites, specifically the illustrations by John Everett Millais, William Holman Hunt, Dante Gabriel Rossetti and Arthur Hughes for Edward Moxon's edition of Tennyson's *Poems* (1857). The brothers Edward and George Dalziel ran the most successful wood engraving business at the time and were responsible for the high quality of the reproductions.

In the 1860s, Thomas Bolton perfected a technique whereby the photographed image of a drawing could be transferred to a photographically sensitized wooden block. This permitted the wood engraver to work without destroying the artist's original drawing. Further refinement of electrotyping and of the presses ensured higher volume and lower production costs.

Naturally it was important to the artist that his work be 'cut' well. 'Dalziel has made an incredible mull of it in the cutting', complained Rossetti about the engraving of his drawing *The Maids of Elfen-Mere* for the Moxon edition of Tennyson.[7] Herkomer's reaction to the cutting of his drawing *Sunday at Chelsea Hospital* (see Figure 73) was similar, it being 'carefully

MURDER WILL OUT.

Check aker (to Jones, who has just seen Act 1 of MACBETH at the Little Duffington Theatre — "WON'T YE TAKE A PASS, SIR? THERE'S THE MURDER OF DUNCAN IN THE SECOND ACT!"

Jones — "THANKS, NO! I'VE SEEN THE MURDER OF MACBETH IN THE FIRST!"

21

(*Drawn by* H. HERKOMER.)

" A thousand times is former woe repaid by present bliss."—*p.* 72.

22

drawn but badly enough engraved', as he later stated in his memoirs.[8] The ultimate goal was to find an engraver who could render the artist's lines so faithfully that the final result bore no trace of the engraver's hand.

By the late 1870s, mechanical reproduction became more refined and the wood engraver was gradually eliminated: for example, after 1880, the *Graphic*'s illustrations were entirely reproduced via a photomechanical process. Ironically, mechanical reproduction coincided with a visible decline in the quality of the *Graphic*'s illustrations. In 1882, Herkomer wrote:

I have spoken so highly of the *Graphic*, that it is necessary for me to say that I cannot feel the pleasure in their present issues that we all used to feel formerly. The managers declare that the public require the representation of a public event, and are satisfied if it is correct and entertaining, caring nothing for the artistic qualities of the drawing.[9]

From the first issue, the *Graphic* was a success, though at sixpence a copy it was keyed to a middle-class audience. It became a direct rival of the form of illustrated journalism refined by the *Illustrated London News*[10] and, like that paper, the *Graphic* covered fashionable society, theatre news, military events and so on. H. Sutherland Edwards, the first editor of the *Graphic*, brought with him many of his staff from the defunct *Illustrated Times*, a cheap working-class paper which had frequently published poignant images of urban misfortune.[11] Yet it was Thomas, as the *Graphic*'s founder and manager, who was the controlling force behind the selection of illustrations. His humane impulse was probably strengthened by his own youthful experience of poverty after being orphaned at the age of six.[12] In addition, several of the contributing artists, including Herkomer, Pinwell, Holl and Fildes, were personally familiar with hard times.

Thomas, who encouraged his artists to wander the London streets in search of subject matter, sought a largely unprecedented authenticity in his illustrated journalism – an authenticity that had been anticipated by photography though it was not yet in use for general illustration.[13] At the same time, the *Graphic*'s illustrations achieved a higher artistic standard than that generally seen in contemporary illustrated papers, because Thomas sought out talented artists. The 'Big Five'[14] were Herkomer, Frank Holl, Luke Fildes, William Small (1843–1929) and Charles Green (1840–1898). Other prolific contributors included Edward J. Gregory (1850–1909), Arthur Boyd Houghton (1836–1875), Sydney Hall (1842–1922) and Robert W. Macbeth (1848–1910).[15] Artistic excellence was a primary motive from the beginning: according to Thomas 'the originality of the scheme consisted in establishing a weekly illustrated journal open to all artists, whatever their method, instead of confining my staff to draughtsmen on wood as had hitherto been the general custom'.[16]

21 *Murder Will Out. Fun*, 1 May 1869, p. 84

22 *A thousand times is former woe repaid by present bliss. The Quiver*, 1868, p. 73

When the *Graphic*'s founder died in 1900, Herkomer sent a memorial letter to *The Times* that is worth quoting at length:

To have founded an artistic weekly newspaper ... open to all draughtsmen of talent ... would be enough to entitle any man to great respect. But he did more than this – more than improve illustrated journalism, he influenced English art, and that in the wholesomest way. It is not too much to say that there was a visible change in the selection of subjects by painters after the advent of the *Graphic*. Mr. Thomas opened its pages to every phase of the story of our life ... Whether it was to do the old Chelsea pensioners in church, cattle drovers at an improvised church service, a two-penny lodging house for women in St. Giles's, a scene in Petticoat Lane ... the flogging of a criminal in Newgate Prison, an entertainment given to Italian organ grinders, it mattered little. It was a lesson in life and a lesson in art. I am only one of the many who received these lessons at the hands of Mr. W. L. Thomas, and it was in this way that he catered to the public in the pages of the *Graphic*.[17]

Interestingly, Herkomer's letter cited six of his own images of the poor and downtrodden published in the paper's early years. By 1900, the focus of his career was primarily portraiture, and the outward appearance of his lifestyle emulated that of his wealthy clients. While Herkomer never forgot the hardship and struggle of his early life or that of his parents, he left no written record of his political views on improving the lot of those less fortunate or gifted than himself.

Spreading urban blight, severe economic depression, and the ever-increasing number of paupers in London's streets, said to be more than a million during the 1870s, made the problem of poverty increasingly visible.[18] At the same time, the novels of Dickens, reissued throughout the 1870s in the Household Edition of *Complete Works*, helped to keep the plight of the poor on the conscience of the public.[19]

While contemporary paintings had certainly treated aspects of poverty – examples are Thomas Faed's depictions of indigent Scottish cottagers and James Clarke Hook's of impoverished fisherfolk – they tended to idealize the subject, to seek timeless truths in the dignity or pathos of the scene or, as in the case of William Powell Frith, to render crowded panoramas which 'united' all classes within a wealth of narrative detail. Such imagery appealed on one level to the emotional sympathies of the viewer, but at the same time the reduction of such subject matter to a pious or sentimental plane offered a watered-down version of harsher truths.

The *Graphic*'s illustrations of social issues were more realistic, synthesizing reportorial observation with artistic interpretation in the striated dark lines of wood engraving. Subjects treated (often accompanied by crusading articles) included the problems of old age (Herkomer, *Old Age: a Study in the Westminster Union* (see Figure 81); alcoholism among the poor (Charles Green, *Sunday Afternoon in a Gin Palace*, 8 February 1879); and the exploitation of child labour (R. W. Macbeth, *A Lincolnshire Gang*, 15 July 1876). Other illustrations showed the poor being cared for in religious institutions (William Small, *Sunday Afternoon in St. Giles – Tea at the Working Men's Christian Institute*, 13 January 1872); hospitals (Charles Green, *The Outpatients Room in University College Hospital*, 6 January 1872); and missions (R. W. Macbeth, *Our London Poor – A Tea to Seven Hundred Tramps and Beggars in Moorgate Street Hall*, 15 January 1876). This particular focus accentuated the idea of Christian charity or 'good works', the principal means of alleviating the sufferings of the 'deserving poor'. While imagery of this type reinforced the status quo and no doubt eased the guilt of a middle-class readership, the illustrations were often accompanied by appeals for donations, thus encouraging a sense of social responsibility from those who had the material wherewithal to help.

Luke Fildes, who had been asked by Thomas to contribute to the first issue of the *Graphic*, probably suggested to Herkomer the possibility of employment at the paper. However, Herkomer, who was often forgetful about acknowledging the help of others (he said, for example, that he 'had had a terrible fight for recognition' when he was starting out, which was not true),[20] noted in his memoirs that he alone had sought out the *Graphic*'s editor.[21] His first illustration of a group of gypsies engaged in basket-weaving, *A Gipsy Encampment on Putney Common* (Figure 23), was accepted immediately. Herkomer's distinctive curly lines and closely woven cross-hatching underscore the tattered appearance of the figures, while his preliminary study of the central gypsy figure (Figure 24) is a fine example of his early vigorous drawing style.

Although Herkomer's gypsy subject was based on a scene that he had observed at first hand, the final illustration relied on posed life studies, made to flesh out the details. Like Luke Fildes in his illustration *Houseless and Hungry*, which appeared in the inaugural issue of the *Graphic*, Herkomer paid the characters he had initially observed on the spot to come to his studio to pose: 'I made my studies ... and then drew them onto the block, not, alas, in the free way in which these studies were done, but in careful line, as exact facsimile work was always insisted upon by engravers in those days.'[22] Yet he also stressed the importance of interpretation or 'art', even when creating an eyewitness illustration for a newspaper. In an article on wood engraving published in 1882, Herkomer wrote, 'The truth of a scene represented by mere mechanical skill without the spirit of interpretation would be nil ... the highest refinement of expression is but an interpreted representation of fact, the product of a mind capable of ascertaining truth.'[23] Even so painstaking an observer as Gustave Doré, who published his wood engravings of London life in

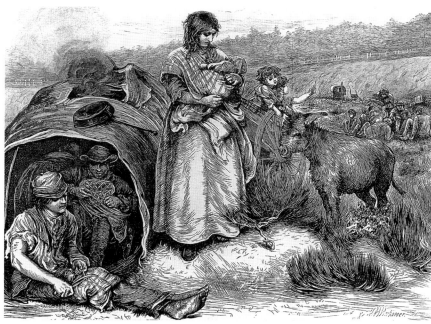

23

23 *A Gipsy
Encampment on Putney
Common. The Graphic,*
18 June 1870, p. 680

24 *Preliminary Study
of a Gypsy,* 1870, pen
and ink

(Tate Gallery, London), exhibited at the Royal Academy in 1868.[25] But the younger artist's uncompromising treatment of the subject is somewhat removed from Walker's more heroic image, which is indebted to the idyllic pastorals of the French artist Jules Breton, much admired by Walker on a visit to Paris in 1863.[26]

In his later writings, Herkomer frequently emphasized his early indebtedness to Walker. However, comparisons of Walker's work with Herkomer's *Graphic* illustrations, from his earliest subjects on, point up the differences between them in terms of style and narrative focus. Herkomer's muscular line and often harsh interpretation, particularly in his urban subjects, contrast with Walker's gentler, more poetic tone. Although Herkomer's article on wood engraving was written in 1882, its tenets seem applicable to his early *Graphic* illustrations. While he praised Walker's search for 'the truth that was in keeping with his love of the tender and graceful', Herkomer also singled out the more objective goals of the German realist Adolph Menzel, who 'looks for the truth that lends itself to artistic treatment'. That Menzel's results seemed crude at times meant to Herkomer that they also conveyed a realistic sense of 'grim truthfulness'.[27] Long familiar with Menzel's art, which he encountered during his frequent visits to Germany, Herkomer particularly admired Menzel's ability to depict crowded scenes that showed the various characteristics and expressions of individuals within the group – 'so many faces packed closely together, with each to tell his story' – an assessment apposite to many of Herkomer's own crowded *Graphic* images.[28]

Menzel's celebrated wood engravings for Franz Kugler's *History of Frederick the Great* (1839–1842) were well known in England,[29] and as late as 1896 Herkomer wrote enthusiastically about them.[30] Other

24

London: A Pilgrimage in 1872 and who, with his co-author Blanchard Jerrold, tramped the London streets making on-the-spot notes, made his final drawings largely from memory in order to drive home a particular social or formal point.[24]

Herkomer freely admitted that his choice of a gypsy subject for his first *Graphic* engraving was inspired by Frederick Walker, specifically mentioning Walker's sad and noble gypsy group in *The Vagrants*

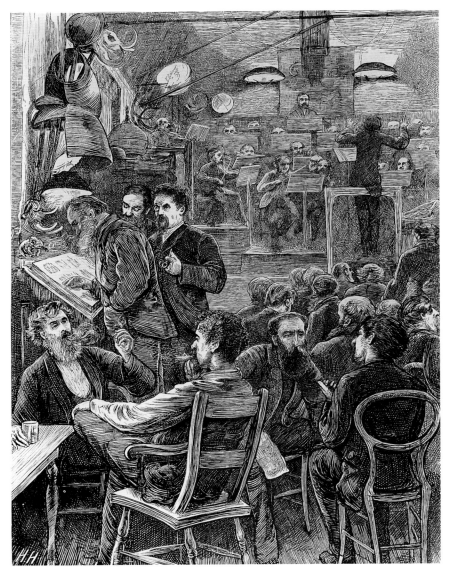

25 A 'Smoking
Concert' by the
Wandering Minstrels.
The Graphic, 25 June
1870, p. 717

in the more static gypsy subject. Gas lamps in the background create strong contrasts of light and shade and figures overlap or are cut off at the sides, though each face is portrait-like in its individuality. Herkomer's tipped-up vertical design – orchestra players in the background, oversize figures looming in the foreground – resembles Edgar Degas's complex theatre compositions of around the same time, for example L'Orchestre de l'Opéra (1868–1869; Musée du Louvre). Though this work was unknown to Herkomer,[33] it does suggest that his emergent style (to the extent that it differed from those of his Graphic contemporaries) seemed to share the concerns of his Continental counterparts, who were abandoning traditional formal boundaries.[34]

In a second musical subject, A Sketch at a Concert Given to the Poor Italians (Figure 26), another typically crowded and asymmetrical design, one of the figures stares boldly at the viewer, an expressive motif that Herkomer frequently used later in paintings. The artist probably identified with the earnest performer (on stage at the left), for he himself, short of funds during his early days in London, had tried (unsuccessfully) to join a minstrel group as a zither player.[35]

Steeped in the slice-of-life authenticity Thomas encouraged, one of Herkomer's most animated urban scenes is The Sunday Trading Question – A Sketch in Petticoat Lane (Figure 27). While Herkomer's treatment of a contemporary social issue is sympathetic – Jewish merchants sell goods on Sundays because they observed the Sabbath on Saturdays – the Graphic's accompanying article (not written by Herkomer) reflects, in its subtly patronizing tone, the undercurrent of anti-Semitism that ran through Victorian life.[36]

Among other social issues tackled by the Graphic were the problems of urban crime and the treatment of criminals. The magazine's illustrations of prisoners usually portrayed them as social outcasts. Arthur Boyd Houghton's Night Charges on their Way to Court (11 December 1869) depicts a queue of prisoners as odd-looking misfits, except for one young street waif; Fildes's prisoner in The Bashful Model (8 November 1873) is a fat figure of fun who has to be held down by six officers; and William Small's The British Rough (26 June 1875), from the 'Heads of the People' series, stands menacingly beneath a poster marked '£100 reward'. On the other hand, Herkomer's A Sketch in Newgate – The Garotter's Reward (Figure 28) depicts the criminal (his head lowered after receiving a flogging) as a degraded victim. Even the accompanying article discussed the need for prison reform and a softening of 'iron discipline'.[37] The sharply receding floor planks add an expressionist dimension to the image and foreshadow the design of Herkomer's workhouse engraving Old Age: A Study at the Westminster Union (see Figure 81).

English artists, including Millais and Charles Keene, sought in their own art the spontaneity of Menzel's illustrations, imitating his freedom of line to suggest seemingly eyewitness accounts of past history.[31] Unlike his illustrations, Menzel's paintings, which Herkomer also admired, were little known in England, and Herkomer's praise for their innovative qualities in his article on wood engraving (1882) was ahead of its time. Indeed, his esteem for both Menzel's illustrations and his paintings, the latter with their freer touch and greater structural complexity, helped him to formulate his own distinct Graphic style.

A week after Herkomer's gypsy subject appeared in the Graphic, one of his more typically crowded urban scenes, entitled A 'Smoking Concert' by the Wandering Minstrels, was published (Figure 25). Though not an image of poverty per se (it depicts a group of wealthy amateur musicians who gave concerts to raise money for charity),[32] the busy line and massed detail of the image has a spontaneous on-the-spot quality lacking

Herkomer contributed three of the ten illustrations in

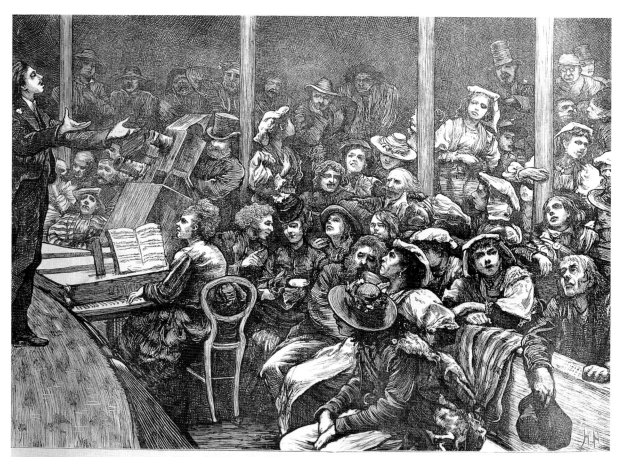

A SKETCH AT A CONCERT GIVEN TO THE POOR ITALIANS IN LONDON

26 *A Sketch at a Concert Given to the Poor Italians in London. The Graphic*, 18 March 1871, p. 253

the 'Heads of the People' series, which were published in the *Graphic* between 1875 and 1879: *The Agricultural Labourer – Sunday* (Figure 30); *The Brewer's Drayman*; and *The Coastguardsman* (Figure 31). Other illustrations in the series were by William Small, M. W. Ridley and Charles Green. An earlier 'Heads of the People' series by Kenny Mathews had run in the *Illustrated London News* in 1840 and the *Illustrated Times* (1855–1870) frequently portrayed London street types and working-class characters.[38] The *Graphic*'s 'Heads of the People' covered a social cross-section, including a society belle being presented at court (Small's *At Court*, 23 October 1875); a lawyer (Small's *The Barrister*, 11 December 1875); and a heroic fire-fighter (Charles Green's *The Fireman* [frontispiece, vol. 20, 1879]). Dressed in the clothing of their trades, Herkomer's *Brewer's Drayman* and *Coastguardsman* are larger-than-life figures with strong hands and determined faces. *The Coastguardsman* was reproduced as a 'wash' rather than a 'line' engraving, for it was published at the end of the series, when the *Graphic* began to make use of complete photo-electric printing processes.

Herkomer depicts *The Agricultural Labourer* reading a Bible rather than pursuing his livelihood in the fields. The peasant's rough-hewn dignity and the piety of the scene underscore the artist's, and indeed

the prevailing, view of the saintliness inherent in a rural way of life. An early image of pious rustics in church, *Divine Service for Shepherds and Herdsmen – A Study at the Berner's Hall, Islington* (Figure 29), although transplanted to urban Islington, again plays on Victorian nostalgia for the simple values of an idealized rural past, a recurring theme in a number of Herkomer's later exhibited paintings.

A large boost to the *Graphic*'s sales, eight months after it began publication, resulted from its coverage of the Franco-Prussian War (1870–1871).[39] Thomas dispatched his artist Sydney Hall (1842–1922) to sketch French participation and E. J. Gregory to cover the Prussian side.[40] The *Illustrated London News* had set a precedent for on-site coverage when it used the French artist Constantin Guys (1805–1892) as a special correspondent during the Crimean War (1853–1856).[41] In the early days of illustrated journalism it was common to develop visual images from written accounts of foreign events, but Hall's and Gregory's drawings for the *Graphic* were sent across the Channel by balloon post.[42] While some of these war sketches were in publishable states, others were hastily drawn rough notes, which other artists worked up into finished versions for the engravers.

Herkomer, who was not at the front, was asked by

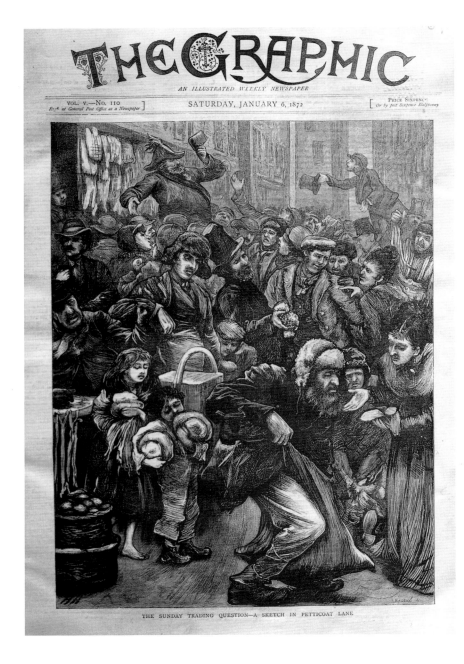

THE SUNDAY TRADING QUESTION—A SKETCH IN PETTICOAT LANE

27 *The Sunday Trading Question – A Sketch in Petticoat Lane. The Graphic*, 6 January 1872, p. 61

Thomas to make several drawings from Sydney Hall's sketches.[43] *Prussian Spies at Tours* (two little boys suspected of spying for the Germans being led away by French troops) and *Count Kératry's Breton Army – Trying on Uniforms at St. Quimper* (Figure 32) were worked up from Sydney Hall's rough notes or 'hieroglyphics', as another artist called them.[44] Herkomer's distinctive use of space and line, however, make them very much his own. Despite his German origins, there is no visual evidence that he took sides, and indeed, as a Bavarian, he disliked the controlling influence of the Prussians in his own native region.[45] Between February and April 1872, his illustrations for a Franco-Prussian War memoir, *The Story of the Plebiscite*, appeared in the *Cornhill Magazine*. The intensely expressive drawings (see Figure 33) closely follow the drama of the text, which is told from an Alsatian point of view.

In July 1870, just prior to the outbreak of the Franco-Prussian War, Herkomer stayed in the French fishing village of Tréport, near Dieppe. The holiday, which was also a sketching campaign, was his first visit to France, though one fraught with anxiety as the war drew nearer. One of the Tréport sketches, *Anxious Times – A Sketch at Tréport, France* (Figure 34), was a scene that Herkomer had witnessed.[46]

Like his first gypsy subject, this illustration has a static, posed quality, for each character sat for Herkomer at his lodgings.[47] Fearing for his life on account of his German birth, Herkomer left France soon after war was declared and finished the drawing in his Chelsea studio. This illustration is particularly significant because it was the first of the more than 16 drawings published in the *Graphic* that Herkomer used later as stepping-stones for much larger works in other media such as watercolour and oil.[48] His watercolour version, *At Tréport – War News 1870* (Bushey Museum Trust), was shown in 1871 at the Dudley Gallery, and its first owners were George and Edward Dalziel,[49] the celebrated engravers, who had turned wood engraving into an art form. The *Art Journal* admired the 'multiplicity of detail and studied character', but found the work 'crowded to excess'.[50]

In 1872 Herkomer contributed to the 'Rome' series published by the *Graphic*.[51] Although the accompanying descriptive articles are ascribed to 'our artist',[52] as far as can be determined, Herkomer, although he was a frequent visitor to Germany after 1870, did not make his first visit to Rome till 1890.[53] Thus, he evidently made illustrations from written descriptions, resorting to the time-honoured method more common in the early years of illustrated journalism. That Herkomer chose to illustrate beggars and outsiders such as those in *Rome – On the Steps of St. Peter's – 'Per Carità, Signori'* (Figure 35) is entirely idiosyncratic. By comparison, the other illustrations by various artists in the series are conventional in terms of both subject matter and design and are more typical tourist scenes. In a more comic vein, in *Rome – The Quack Doctor* (Figure 36) a hook-armed dentist, surrounded by a street orchestra to drown his victim's cries, pulls a patient's tooth, echoing an Italian tradition of quasi-humorous treatments of similar themes.

In contrast to his *Graphic* illustrations of impoverished city folk in London and Rome, Herkomer's Bavarian images generally depict peasants or tourists in pleasant surroundings, reflecting that favourite Victorian dichotomy of city versus country. The artist's '*Graphic* Bavaria' formed one of the paper's intermittent travelogue features, like the 'Rome' series, though unlike the latter illustrations, the Bavarian scenes were eyewitness accounts. Travel features presenting aspects of Bavarian peasant life as well as Alpine tourism were of interest to a middle-

class readership whose expanding wealth enabled them to travel abroad. The *Graphic*'s readers learned, for example, about the Oberammergau Passion Play, the beauty of peasant costume, the benefits of Bavarian spas and the challenge of Alpine climbing.[54]

Herkomer's *A Dilemma* (Figure 37), which illustrates the plight of two lost English tourists, is typical of this travel focus. Another picturesque subject, *Tourists in the Bavarian Alps – The Echo* (Figure 38), accompanied by an article extolling the beauty of Partenkirchen, is autobiographical: Herkomer's father, Lorenz, accompanied by Lulu Griffiths (Herkomer's mistress) and a cousin, Herman Herkomer,[55] in the background, observe two peasant women setting off a small cannon, to demonstrate an echo.

Peasants are also shown at work or simply enjoying themselves, as in *Carnival Time in the Bavarian Alps* (18 April 1874), in which a parade of costumed peasants are celebrating a traditional holiday;[56] *Auf der Alm*, set in a peasant inn (27 March 1875); *The 'Schuhplattl' Dance* (a traditional peasant slap-dance) (Figure 39); and *A 'Kegelbahn' in the Bavarian Alps* (a skittle [bowling] alley) (see Figure 69). The tilted perspective of the last two illustrations accentuates the energy inherent in the activities described, while the complex design underscores how very different Herkomer's *Graphic* illustrations looked in comparison with those of his English contemporaries, not only in terms of subject matter but in formal presentation as well.

Even at the outset of his 'Graphic Bavaria' series, deliberately disorienting spaces are an important visual ingredient. For example, in *Returning from Work, A Sketch in the Tyrol* (Figure 40), Herkomer's first published Bavarian subject,[57] the muscular peasant's swaggering pose is further accented by the distortion behind him. The original pencil sketch for the central figure (Figure 41), with its twisted lines and exaggerated position, exudes a sense of animation and expression that is diminished in the published image. In *Going Down the Slide* (Figure 42), one of Herkomer's most dramatic examples of exaggerated perspective heightens the sense of adventure.

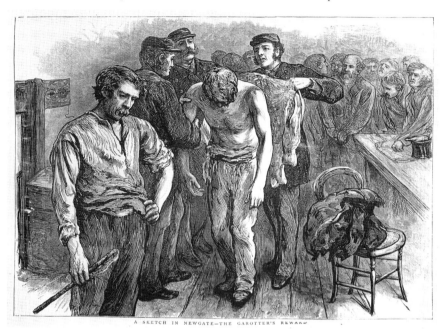

A SKETCH IN NEWGATE—THE GAROTTER'S REWARD

28 *A Sketch in Newgate – The Garotter's Reward. The Graphic*, 9 March 1872, p. 221

29 *Divine Service for Shepherds and Herdsmen – A Study at the Berner's Hall, Islington. The Graphic*, 20 January 1872, pp. 56–57

30 *Heads of the People,*
Drawn from Life II –
The Agricultural
Labourer – Sunday. The
Graphic, 9 October
1875, p. 360

HEADS OF THE PEOPLE—"THE COASTGUARDSMAN"
DRAWN BY HUBERT HERKOMER

31 *Heads of the People
– The Coastguardsman.
The Graphic*, 20
September 1879,
p. 292

32 *Prussian Spies at*
Tours and *Count*
Kératry's Breton Army
– Trying on Uniforms
at St. Quimper. The
Graphic, 3 December
1870, p. 549

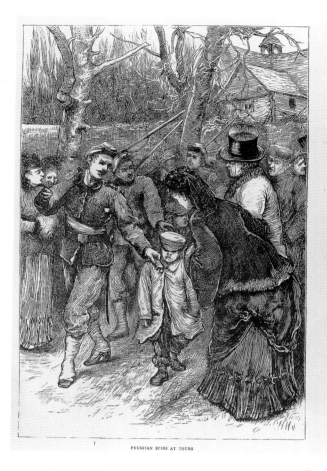

PRUSSIAN SPIES AT TOURS

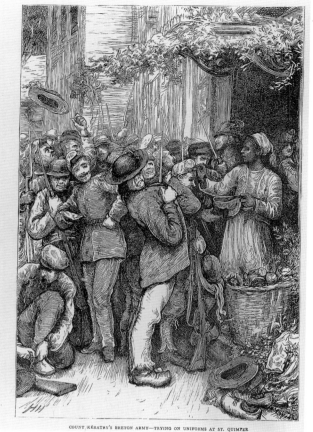

COUNT KÉRATRY'S BRETON ARMY—TRYING ON UNIFORMS AT ST. QUIMPER

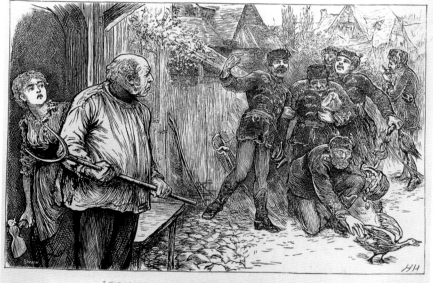

I HAD GRASPED A PITCHFORK: GREDEL STOOD BEHIND WITH AN AXE.

33 *I had grasped a*
pitchfork: Gredel stood
behind with an axe. The
Story of the Plebiscite.
The Cornhill Magazine,
February 1872, p. 6

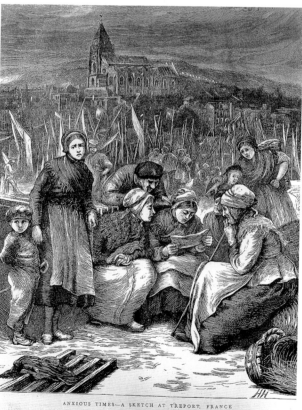

ANXIOUS TIMES—A SKETCH AT TRÉPORT, FRANCE

34 *Anxious Times – A*
Sketch at Tréport, France.
The Graphic, 26 November
1870, p. 512

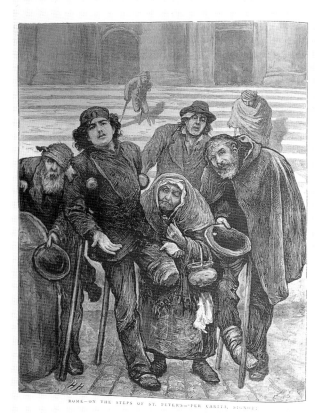

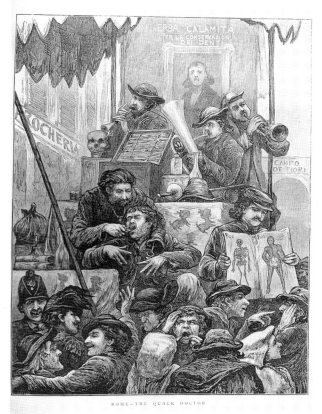

35 *Rome – On the Steps of St. Peter's – 'Per Carità, Signori'. The Graphic*, 24 February 1872, p. 172

36 *Rome – The Quack Doctor. The Graphic*, 11 May 1872, p. 437

35

36

37 *A Dilemma. The Graphic*, 24 June 1876, pp. 610–611

38 *Tourists in the Bavarian Alps – The Echo. The Graphic*, 7 October 1876, p. 353

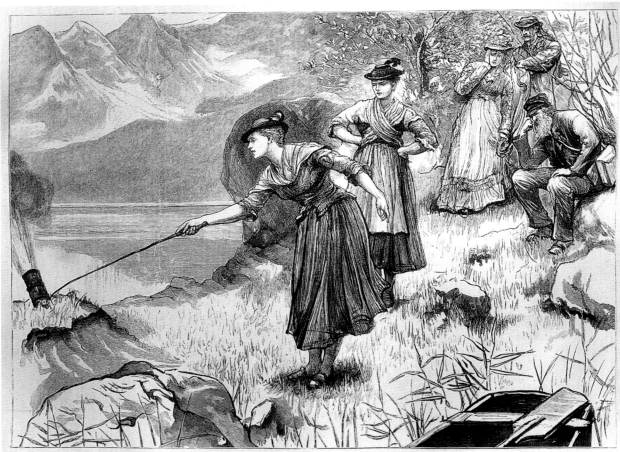

TOURISTS IN THE BAVARIAN ALPS—THE ECHO

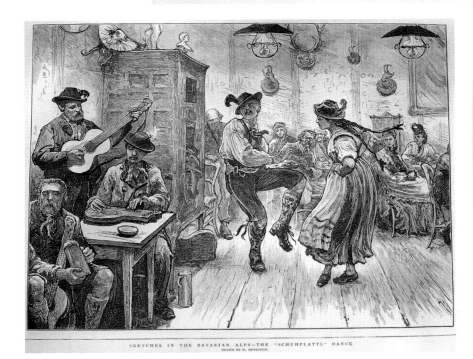

SKETCHES IN THE BAVARIAN ALPS—THE "SCHUHPLATTL" DANCE
DRAWN BY H. HERKOMER

39 *Sketches in the Bavarian Alps – The 'Schuhplattl' Dance. The Graphic*, 22 March 1873, p. 276

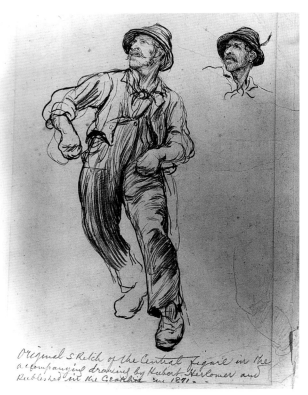

41 Original sketch of the central figure in *Returning from Work, A Sketch in the Tyrol*, 1871, pencil

40 *Returning from
Work, A Sketch in the
Tyrol. The Graphic*, 19
August 1871, p. 189

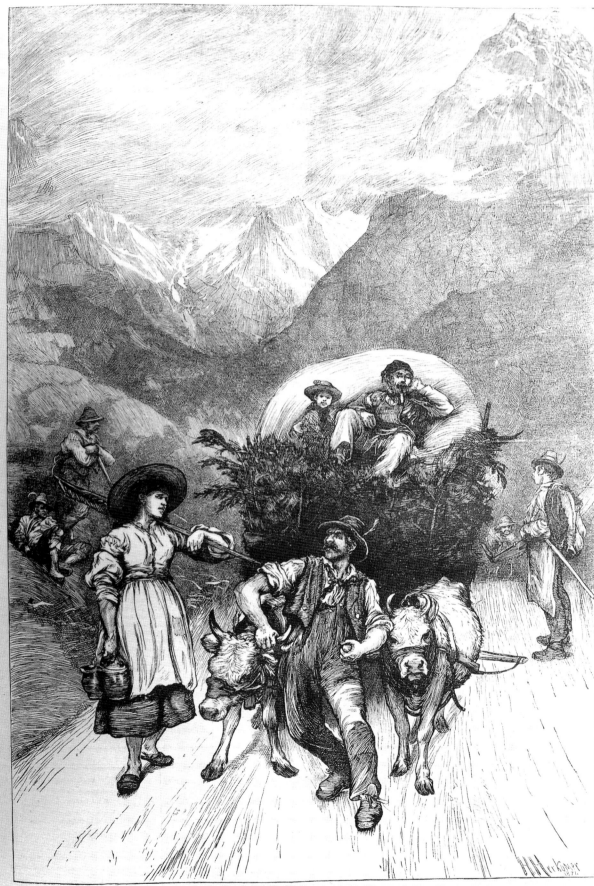

RETURNING FROM WORK, A SKETCH IN THE TYROL

42 *A Visit to the Berchtesgaden Salt Mine, Bavaria II – Going Down the Slide. The Graphic*, 3 April 1875, p. 352

43 *Sketches in the Bavarian Alps – The Arrest of a Poacher. The Graphic*, 17 May 1873, p. 465

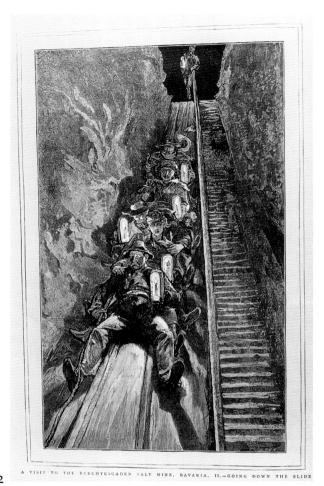

A VISIT TO THE BERCHTESGADEN SALT MINE, BAVARIA, II.—GOING DOWN THE SLIDE

42

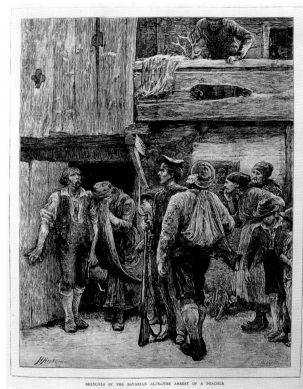

SKETCHES IN THE BAVARIAN ALPS—THE ARREST OF A POACHER

43

The sombre mood of *The Arrest of a Poacher* (Figure 43) is one of the few images in Herkomer's '*Graphic Bavaria*' series to capture a sense of the peasants' poverty and deprivation, and it was an image to which the artist would return to inspire the composition and tone of his last great genre painting, *On Strike* (see Figure 88). Despite this exception, the predominantly cheerful tone of Herkomer's '*Graphic Bavaria*' series offers a pointed contrast to his gritty urban images and endorses his affection for the tradition-bound values of a rural way of life on the one hand and a distaste for the forces that undermined those values on the other.

English rustics and Welsh landscapes: Herkomer's early pastoral idylls

In 1869, the first year he exhibited his work in London, Herkomer showed at the Dudley Gallery a watercolour of a farm girl selecting cabbages in a garden, entitled *Choosing* (Figure 44). Based on his wood engraving (Figure 45) published in *Good Words for the Young* to accompany Charles Camden's short story, 'Lonely Jane', the composition was inspired by a sketching trip to the village of Hythe (near Southampton) in the summer of 1868. Although Herkomer visited the area to sketch from nature, he later admitted in his memoirs that while there he had 'entirely missed the many subjects that were around me – the picturesque villagers, the life in cottage and field'.[1] Indeed, for this first illustration he drew a girl dressed in a hood and pinafore whom he had seen near his lodgings, because she was, as he wrote, 'just such a girl as Birket Foster made so popular and Frederick Walker and George Mason made so picturesque'.[2] Several other illustrations by Herkomer for *Good Words for the Young* (see Figure 46) were similarly inspired by these artists' example, though the densely filled space, compact design and rather ominous mood are uniquely his own.

Comforting and poetic scenes of rural life by the above-mentioned artists, as well as by others of the Idyllic School such as John William North and George Pinwell, were immensely popular in the 1860s and 1870s. As one jaded art critic commented, 'English artists are working this field to weariness.'[3] Antecedents for their picturesque vision of English country life can be found in the 'fancy pictures' of Thomas Gainsborough (1727–1788) and the cottage scenes of George Morland (1763–1804) and David Wilkie (1785–1841). Rural sentiment in the style of Walker and his followers flourished up to the end of the nineteenth century in the art of such followers as Helen Allingham (1848–1926), who exhibited frequently in London in the 1880s and 1890s.

Although life for many country folk and their families in the late Victorian era was one of unremitting toil and hardship, the English farm worker was raised to near-mythic status in a nation that viewed his now-threatened rural way of life as an idyllic counterpoint to the grim reality of industrial expansion. Victorian cities, with their stress-provoking crowds and noise, also fuelled a conception of the countryside as timeless and unspoiled. This rustic ideal was further underscored in Victorian literature – George Eliot's parables of village life (*Silas Marner* [1861]; *Felix Holt* [1866]), Anthony Trollope's unchanging Barchester, R. S. Surtees's rollicking hunting chronicles – which provided an escapist haven for a largely urbanized middle-class readership.[4] A typical image in this vein is Frederick Walker's wood engraving, published in *Good Words* in October 1870, of a well-dressed, attractive couple binding hay bundles, which accompanied a poem called 'Binding Sheaves', by the popular rustic poet Jean Ingelow. Here the rural setting serves as a backdrop for romance and reverie in a pastoral tradition, which had been exalted for centuries both in art and literature. Herkomer himself held strong views about the superiority of country over city life[5] and, with only a few exceptions, his rural imagery, like that of his contemporaries, depicts the peasant as cheerful and uncomplaining.

While Herkomer consciously sought material that suggested the rural ideal of Walker for this first exhibited watercolour (see Figure 63), the picture elicited a contemporary assessment that, as noted with his *Graphic* illustrations, pointed up the differences in temperament between the two artists. According to one critic, *Choosing* represented 'an ugly girl, choosing bad cabbages, with an impossible background'.[6] Walker's pictures were the opposite of 'ugly', and Herkomer's vigorous facture in this early work anticipates his bolder Bavarian peasant images of the late 1870s. With its vertical format, detailed foreground juxtaposed with spare background and high horizon line, *Choosing* also looks forward to compositions by the French painter of peasants Jules Bastien-Lepage (1848–1884), whose work was highly influential in Britain in the 1880s.

In the fall of 1869, Herkomer undertook another sketching campaign, this time to Sussex,[7] in the company of his friends from the South Kensington Schools, Edward Brewtnall (1846–1902) and two other fellow students, one of whom was probably Robert Rasell, who settled in Sussex and had a minor career as an artist.[8] According to Edmund Gosse, Brewtnall (who achieved some success as an illustrator and painter, but is now largely forgotten) 'introduced Herkomer, then wholly illiterate, to the English poets', and was his 'closest friend and confidant' at the time.[9] Perhaps ashamed of his youthful ignorance and complete lack of schooling, Herkomer endeavoured to cover certain elements of his past, though

44 *Choosing*, 1868, watercolour

45 *Lonely Jane. Good Words for the Young*, 1 November 1868, p. 28. This illustration accompanied a short story by Charles Camden entitled 'Lonely Jane'

46 *Amy and her Doves. Good Words for the Young*, 1 January 1871, p. 176

44

45

46

never his impoverished background. His selective forgetfulness is a constant trait throughout his career, as I have already noted. Although he always acknowledged his debt to the art of Walker, Herkomer had more difficulty remembering those who actually helped him in his quest for social and artistic success, recalling in his memoirs only the high-spirited fun he and his companions enjoyed together.

During daily sketching forays they made studies of farm workers in the local fields. 'I found my subject in a group of peasants hoeing in a turnip field', Herkomer wrote in 1910:

I was struck at once with the pictorial aspects of the scene, with the strong relief of these figures against the trees in the background, which were in their autumnal garb, rich in russet and gold. Then, whilst I was watching, a little girl approached the oldest man of the group and handed him some refreshments. He stiffly and slowly straightened his back, and remained standing whilst the others were in various attitudes at their work. The child gave the final touch to the sentiment, as I thought.[10]

From this scene Herkomer produced a large watercolour entitled *Hoeing*, which was exhibited at the Dudley Gallery in February 1870. While the present whereabouts of this work remain unknown, we do know what it looked like, for it was reproduced as a wood engraving, *Jack and Jane*, in *Good Words for the*

Young (Figure 47).[11] The wood engraving illustrates a story of two children who belong to a team of field workers. Despite Herkomer's claim to have conceived the scene while on a companionable sketching foray, the composition was probably taken from *The Gang Children* (Figure 48), an illustration by his close friend George Pinwell. This was published in the *Sunday Magazine* in 1868 with a crusading article and poem against the practice, common at the time, of using very young children in field labour gangs.

Hoeing was Herkomer's first success at exhibition. Hung in the place of honour at the Dudley Gallery, it was sold for £40,[12] a fortune for the young artist. The drawing was praised for its individual characterization of each figure, although one critic found 'the picture, as a whole . . . painfully scattered, the composition sadly at fault'.[13]

By his own description, Herkomer was intrigued by the design possibilities of the scene, but the thematic motif – the contrast between youth and old age – initiates a pattern seen in many of his subsequent genre paintings. He later explained his work methods at that time, emphasizing the speed with which he could complete a picture, a skill that stood him in good stead when his career became predominantly based on portraiture:

I looked long and hard at the scene and tried to take it all in, then returned to the house, and sketched out the group and designed the lines of background. For this drawing I used the largest piece of paper I had. These few strokes on that paper suggested to me the picture, and I could see it in my mind's eye . . . I dashed at it in my impulsive way, and worked very rapidly. This rapidity of work was not quite to the liking of my comrades, as it gave me more to show at the end of the day than either of the other two.[14]

One area in which Herkomer was indisputably indebted to Walker was his use of the latter's watercolour technique. Walker had adopted William Henry Hunt's method of applying dry paint in a web of tiny dabs of colour, a style that became a hallmark of Victorian watercolour. Herkomer used watercolour throughout his career, for both portraits and subject pictures, and some of his best work is executed in this medium. He could also work in any size and in a variety of watercolour methods. Like Walker, he used quantities of bodycolour (Chinese white) to highlight and build up the surface, which resulted in an opaque, fresco-like finish. While Walker made a network of tiny dots of colour over most of the surface, Herkomer tended to work the paint finely only in the areas requiring the most detail, particularly facial features. The background received a much broader touch, with networks of small curved strokes running parallel to one another. This became a recognizable ingredient of his style over the years, one visible in his oil paintings and graphic art as well as in his watercolours.

A number of Herkomer's early watercolours, while

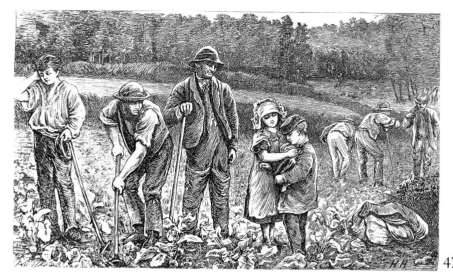

47

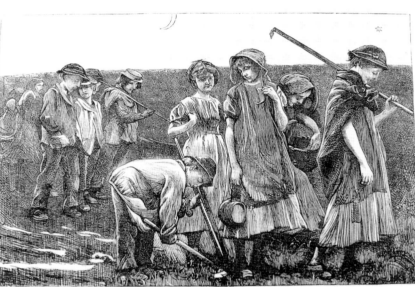

48

Walkerian in their melancholy mood and low-keyed tones, also display Herkomer's more muscular handling of paint and quirky structure. *The Old Gardener* (see Colour plate V), painted for Clarence Fry, Herkomer's patron and friend, depicts 'Foster' working in the grounds of Fry's residence in Watford, not far from Herkomer's home in Bushey. *Rest: Aldenham Church*[15] (Figure 49), another local subject, with its graveyard setting and forlorn figure, forecasts the gloomy aspect of several of Herkomer's much larger oil paintings of the 1870s, and in *The Idler (The Boy and the Apple Blossoms)*[16] (see Colour plate IV) the boy's wistful pose matches the incisiveness of the artist's later watercolour portraits.

In a more jovial mood are Herkomer's cottage scenes, such as *The Bad Boy* (Figure 50) and *Summertime (A Front Garden)* (Figure 51), which belong to a series of 40 watercolours of Bushey commissioned by the Fine Art Society in 1888 and exhibited with the title 'Around My Home'.[17] These images' sense of fun prompted a contemporary writer to comment that such a quality had never before been 'so freely or

47 *Jack and Jane. Good Words for the Young*, 1 June 1870, p. 444

48 George Pinwell, *The Gang Children. The Sunday Magazine*, 1 October 1868, p. 25

49 *Rest: Aldenham Church*, 1876, watercolour. Inscribed 'November 14, 1876'

50 *The Bad Boy*, 1888, watercolour

51 *Summertime* (*A Front Garden*), 1887, watercolour

49

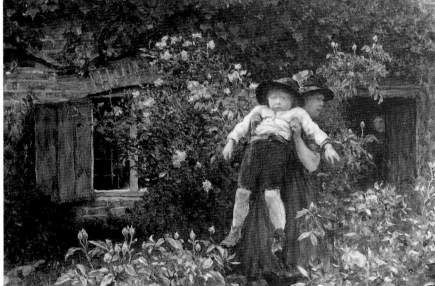

50

51

even successfully displayed in his works, distinguished as some of them are by the sense of pathos of old age, of which his masterpiece *The Last Muster* [see Colour plate XVII] is the crowning instance'.[18]

Another watercolour in the series, *The Woodman* (Figure 52) shows the artist's freer, sketchier style, which echoes the edgeless technique and airy expanses of the landscape painter and illustrator John William North (1842–1924). By the late 1880s Herkomer had grown to admire the work of North,

52 *The Woodman*, 1887, watercolour

who was Walker's closest friend and painting partner till the latter's death in 1875. In an enthusiastic article published in 1893, Herkomer wrote that North's 'greater power of drawing and composition' made him 'the originator of the germ of that school to which we naturally give the name of the "Walker School"'.[19] This was quite a claim for someone who was either largely forgotten at the time or viewed as second-rate, and one wonders whether Herkomer may have had an ulterior motive. However, his description of a

variety of watercolour practices and in particular his discussion of North's unique approach to the medium, in terms of both colour and application – liberal use of blotting paper, softened edges, speed, the banishment of bodycolour (formerly much used by Herkomer) and the suggestion of 'design and composition without the necessity of representing any object definitely'[20] – is convincing, and stands as a fine example of Herkomer's ability to define the essence of the craft of art as well as of his lifelong desire to teach those skills to a wider public.

In the same article, he condemned the overuse of photography, asserting that it encouraged sharp outlines and the abandonment of preliminary sketching.[21] This was a complete turnabout from his earlier embrace of the medium, which he had used both in the form of the camera obscura (a centuries-old artist's tool) and photographic prints to help compose his huge Welsh landscapes of the early 1880s. Herkomer began to experiment with print photography in 1878 and wrote numerous enthusiastic letters about it to Mansel Lewis. Herkomer learned the craft from photographers at Elliott and Fry, the firm run by Clarence Fry. In Herkomer's darkroom at Dyreham, his home in Bushey, his wife Anna printed the images while his inamorata Lulu did the developing.[22]

53

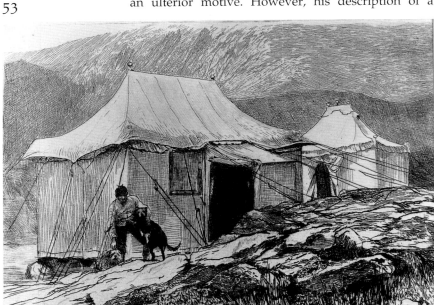

After a holiday in July 1878 at Mansel Lewis's castle in Wales, Herkomer hatched a plan to return and

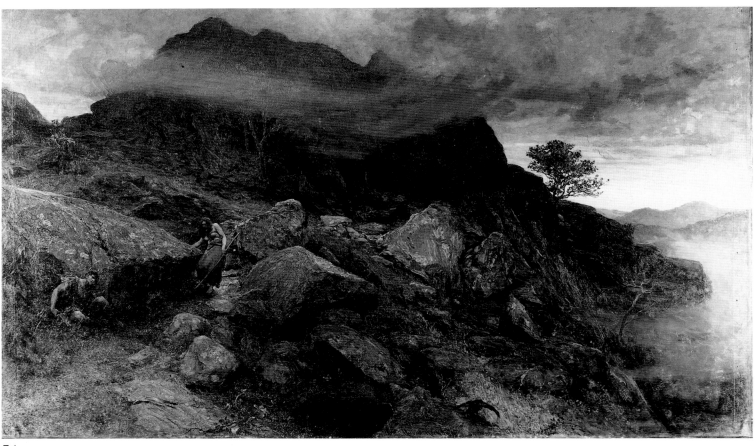

paint the wild and stormy scenery around Lake Idwal in North Wales in the company of his host, his father Lorenz (who prepared his canvases and painting materials) and several other family members. These elaborate camping expeditions, which Herkomer outlined in a two-part descriptive article, 'Notes on Landscape Painting', published in 1880 in the *Portfolio*,[23] were undertaken for two months every spring from 1879 till 1884. The goal was to produce one big landscape painting each trip. By the second expedition the tents had become larger and more comfortable (see Figure 53), and dual painting huts (the second hut was for Lewis) and even an etching studio were rigged up. These painting campaigns produced several canvases in the tradition of the 'dreary landscape', or what Herkomer termed 'the grey day landscape'.[24] They included *Windswept* (present location unknown), exhibited at the Royal Academy in 1880; *The Gloom of Idwal* (present location unknown), a large sunset scene (eight and a half feet wide) of rainswept hills and rock outcroppings which was shown at the Grosvenor Gallery in 1881, and

praised as 'poetic';[25] *Homeward* (1881; Altes Rathaus, Landsberg), its central motif of a woman holding a lamb used again by Herkomer in *The Foster Mother* (1892; Bushey Museum Trust); and *Found* (Figure 54), which was purchased from the Royal Academy exhibition of 1885 by the Chantrey Bequest for £800.

This latter work was painted near Port Madoc in Carnarvonshire, and incorporates its forbidding scenery. Powerfully theatrical, the narrative of the painting is based on *Found*, a play with a Welsh druidical plot that is set in the period of the second invasion of Britain by the Romans. Herkomer wrote or adapted the play, but he never produced it,[26] though two years later, in 1887, he finally did mount and star in his first theatrical production, *The Sorceress*, in the Herkomer Theatre at Bushey (see Chapter 10, below).

Another landscape dating from much later but related to *Found* is *Watching the Invaders* (Figure 55), which was exhibited at the Royal Academy in 1902. The painting was inspired by Herkomer's fascination with the myths told by the early Welsh bards,[27] an

53 *The Tents*, Herkomer's accommodation at Lake Idwal, North Wales, in 1880 for a landscape-painting expedition in the wild and rugged scenery. Illustrated in Hubert Herkomer, 'Notes on Landscape Painting', *The Portfolio* 2 (1880), p. 176

54 *Found*, 1885, oil on canvas

55 *Watching the Invaders*, 1902, oil on canvas

55

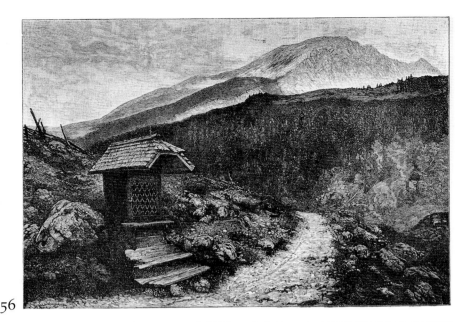

56

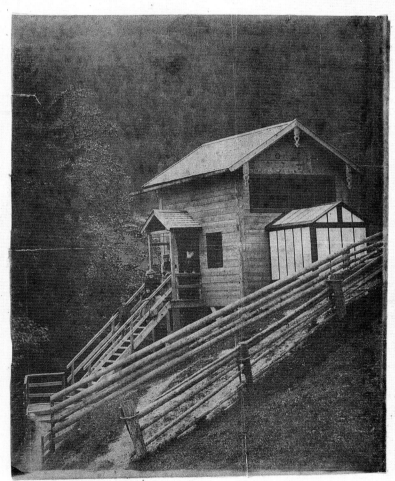

Hubert's studio at Ramsau Bavaria
Hubert's father Lulu, Maggie & Siegfried & Elsa on steps

57

enthusiasm analogous to his love of the national mythologies that inspired Richard Wagner. The figures in this later painting are more prominent and the landscape is more symbolic and stylized. The curving river in the background suggests the design of Walker's last oil painting, *The Right of Way* (1875; National Gallery of Victoria), a favourite of Herkomer's which he persuaded the National Gallery of Victoria in Australia to purchase in 1891 when he was acting as its art advisor.[28]

Herkomer's lifelong loyalty to Wales and Welsh traditions may have been sparked by his second and third wives, the sisters Lulu and Margaret Griffiths, who were Welsh. With Mansel Lewis's encouragement, he also came to admire the bardic traditions of the Eisteddfod. After attending the Eisteddfod in 1895, Herkomer decided to redesign the bardic regalia and costumes. He also made a watercolour of the Eisteddfod's Arch-Druid *Hwfa Mon* (1896; Forbes Magazine Collection). Exhibited at the Royal Watercolour Society in 1896, this honest and strangely affecting portrait of a celebrated but plain-looking individual was attacked for being 'uncomplimentary'.[29]

In July 1879, after two months spent painting in North Wales, Herkomer travelled to Ramsau in Bavaria. Here he visited his parents and began work on a huge Bavarian mountain landscape entitled *God's Shrine* (Figure 56), which he painted in a tall wooden studio constructed by his father (Figure 57). With its low-keyed colours, twilight sky and ominous mood, this work resembles Herkomer's Welsh scenes. His enthusiastic letters to Mansel Lewis during this time abroad[30] indicate that his emotional and artistic response to this Alpine scenery differed little from his experience of North Wales, for he was ultimately seeking eternal truths in nature – its mystery and expression. Herkomer commemorated the death of his mother in the painting by inscribing her initials, 'J. H.', and her death date, 24 December 1879,[31] on the wooden roadside shrine that dominates the foreground, while in the background the sunset sky, fallen trees and infinite road symbolize the transience of life.

Herkomer's interest in landscape painting during the 1870s was fostered in part by a close friendship with the brilliant young painter Cecil Gordon Lawson (1851–1882). Herkomer particularly admired the expansive vision of Lawson's landscapes, their poetic realism (he was often grouped with the Idyllic School) and their rough, scumbly technique. The two artists probably met through Francis Wilfrid Lawson (1842–1935), Cecil's older brother, who was an illustrator at the *Graphic* and for magazines like the *Quiver*. After the overwhelming success of *The Last Muster* (see Colour plate XVII) in 1875 and the negative reception of his Bavarian subject *At Death's Door* (see Colour plate IX) the following year, Herkomer

was searching for a different artistic path and briefly found it in landscape painting.

According to Cecil Lawson's biographer Edmund Gosse, Herkomer helped Lawson recover his desire to paint again after the rejection of his piece, *The Hop Gardens of England* (private collection), by the Royal Academy in 1875.[32] In a letter to Mansel Lewis, Herkomer raved about the landscape 'he [Lawson] painted whilst with me. It is a sunrise – autumn – all the clouds rising up – and the sun red in the mist! It is a glorious work. If this fellow lives he will be at the head of all landscape painters of the day.'[33] The rejected picture was accepted for the following year's exhibition and Lawson and Herkomer, who remained close, even planned trips to Bavaria together.[34] While Herkomer was praising Lawson's great talent, few others seemed to notice. Not until the Grosvenor Gallery began to show this artist's work in 1878 did his reputation soar. When Lawson lay mortally ill, Herkomer was the only person other than family members who was present for his final moments. Lawson's tragically early death in 1882 at the age of 30 devastated his friend.[35] Asked by Gosse to contribute illustrations along with Whistler to a memoir of the artist that accompanied Lawson's memorial exhibition in 1883 at the Grosvenor Gallery, Herkomer made an etching of *The Hop Gardens of England* (Figure 58) and supplied the frontispiece portrait (Figure 59).

58

Interestingly, Lawson's important role in Herkomer's life in those early years was omitted from the memoirs he published in 1910, a pattern of forgetfulness I have already noted. But the distance of 30 years dimmed many of Herkomer's memories, and his former generosity of spirit was replaced in old age by other dreams of the vanishing world of Victorian art and his fears of relinquishing his place in it.

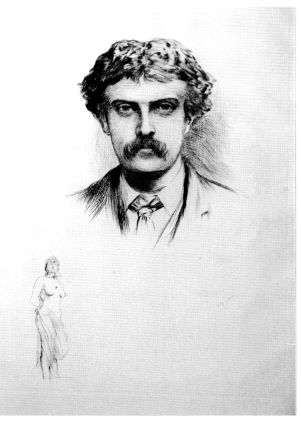

59

56 *God's Shrine*, 1879, oil on canvas

57 Photograph of Hubert Herkomer's studio at Ramsau, Bavaria. Hubert's father, Lulu, Maggie and Siegfried and Elsa on the steps, 1879

58 Cecil Lawson, *The Hop Gardens of England*, etching by Herkomer reproduced in Edmund Gosse, *Cecil Lawson: A Memoir with Illustrations by Hubert Herkomer A.R.A., J.A. McN. Whistler and Cecil Lawson* (London, 1883), opposite p. 7

59 Etching by Herkomer of his watercolour portrait (now in the National Portrait Gallery, London) *Cecil Lawson*, reproduced in Edmund Gosse, *Cecil Lawson: A Memoir with Illustrations by Hubert Herkomer A.R.A., J.A. McN. Whistler and Cecil Lawson* (London, 1883), frontispiece

'Romantic and paintable': Herkomer's Bavarian peasant realism

During the course of the nineteenth century the peasant, who had formerly been viewed as coarse and brutish (a view still evident in Balzac's novel *Les Paysans* [1844] and Zola's *La Terre* [1887]), came to be seen as a productive symbol of the countryside; his life, led close to the soil, was considered the antithesis of the corrupt values of the urban world. Immediately after the revolutions of 1848 in Europe, the peasant was taken up as a subject by artists such as Gustave Courbet and Jean-François Millet, who endowed their peasant scenes with a grandeur and dignity previously reserved for historical themes.

By the mid-1860s, scenes of peasant life had become an exhibition staple.[1] Millet's peasants, for example, with their rustic gravity and classical grace, are depicted not as revolutionary symbols tied to social upheaval but as tireless and uncomplaining in a life of toil. Millet, Jules Breton, Gustave Brion, Edmund Frère (much praised by Ruskin), and the Ecouen School of painters are but a few of the Continental artists whose paintings of humble peasant life were frequently exhibited and sold in London from the 1860s onwards, adding a new twist to the popularity of rural imagery in England.[2]

Frederick Walker and his followers were strongly affected by French peasant realism. Like Millet, Walker (sometimes dubbed 'the English Millet' by his contemporaries) relied upon models from classical antiquity to heroicize his peasant figures.[3] Although they drew thematic and stylistic sources from French realist art, their work had a distinctly national tone that subtly endorsed the class-consciousness woven through the social fabric of British life. As the art critic Harry Quilter noted,

English painting, at least English idyllic painting, would scarcely have risen to the impersonal view of the peasant which we find held by Millet; entire deference to the squire and his lady, not even yet quite eradicated from the mind of the English lower classes, is hardly consistent with the representation of the dignity of labour which Millet showed us so persistently, and in the truth which he believed to the utmost ... And though we allow in England that a labourer may be picturesque, may be healthy, may even be cheerful, we hardly allow, as far as our own art is concerned, that he may be unconscious that he is a labourer, and may forget, even in his prayers, the position in which it pleased God, and the customs of his country, to place him.[4]

A more austere style of rural sentiment is found in the work of Alphonse Legros (1837–1911), a French artist who settled in England in 1863.[5] Despite long

residence in England, Legros, who had been close to Edouard Manet, Courbet, Degas and Henri Fantin-Latour before his self-imposed exile, painted French peasant subjects throughout his career.[6] His restrained depictions of French peasants at prayer, exhibited at the Royal Academy from 1864 onwards, are the opposite of the prettified figures and settings and the fussy touch typical of works by Walker and the Idyllists. After some initial misgivings about Legros's use of 'low tones' and 'homely women' in his paintings, by the late 1860s his realism was accepted by the English audience.[7]

By then the time was ripe for an alternative rural tradition in English art, one typified by more vigorous and monumental imagery. Even as they were developing greater familiarity with French peasant themes, English art lovers kept abreast of developments in Germany as well, principally through regular reports to the British press from the 1860s onwards by the correspondent Joseph Beavington Atkinson.[8] In addition, painters of contemporary German peasant life such as Ludwig Knaus (1829–1910) were well represented at the International Exhibition in London in 1862.

Herkomer and his father spent the spring and summer of 1871 in Garmisch in the Bavarian Alps and returned there the following year for six months. In 1873 they spent another extended summer in Germany, this time in Ramsau (see Figure 57), and from this time onwards Herkomer's frequent visits inspired a large number of works with Bavarian peasant subjects, primarily for exhibition in England. As we saw in Chapter 1, after his mother's death in 1879, a castle-like tower in her memory, the *Mutterturm* (see Figure 6), rose on property he had purchased earlier for his parents in Landsberg-am-Lech. Upon its completion in 1885, it became his lifelong Bavarian residence.

Herkomer's German travels were initially financed by the sale of wood engravings to the *Graphic* and other magazines, and by W. L. Thomas's commission for a watercolour version (location unknown) of the Chelsea Pensioners engraving (see Figure 73), which appeared in the *Graphic* in 1871.[9] According to Herkomer, his primary aim was to live among the peasants and to use them as models for his paintings.[10] But on his first visits he probably also spent time in Munich (where as we have seen he had briefly

attended the Academy in 1865), becoming acquainted with current stylistic trends and meeting artists. One of his English biographers claimed that Herkomer posed for a figure in Karl Theodor von Piloty's huge 'machine', *Thusnelda in the Triumphal Procession of Germanicus* (1869–1874; Neue Pinakothek, Munich),[11] which suggests an acquaintance with the prominent teacher, who attracted flocks of foreign students. Indeed, a cowering figure at the right in the painting *does* strongly resemble Herkomer, who wore a heavy beard at the time. Herkomer himself never mentioned any association with Piloty in his voluminous writings, however.

Piloty, who became the Director of the Academy in 1874, left his mark on two students – Franz von Defregger (1835–1921), who himself became an influential Munich Academy teacher, and Wilhelm Leibl. Herkomer's contemporaries compared his depictions of Bavarian peasant life to the work of both Defregger and Leibl,[12] and in 1884, in a letter to Edmund Gosse, Herkomer privately acknowledged his artistic allegiance to Leibl:

That a tame and inartistic spirit is cursing our English art is undeniable . . . The elements will be corrected by two men who are the reactionary spirits of the sentimental – Leibl and Bastian [sic] Lepage. They merge into the other extreme of ugliness, but it will have a wholesome effect . . . If I can be one of the spirits with Leibl – having a path and philosophy of my own (but searching for kindred thoughts) I shall be happy.[13]

Leibl inspired a group of Munich artists known as the *Leibl Kreis*, who spurned anecdotal art in favour of more purely formal concerns. From 1873 till his death, he lived among peasants in a number of Bavarian villages, and peasant subjects were the principal focus of his *oeuvre*. During his early years in Munich, he rarely exhibited, but his work could be seen at the numerous art clubs in the city. In 1874 he issued a series of etchings of peasant 'heads'. His *Die Dorfpolitiker* (*The Village Politicians*) (see Figure 70), exhibited at the Paris Universal Exhibition in 1878, brought him international recognition.[14]

The most popular German peasant genre at mid-century was the work of the so-called 'village tale' painters.[15] This group included artists such as Defregger and Ludwig Knaus. Peasant subjects by the 'village tale' painters were anecdotal, often humorous and usually picturesquely costumed. Their idealized vision of rural life matched that of Walker and the Idyllists, though their coarseness was alien to the prim Victorian sensibility. A literary reference point for these artists is found in the celebrated peasant tales of Berthold Auerbach (1812–1882),[16] while pictorially their work suggests the Scottish peasant scenes of David Wilkie, whose work was well known in Germany through engravings and whose *Reading of the Will* (1820) was on display in the Munich Pinakothek from the time it opened in 1853.

Defregger, who was born a peasant in the Austrian Tyrol, was by the 1880s the most popular Munich School artist.[17] His peasant scenes describe an idealized world of dancing, sport and relaxation, often in crowded tavern interiors; some of his subjects carry nationalistic overtones. The lively peasant realism of Ludwig Knaus, Defregger's counterpart in Berlin, was equally appealing to middle-class taste.[18] Both artists' work was known in England; Knaus's art was the subject of an article in the *Magazine of Art* in 1885.[19] Defregger and Knaus were friendly with each other, and among Knaus's friends in Berlin was his older colleague Adolph Menzel.[20] Interestingly, although Herkomer wrote effusively about Menzel (as I noted in Chapter 2) and exhibited drawings lent him by the master in the Herkomer Art School Gallery,[21] he never mentioned any acquaintanceship with, or public admiration for, these other artists. His note to Gosse about Leibl was a private communication. This was in contrast to his many published enthusiasms for Walker and the Idyllists – a loyalty that reflected his desire to achieve recognition as an English artist, though in later life his work took on a decidedly more Continental tinge.

Although Herkomer always publicly declared himself an English artist, his choice of a Bavarian peasant subject for his first major exhibited oil painting points up the ambivalence of his national priorities even at the outset of his career. *After the Toil of the Day* (see Colour plate VIII), which was exhibited at the Royal Academy in 1873, is set in the village of Garmisch near Oberammergau in the Bavarian Tyrol. Despite this, the picture exudes a Walkerian tone and, in fact, at its exhibition it was mistaken for a painting by Walker.[22] Herkomer himself admitted that the scene he had observed in Garmisch – 'old people congregated at Eventide awaiting the workers from the field' – had presented the 'possibility of treatment in the "spirit" of Walker's art and with the sentiment that was the keynote to that school of which he was so brilliant an exponent'.[23]

The sentiment of pathos to which Herkomer refers was a pictorial ingredient much praised by Victorian critics.[24] 'Pathetic realism', as it might be called, while often based on observation, could also incorporate abstract concepts such as timelessness and intimations of mortality. The pathos of old age and the presence of death were explicit themes or implied undercurrents in several of Herkomer's important Bavarian pictures and forecast the more overt symbolism of his later work.

Herkomer began work on *After the Toil of the Day* during his first six-month visit to Garmisch in 1871. The painting was nearly finished when the artist brought it back to London. He showed it to Walker's friend the painter Stacy Marks, who advised him to begin again.[25] He reworked the composition in

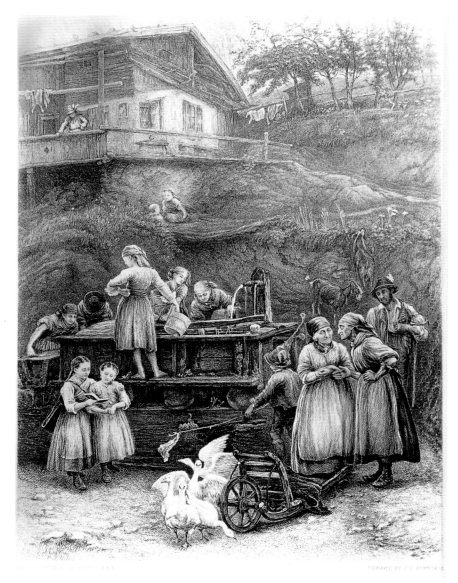

60 *At the Well*, 1871,
engraving of the
watercolour by
Herkomer exhibited
in 1872 on the
occasion of his
election to the Royal
Institute of Painters in
Watercolours,
reproduced in *The Art
Journal* 43 (1881),
p. 201

achieved in his watercolours,[27] problems in the
preservation of *After the Toil of the Day* emerged
almost immediately. As early as 1876, he was forced
to make major repairs, and although he carried out
periodic 'touch-ups' in subsequent decades, surface
deterioration has dulled the painting's initial impact.[28]
Nevertheless, it achieved a notable success at its exhi-
bition at the Royal Academy in 1873. 'All things con-
sidered, *After the Toil of the Day* (657) must be placed
foremost among the few bright and promising things
to be found in Burlington House this year', enthused
one critic. 'Each person of the little drama is brought
under the influence of the evening light, and by some
subtle means they are all made to express that influ-
ence.'[29] But *The Times* felt that 'H. Herkomer's best
chance in *After the Toil of the Day* (657) is to be mis-
taken for F. Walker.'[30]

Herkomer found a buyer for his picture even before
the exhibition. The Messrs Waller, builders who were
constructing a new wing at the home of Mansel Lewis
in Wales, mentioned to their employer that their
workshops in Smith Street, Chelsea, were situated
next to the studio of a young and talented painter
named Herkomer. When Mansel Lewis came to
London in March 1873, one of the Wallers took him to
see Herkomer's work in progress. Having spent much
of the previous year himself in the Bavarian Tyrol,
Mansel Lewis was immediately attracted to the paint-
ing. A few days later he purchased it for £500, a huge
sum for the work of a beginning artist. In addition, he
commissioned a second work, which was also to have
a Bavarian theme.[31] It was the beginning of an endur-
ing patronage and close friendship.

As I have said, Herkomer's surviving correspon-
dence with Mansel Lewis covers a period of 40 years,
ending only with the artist's death. Himself a painter
and etcher, Mansel Lewis exhibited at the Royal
Academy between 1878 and 1882. Herkomer fre-
quently visited Mansel Lewis's home and often
helped and encouraged his gifted patron with his
work.[32] In 1873, with the money from Mansel Lewis's
purchase of *After the Toil of the Day*, Herkomer was
able to buy the cottage in Bushey where he settled
with his parents.

In 1878 *After the Toil of the Day* was exhibited with
The Last Muster (see Colour plate XVII) at the Univer-
sal Exhibition in Paris.[33] Because of the greater
celebrity of the latter work – Herkomer was awarded
a medal of honour – his Bavarian peasant painting
was largely passed over, though an illustration of it
was reproduced as *Après le travail* in *L'Art* in 1879.[34]

Herkomer returned to the 'end of the day' theme in
the set design (Figure 61) for his 'pictorial-music-play'
An Idyl, created and produced by him at the
Herkomer Theatre in Bushey in 1889 (we'll discuss
this in greater detail in Chapter 10, below). Changing
the locale from the Bavarian Alps to an English
village, Herkomer used his first major painting as the

Garmisch the following summer, making the land-
scape more prominent.

Herkomer's village theme and various details
clearly derive from Walker's painting *The Street,
Cookham* (1866; private collection), which was repro-
duced as an etching by Birket Foster.[26] In Herkomer's
painting, however, figures are interspersed at stages
along the roadway to enhance the illusion of depth
and the road's abrupt ending in the immediate fore-
ground lends the composition a tilted look, as though
it were viewed through a camera lens or camera
obscura, favourite devices of Herkomer's at this time.

Other works related to this first major exhibition
painting include Herkomer's exquisite watercolour
The Goose Boy (see Colour plate VII) and another
watercolour painted in Garmisch in 1871, *At the Well*
(Figure 60), which originally belonged to the artist's
patron, Clarence Fry, and recalls the popular 'village
tale' genre of German artists like Knaus and Defreg-
ger.

Because Herkomer lacked experience working in oil
and wished to duplicate the fresco-like finish he

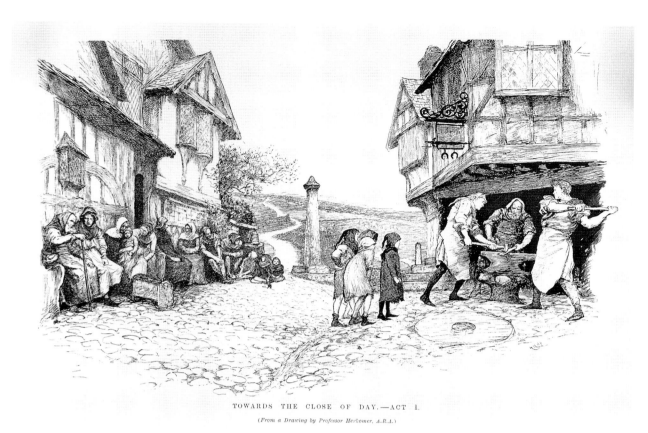

TOWARDS THE CLOSE OF DAY.—ACT I.

(From a Drawing by Professor Herkomer, A.R.A.)

61 *Towards the Close of Day*, 1889. Set design by Herkomer for his pictorial-music-play *An Idyl*, reproduced in *The Magazine of Art* (1889), p. 318

inspiration for his play. 'This picture started the idea of this play', he wrote:

The first thing I saw in my mind was a fourteenth-century street in England, with a distance beyond; with old people and children on one side, and a smithy on the other side of the street. From this picture I started my story, never losing sight of the scenic effect I sought to produce.[35]

The set design is more consciously stylized than its original source and the anvil-hammering figures suggest the inspiration of Richard Wagner, whose music and stagecraft Herkomer admired, particularly after seeing his first complete performance of Wagner's *Ring of the Nibelungen* in London in 1882.[36]

A number of Herkomer's early Bavarian peasant watercolours were purchased by his first patron, the Watford businessman Clarence Fry, and several were reproduced as engravings in the 'Graphic Bavaria' series. *Carnival Festivities in the Alps* (Figure 62) is intriguing because the fantastical nature of the subject matter displays the wilder, more imaginative side of Herkomer's creativity. It appeared as a double-page engraving in the *Graphic* magazine as *Carnival Time in the Bavarian Alps*, accompanied by a description of the traditional rite being celebrated.[37] On 30 December 1873, Herkomer married his first wife Anna, a German by birth whom he had met through the Fry family, and he spent his honeymoon with her in Bavaria. This could account for the specific date on the watercolour (26 January 1874), which was most

likely painted in Ramsau, where they also spent the spring and summer months.[38]

A watercolour of May 1874, *The Woodcutters* (present location unknown), was also reproduced as a popular print (Figure 63). Although closer to German genre painting of this type,[39] *The Woodcutters* was perceived, at least in English eyes, as being in the manner of the 'Walker–Pinwell' school.[40] Herkomer portrayed himself as the figure at the left observing peasants cutting wood, possibly for the painting hut he built in Ramsau (see Figure 57). At a later time, Herkomer tried to emphasize that these early works, though conceived in Bavaria, were different from those of his German contemporaries. In visual terms, however, his assessment is somewhat unconvincing:

I brought the desire for sentiment in art from England, but I left my English eyes in that country, and did not paint English peasants in Bavarian costumes; the peasant as I represented him was true to nature – Bavarian to the core. Yet there was a 'something' in my interpretation that differed from the works of German painters who had been trained in Germany.[41]

As in the work of Walker and his followers, the pathos of old age was a recurring theme in a number of these early watercolours such as *Abendbrodt* (*The Evening Meal*) (1872; Watford Museum) and *Weary* (Figure 64, in which a melancholy figure seems overwhelmed by her milieu (a huge ceramic stove looms behind her). The watercolour's surface is animated with the artist's characteristic swirling brushstrokes, while the figure's dress is speckled with scratched-in streaks of bodycolour highlights.

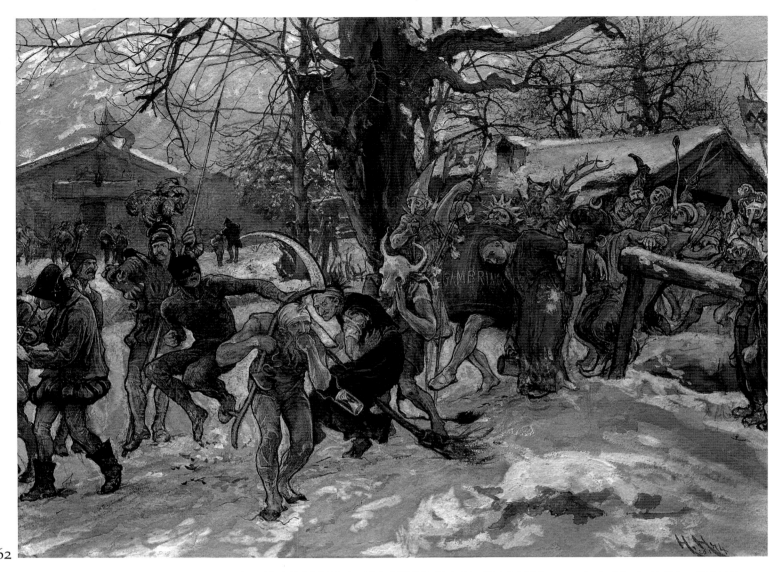

62

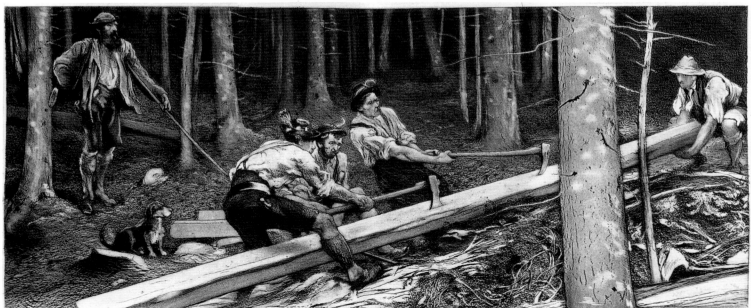

The Wood-cutters

63

While themes of work and play and the resignation of old age inform these watercolours, *The Poacher's Fate* (Figure 65) treats peasant poverty and hardship. After the success of *The Last Muster* at the Royal Academy in 1875 – a picture which Herkomer admitted 'emancipated me from Walker'[42] – he exhibited in England Bavarian images with an edgier, more Continental tone, some with German-language titles (see, for example, Colour plate X). *The Poacher's Fate* was painted in Bavaria in 1875, shortly after his Academy triumph, and, as in *The Last Muster*, its central focus is a death scene. Inscribed with a specific date ('24.11.75'), the watercolour probably commemorates a tragedy Herkomer had witnessed during one of his frequent hikes in the Bavarian Tyrol.[43] Only the lower half of the dead poacher's legs and one claw-like hand protrude upward from the right foreground.[44] The composition with its bizarrely cropped limbs projects the sense of immediacy that Herkomer so admired in the art of Menzel.[45] In addition, its looser technique – thin washes with a minimum of stippling – forecasts the broadening of Herkomer's touch in later works.

Several of Herkomer's early Bavarian watercolours were exhibited in 1876 in Berlin,[46] where both Menzel and Knaus lived, and it is likely that Herkomer's friendship with Menzel dates from this time. Herkomer's German biographer, the art critic Ludwig Pietsch, noted that the artist's peasant scenes were particularly admired for 'their realistic power, sharp observation, truthful colour and the energetic character of their draughtsmanship'.[47] In general, however, Herkomer refrained from exhibiting his peasant subjects in Germany, perhaps fearful of being identified as a German artist by his British colleagues. Instead, he mainly showed portraits there and, in the Secessionist years, Symbolist images. One exception in 1879 came at the International Art Exhibition in Munich, where he showed his watercolours, including a portrait of Wagner (see Figure 93) and several Bavarian peasant scenes – in the English section of the exhibition.[48]

In 1878, along with the already-mentioned oil paintings, Herkomer sent *The Poacher's Fate* (Figure 65) and *The Woodcutters* (Figure 63) to the Paris Universal Exhibition. In an article on the British watercolours on view there, the French critic Charles Tardieu pointedly mentioned Herkomer's German origin, noting that his 'remarquables *water colour drawings* diffèrent notablement des aquarelles des ses nouveaux compatriotes'. He also called attention to their freer, more vigorous style in comparison with the finely detailed touch of the other English artists.[49]

In March 1876 Herkomer completed the second Bavarian work commissioned by Mansel Lewis, though the subject itself, *At Death's Door* (see Colour plate IX), was chosen by the artist. A large painting, it

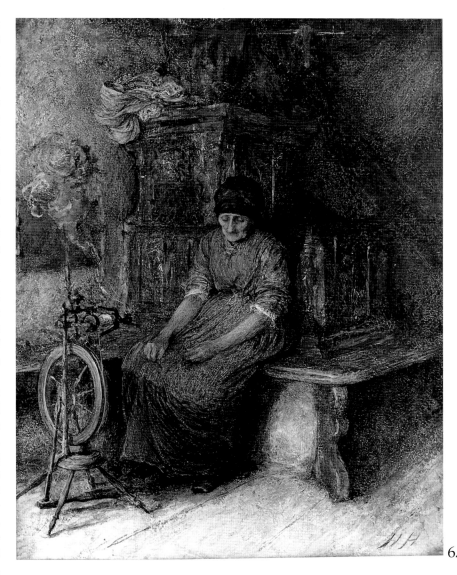

64

depicts members of a Bavarian peasant family waiting for a priest to administer the last rites for a dying relative. The gloomy image, with its rough-looking peasants and oppressive dark brown and green tones relieved only by the colours of a pale sunset, drew a generally unfavourable response when it was shown at the Royal Academy in 1876. Never one to pass up the possibility of reworking a subject, Herkomer painted a watercolour version, and a double-page engraving appeared in the *Graphic* (Figure 66).

After his stunning success with *The Last Muster* the previous year, Herkomer deliberately planned *At Death's Door* and two subsequent scenes of Bavarian peasant life as major exhibited works of a very different type:

My chief object in doing German subjects was to strike out in a new vein, fearing to be 'ticketed' all my life with the one article which had been successful. I lost favour in the eyes of the public, who fully expected me to paint nothing but Pensioners for the rest of my life.[50]

Aware that the more rugged tone of his Bavarian themes of the late 1870s caught the English art audi-

62 *Carnival Festivities in the Alps*, 1874, watercolour

63 *The Woodcutters*, 1874, engraving by Herkomer of the original watercolour

64 *Weary*, 1872, watercolour

65 *The Poacher's Fate*,
1875, watercolour

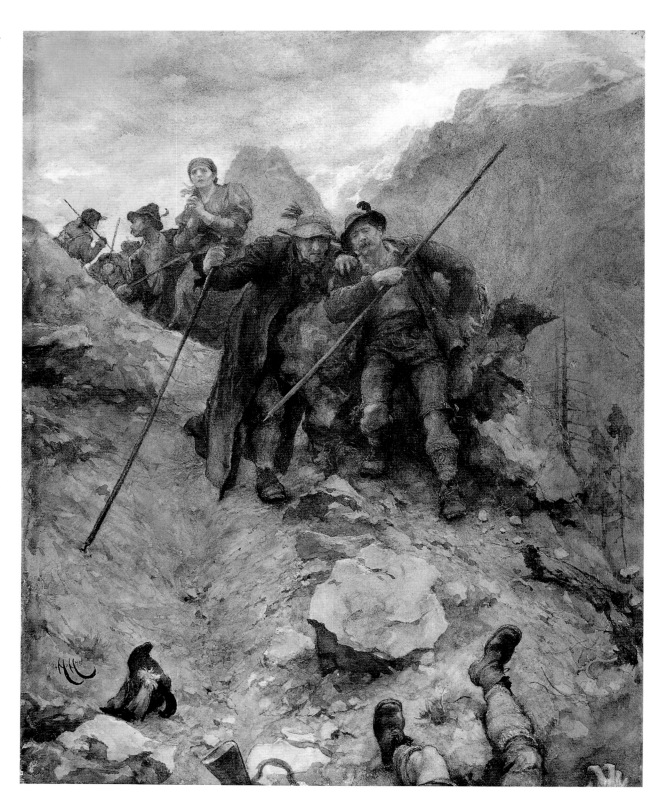

ence by surprise, Herkomer wrote to Mansel Lewis from Munich in 1877:

They wont [sic] have my Bavarians without a grumble. For I will not stick to one subject and get mannered! . . . and see the sickly pictures of English subjects that crowd the walls of exhibitions – a sickly sentiment – that is what they want and they shall not get it from me – even if I have to keep at the pictures I love best. It makes me wild sometimes. Had I not shown them I *can* paint an English subject they would have been contented.[51]

That Herkomer had doubts about his proclamation against popular taste, especially where it concerned money, is also revealed in the same letter. 'Now as I live by my art', he wrote, 'unfortunately I must make small compromises . . . Conclusion, I mean to please an idiotic public and also myself.'[52] In spite of the critical reception, these large Bavarian pictures, produced during a relatively short period, are among Herkomer's most interesting depictions of rural life –

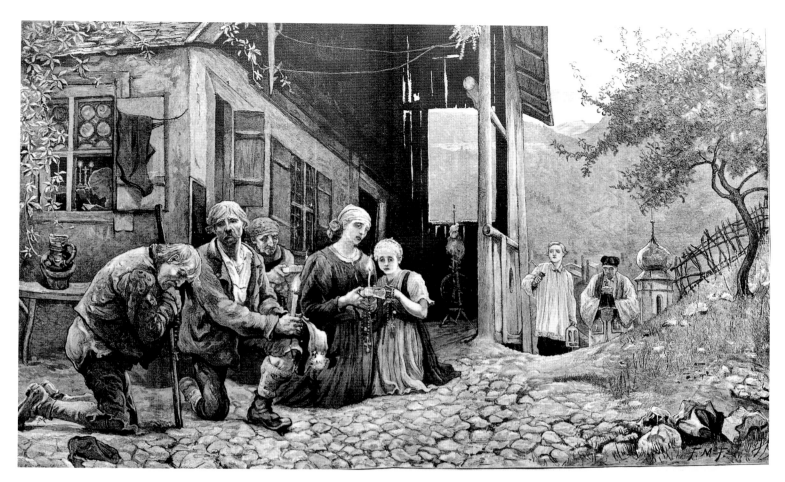

a synthesis of the narrative elements integral to Victorian genre painting with a forward-looking structure inspired by the art of the Continent.

At Death's Door, with its theme of peasant piety and religious customs, belonged to a genre then popular, particularly in France. Numerous works of this type were already known in England – for example Millet's *The Angelus* (1858–1859; Louvre), exhibited in London in 1872; the popular peasant funeral scenes by the Dutchman Josef Israëls; and the religious genre paintings of Alphonse Legros. Herkomer appears to have been personally acquainted with Legros, for he mentions him enthusiastically in private correspondence,[53] though Legros's name is not mentioned in any of Herkomer's later published writings, another reminder of his selective forgetfulness. As Edmund Gosse pointed out, Herkomer in his early years 'was intimately acquainted with other painters to each of whom he owed great stimulus, and whose names, when he came to write *My School and my Gospel*, had almost if not quite escaped him'.[54]

Having been so forthright in his acknowledgement of Walker's influence on his art, Herkomer must have felt that an admission of other sources of inspiration would diminish his stature in the eyes of his peers and those he thought would assure the longevity of his reputation. The several memoirs he published towards the end of his life attest to his desire to control the outflow of information about his goals and accomplishments, and his frequent memory gaps make an intriguing, sometimes fathomable, puzzle.

Because of the previous year's triumph with *The Last Muster*, *At Death's Door* was extensively reviewed by contemporary critics who were doubtless expecting another success from the young artist. The *Athenaeum* found it much inferior to the earlier work: 'The sentiment of the picture is cheap, its execution rough and slovenly ... and the whole defective in harmony and solidity.'[55] 'In returning to primitive Bavarian life', noted the *Illustrated London News*, 'Mr. Herkomer also resumes certain technical peculiarities that were partially laid aside in last year's pictures.'[56] Others appreciated the simple dignity and virtue expressed in a scene that portrayed the 'sincerely devout'.[57]

Herkomer planned to send the picture to the 1878 Universal Exhibition, confident that 'the French will like my *At Death's Door*',[58] but it was not included in the final selection.

The third work commissioned by Mansel Lewis, entitled *Der Bittgang: Peasants Praying for a Successful Harvest* (see Colour plate X), was exhibited at the Royal Academy in 1877. The six-and-a-half-foot-high painting, like the previous Bavarian subject, was misunderstood by the press. One writer, for example, asserted briefly that 'it will not enhance his reputation'.[59] An earlier watercolour version of the subject

66 *'At Death's Door' from the Picture by Hubert Herkomer in the Late Exhibition of the Royal Academy. The Graphic*, 26 August 1876, pp. 217–218

67 *Sketches in the Bavarian Alps II – 'Der Bittgang'. The Graphic*, 13 February 1875, p. 160

surface, attempting to give it a smoother finish.[62] The colours he used duplicate the muddy earth tones of *At Death's Door* and fit into the familiar range of gloomy shades favoured by other Victorian painters of contemporary life such as Luke Fildes and Frank Holl.

In an article written in 1882, the English critic J. W. Comyns Carr wrote that *At Death's Door* and *Der Bittgang* would have been more congenial to an English audience if the material had been more familiar. The subjects were 'remote from English sympathies', he noted, and 'demanded for [their] appreciation special knowledge of a particular local custom'.[63] The fourth and final Bavarian picture in the series was a huge watercolour entitled *Light, Life, and Melody* (see Colour plate XI). In contrast to the two works I have just discussed, it was considered a success when it was shown in 1879 at the Grosvenor Gallery, a venue noted for its more daring exhibitions. 'It is with a sense of relief and exuberant renewal of life', commented one writer, 'that we pass to an immense and robust watercolour drawing by Mr. Herkomer, which, placed among the oil pictures, is perfectly holding its own ... The title refers to the brilliant summer twilight in these elevated regions, the healthy existence there and the sweet strains of the zither.'[64] Clearly the subject, with its universal theme and livelier aspect, was more generally accessible, and the picture was hung in a place of honour at the Grosvenor Gallery.

Founded by the Scottish aristocrat and amateur artist Sir Coutts Lindsay, the Grosvenor Gallery opened in London in 1877. Lindsay and his two Assistant Directors, the above-mentioned Carr and Charles Hallé, insisted on showing a wide variety of progressive art by both contemporary British and Continental painters. The catholicity of the gallery's taste drew the following observation from a bemused writer:

The dainty luxuriousness of the boudoir-life which Tissot loves to house among the exotic growth of splendid conservatories ... finds a place here side by side with the rude and homely enjoyment of zither music, beer and skittles, of Herkomer's Bavarian *bauern*.[65]

In the centre of the picture, Herkomer portrayed himself plucking the strings of a zither, an instrument that he played expertly. A female figure, modelled after Lulu Griffiths, stands behind him, her expression signifying her absorption in the music. The theme of music and its analogy with art became an obsession during the 1860s and 1870s, when the abstract and suggestive qualities of music were seen as cognate to those of painting.[66] Examples include Whistler's figurative 'symphonies' and Albert Moore's musically themed genre scenes. Both artists' works were frequently exhibited at the Grosvenor Gallery.

Herkomer planned *Light, Life, and Melody* as the

(now in a private collection) was painted in October 1874 in Ramsau, near Berchtesgaden, where the artist had taken his ailing wife Anna, and reproduced in Herkomer's '*Graphic* Bavaria' series in February of that year (Figure 67). The theme is related to images of specific peasant rites such as Legros's *The Pilgrimage* (1871; Walker Art Gallery, Liverpool) and *Blessing the Sea* (1872; Sheffield Art Gallery), which were exhibited at the Royal Academy in 1872 and 1873 respectively. Herkomer, in a rare display of shaken confidence, continually revised the canvas, explaining the changes in a series of letters to his patron.[60]

The female figure at the top of the painting was modelled after Lulu Griffiths, the nurse in Herkomer's household who by 1876 had become his mistress, a situation undoubtedly known to Mansel Lewis, who by now was affectionately familiar with the Herkomer household. Herkomer also painted himself into the picture as the figure, hand cupped to chin, who broodingly watches Lulu from the top of the procession.[61] Before sending the picture to the Royal Academy the artist continued to fiddle with its

closing scene in a series designed for his patron as allegories of human experience. In a letter he wrote to Mansel Lewis just before beginning the final work, he explained, 'You have a peaceful evening scene [Toil]; in Death's Door you have human suffering; you have a religious subject in Bittgang; and if you will have this fourth, you will have one with life in its freshest and strongest aspects.'[67]

The image recalls Herkomer's earlier tavern scenes which were published in the 'Graphic Bavaria' series (see Figure 39), as well as several watercolours such as *Immer Wird's Schlimmer* (Figure 68), painted in Ramsau in June 1877, which depicts Herkomer at the zither, and *The Shooting Gallery* (1877; Bushey Museum Trust), a lightly washed sketch. *A 'Kegelbahn' in the Bavarian Alps* (Figure 69), published as a double-page engraving in the *Graphic*, is the immediate fore-runner of *Light, Life, and Melody*, though in the arrangement of the figures in the engraving and the thematic focus on sport (a *kegelbahn* is a skittle [bowling] alley) rather than on music, it differs from the exhibited version.

Painted primarily in Ramsau, Bavaria, over a period of two summers, *Light, Life, and Melody* was completed in early 1879.[68] In order to achieve a greater sense of volume, the artist modelled the figures in wax before revising their positions in the scene.[69] Herkomer's alterations may have been inspired by Wilhelm Leibl's *Die Dorfpolitiker* (*The Village Politicians*) (Figure 70), which he would have seen at the Universal Exhibition in 1878 when he travelled to Paris in mid-October with Mansel Lewis.[70] The close proximity to the picture plane of several figures in Herkomer's image recalls comparable formal elements in Leibl's painting, though Herkomer's overall composition, with its disparate narrative elements and vaporous background view, lacks a single focus.

While one observer was puzzled by what he perceived as an 'error of perspective' in the picture,[71] another technical aspect was almost universally praised – the artist's use of watercolour for a work of such a large size (it is seven feet high and five-and-a-half-feet wide). After painting the image on four large sheets of paper joined by a paper-pulp concoction devised by his father, the artist informed Mansel Lewis that 'No picture of mine was ever so rich in colour or so powerful in effect.'[72] With his usual

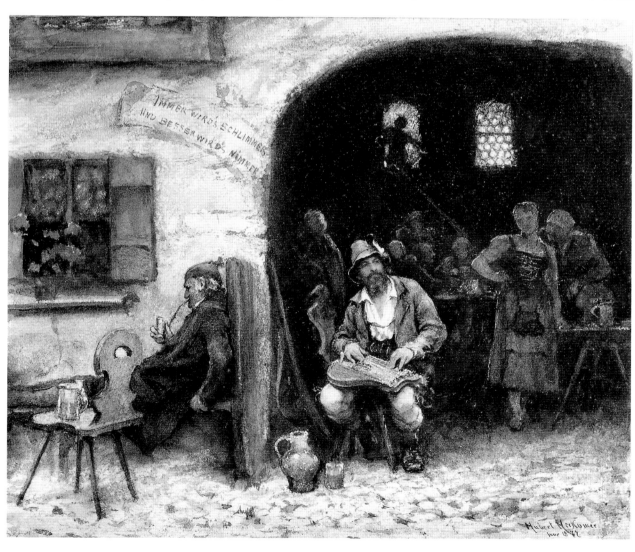

68 *Immer Wird's Schlimmer*, 18 June 1877, watercolour. The inscription on the background wall is used in the title, and translates as 'It always gets worse and never gets better.'

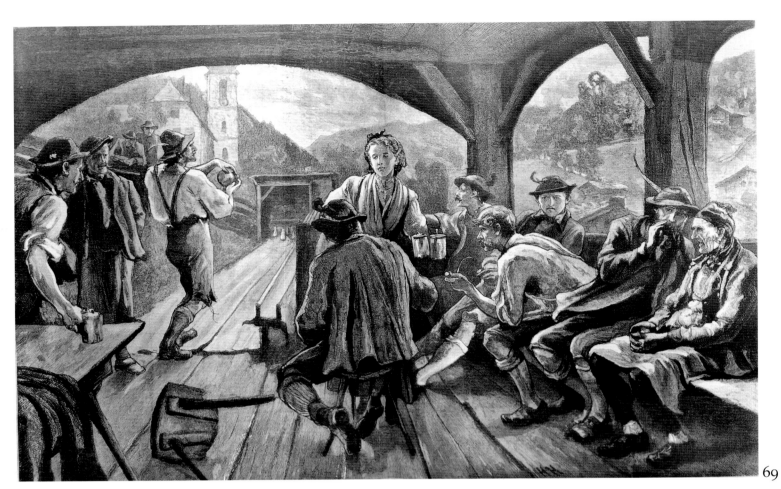

69

69 *A 'Kegelbahn' in the*
Bavarian Alps. The
Graphic, 6 April 1878,
pp. 352–353

70 Wilhelm Leibl, *Die*
Dorfpolitiker (*The*
Village Politicians),
1876–1877, oil on
canvas

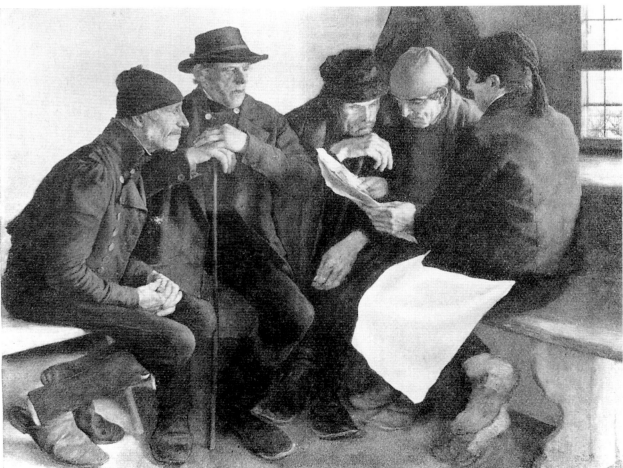

70

enthusiasm and flair for self-promotion, Herkomer believed he had revolutionized watercolour technique,[73] though, as with several of his experimental surfaces, preservation problems made repairs a necessity.[74]

Experimentation with watercolour technique was certainly not new. For his large watercolour *Phyllis and Demophoön* (1870; Birmingham Museum), the Pre-Raphaelite painter Edward Burne-Jones, who frequently exhibited at the Grosvenor Gallery, used a mixture of watercolour and gum that resulted in an unorthodox picture surface. It was probably this as much as the nudity of the subjects that angered the tradition-bound 'keepers of the flame' at the Old Watercolour Society, and Burne-Jones resigned his Society membership soon after the work's exhibition.[75]

Herkomer, instead of using bodycolour (Chinese white) to build up on the surface to achieve needed highlights as he usually did in his watercolours, scraped away the highlights with a knife, revealing the white of the paper itself for the desired effect.[76] The result was a vigorously animated surface that, according to one observer, 'was calculated to sacrifice the more refined charms of watercolours',[77] certainly Herkomer's aim at this time. Herkomer employed a similar method on a smaller scale for his portrait of Richard Wagner (see Figure 93), which was exhibited at the Grosvenor Gallery in 1878; and for *Grandfather's Pet*, his Royal Academy subject for 1880, illustrated here in his etched version (Figure 71). A favourite male model who appeared in a number of Herkomer's Bavarian pictures is reprised in a small oil painting of 1881, *Carding Wool* (see Colour plate XII), his quizzical figure emerging from swirling strands of wool in the foreground.

Light, Life, and Melody is the high point among Herkomer's images of Bavarian peasant life. With its musical theme and abstract title, so in tune with trends in the Aesthetic Movement, the picture established Herkomer's unique style as a vital presence in English art.

Herkomer painted Bavarian peasant scenes intermittently for the rest of his life. In November 1885 he exhibited a group of 51 watercolours and sketches painted in Ramsau in the autumn of that year. Commissioned by the Fine Art Society and entitled *Life and Work in the Bavarian Alps*, they were exhibited at the Society's galleries in Bond Street. Herkomer, who portrayed his Bavarian peasants with an eye to the realism of his Continental counterparts, was taken to task on this occasion for depicting them as coarse, with 'ugly and audacious elements'.[78] A surviving watercolour from the series, *Learning his Craft (Bavarian Peasants)* (Figure 72) is a beautifully composed image of vertical and horizontal shapes, incorporating a favourite sentiment of the artist, that of the contrast

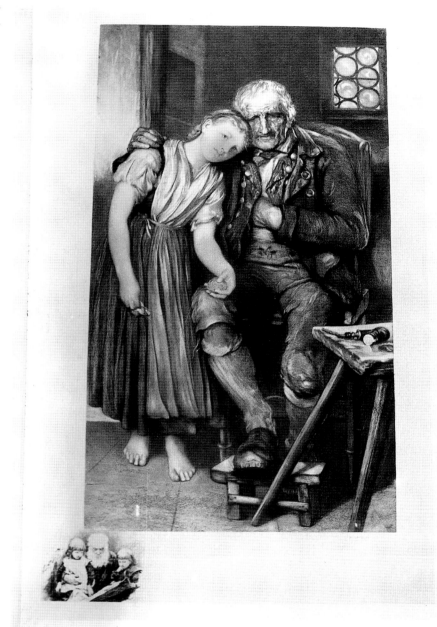

of youth and old age. A much later peasant watercolour, *Fisherman at Hintersee* (Laing Art Gallery, Newcastle), painted in 1905 and exhibited at the Royal Watercolour Society that year, is more impressionistic, with large dots of high-keyed colour and a dramatic Alpine background.

In 1900 the London art firm of Thomas Agnew and Sons commissioned from Herkomer a painting for its exhibition 'Distinguished Artists of the English School'. That Herkomer chose to paint a Bavarian genre subject, *Pro Patria (For the Fatherland)* (see Colour plate XIII), for such a traditionally British venue is intriguing. At this late stage in his career he had carved out a lucrative niche in Germany, but this was primarily as a portrait painter. The landscape background of *Pro Patria* shows the river Lech and the town of Landsberg as viewed from the balcony of the artist's summer residence, the *Mutterturm*. A homage

71 *Grandfather's Pet*, 1880, etching. At the lower left is a portrait of Herkomer's father, Lorenz, reading to his grandchildren, Elsa and Siegfried

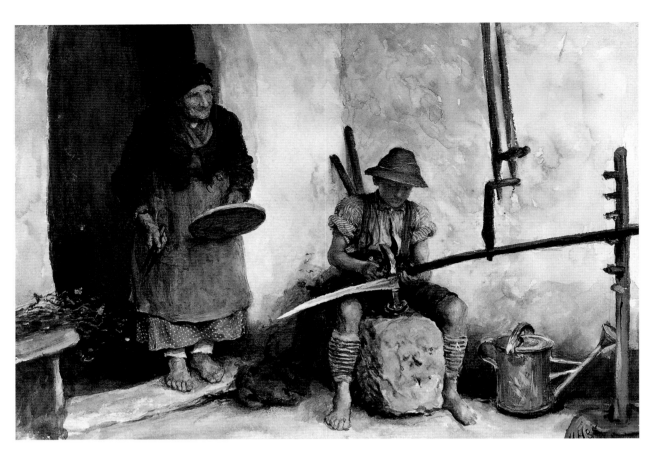

72 *Learning his Craft*
(*Bavarian Peasants*),
1885, watercolour

to the beauty of the area, the painting's bright colours
are unusual in Herkomer's *oeuvre* and clearly show
the influence of Impressionism, as well as the high-
keyed colourism learned from his experimentation
with enamelling techniques at the turn of the century.

The Last Muster: a planned triumph

The phenomenal success of *The Last Muster: Sunday in the Royal Hospital, Chelsea* (see Colour plate XVII), which Herkomer exhibited at the Royal Academy in 1875 (and at national and international exhibitions over the following 40 years), assured him lasting fame during his lifetime. Its popular and critical triumph initially overwhelmed him, however. 'It is a rare thing to have such a fuss made over my *Pensioners*', he wrote to Mansel Lewis from Munich in 1877; 'Well, that is once – never to appear again in a painter's lifetime. It settles him.'[1]

As we have seen, Herkomer went out of his way in the years immediately following *The Last Muster* to paint subject pictures that differed markedly from this *tour de force*. 'I lost favour with the public', he told a contemporary critic several years later, 'and showed some feebleness in the new efforts, but it prevented me from being spoiled by the success of one picture.'[2] On the other hand, the narrative elements of *The Last Muster*, which invite reflection on larger issues, provided the conceptual anchor for many of his genre paintings, and in that sense he rarely strayed from the didactic sentiments of this monumental and celebrated work.

Herkomer based the composition of *The Last Muster* on his wood engraving *Sunday at Chelsea Hospital* (Figure 73). The image was a favourite of the *Graphic*'s founder W. L. Thomas, who commissioned a watercolour version (present location unknown) from Herkomer in December 1871. The subject came to the artist when he attended service in the Chelsea Hospital Chapel. 'The idea was to make every man tell some different story, to be told by his face, or by the selection of attitude', he wrote.[3] His group of old Chelsea Pensioners, their faces marked by age and hardship, included one who had answered the 'last muster'; the fingers of the Pensioner seated next to him feel for a pulse that no longer beats. Although the inmates of the Chelsea Hospital were seasoned war veterans who qualified for residence because of indigence, the artist's primary focus here is on the pathos of old age and death rather than on a specific social condition.

Herkomer completed the painting in two months: work began in January 1875[4] and the canvas is inscribed at the lower right 'March 1875'. The artist left a detailed account of how he executed the painting, planning it from the start to be a triumph.[5] This was the first time he had worked on such a large scale, and his tiny Chelsea studio, a box-like room with proportions hardly bigger than the canvas itself, made the creation of the painting more difficult.[6] Along with the basic design for the composition, which dated to his engraving of 1871, Herkomer worked from numerous sketches and studies for the figures. The earliest known study (Figure 74) dates from 1870. When Mansel Lewis visited Herkomer's Chelsea studio in 1873 to purchase *After the Toil of the Day*, he noticed that all four walls were covered with sketches of Chelsea Pensioners,[7] which gives some sense of the artist's long-term involvement with the project.

Herkomer made no preliminary cartoon but worked directly on the canvas. The two Pensioners who had posed for the principal figures in the earlier engraving were still alive and were pressed into service again.[8] Herkomer also included in the painting a portrait of his father, Lorenz (white-bearded figure, third row from the left), who had himself led a life of poverty and hardship, now costumed as a Chelsea Pensioner. In the background, lined up along the south wall of the Chapel, are several tiny figures in civilian clothes reading from prayerbooks. These have been identified as Clarence Fry (second from the left), Herkomer's first patron, who bought *The Last Muster* for £1 200 before it was exhibited; next to him, Herkomer's first wife, Anna; Mrs Sophie Fry; the artist, his contemplative pose giving him the appearance of a bearded mystic; and the Fry's small son with his nurse.[9] These personal elements lend a deeper, more personal meaning to the work.

Herkomer's depiction encompassing the west end organ loft and the south oak-panelled wall in the background is among the earliest-known interior views of the Chapel. The Royal Hospital, Chelsea, and its Chapel, designed by Christopher Wren, were completed by 1685.[10] Authentic details that were recognizable to Herkomer's contemporaries are the tattered regimental colours and standards in the background of the painting, which have long since been removed from the Chapel.

Because Herkomer wanted to create, in his words, 'a dry fresco-like appearance'[11] for his picture's surface, similar to that of *After the Toil of the Day*, he used an unprepared linen canvas, treated only with sizing rather than the more usual paint-based undercoating. The resulting surface proved extremely

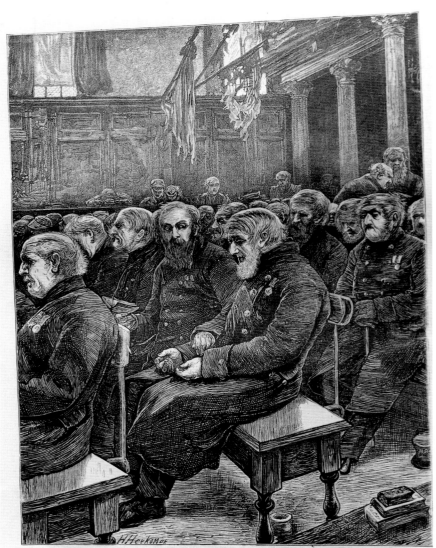

SUNDAY AT CHELSEA HOSPITAL

73

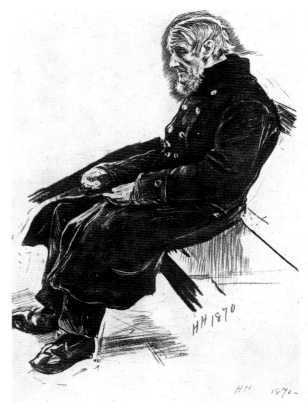

74

73 *Sunday at Chelsea Hospital. The Graphic*, 18 February 1871, p. 152

74 *Study of a Chelsea Pensioner*, 1870, pencil, charcoal and bodycolour on paper

75 *'The Last Muster': Sunday at the Royal Hospital, Chelsea. The Graphic*, 15 May 1875, pp. 474–475

fragile, and it has required periodical repair work ever since – another example of Herkomer's experimenting gone awry.

In his study of the artist published in 1882, Comyns Carr early recognized Herkomer's proclivity for technical experimentation and aligned it with the visual audacity of his art:

He loves to test new processes, to make trial of unaccustomed modes of expression, and these constantly renewed researches into the technical problems of art, of necessity react upon the intellectual impulse under which he labours, tending to give a changing and unsettling character to much of the work he produces.[12]

To work out the perspective in the painting, Herkomer used a camera obscura, tracing onto glass the lines of the Chapel floor after sighting through a pinhole, though he guessed at the distances between the figures.[13] His habitually 'off' structure – in this case the sharp angles of the background architecture and foreground black-and-white marble squares – amplifies the discovery of the death in the foreground and its impact on the assembled figures.

Although W. L. Thomas and others discouraged Herkomer from turning his Pensioner subject into a large-scale exhibition picture (Thomas reasoned that the red colour of the uniforms worn by the hospital inmates would overwhelm the work),[14] the artist, in a switch from his former acquiescence to the advice of his friends, ignored their suggestions and pursued his new project. 'I must mention', he wrote in a smug aside in his memoirs, 'that all those friends who tried to dissuade me from painting that subject in oils were most ready to acknowledge their mistake.'[15]

Even prior to its exhibition, *The Last Muster* was an assured success. The Royal Academy Hanging Committee responsible for selecting pictures for the big summer exhibition applauded when the painting was brought before them, and individual Academy members wrote personal notes of praise to the 26-year-old artist.[16]

The press reiterated the enthusiasm of the Academicians. 'The picture which in many if not all, respects, deserves to be called the most remarkable work of this exhibition [is] Mr. Herkomer's *Last Muster* on the chapel benches of Chelsea Hospital', was *The Times*'s opinion:

He has sent good work to the Academy before this, but nothing that gave promise of such an achievement as we have to acknowledge in this picture. The assemblage of various heads, all old and worn with hardship, but differing in every other particular, is presented with a power of painting, and a grasp of character as rare as they are admirable. In these respects there is little if anything here exhibited which comes near it.[17]

'The artist has at once lifted himself into fame and

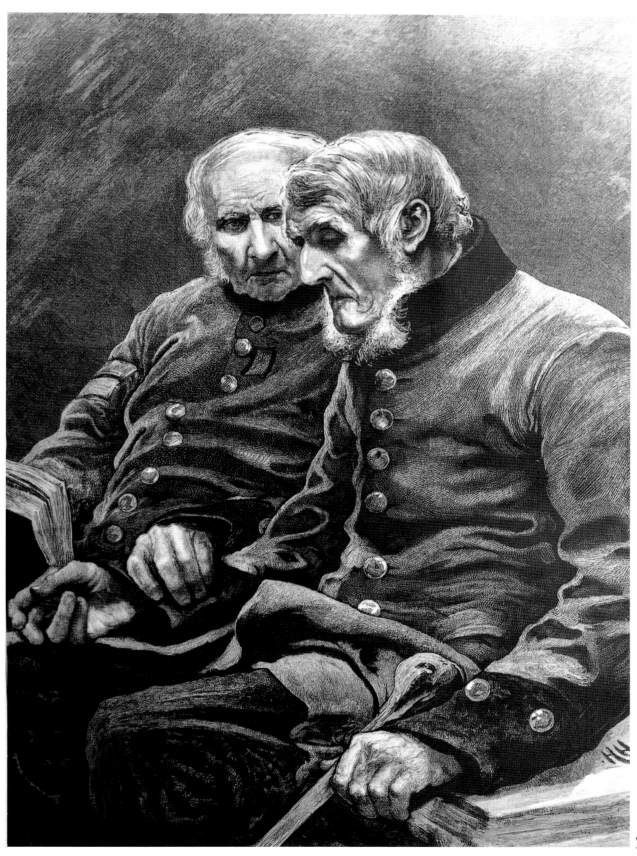

75

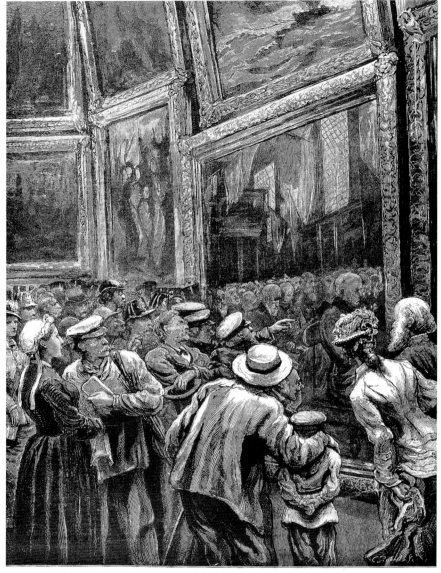

THE PARIS EXHIBITION—A SKETCH IN THE ENGLISH FINE ART COURT

76 *The Paris Exhibition – A Sketch in the English Fine Art Court. The Graphic*, 29 June 1878, p. 618

row of hands, then a row of legs, and finally a row of boots. It had no beginning and no end; it was a section of the chapel congregation cut out.[20]

When *The Last Muster* was shown in the English section of the Paris Universal Exhibition of 1878, it received one of the two medals of honour (the other went to John Everett Millais), instantly bringing international stature to the young artist. As Herkomer later recalled in his memoirs, 'My name stood at the top of the list; and standing with Millais, I gained an immediate position in the eyes of the world, which, under ordinary circumstances, would have taken years to obtain.'[21] The *Graphic* magazine, which had set the course of Herkomer's career, published in its issue 26 October 1878 (on page 412) a portrait of their young contributor and a brief biography in celebration of his Continental success. So great was the crush of visitors to the Paris Exhibition's English Fine Art Court to see the painting that the magazine also illustrated the crowds gathered around to view it (Figure 76).[22]

As I noted earlier, Herkomer considered *The Last Muster* to be the painting that ended his dependence on Frederick Walker.[23] The time-consuming technique he so admired in Walker's art was no longer feasible within the time span he had set for himself to complete the picture. While the objective realism and life-size figures of Herkomer's painting reflect a stylistic departure from Walker, the choice of subject matter *does* suggest a connection, for depictions of sad and bent old people were frequently painted by Walker and the Idyllists. George Pinwell's watercolour *A Seat in St. James's Park, London* (1869; Art Gallery of New South Wales) based on his illustration published in *Once a Week* in the autumn of 1869,[24] which depicts among its figures an old man seated on a park bench, may have inspired Herkomer's dead Pensioner, whose demeanour and pose bear a striking resemblance to the old man in Pinwell's drawing. Herkomer, particularly at the outset of his career, made obvious references to Pinwell's work.

Other imagery that is more closely related to Herkomer's Pensioner subject and that, in a sense, set the stage for the acceptance of its monumental realism, are the scenes of peasant piety by Alphonse Legros. When *The Last Muster* was exhibited at the Paris Universal Exhibition in 1878, the critic Edmond Duranty remarked that the picture suggested the influence of Legros,[25] though Legros's imagery eschews the narrative sentiment that gives Herkomer's painting its emotional pitch.

The Last Muster works on several levels. As an image of old age and death, it is a modern *vanitas*, an emblem of the transience of the material world. As a patriotic image of old soldiers, it shares an affinity with military painting. And with its oblique reference to urban poverty, it sets the tone for a number of the

fortune', commented another critic.[18] Honouring all the attention granted to one of their foremost illustrators, the *Graphic* published a double-page wood engraving (Figure 75) which reproduced a detail of the dead protagonist and his anxious seat-mate.

The one dissenting voice amid all the praise was that of the foremost art critic of the day, John Ruskin. While he found the 'group of grand old soldiers a most notable, true, and pathetic study', he also felt that it was 'scarcely artistic enough to be reckoned as of much more value than a good illustrative woodcut'.[19] Of course the painting originated as an illustration, but Ruskin's comment indicates how far those artists nurtured on black-and-white illustration had departed from traditional ideas of what a work of art should be. Ruskin's criticism, which Herkomer respected, is echoed in the artist's description of the work:

The upper half of the picture was all architecture, the middle half a dense row of heads, after which followed a

artist's subsequent social themes, such as *Eventide* (see Colour plate XV) and *Hard Times: 1885* (see Figure 85).

Herkomer's sympathy for the trials of old age resulted from his constant companionship of, and need to support, his own toil-worn parents. Interestingly, the central motif of *The Last Muster*, that of the death scene in the foreground, often went unremarked upon at the time.[26] Images of death were not uncommon in Victorian pictures but, with remarkably few exceptions, such as *The Last Muster*, the focus generally centred on the tortured emotions of those left behind. The Victorian obsession with death resulted in part from the appalling mortality rates, which made death a constant presence, particularly in overcrowded cities, where sanitation was minimal and air and water dangerously polluted. At a time when religious faith was becoming eroded in the face of new scientific discoveries, a sense of spiritual loss became pervasive. As doubts about immortality and faith increased, even Queen Victoria succumbed. ' "She asked me," once reported the Dean of Windsor, "if there ever came over me (as over her) waves or flashes of doubtfulness whether, after all, it might all be untrue".'[27]

Public display of grief was one emotion the Victorians felt comfortable with. Even the demise of popular characters in serialized fiction, such as the death of Little Nell in Dickens's *Old Curiosity Shop* (1841), was an occasion for extraordinary public response. The elaborate funeral rites and mourning customs of the Victorian era, as well as sentimental consolation literature – mourning manuals, obituary poems and treatises on life in heaven – provided those left behind with further solace. Even at the end of the nineteenth century, when the garish funerals of the urban classes were less *de rigueur*, in George Gissing's *In the Year of Jubilee* (1895), Mr Lord's request for a simple, unostentatious burial was put down to 'the old man's excessive meanness' by the *nouveau riche* Fanny French.[28]

The deathbed scene, so common in the Victorian novel (that of Mary's father in Gaskell's *Mary Barton* [1848]; that of Helen Burns in Charlotte Brontë's *Jane Eyre* [1847]), is echoed in Herkomer's illustration for the lines 'Here is a ducat. I have no more; all the rest is for my burial' (Figure 77) in a story entitled 'The Last Master of an Old Manor House', published in the *Cornhill Magazine* in 1872. The pathos of this scene stands in marked contrast to the subtle emotion of *The Last Muster*.

Herkomer's reserved variation on the Victorian obsession with death tapped another favourite sentiment – that of patriotism. 'There is hardly another subject that so appeals to English hearts', wrote the artist in 1875, '– men who have fought for their country, and have come to their last home preparing for their last journey.'[29] That *The Last Muster* was generally interpreted as a military subject by the picture's contemporary viewers is revealed in the

"HERE IS A DUCAT. I HAVE NO MORE: ALL THE REST IS FOR MY BURIAL."

notices that appeared after its exhibition. The incident of the death itself was rarely mentioned except in military terms.[30] When the *Graphic* wrote of the popularity of the painting at the Paris Universal Exhibition in 1878, it noted that 'The military taste of the French is proverbial, and that this picture, so essentially military in its tone, should be a general favourite, is hardly to be wondered at.'[31] On the other hand, Charles Pascoe, in the American edition of the *Art Journal*, connected the social circumstances of the old men to their soldiering. While noting that 'The crimson and blue ribbons of the war-worn veterans tell of the allotted threescore years that have passed since the hard days of the Peninsular War', he added that 'Their wrinkled faces and grizzly white beards speak of their ... fourscore years of labor and sorrow.'[32]

A major antecedent for portraying Chelsea Pensioners as heroic symbols is David Wilkie's celebrated painting *Chelsea Pensioners Reading the Gazette of the Battle of Waterloo* (1822; Apsley House, London), which, when it was exhibited at the Royal Academy in 1822, had to be protected by a railing from the crowds pressing to see it.[33] Other related works include the many battle images that proliferated after 1870 to commemorate in heroic style the almost yearly colonial campaigns. Lady Elizabeth Butler's battle paintings honoured past wars. The year before *The Last Muster*'s exhibition, her painting *Calling the Roll after an Engagement at Crimea* (*The Roll Call*) (1874; The Royal Collection) was the sensation of the Academy and, like Wilkie's *Chelsea Pensioners*, Lady Butler's painting had to be guarded from the eager crowds. Its image of a battle-weary soldier pitched over in the snow no longer able to answer the roll or 'muster', and of his comrades' bereavement, was praised for its lack of sensationalism and its quiet reserve.[34] Not until Herkomer fully conceived his painting in 1875 did he give it the quasi-military title

77 *Here is a ducat. I have no more: all the rest is for my burial.* Illustration for a story entitled 'The Last Master of an Old Manor House'. *The Cornhill Magazine*, October 1872, p. 475

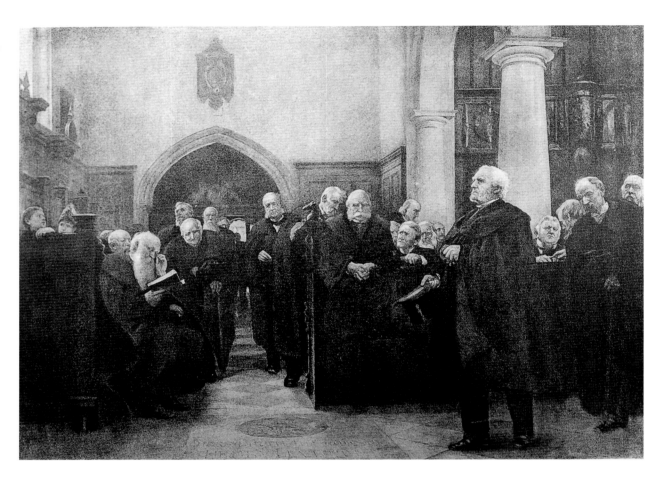

The Last Muster, probably in direct response to the accolades bestowed on Lady Butler's similarly entitled *The Roll Call* in 1874.

While the narrative component of *The Last Muster* makes it at once a sympathetic image of impoverished elderly men in a charitable institution, a symbol of patriotism and an icon of death, it was to the latter reading that Herkomer's own colleagues responded. Following *The Last Muster*'s highly publicized reception in 1875, the subject of death was the focus of an unprecedented number of works in the Royal Academy exhibition of 1876. The resulting onslaught of pictorial morbidity was greeted with exasperation. Herkomer's own entry in the 1876 Academy exhibition, *At Death's Door* (see Colour plate IX), a variation on the lugubrious strain so popular that year, treated the subject in the more usual manner, focusing on the response of the bereaved. Annoyed by the 'gloomy choice of subjects' that had become so common, one writer noted that Herkomer had 'a dangerous tendency to the morbid if not the painful, which his rare ability makes it the more important he should resist'.[35]

Several of Herkomer's later works express sentiments similar to those in *The Last Muster* and, as late as 1909, he made a lithographed version of the painting, lithography being the last of his many experiments in the graphic arts (see Chapter 11, below). *The Chapel of the Charterhouse* (Figure 78) was exhibited at the Royal

Academy in 1889. Its genesis came about, as Herkomer remarked in his memoirs, because 'I was beset by an uneasy feeling as to whether I had been sufficiently loyal to my imaginative art since I had taken up portraiture', an uneasiness exacerbated by his sense that both his colleagues and the public saw his focus on portrait painting solely as a means for him to amass a fortune.[36] His apparently endless portrait commissions certainly left him little time to paint the themes with which he had established his career and his numerous public activities (see Figure 79) – lecture demonstrations, original productions at his theatre in Bushey, the Herkomer Art School and so on – were sometimes subjected to derision in the press:

His average year's work would rank fairly high if he would now and then deprive the public of opportunities for seeing pictures which are demonstratively crude and unfinished ... While three [portraits] would adequately advertise his skill, which after all is not that of Titian, Van Dyck and Hals, still less of Rembrandt, at whose laurels the energetic Associate seems to be aiming, while with voice, etching needle, pen and paint brush he poses as the apostle of fine art, and puts himself in evidence without a stint.[37]

With *The Chapel of the Charterhouse*, Herkomer deliberately chose a subject that looked back to the formula of *The Last Muster*. It took two years, with many interruptions, to complete. Although the artist thought of his painting as a successor to his earlier Pensioner subject, as did most of its viewers, there was a decided difference. Now at the height of his fame as a

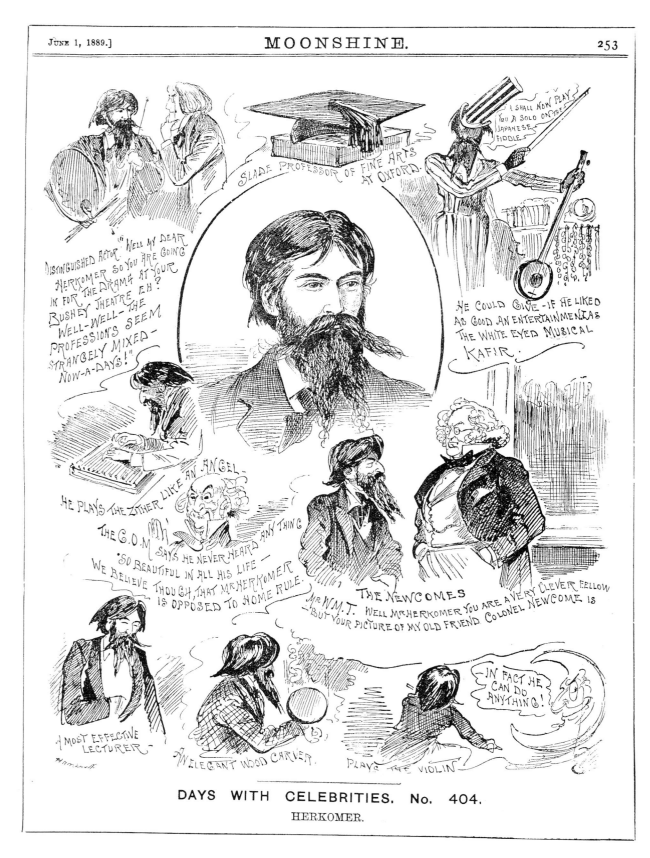

79 A. Bryan, 'Days with Celebrities: Herkomer', *Moonshine*, 1 June 1889, p. 253. A caricature showing the diversity of Herkomer's many activities

society portrait painter, Herkomer chose the models for the figures in his painting from among his accomplished and notable friends and acquaintances, including the great English statesman William Gladstone.[38]

The artist's father, Lorenz (the white-bearded figure in the left foreground), who died in 1888 just prior to the painting's completion; the artist's third wife, Margaret Griffiths, whom he married in Landsberg in 1888; and his eldest son, Siegfried, aged 14, are also recognizable figures in the painting. Such personal ingredients, often introduced by Herkomer into his

subject pictures, transcend the immediate theme to signify a private *memento mori*, in this case, the commemoration of the death of his beloved father, and also the celebration of his newfound domestic happiness, which helped him to complete the painting after several false starts.[39]

The artist's rough sketch for the painting (see Colour plate XIV) denotes the placement of the figures and the simple grandeur of the Charterhouse Chapel interior; the more static exhibited version underscores his insecurity in attempting to duplicate a much earlier success. Despite this, *The Chapel of the Charterhouse* was purchased for the nation under the Chantrey Bequest, though as we have seen the press derided the choice and mocked the artist for having too many other 'dramatico-musico-artistic eccentricities' on his plate.[40]

At the end of the nineteenth century, when Herkomer's reputation as one of the great portrait painters of his generation had been established, the French writer Robert de la Sizeranne analysed *The Charterhouse* as a group portrait.[41] That Herkomer thought of his much earlier painting *The Last Muster* in similar vein is made clear in his memoirs. 'I have at last come to acknowledge, though reluctantly, that portraiture is my true *métier*. So far back as 1875, when, as a young man of twenty-five, I painted the Chelsea Pensioners, I certainly touched this, my real bent.[42] Comyns Carr, in his 1882 essay, also assessed *The Last Muster* mainly in terms of portraiture.[43] Indeed, Carr's perception of it may have encouraged Herkomer to turn to portraiture as the dominant focus of his art in the 1880s.

From the indigent Chelsea Pensioners who had served their nation in war to the Charterhouse gentlemen modelled on important leaders, *The Last Muster* and *The Chapel of the Charterhouse* mirror Herkomer's own altered status – from an impoverished immigrant artist to a portrait painter who in his newfound wealth had much in common with the important sitters who flocked to his studio.

Herkomer made a final attempt to repeat the success of his much earlier masterpiece *The Last Muster* with *The Guards' Cheer* (Figure 80); it commemorates a scene the artist had witnessed during the celebration in London of Queen Victoria's Diamond Jubilee in 1897. The artist, who was friendly with members of the British royal family, may have thought that creating a companion piece to his most famous work for the Queen's Jubilee would further enhance his standing with them as well as with his colleagues at the Royal Academy who, at that time, were questioning his citizenship and national loyalty.[44] A draped Union Jack and cheering veterans in the painting emphasize the patriotic sentiment. At a time when Herkomer's reputation in Germany was also at a high point, an engraving of the picture, which was displayed in a Berlin gallery in 1898, was ordered removed, its nationalist imagery having aroused anti-British reactions.[45]

The Guards' Cheer was warmly received, though the critics responded more to its sentiments than to its technical merits. Herkomer's moralism and unabashed sentiment seem old-fashioned in comparison with other British art at the turn of the century, though there was still a good deal being produced in that vein. Marion Spielmann, the editor of the *Magazine of Art* and the artist's good friend, put the painting 'in second place in the sum of the artist's achievements – that is to say, immediately after his masterpiece, *The Last Muster*',[46] while the *Athenaeum*, generally sour about Herkomer's late work, found it 'a leading picture of the year', though it criticized his habitual shortcoming in Victorian eyes – 'the queer perspective'.[47]

Although Herkomer acknowledged that *The Guards' Cheer* was meant as a companion to *The Last Muster*, he regarded the later painting in a significantly different light. 'It is a national, historical and patriotic subject', he wrote. 'The very heart of that great day was touched in those soldiers of the past, for it was essentially a military display.'[48] By now, Herkomer had begun to regard both his subject pictures and his portraiture – the latter now the predominant focus of his career – as documents of modern history that recorded the spirit of his own age for the enlightenment of future generations. Such work would reach its apotheosis in the huge group portraits (see, for example, Figure 110) which he painted as memorials, both to his art and to his era, at the close of his career.

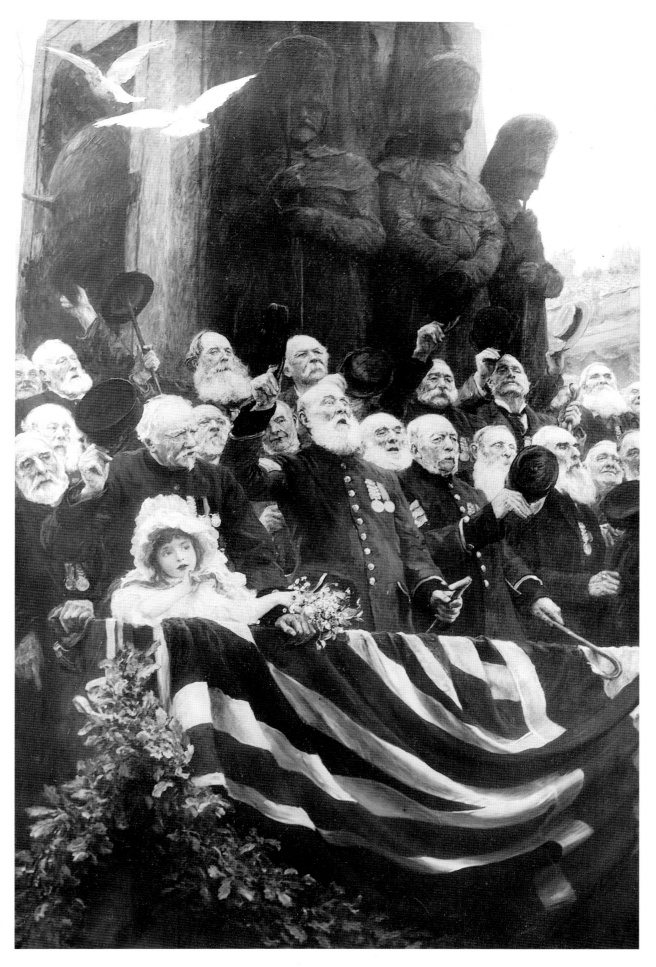

80 *The Guards' Cheer*,
1898, oil on canvas

Herkomer's social realism

81 *Old Age: A Study in the Westminster Union*, wood engraving. *The Graphic*, 7 April 1877, pp. 324–325

82 *Low Lodging House, St. Giles. The Graphic*, 10 August 1872, p. 124

'The World hates to be reminded of the sorrowful side of humanity.'

Herkomer's social subject pictures were inspired, according to his memoirs, by his response 'towards the pathetic side of life, towards sympathy for the old and for suffering mankind'.[1] That such humanitarian impulses were encouraged by W. L. Thomas, the founder of the *Graphic* magazine, was an added incentive for Herkomer to seek out subjects that touched on social problems. When some of the *Graphic*'s social themes were translated into exhibition pictures their potent veracity resulted in a hard pill for critics and prospective patrons to swallow.

While the subject of urban poverty is only tangential to the principal themes of old age, death and patriotism in *The Last Muster*, it is a central concern in *Eventide: A Scene in Westminster Union* (see Colour plate XV). A group of old women (some are seated, sewing at a table, while others shuffle about in the gloomy interior) are portrayed in the day room of the St James's workhouse on Poland Street in Soho, which was administered by the Westminster Poor Law Union. As with *The Last Muster*, the artist witnessed the scene while roaming around London in search of a subject.[2] The exhibited painting was based on his double-page wood engraving *Old Age – A Study in the Westminster Union* (Figure 81), after it appeared in the *Graphic*. An on-the-spot oil study (1876; private collection) for the engraving survives, as does a watercolour version (1877; Walker Art Gallery) of the exhibited picture.

Eventide was regarded as a 'female' companion to *The Last Muster*, in part because it depicts old women in a charitable institution and in part because of its intimations of mortality. That the artist's response to the plight of the women he observed in the workhouse issued from deeply felt sympathy was corroborated by J. W. Comyns Carr, who quoted from the artist's statement about the genesis of *Eventide*:

I was struck by the scene in Nature. I felt that every one of these old crones had fought hard battles in their lives – harder battles by far than those old warriors I painted – for they had to fight single-handed and not in the battalions as the men did.

Upset that *Eventide* was less popular with the public than his earlier Pensioner subject, Herkomer concluded that 'the world hates to be reminded of the sorrowful side of humanity'.[3]

The day room of the workhouse depicted by Herkomer in the painting is typical of the dreary, jail-like interiors of such establishments. Indeed the punitive nature of the English workhouse, and the attitudes towards the poor that such incarceration implied, were the subject of scathing commentary by the French social historian Hippolyte Taine who, on a tour of England in 1873, wrote: 'The doctor put me into the hands of a clergyman who was one of his friends ... [He] took me to St. Luke's Workhouse. Everybody knows that a workhouse is an asylum a little like a prison.'[4]

The workhouse was depicted as a dreaded place of last resort in such novels as Charles Dickens's *Oliver Twist* (1838), Frances Trollope's *Jessie Phillips* (1844) and George Moore's *Esther Waters* (1894). Jack London's account in *The People of the Abyss* (1902) of a night spent in the Whitechapel workhouse casual ward is a portrayal of human degradation and maltreatment that echoes the documentary account in James Greenwood's *A Night in a Workhouse*, published 40 years earlier. Henry James's working-class hero Hyacinthe Vivier in *The Princess Casamassima* (1886) employs the universal fear of the workhouse as an instrument for social change:

He amused himself with an inquiry if she were satisfied with the condition of society and thought that nothing ought to be done for people who at the end of a lifetime of starvation-wages had only the reward of the hideous workhouse and a pauper's grave.[5]

Herkomer had portrayed indigent women in grim institutional settings in two earlier *Graphic* engravings – *Low Lodging House, St. Giles* (Figure 82) and *Christmas in a Workhouse* (Figure 83). In the latter, a plaque on a background wall reads 'God Bless our Master and Matron', a motto perhaps intended by the artist to be read ironically or, conversely, to emphasize the notion of charity and 'good works' so soothing to those Victorians largely isolated from the ghetto-like horror of London's slums.

While scenes of life in the workhouse are rare in Victorian painting, Herkomer was obviously indebted to such precedents as Frederick Walker's *The Harbour of Refuge* (1872; Tate Gallery), set in the almshouse at Bray, and Luke Fildes's *Applicants for Admission to a Casual Ward* (1874; Royal Holloway College), which shows a line of poor people applying for tickets to the temporary shelter attached to a workhouse. Indeed,

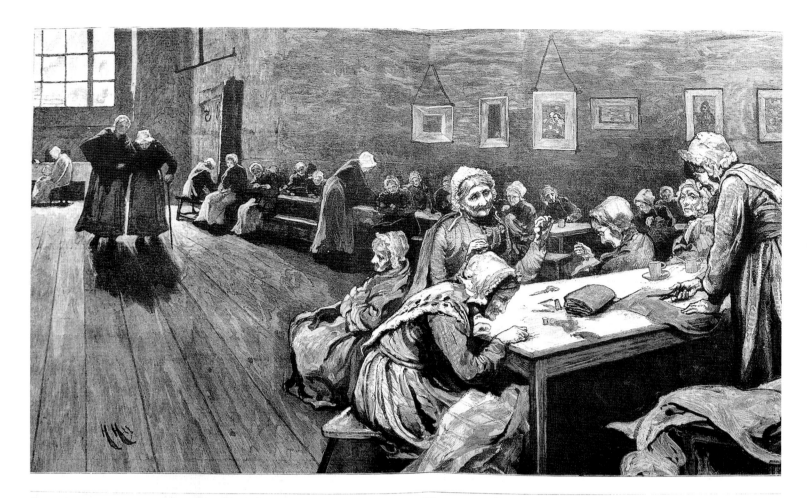

OLD AGE—A STUDY AT THE WESTMINSTER UNION
BY HUBERT HERKOMER

81

Herkomer acknowledged his close friendship with Fildes by including in the background of *Eventide* a reproduction of *Betty*, a painting (now in the Forbes Magazine Collection) by Fildes of a milkmaid, whose beauty and girlish vigour contrast with the bent and wizened aspect of the workhouse inmates. The other recognizable 'picture within a picture' on the walls of *Eventide* is the reduced version of *The Last Muster* (see Figure 75).

Herkomer's broad handling of paint, already noticeable in *The Last Muster* where it was necessitated in part by his haste to complete that work, is even more obvious in *Eventide*. The dark flat forms of two figures that seem to be shuffling forward, their heads outlined by an eerie light sifting into the room from the window above them, cast long, symbol-laden shadows. In the immediate foreground, more clearly defined figures loom into the viewer's space, while the plunging perspective accentuates their disquieting proximity and the larger message of the old women's deprivation and loneliness.

Spatial distortions were a pronounced ingredient in Herkomer's art from the time of his earliest *Graphic* engravings, though he attempted to soften them somewhat in his exhibited pictures with mechanical aids such as a camera obscura rigged up by his father.

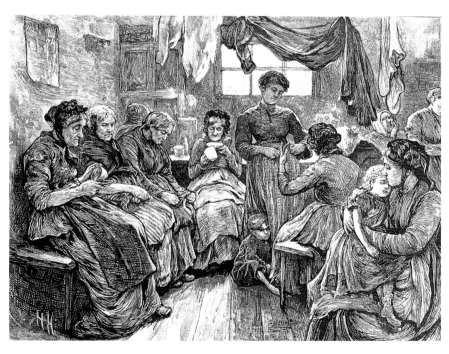

82

However, the perspective in *Eventide* is still 'off', a factor noted by critics at the time. As Comyns Carr noted in 1882, *The Last Muster* 'succeeds by the simple strength of its portraiture', whereas *Eventide* 'overpowers the elements of purely human interest by

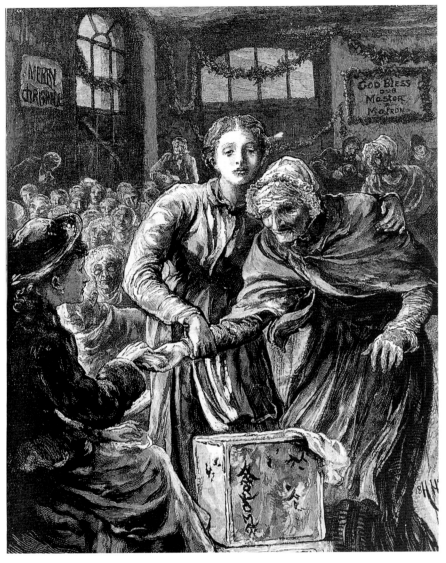

83 *Christmas in a Workhouse. The Graphic*, 25 December 1876, p. 30

laying stress upon the cheerless spaces of bare wall and the expanse of boarded floor'.[6]

Eventide was exhibited at the Royal Academy in 1878 and at the Paris Salon in 1879. While it was warmly received in Paris, its reception at the Royal Academy exhibition was less favourable, and the slum context was generally ignored. For example, Blackburn's *Academy Notes* opined that the artist had depicted 'happy and comfortable old age ... in short to give the sunny side of life in a workhouse'.[7] As to style, the *Illustrated London News* critic focused negatively on *Eventide*'s broad technique. To him, it was a manifestation of the artist's German origins, the picture's 'muscular and petulant ardour' issuing from 'that most vigorous of the athletes of the Deutsche Turnverein ... Although replete with expression, it is bold and broad, well-nigh to the verge of coarseness.'[8] However, the art reviewer for the *Athenaeum*, F. G. Stephens, was genuinely touched by the scene. Here was a subject

to reach all hearts ... a home for our fellow beings beaten in the battle of life ... Should Mr. Herkomer's beautiful work draw out more strongly our sympathies for our less

fortunate fellow beings, [it] will in its more important object have fulfilled the intentions of its author.[9]

This is not to say that Herkomer's *Eventide* was a militant drama of social protest. Yet the sometimes harsh images in which Herkomer (and to a lesser extent the more sentimental Frank Holl and Luke Fildes) represented the poor and the deprived denote an engagement that, while not necessarily making an overt statement for political and social change, does encourage a viewer's sympathies. Just the fact that Herkomer had, with *Eventide*, painted a subject that was so alien to the experience of the normal viewing public invited either public compassion or censure. As with Courbet's and Millet's earlier paintings, heroic depictions of society's anonymous victims could be counted upon to draw a response that, in the end, was often more revealing of the viewer's political and social sensibility than of the artist's.

The dangers of the sea and the fate of dependent relatives after a seafaring accident were subjects that strongly appealed to Victorian sensibilities, and Herkomer's *Missing – A Scene at the Portsmouth Dockyard Gates* (see Figure 84) had its antecedents in such pictures as Frank Holl's poignant *No Tidings from the Sea* (1871; The Royal Collection). Certainly the emotional thrust of Herkomer's painting was more palatable to Victorian middle-class taste than the artist's earlier images of oppressed workhouse women and primitive Bavarian peasants. *Missing* was commissioned by Mansel Lewis in 1880,[10] and it was favourably received at the Royal Academy when it was exhibited the following year. Herkomer informed Mansel Lewis on at least two occasions that he considered it among his greatest works.[11]

In 1895, in a curious change of heart that suggests his angst about the evolution of modern art and his place in it, Herkomer begged the painting's owner to return the picture to him in exchange for *Our Village* (see Figure 123), his old-fashioned Walker-inspired scene of English country life exhibited at the Royal Academy in 1890.[12] Mansel Lewis complied with the artist's wishes, and *Missing*, an intriguing synthesis of Victorian sentiment and progressive style, was returned to Bushey, where the artist destroyed it.[13] A watercolour copy (Figure 84) has survived, though it is much smaller than the original, which was eight feet high, matching the monumental Welsh landscapes Herkomer painted in Lewis's company in the early 1880s. Herman G. Herkomer (1862–1935) (see Appendix 2), the artist's cousin and a talented painter in his own right, and who was staying in Bushey in 1882,[14] made the copy of *Missing*. It was supposed to be sent to the *Graphic* for publication but it was not reproduced.

Herkomer's next important treatment of a social

theme, *Hard Times: 1885* (Figure 85), was suggested by a group he saw resting at the roadside in Coldharbour Lane (his students thereafter called it 'Hard Times Lane') near his Bushey home.[15] The economic depression that began in 1873 worsened during the 1880s and hundreds of workers 'on-the-tramp' for the all too few available jobs were a common sight.

Although Herkomer did not begin to paint *Hard Times* until January 1885, the subject seems to have percolated in his mind as early as March 1884, when he saw a work in progress with a 'tramp' theme by a student at his school in Bushey.[16] Herkomer told the student – a young Welsh woman named Mary Godsal who kept a voluminous diary of her experiences at the Art School[17] – to keep working on her picture and 'to get real tramps and pose them under a hedge, and a sick child, and put them in several positions'.[18] In addition, Miss Godsal seems to have been the first to use Annie Quarry, described as 'a very pretty woman', as a model.[19] It was the Quarry family of Merry Hill Lane, Bushey, that Herkomer portrayed in *Hard Times*. James Quarry, who posed as the out-of-work navvy, was himself a fully employed labourer. His wife, Annie, posed with their two sons, Frederick George (b. 1884), the infant at her breast in the picture, and James Joseph (b. 1870), who leans against her knee.[20] Thus Herkomer's scene of roadside destitution, described so graphically in his memoirs,[21] was actually contrived, and possibly initially inspired by a student's groping example.

In contrast to the background, which was painted from nature, the figures were posed and painted indoors, in 'the angle room' of the Herkomer Art School.[22] They are finely detailed, in contrast to the broad brushstrokes that describe the sweeping road and large expanse of sky and to the thick encrustations of paint that build up the folds and furrows of the woman's black dress. In order to depict the background accurately, the artist worked in a glassed-in hut built for him in Coldharbour Lane, where he captured on canvas the natural effects of light and the low, cheerless tones of the wintry landscape. The red roofs of the Atkin's farm buildings, now torn down, appear in the distance.[23]

Hard Times was the first of several rural images painted by Herkomer in the 1880s and 1890s that reflect his rekindled interest in the art of Frederick Walker. With the large-scale realism of paintings such as *The Last Muster* and *Eventide*, Herkomer felt he was emancipated, at least stylistically, from his youthful dependence on Walker. But now, after a period of painting scenes of Bavarian peasant life and social subjects such as *Pressing to the West* (see Figure 113) that seem more closely related to the work of his German contemporaries, Herkomer again refocused on the thematic sources of his subject pictures.

Although Walker had died at the age of 35 in 1875, his influence was still very much felt in England. In

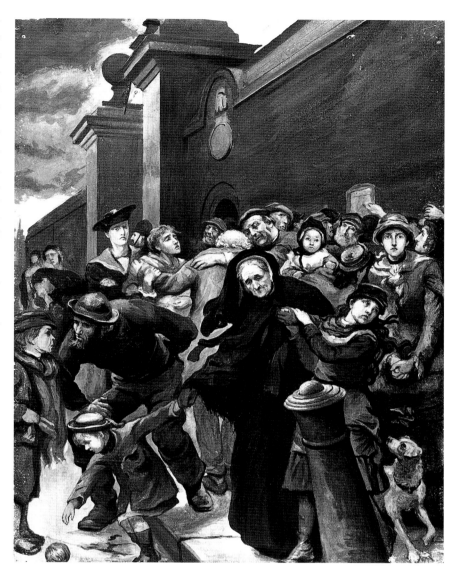

1884, Herkomer placed on view in the picture gallery at the Herkomer Art School Walker's watercolour *Philip in Church* (1863; Tate Gallery)[24] so that the students could see for themselves the art their master held in such high esteem;[25] and in 1885 his etchings after *Philip in Church* and another work by Walker, *The Old Gate*, were shown along with *Hard Times* at the Royal Academy. A major exhibition of Walker's work at the Dunthorne Gallery that same year also broadcast the appeal of his art on a national scale.

The description of the husband in Herkomer's painting as 'an Apollo or Hermes incarnated in the shape of an English "out of work" ',[26] recalls a similar assessment of Walker's heroic figures (Ruskin called them 'galvanised Elgin'). Perceiving the worker in symbolic terms – as a strong individual who, in a sense, embodied the values of a pre-industrial past – brings to mind earlier depictions of this type: for instance, the shirtsleeved navvies in Ford Madox Brown's *Work* (1857; Manchester City Art Galleries), in George Elgar Hicks's *The Sinews of Old England* (1857; private collection) and in George H. Boughton's *The Miners* (1878; Walker Art Gallery, Liverpool). A

84 Herman G. Herkomer, copy of Hubert Herkomer's *Missing: A Scene at the Portsmouth Dockyard Gates*, 1881, watercolour. Herkomer destroyed the original painting (oil on canvas, formerly in a private collection, Wales) in 1895

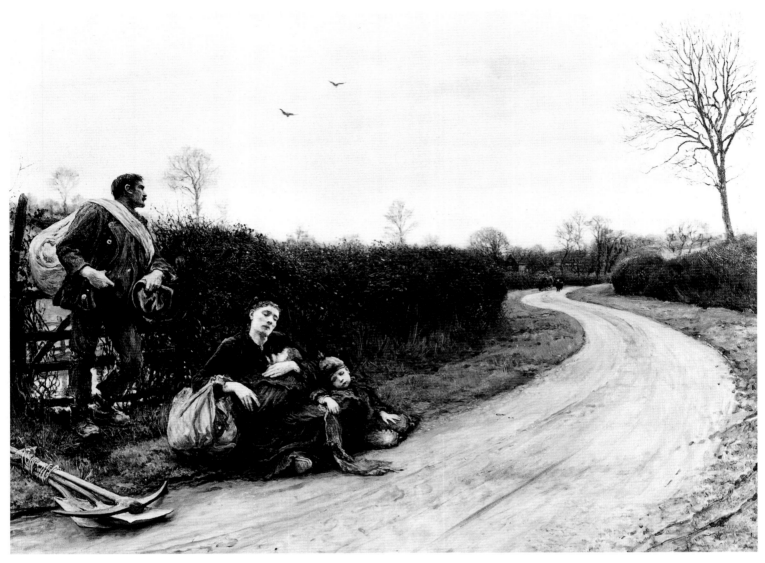

85 *Hard Times: 1885*, 1885, oil on canvas

similar ideology prevailed in heroic depictions of workers on the Continent, for example in Adolph von Menzel's *The Ironworks* (1876; Staatliche Museen, Berlin), Jean-François Raffaelli's *At the Foundry* (1886; Musée de Lyons), and Jules Dalou's *Monument to Labour* (1889–1891; Petit Palais, Paris). While the motives behind such dignified portrayals of the worker were doubtless well-intentioned, they ultimately distanced him and reduced to myth the meaning of his struggle in the real world. In *Hard Times*, the intimation of better days ahead, underscored by the idealized male figure, is further suggested by the prominent placement of his work tools, implying that his physical strength will eventually overcome adversity. Standing upright against a wooden fence, the husband in *Hard Times* looks steadily into the distance, his gesture suggesting hope for future employment at the end of the winding road pictured before him.

When *Hard Times* was exhibited at the Royal Academy in 1885, it was universally viewed as reformist – the more conservative condemning its

'modern sociology' and 'mawkish sentiment', the more liberal hailing it as 'a cry for humanity in these hard times'. In 1905, it was still being described as 'art on the way to make socialists of us'.[27] Frequently reproduced (a detail recently appeared on the cover of the Penguin edition of Elizabeth Gaskell's *Mary Barton*), the painting has come to symbolize the suffering and deprivation of the Victorian working class. Despite its descriptive Dickensian title, however, and its obviously sympathetic portrayal of the plight of an unemployed labourer and his family, *Hard Times* is less polemic than allegory, concerned more with hope than with destitution.

Alluding to the timeless and the heroic, the figures in *Hard Times* contrast with the tattered, grimy appearance of the displaced family seen in Joseph Farquharson's *Where Next?* (Figure 86), which was exhibited at the Royal Academy in 1883. Yet the proximity of dates and the coincidence of subject matter suggest that Herkomer must have known the picture.[28] With his very different approach to the theme, Herkomer may have been responding to Farquharson's example by showing him how he thought

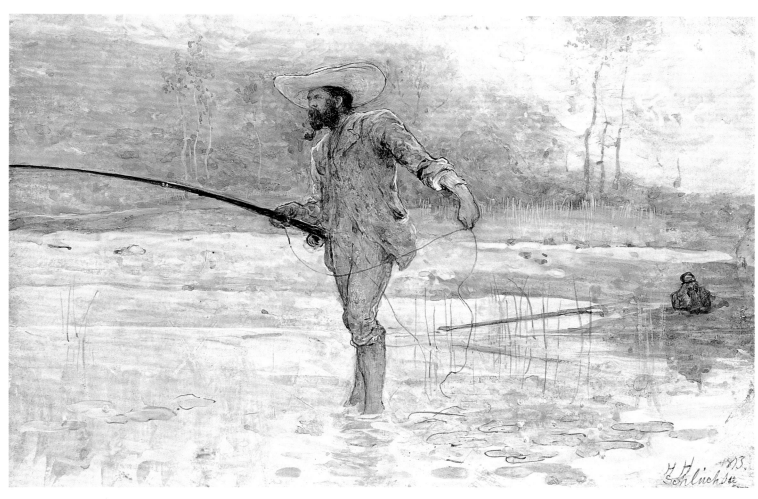

I *Fishing in the Black Forest* (*Clarence Fry Fishing*), 1873,
watercolour and bodycolour. Inscribed 'Schluch See'

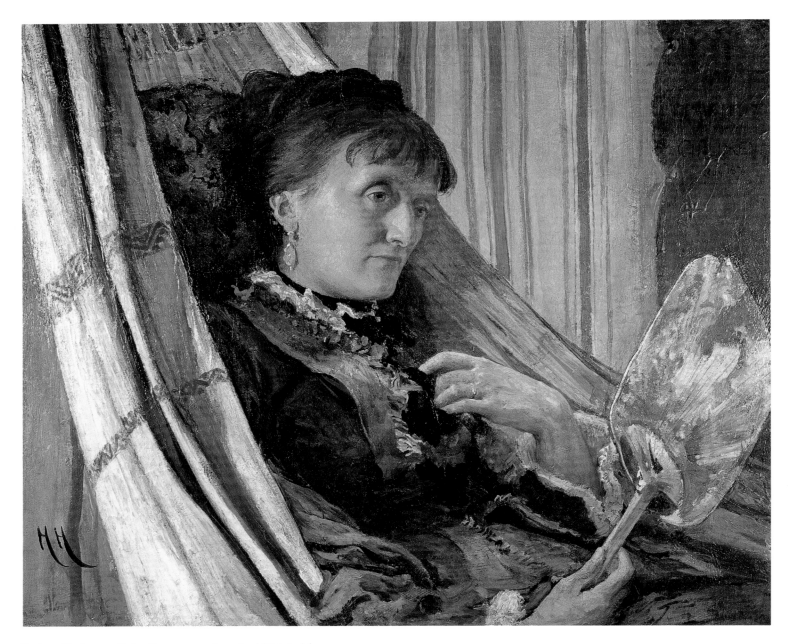

II *Anna Herkomer*, 1876, oil on canvas. Inscribed 'Painted for our dear! children! Aug. 1876'. Watford Museum. Anna was the artist's first wife

III *Lulu Herkomer*, c. 1885, oil on canvas. Lulu was the artist's second wife

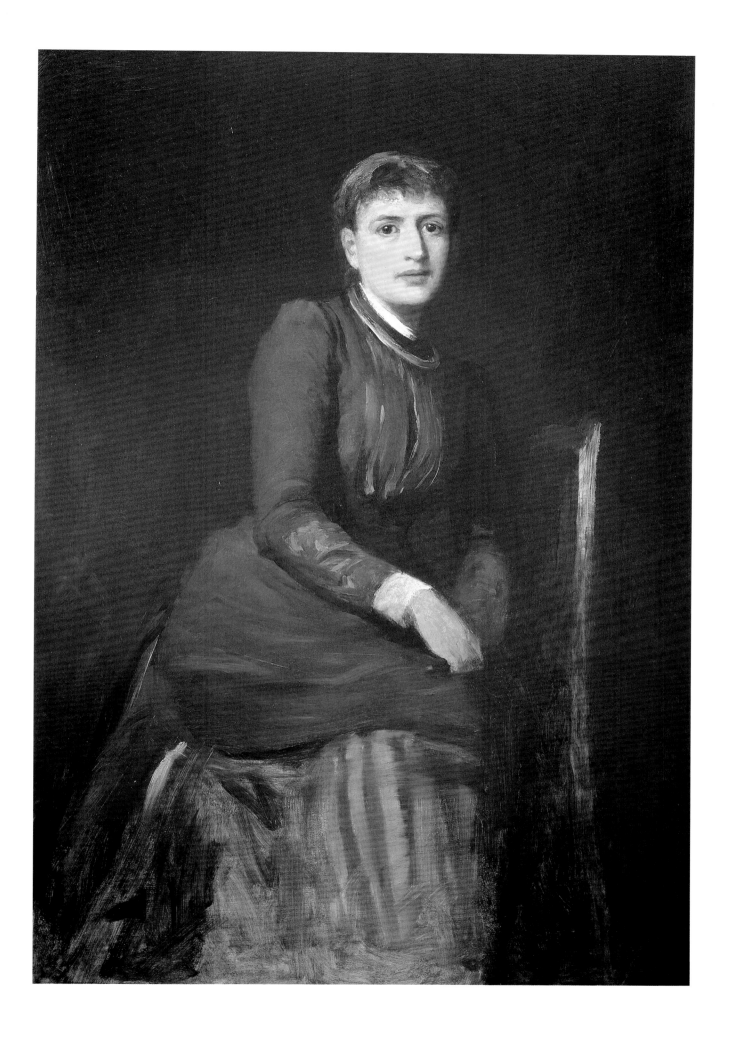

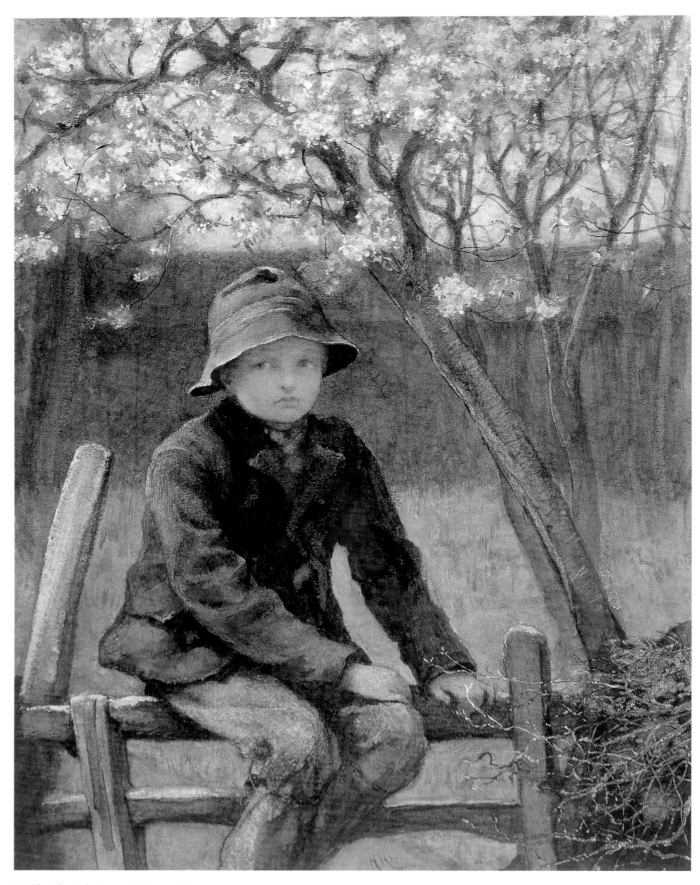

IV *The Idler* (*The Boy and the Apple Blossoms*), 1877,
watercolour

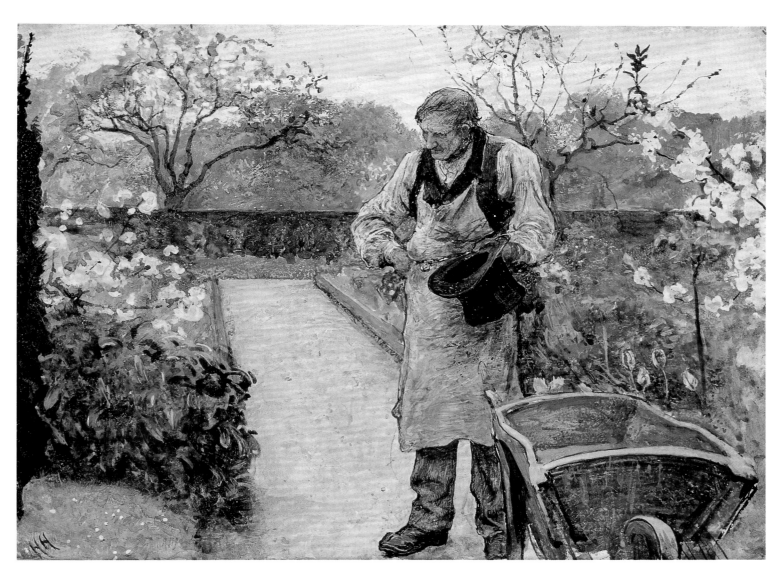

V *The Old Gardener*, 1873, watercolour

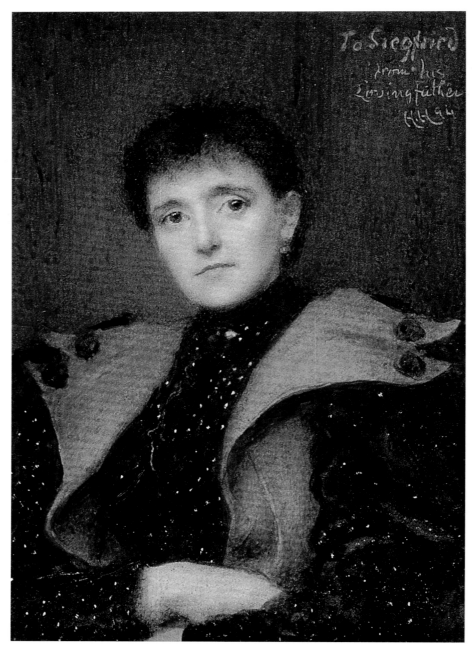

VI *Margaret Herkomer*, 1894, watercolour. Inscribed 'To Siegfried from his loving father'. Margaret was the artist's third wife

VII *The Goose Boy*, 1877, watercolour

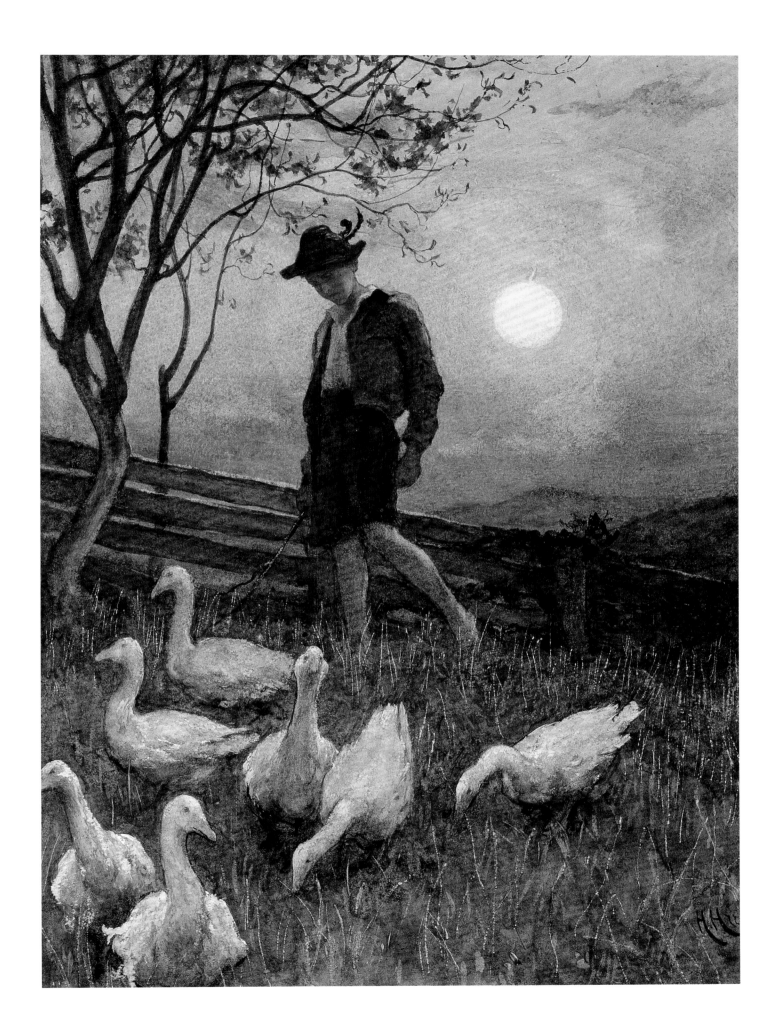

VIII *After the Toil of the Day*, 1873, oil on canvas

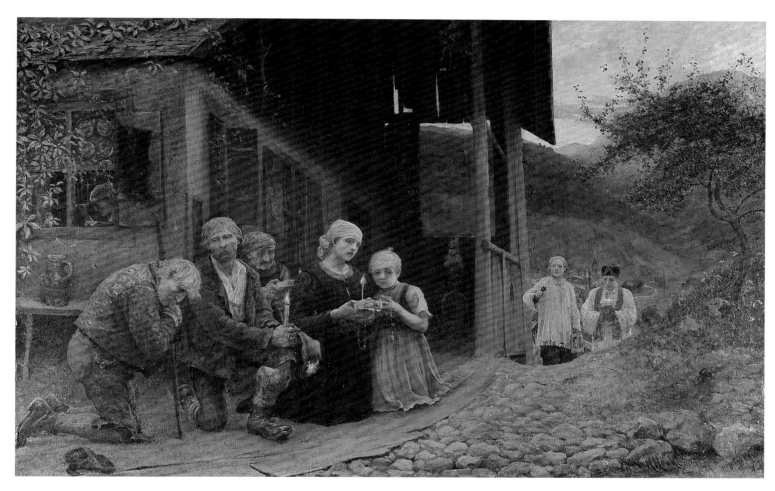

IX *At Death's Door*, 1876, oil on canvas

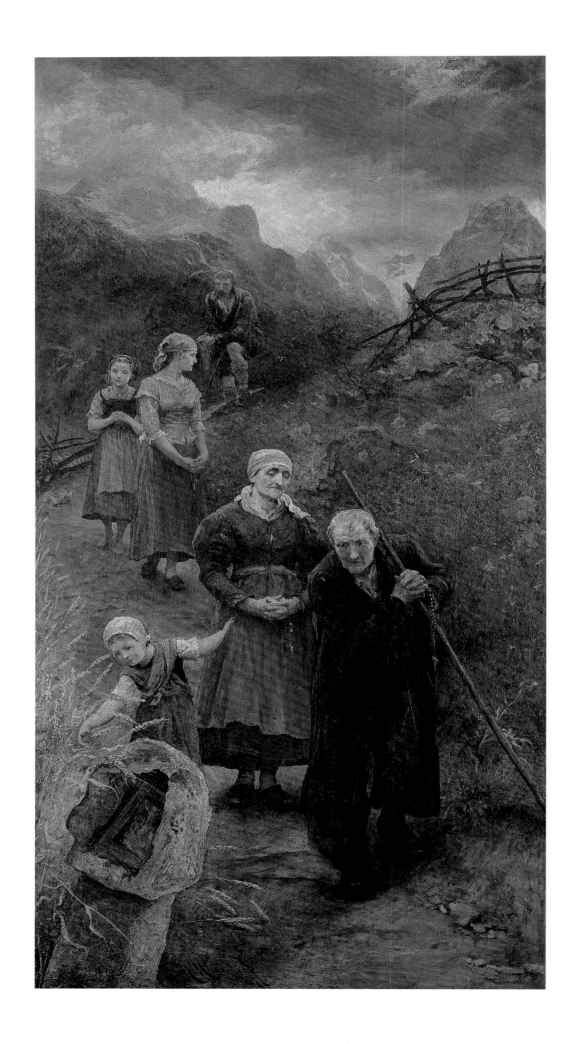

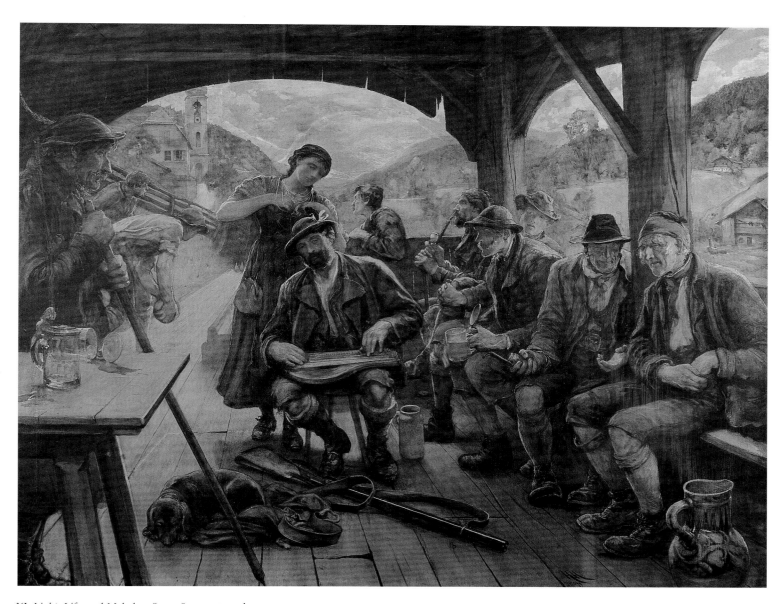

XI *Light, Life, and Melody*, 1877–1879, watercolour

X *Der Bittgang: Peasants Praying for a Successful Harvest*,
1877, oil on canvas

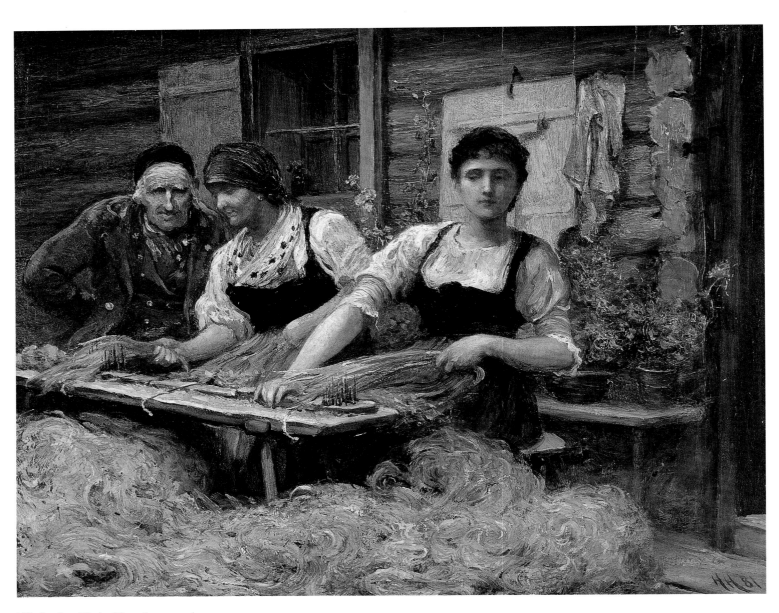

XII *Carding Wool*, 1881, oil on panel

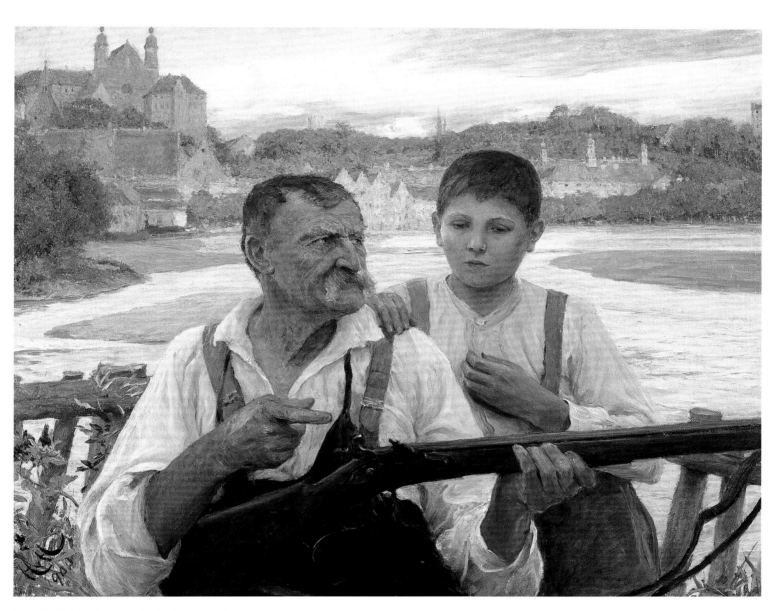

XIII *Pro Patria* (*For the Fatherland*), 1900, oil on canvas

XIV Study for *The Chapel of the Charterhouse*, c. 1887, pen,
watercolour and bodycolour on waxed paper

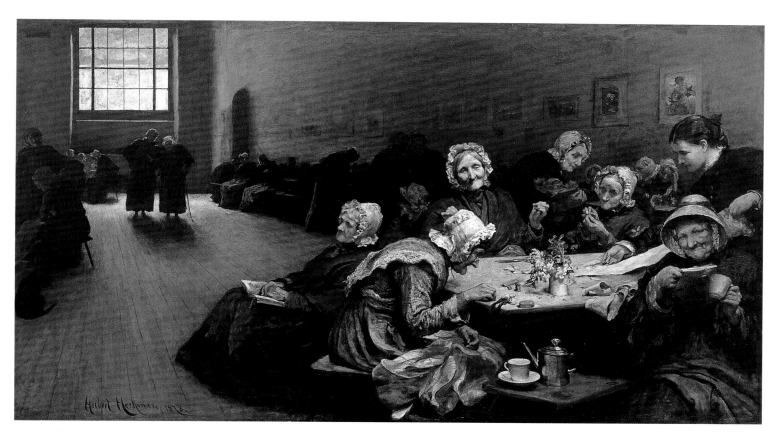

XV *Eventide: A Scene in Westminster Union*, 1878, oil on
canvas

XVI *Hans Richter*, 1882, oil on canvas

XVII *The Last Muster: Sunday in the Royal Hospital, Chelsea*,
1875, oil on canvas

XVI *Hans Richter*, 1882, oil on canvas

XVII *The Last Muster: Sunday in the Royal Hospital, Chelsea*,
1875, oil on canvas

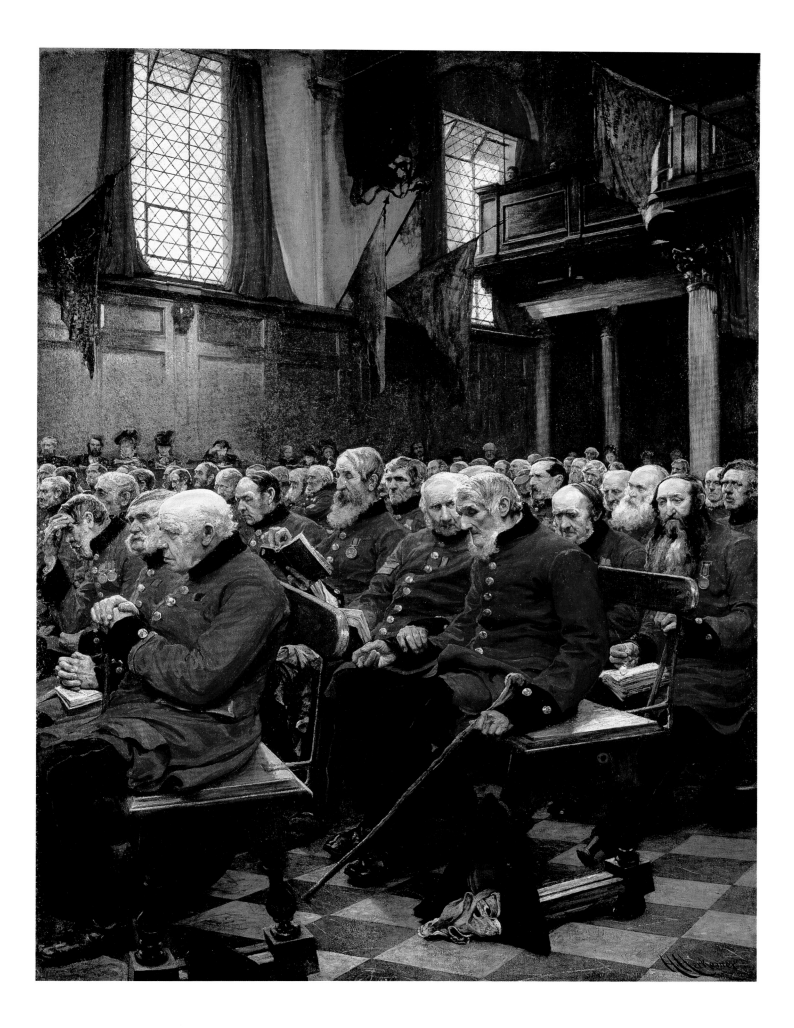

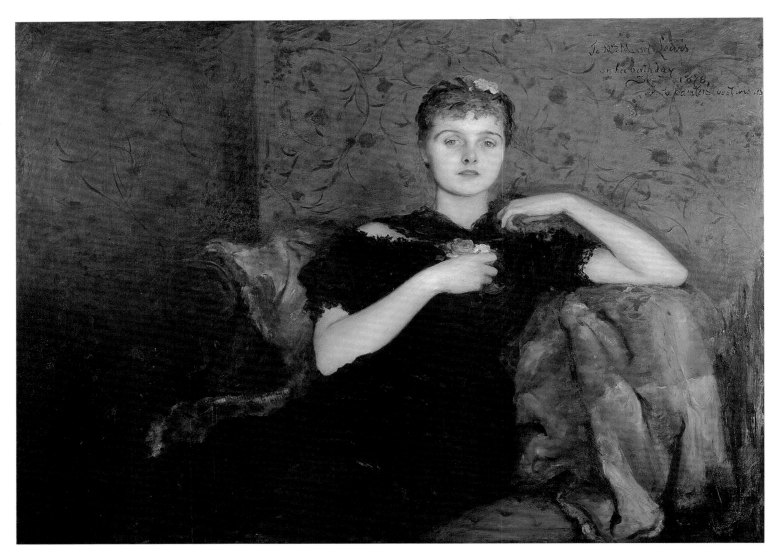

XVIII *Mrs C.W. Mansel Lewis*, 1878, oil on boards. Inscribed
'To Mrs Mansel Lewis on her birthday Sept. 1878 with the
painter's best wishes'

XIX *Sir Herman Weber*, 1902, oil on canvas

XX *The Children of Baron von Erlanger*, 1895, watercolour

XXI *Miss Katherine Grant* (*The Lady in White*), 1885, oil on canvas

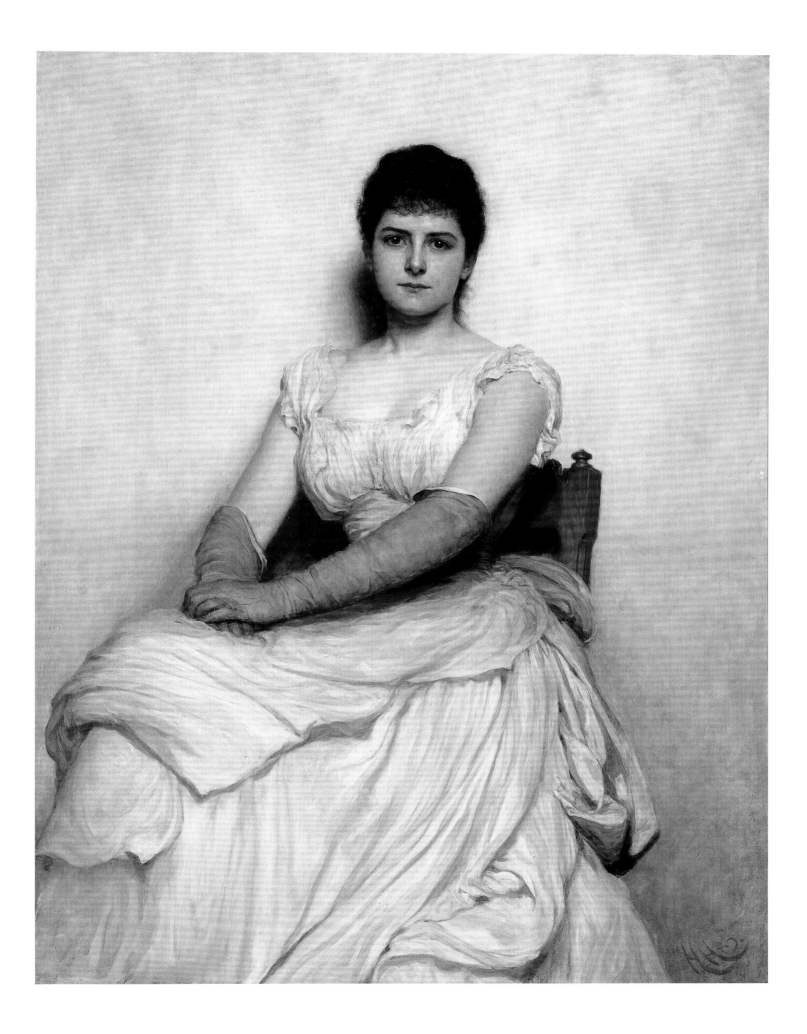

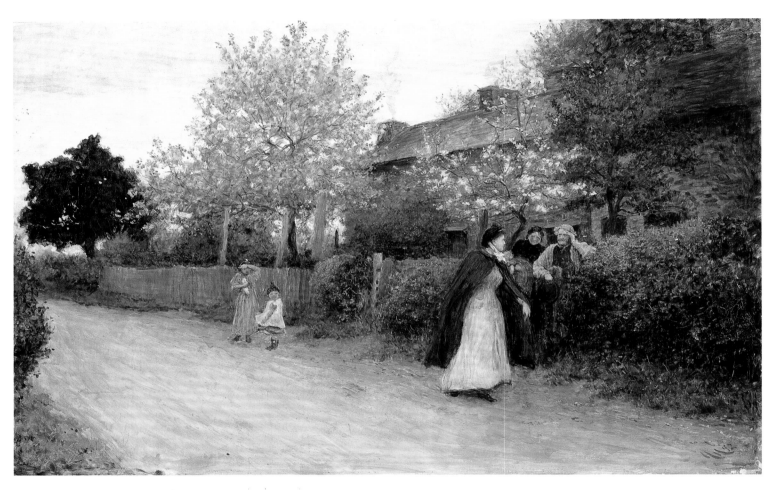

XXII *Our Village Nurse*, 1892, oil on canvas

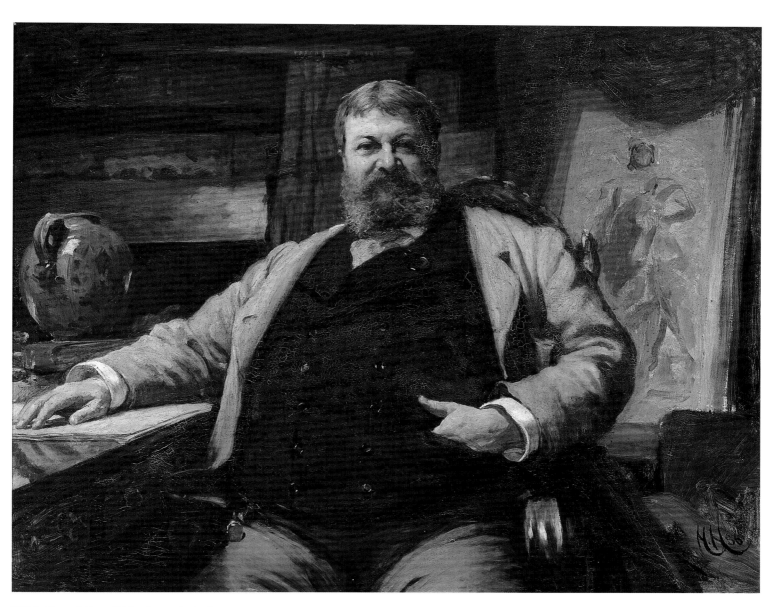

XXIII *Henry Hobson Richardson*, 1886, oil on canvas

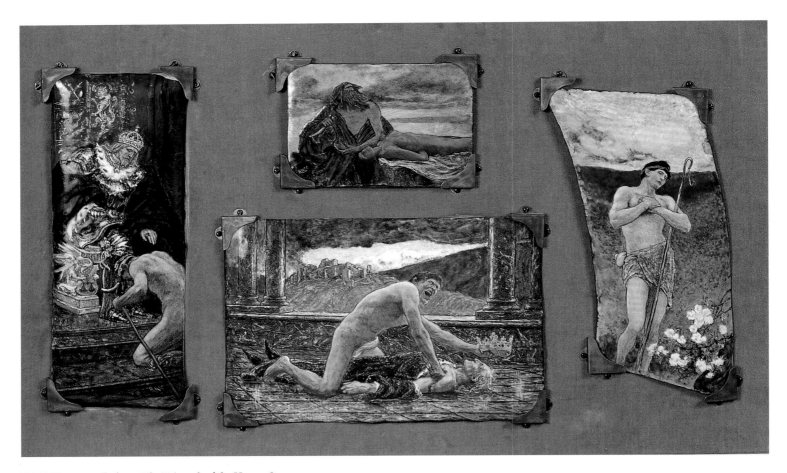

XXIV Four panels from *The Triumph of the Hour*, 1899,
enamel. The panels are entitled (from top clockwise): 'The
Mistaken Shall Fail'; 'Faith Shall Engender Hope'; 'The
Lowest Shall Destroy the Highest'; 'The Raised Shall Touch
the Fallen'

such a subject should be painted. Ironically, Farquharson's depiction of a contemporary social problem, with its suggestion of the potentially threatening behaviour of the victims of poverty, looks back to the harsh documentation explored in the early pages of the *Graphic* magazine. In comparison with Farquharson's sickly drifters, Herkomer's family suggests survival and hope.

Though sympathetic to the suffering of the poor and toil-worn, Herkomer showed little patience for what he termed the 'unemployable' and those who openly protested against the system.[29] He and his family had gone through grim periods of impoverishment, but by 1885 Herkomer was reaping the rewards of success within the system. While he informed his readers and lecture audiences of the hardships he himself had suffered, he was also adept at reminding them that he had become successful through extremely hard work and ambition. While the Victorians acknowledged the sufferings of the poor with charity, sympathy and religious exhortation, actual social change to alleviate their deprivation was still essentially a thing of the future. *Hard Times*, in a larger sense, reflects these predominant social values.

Depictions of the rural wayfarer have long been popular in English painting.[30] Herkomer doubtless knew Frederick Walker's large oil painting *The Wayfarers* (present location unknown), which Frank Holl copied into the background of his portrait of the art dealer William Agnew (Thos. Agnew and Son Ltd.) in 1883.[31] An earlier example of a displaced family on-the-tramp is George Frederic Watts's *The Irish Famine* (1848–1850; Watts Gallery, Compton, Surrey), which documents the appalling suffering of the rural poor in Ireland during the potato famine. And the suffering embodied in the haggard face of the wife in *Hard Times* shares the timeless vision of care-worn womanhood portrayed by Watts in another of his early social themes, *Under a Dry Arch* (c.1850; Watts Gallery, Compton, Surrey). Herkomer made a special trip to London in March 1882 (accompanied by his cousin the painter Herman G. Herkomer) to see the huge exhibition of Watts's paintings then on view at the Grosvenor Gallery, where these early social subject pictures were seen for the first time in public.[32]

Although images of female melancholia date back to classical times, the depiction of the wife as 'the bearer of the burden' in *Hard Times* can also be viewed not only as a symbol of dutiful suffering but as an example of the wide gap between male and female attitudes and expectations in the Victorian era. When contrasted with the upright composure of the husband in *Hard Times*, his wife's exhausted demeanour and downcast face create a picture of hopeless dejection. Such male/female separateness added a dimension of tension to many later Victorian

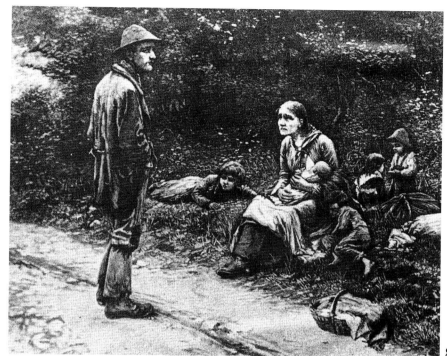

86

87

domestic genre scenes, painted perhaps in subconscious reaction to the growing movement towards greater female independence. Examples range from William Quiller Orchardson's bored upper-class couple in '*Mariage de Convenance*' (1884; Aberdeen Art Gallery), who sit at opposite ends of an enormous dining table, to the carefree navvy followed at a distance by three female relatives burdened with babies and heavy bundles in George Henry Boughton's *The Bearers of the Burden* (Figure 87). Herkomer also made the undercurrent of male/female friction a subtheme in *On Strike* (Figure 88). Conflicts between male and female were also explored in late-nineteenth-century Naturalist novels such as George Gissing's *New Grub Street* (1894), in which the idealistic motives of the writer-protagonist George Reardon contrast with the

86 Joseph Farquharson, *Where Next?*, 1883, oil on canvas

87 George Henry Boughton, *The Bearers of the Burden*, 1875, oil on canvas

more materialistic concerns of his wife Amy, and in *Esther Waters* (1891) by George Moore, which graphically describes the brutal treatment of Mrs Waters by her husband.

Herkomer's *Hard Times* inspired numerous works by the younger generation of English painters, who received most of their art training in France. While these artists are predominantly recognized for their emulation of the style of the French painter Jules Bastien-Lepage, whose influence in England in the 1880s was pervasive, it is obvious that Herkomer's innovative structures and unusual thematic choices also served as reference points for some of them.

Fred Brown's *Hard Times*, shown at the inaugural exhibition of the New English Art Club in 1886, was probably inspired by Herkomer's identically titled subject from the previous year, although the harsh tone of Brown's image (an itinerant worker seated in a cheerless pub) is closer to Degas's *Absinthe* (1876; Musée du Louvre), a work that was in an English collection until the 1890s. Brown (1851–1941) was a founding member of the New English Art Club, which was organized by a group of French-trained British artists to provide a venue less restrictive than the Royal Academy for exhibiting their work.[33] Another founding member was Thomas B. Kennington (1856–1916), whose *The Pinch of Poverty* (1889; Art Gallery of South Australia) and *Homeless* (1890; Bendigo Art Gallery, Australia), both echo Herkomer's depiction of the destitute woman and her children in *Hard Times*. Several of the French-trained artists who congregated at the village of Newlyn in Cornwall in the 1880s and 1890s also painted social themes reinterpreting Herkomer's wayfarer subjects,[34] although, like Kennington, they too focused on female suffering: for instance, in Stanhope Forbes's *Their Ever-Shifting Home* (1887; Art Gallery of New South Wales, Sydney, Australia), and in Blandford Fletcher's *Evicted* (c.1887; Queensland Art Gallery, Australia). Herkomer's followers in the genre of the social outcast offered an image of women in the late Victorian period that contrasted markedly with the more commonly seen *femme fatale*, New Woman or Holy Mother.[35]

By the end of the nineteenth century, labour disputes and strikes became far more frequent and violent as workers demanded improved wages and working conditions. In literature, for example, there was a vast difference between the non-violent and reasonable striking workers in Elizabeth Gaskell's mid-century novel *North and South* (1854–1855) and Paul Muniment's angry mob that would 'lift a tremendous hungry voice and awaken the gorged indifference to a terror that would bring them down' in Henry James's *The Princess Casamassima* (1886). Such late-century social changes are reflected in Herkomer's *On Strike*

(see Figure 88), the diploma picture he painted on election to full membership in the Royal Academy in 1891. In the painting, the monumental on-strike worker dominates the canvas, his tensed fingers compounding his disquieting facial expression. Unlike the idealized toiler tied to old-world tradition in *Hard Times*, the worker in *On Strike* is portrayed with objective forcefulness.

It is significant that Herkomer chose a serious social subject for his diploma picture. It was as if, at a time when portraiture was the dominant focus of his career and he had reverted to a Walkerian vision in his subject pictures, he wished to reassert his earlier status as an innovative and socially aware artist whose genesis had taken place in 'the eye witness school' of the *Graphic*'s demanding requirements. That he had consciously sought to be 'modern' in his diploma work is revealed in another, probably aborted attempt, an unfinished study entitled *In the Black Country* (Figure 89), also painted in 1891. With its plunging perspective and prominent foreground figures, this image of a coal miner and his family shares affinities with the grim expressionist vision of *Eventide* (see Colour plate XV).

As workers became more visibly militant, paintings with strike themes proliferated. Artists frequently depicted crowded gatherings that celebrated social protest and the power of change. For example, Dudley Hardy's *The Dock Strike, London 1889* (Figure 90), exhibited at the Royal Academy in 1890, is a typically animated and crowded documentation of an actual strike.[36]

A similarly crowded scene is portrayed in Robert Koehler's *The Strike* (Figure 91), which was exhibited in New York in May 1886 and reproduced that month as a double-page engraving in *Harper's Weekly*. Herkomer, who was in America fulfilling portrait commissions from December 1885 to May 1886, most certainly knew the picture, for it created a sensation during its exhibition.[37] In Koehler's painting, which depicts an actual strike incident at a Pittsburgh mill, the workers bring their protest (one reaches down to pick up a rock) to a courtly mill owner. Koehler was a well-known socialist, and his sympathy for the workers in this painting is obvious in the pointed contrast between the poor and the privileged.

Rather than a crowded or violent scene of social protest, in *On Strike* Herkomer chose to portray a lone worker living with the consequences of his act of defiance. 'Nobody will deny', wrote one Academy critic,

that in these days of labour disputes and acute social questions such a subject is appropriate to art; and in his figure of the gaunt, dogged and surly labourer, of his unhappy wife and half-famished children, Mr. Herkomer has given us a summary of one side, and a very important side, of modern civilisation.[38]

The size and obvious coarseness of the main figure

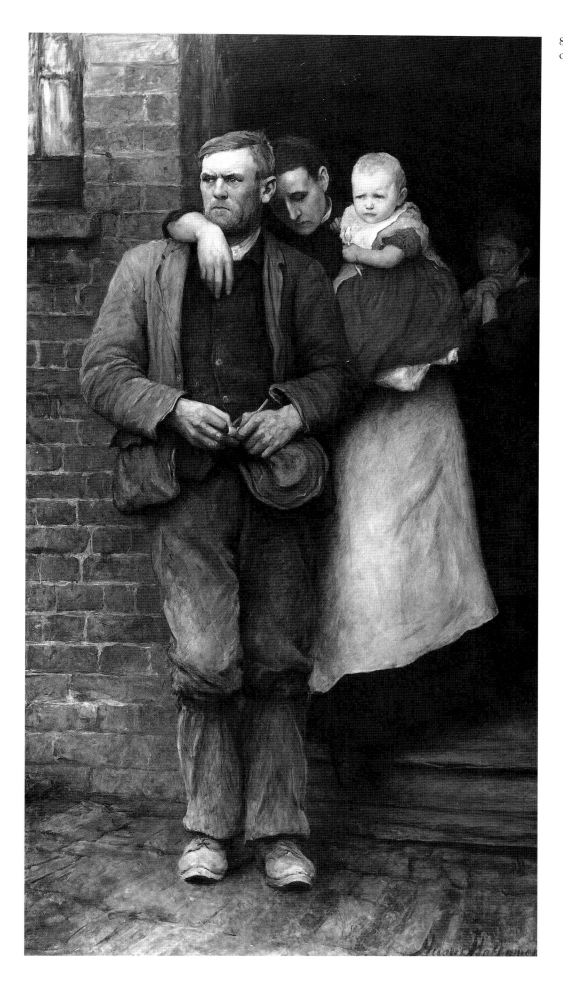

88 *On Strike*, 1891, oil on canvas

89 *In the Black Country*, 1891, oil on canvas

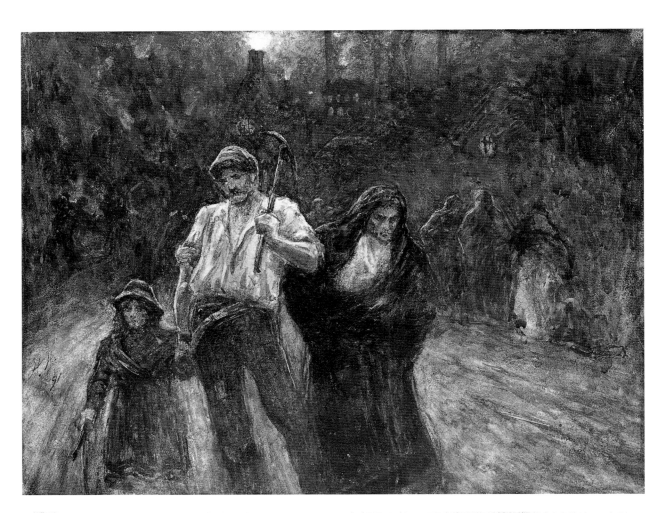

90 Dudley Hardy, *The Dock Strike, London 1889*, 1890, oil on canvas

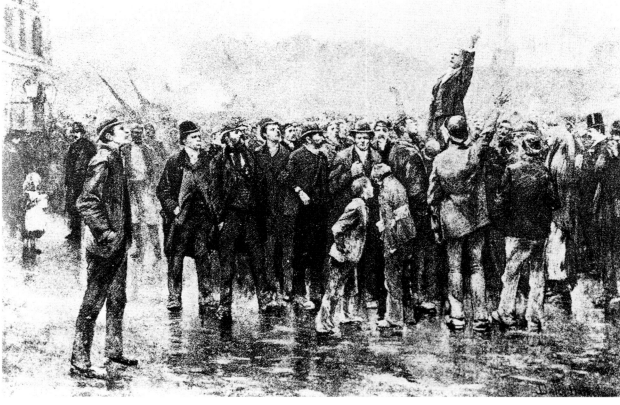

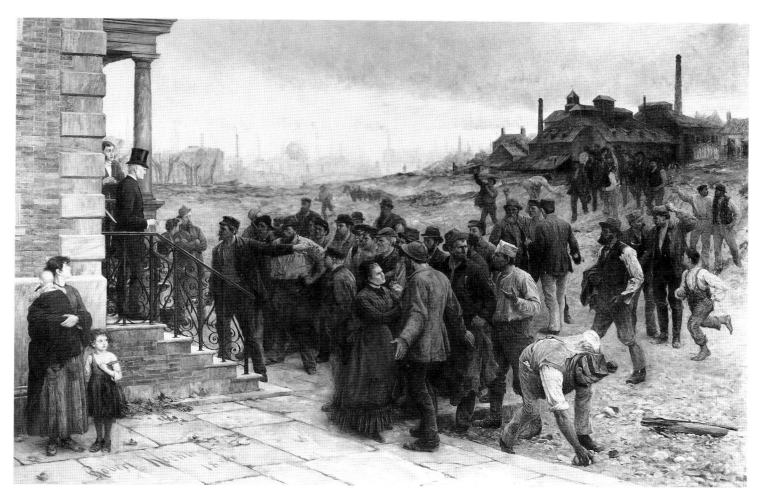

reflect the influence of contemporary French painting, in particular that of Jules Bastien-Lepage, whose art Herkomer admired. Tom ('Money') Birch, one of the artist's favourite models and a gardener on his Bushey estate, posed for this figure. It is difficult to assess whether Herkomer's worker is supposed to represent an urban or an agricultural labourer. Given the publicity about the London dock strike in 1889 and Dudley Hardy's painting of the subject (see Figure 90), it might be assumed that Herkomer was inspired by the same incident. Indeed, one contemporary critic called the painting 'Herkomer's Dockers' Strike'.[39] Because of the number and frequency of strikes among many segments of the working population in 1891, however, the worker portrayed could just as well be lingering outside a village cottage in Bushey as at a tenement in London's East End.

The painting was hung too high at the Royal Academy exhibition and its critical reception was decidedly mixed. One London writer, appalled that such a mean-looking creature as Herkomer's on-strike worker could appear in English painting, compared the work to one then on view at the French Gallery, *The Malcontent* (present location unknown) by the popular German genre painter Ludwig Knaus.[40] The allusion to a work by a German artist is significant, for the prototype for the family in *On Strike* can be

seen in one of Herkomer's earlier Bavarian peasant scenes, a watercolour, *The Arrest of a Poacher in the Bavarian Alps* (Figure 92), which was painted in 1874.[41] The work's composition emphasizes the domestic drama of the scene: a sorrowful wife, her two bewildered children by her side, clings to her defiant husband who is about to be taken away by the police. Interestingly, only one critic took notice of the domestic conflict in the later painting:

> *On Strike*, a really strong study of a working man halting between two views of life – his duty to his comrades and his duty to his family. Of the former motive we only see the trace in the sullen obstinacy of the man's face as he leans against the doorpost of his lodgings. His wife with a baby in her arms, followed by an elder child, is urging the breadwinner to think of their hapless lot.[42]

Portrayed as a surly dissident, the worker in *On Strike* may have supported his fellow strikers in their desire for better working conditions, but at the same time he has involved his wife and children in the chaos of unemployment and economic sacrifice: the sorrowful wife (another 'bearer of the burden' like the woman in *Hard Times*) and her crying children are visual opposites to the figure of the determined husband – as unyielding as the rigid door frame against which he stands.

Extrapolating from this work, it is difficult to assess the artist's own attitudes.[43] In that sense, the painting

91 Robert Koehler, *The Strike*, 1886, oil on canvas

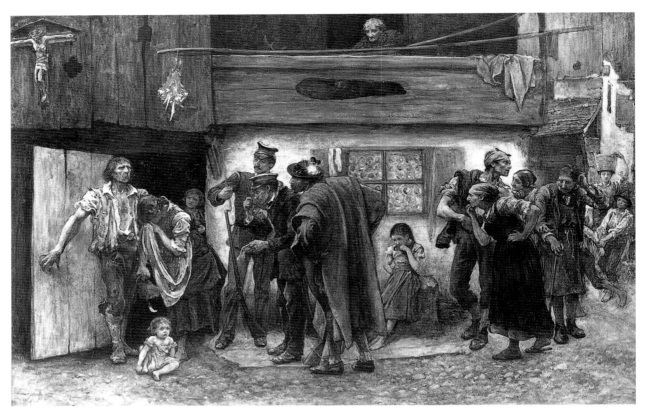

resembles the so-called 'problem pictures' of the 1890s, in which the interpretation of the content, or the outcome of the narrative set up by the picture, is left to the imagination of the viewer. A negative image on the one hand – after all the striking worker threatens the security of the family, a sacred Victorian entity – his monumental size nevertheless evokes heroic parallels. In addition, his expressive face emphasizes the harsh realities of his existence. On another level, the artist's depiction of the modern worker touches upon a much larger issue, the disturbing human effect of industrialization. Uprooted from cottage industries and a rural way of life, the working classes were now tied to long hours in factories and dispiriting jobs in overcrowded cities. The old Victorian platitudes would no longer suffice as militant workers became instrumental in bringing about social change.

Though from a late-twentieth-century vantage point the sentiments expressed in *On Strike* suggest a social engagement or commitment, Herkomer's view of his role as an artist, at least in his late years, was as a recorder of history rather than a reformer or polemicist. Precisely because the message or sentiment in *On Strike* is not overt, it remains Herkomer's most intriguing painting. Its ambiguity demands more from the viewer than the emotive imagery of his earlier works. In attempting to give visual expression to all levels of society – the oppressed or victimized in his subject pictures, the eminent and glamorous in his portraits – Herkomer's ultimate goal was to document all aspects of modern life. 'Truly, art that brings a living individual before our eyes is great art' were his words to a group of Royal Academy students in a lecture series given in 1900; 'Be it remembered that we paint and write for future generations to dream over and wonder.'[44]

Herkomer as portraitist

'Work, work, work will bathe my sorrow.'

Herkomer painted portraits of many of the prominent people of his time – royalty and society figures, military leaders, businessmen, artists and musicians and clerics and academics.[1] In doing so he amassed an immense fortune. All told, he painted approximately 470 portraits and portrait groups, with fees varying from around £500 for a three-quarter length to £10 000 for his last, huge group portrait of the Managers and Directors of the Krupp works in Essen, Germany (see Figure 110) which was finished just before his death in 1914. While portrait painting certainly improved his financial status, he quickly spent much of the money on such costly artistic ventures as the Herkomer Theatre at Bushey, film-making and the building of his Arts-and-Crafts-style house, Lulu-laund.

Stung by criticism for neglecting the kinds of subject pictures that had brought him his initial success, he attempted to validate portraiture's importance as the mirror of contemporary history. 'Great indeed is the art that can satisfactorily portray history-making man' was a dictum that he repeated with variations in publications and lectures.[2] The irony that Herkomer and his two colleagues at the *Graphic* magazine, Frank Holl and Luke Fildes, should launch into lucrative careers as portraitists was not lost on contemporary critics. As one of them wrote in 1885 after seeing portraits by Herkomer and Holl at the Royal Academy and Grosvenor Gallery, 'We glory in a period of material power and prosperity, and our portrait painters are not behind their day and generation ... Under their sympathetic pencil, merchant princes smile smugly over a commerce on which the sun never sets.'[3]

A more immediate inspiration for portraiture as history came from the painter George Frederic Watts (1817–1904), who, after admiring Herkomer's earliest attempts in the late 1870s, had encouraged him to continue his portrait painting.[4] Watts began a series of historical portraits in the late 1840s – a collection of the prominent writers, artists and statesmen of his day – which he gave to the National Portrait Gallery. The portraits were not commissioned, and the sitters were chosen solely on the basis of their achievements, thus meriting their inclusion in a 'gallery of worthies'.[5]

Similarly, Herkomer began his serious venture into portrait painting in 1877 when he painted in succession portraits of such prominent nineteenth-century figures as Richard Wagner (Figure 93), John Ruskin (Figure 94) and Alfred, Lord Tennyson (1879; Lady Lever Art Gallery). All three works were executed in watercolour, the medium he felt most comfortable with at this time and to which he returned throughout his career. Emulating Watts's example, Herkomer painted these portraits without commission and intended them as a gallery of great men to hang in his home. He initially planned to leave the portraits to his children, but later changed his mind.[6]

Although he was extremely fond of Wagner's music – indeed he gave his two eldest children Wagnerian names – he had not yet met the composer. Instead, he informed the German Athenaeum, a London gallery on Mortimer Street where he occasionally exhibited his work, that a portrait of Wagner was theirs if they could get the composer to sit for him. Wagner, who was in London in the spring of 1877 to conduct a series of concerts of his music, allowed the 26-year-old artist to sketch him during rehearsals at the Albert Hall but essentially ignored his presence. Although Wagner was in constant motion, somehow the portrait was completed and when it was shown to him, he was suitably surprised and pleased.[7] Herkomer made a companion water-colour of Cosima Wagner (see Figure 93) in 1878.[8] When the Wagnerian conductor Hans Richter came to London to conduct the complete *Ring of the Nibelungen* in 1882, Herkomer attended the performances and also persuaded the celebrated German maestro to sit for his portrait (see Colour plate XVI), which was presented to him.

Herkomer painted his portrait of Ruskin, arguably one of the great portraits of the Victorian era, after meeting the art critic in Liverpool in November 1878. Herkomer's zither playing and youthful exuberance charmed the ailing Ruskin, and the young artist in turn was much taken with the critic's brilliant conversation and sweet temperament.[9] Ruskin, who was now living at Brantwood in the Lake District, was in such bad health that he was unable to testify at the Whistler versus Ruskin trial, which took place later in the month. The coincidence of the dates raises the question of Herkomer's attitude towards (or relationship with) Whistler, and the possibility of a more political dimension to Ruskin's friendship with

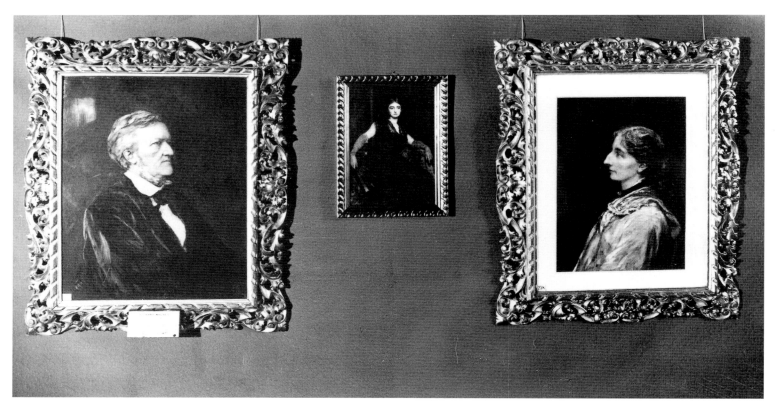

93 Photograph of the installation of the Herkomer commemorative exhibition in Landsberg-am-Lech, 1931, with Herkomer's portraits of Richard Wagner, 1877 (left), and Cosima Wagner, 1878 (right). A lithograph of Herkomer's *The Lady in Black* (1887) hangs between the two portraits

Herkomer. In January 1879, following Ruskin's resignation of the Slade Professorship, he pushed hard for Herkomer to succeed him.[10] Certainly a close friendship ensued, and in December 1879 Ruskin sat for the portrait at his residence, Herne Hill, where Herkomer worked over a period of days.[11] Painted with a spontaneity of touch and a persuasive sensitivity to Ruskin's personal angst at a time when the mental illness that would cloud his last years was beginning to emerge, the portrait's expressiveness and psychological insight are compelling and provocative. Herkomer's technique intrigued Ruskin, who found it hard to believe that the artist achieved such a fine result from a hastily executed charcoal sketch mixed in with the ground colour (usually ochre or grey) to which was added, only at the final stage, the outline and fine details of the face.[12]

The portrait of the publicity-shy poet Alfred, Lord Tennyson was also completed in 1879, after the artist stayed with the Tennyson family at Faringford on the Isle of Wight in December 1878. Herkomer was completely enthralled by 'Alfred the Great', as he called him, but although he enjoyed his conversations with Tennyson on their daily walks, it was difficult to get the poet to sit for him; the final portrait was worked up from a chalk drawing.[13] All three portraits were shown at the Grosvenor Gallery, and etchings after them were made by the artist with copyright retained by the Fine Art Society. Despite the high fees he would soon command for his portraits, Herkomer early established a pattern of doing work for which he received no payment. For example, the portraits of Wagner and Tennyson, executed without commission

and intended for a personal 'gallery of worthies', were eventually given to the sitters' families,[14] and he gave his celebrated portrait of Ruskin to the National Portrait Gallery in 1903 along with a number of his other portraits of eminent Victorians. During the 1890s, Herkomer also made a series of watercolour portraits of his artist friends intended as gifts to them (see for example Figure 95).[15]

Understandably, Herkomer's portraits of older men are particularly sympathetic, for example, his first commissioned oil portrait, that of the diplomat Stratford Canning (first Viscount de Redcliffe) (Figure 98), painted a year before the sitter's death at 92, and the portrait of the engineer Thomas Hawkesley (1887; National Portrait Gallery), painted when the sitter was 80.

Herkomer's decision to focus on portraiture came in the summer of 1881, during his landscape-painting campaign with Mansel Lewis in Wales.[16] In order to gain more portrait commissions and the necessary publicity, he asked a friend, the famous war correspondent Archibald Forbes (Figure 96), to sit for him. The result, exhibited at the Royal Academy in 1882, was a sensation.[17] Here Herkomer's vigorous manipulation of paint underscored the active life and virile appearance of Forbes, who, dressed in his khaki uniform, epitomizes the virile and muscular Victorian male ideal.[18] Commissions for portraits of other great military heroes of the age soon followed and included *Field-Marshal Kitchener, First Earl of Khartoum* (1890; National Portrait Gallery), with background views of the rooftops of Cairo painted by Frederick Goodall (the latter was a near neighbour of Herkomer's in

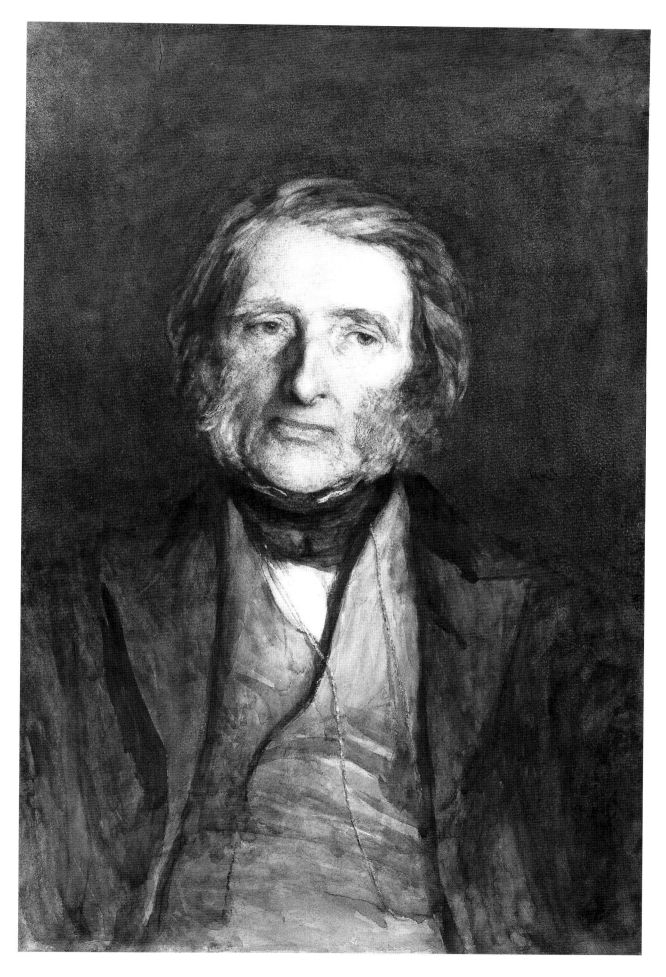

94 *John Ruskin*, 1879, watercolour

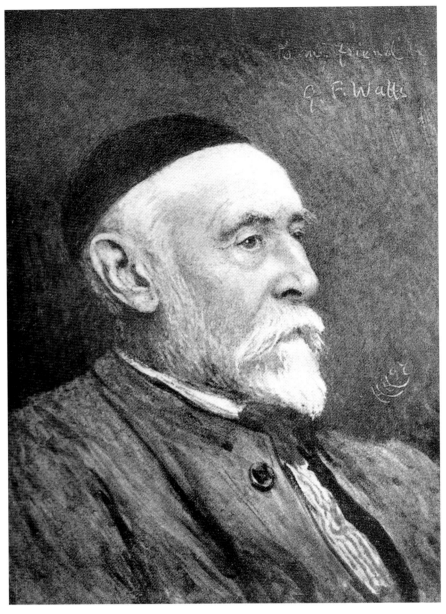

95 *G.F. Watts*, 1897, watercolour. Inscribed 'To my friend G.F. Watts'

and facial expression. Herkomer discussed Lenbach in glowing terms in a memorial article published in 1905.[19]

Depending upon the time of year, Herkomer painted as many as three sitters a day, and seven or more sittings might be required for each portrait. His schedule was often overwhelming, especially in the peak years of the 1880s and 1890s, and it contributed to the physical and mental stress that eventually undermined his health. After the sudden death of his second wife, Lulu, in 1885, he took on a staggering number of portrait commissions in an attempt to assuage his grief.

Herkomer used studio assistants when necessary and the secretarial help of his son Siegfried, for what was essentially the running of a business. Commissions came from all quarters, with sometimes disastrous encounters with recalcitrant sitters, the most hilarious being Herkomer's attempts to complete a subscription portrait (in 1896–1899) of Herbert Spencer, the great Victorian social scientist and philosopher. Spencer's famously cantankerous nature made it impossible for the artist to obtain the usual number of sittings; he worked from a hastily executed watercolour sketch and assorted photographs to achieve a finished portrait that was greeted with horrified rancour by Spencer. It apparently satisfied the subscribers, however, and a cheque was sent to the artist in due course.[20]

Because he painted so many portraits over some 30 years, their quality *did* vary widely and often depended on the artist's rapport or lack of it with his subjects. A number of the portraits are rather grim affairs, in which stiff figures with bleak facial expressions are painted onto dull backgrounds blended from black and grey. At his best, however, Herkomer's ability to capture an insightful likeness is superb; these portraits convey the breadth of his own humanity and his unshakeable faith in the human spirit.

From 1885 to 1894, during his tenure as Slade Professor of Art at Oxford, Herkomer's lecture demonstrations – part party trick and part pedagogy – focused on technique. A favourite ploy was to recruit a professor onstage for a quick portrait-painting session lasting for an hour. A number of the surviving studies give a sense of the artist's almost manic touch and ability to capture a likeness in a very short time. There is probably a connection here with Alphonse Legros, who was famous for painting a head in an hour or less, as demonstrated in lectures he gave throughout England. Such speed and virtuosity seem a deliberate denial of Victorian and Pre-Raphaelite laborious attention to detail.

In his more formal portraits – for instance those of the Tate Gallery benefactor, Sir Henry Tate (Figure 99) and the politician and statesman Spencer Cavendish, the eighth Duke of Devonshire (1897; National Por-

Bushey); *Lieutenant General Sir Robert Baden Powell* (Figure 97), the hero of Mafeking and founder of the Boy Scout movement; and *Admiral of the Fleet, Lord Fisher of Kelverstone* (1911; National Portrait Gallery). Painted over a period of 30 years, these portraits are remarkable historical documents. They also reveal the development of the artist's confidence in this *métier* and the evolution of his palette and technique.

Herkomer worked with remarkable speed and enjoyed talking with his sitters to animate their expressions. He made preliminary sketches to set the pose, and used photographs as well for that purpose. While he employed a freer brushstroke and lighter colours in his later works, for his earlier portraits he favoured a murky palette, tonal subtlety and plain non-descriptive backgrounds, in tune with the realist trends of the Munich and Paris schools. He particularly admired the working methods of the Munich portrait painter Franz von Lenbach (1836–1904), who employed multiple photographs to establish the pose

96

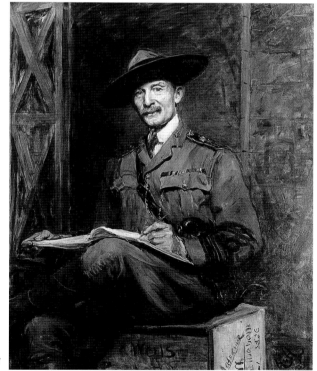

97

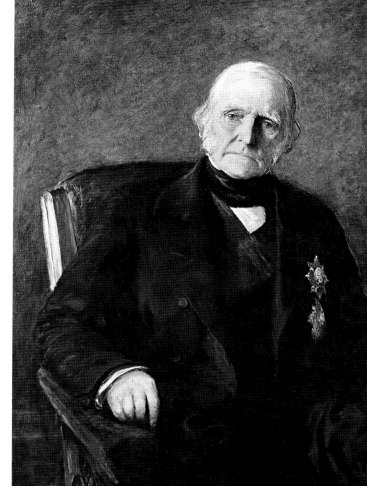

98

Herkomer's bold portrait style was immediately noticed: 'Unquestionably power is displayed', wrote one critic of Herkomer's portraits at the Royal Academy in 1885, 'but of a kind that the French would call "brutale."'[21] Another commented that the 'slash and dash of that clever and audacious painter, Mr. Herkomer A.R.A., whether in subject pictures or portraiture seems ... uncontrolled',[22] a criticism that caused Herkomer to confide to Edmund Gosse that he *did* have 'a close desire to be uncontrolled and audacious' and that he was 'not in the least bit piqued'.[23]

During the 1880s, Herkomer and Frank Holl were declared the best portrait painters of their generation.[24] Following Holl's death in 1888, Herkomer's reputation continued to soar, and in 1898 the French art critic Robert de la Sizeranne declared in a long essay that Herkomer was 'the greatest portrait painter of the United Kingdom ... His portraits are unequalled.'[25] Nevertheless, by the turn of the century the brilliant bravura portraits of John Singer Sargent (1856–1925) dominated both the Royal Academy exhibitions and avant-garde venues such as the New English Art Club. The work of his older contemporaries was increasingly seen as stuffy and old-

96 *Archibald Forbes*, 1881, oil on canvas

97 *Lieutenant General Sir Robert Baden Powell*, 1903, oil on canvas

98 *Stratford Canning, first Viscount de Redcliffe*, 1879, oil on canvas

trait Gallery), he chose side-view poses: the serious miens and imposing figures of these powerful personalities emerge from amorphous backgrounds. More relaxed is the hearty image of Sir Herman Weber (see Colour plate XIX), a chest diseases specialist and Queen Victoria's physician; and the brilliantly expressive portrait of the Hamburg artist Valentin Ruths (Figure 100) at age 75, painted in Germany in 1900.

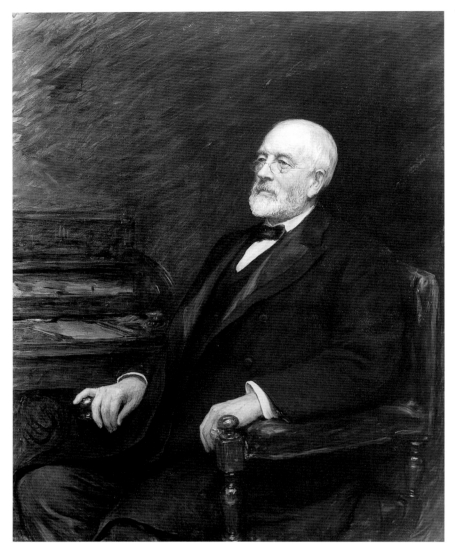

99 *Sir Henry Tate,*
1897, oil on canvas

Lepage's portrait of the celebrated actress Sarah Bern-hardt (1879; private collection), exhibited at the Grosvenor Gallery in 1880, which Herkomer found 'dazzling'.[29] A virtuosic display of whites and creams describing fur, embroidered cloth and other textures, the painting (and its subject) were the talk of London.[30]

Herkomer took unusual care in executing *The Lady in White,* and the 'slash and dash' criticism of the previous year gave way to admiration for the 'finish and delicacy' of the painting.[31] The flowing skirt with its deep sculpted folds suggests the draped goddesses of the Parthenon (in the British Museum), while the subject's impregnable gaze and weighty presence add an air of mystery. The forceful characterization of individual expression, combined with the more purely aesthetic properties of design such as the neutral colour scheme and play of shadow, make this one of the artist's most remarkable portraits. Herkomer kept the painting until 1900, when he sold it to a relative of the sitter. Up until that time he used it to garner publicity and portrait commissions, exhibiting it on the Continent and in America to great acclaim.[32]

A number of Herkomer's female portraits include women of distinction such as Emilia Frances, Lady Dilke (Figure 101), who wrote books on French art and campaigned to improve conditions for working women, and the author Dinah Marie Craik (1887; National Portrait Gallery). While Herkomer is not thought of as a painter of children (except of his own, whom he painted often), his watercolour portrait *The Children of Baron von Erlanger* (see Colour plate XX) is particularly arresting with its intriguing design and self-possessed youngsters, whose gazes out on the world recall Sargent's celebrated painting *The Daughters of Edward Darley Boit* (1882; Museum of Fine Arts, Boston).

From the early days of his career Herkomer befriended members of the British royal family. He was particularly close to Queen Victoria's daughter Princess Louise, a gifted watercolourist and sculptress. Despite her daughter's efforts on his behalf, however, the Queen refused to sit for him (as she did all other such requests) when he was commissioned in 1889 by the National Gallery of Victoria in Melbourne, Australia, to paint her portrait (1892; National Gallery of Victoria). Commanding nearly double his usual fee, Herkomer finally based his likeness of the Queen on the *Jubilee Memorial to Queen Victoria* (1887; Winchester Castle) by the sculptor Alfred Gilbert.[33] Fortunately, the artist's dealings with the Gallery in Melbourne coincided with its need for an art advisor. He was duly appointed and immediately recommended paintings by Frederick Walker, Frank Dicksee, and John W. Waterhouse. Thus works by these English artists entered an Australian public col-

fashioned, though Herkomer was accused of trying to imitate Sargent's style at the turn of the century.[26] The writer George Moore, who championed Impressionism in England and who regarded Herkomer's art as the pinnacle of mechanical conservatism, wrote, 'It is impossible to imagine anything more vulgar than these [Herkomer's] portraits. I do not readily distinguish how and where they differ from richly-coloured photographs.'[27]

Herkomer painted primarily male portraits until the mid-1880s. One early exception is a portrait of the wife of Mansel Lewis (see Colour plate XVIII), which was painted in 1878 on one of the artist's many visits to the Mansel Lewis residence in Wales. His commissions to paint female portraits were more frequent after the international success of *Miss Katherine Grant* (*The Lady in White*) (see Colour plate XXI), which was shown at the Royal Academy in 1885. With a very distant nod to Whistler in his choice of a white-on-white palette, Herkomer painted the daughter of a friend, who sat over a period of months until the portrait was completed.[28] A more immediate source for the white-on-white colour scheme was Jules Bastien-

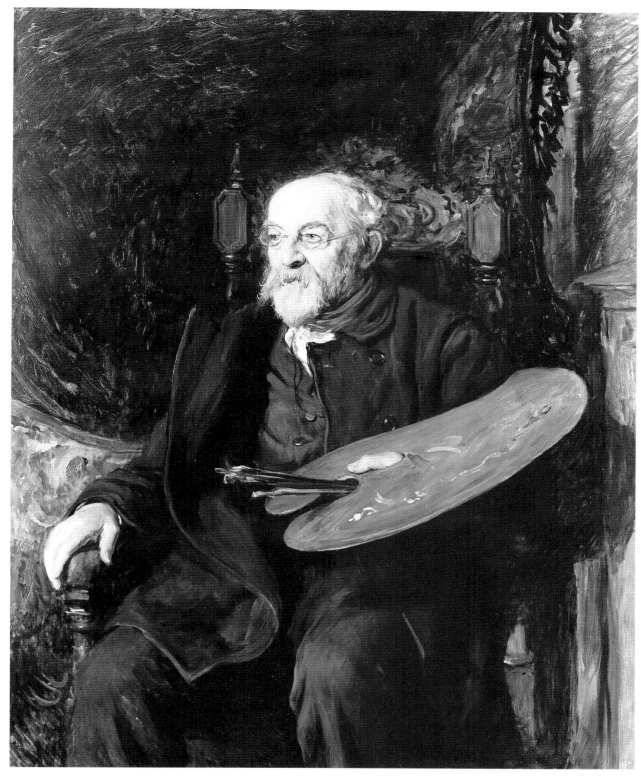

lection for the first time. He also supervised the purchase of several important print collections for the Gallery.[34]

When the heir apparent, the Duke of Clarence, announced his engagement to Princess May of Teck in 1891, the *Graphic* commissioned from Herkomer a portrait to be published in the magazine. After the Duke's sudden death in January 1892, two weeks after Herkomer had made the initial sketches at Sandringham, the portrait was reproduced in a memorial supplement of the *Graphic* (Figure 103) and the artist made a replica, which he gave to the Queen.[35] In January 1901, Herkomer was again summoned by the *Graphic*, this time to the Queen's deathbed at Osborne House on the Isle of Wight to paint a memorial portrait (Figure 102). He was so moved by the occasion that he rejected the publication plans and instead presented the portrait to the family. Lying in a sea of white tulle sprinkled with lilies and other flowers, the dead Queen resembles a floating Ophelia. The artist

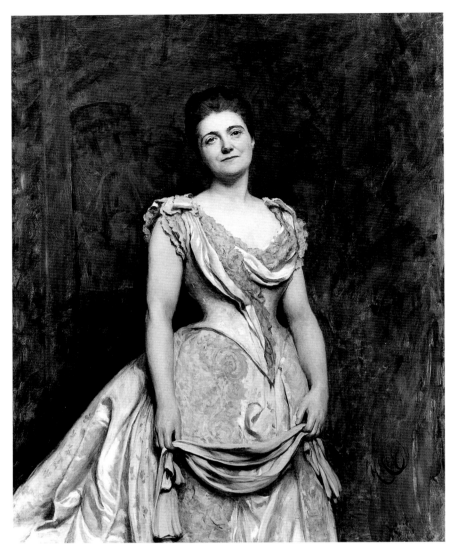

101 *Emilia Frances,*
Lady Dilke, 1887, oil
on canvas

Chelsea or Charterhouse Pensioners with the titans of the boardroom (see Figure 105) or the council members of Landsberg's municipal government (see Figure 106) not only reflects his altered social views in the closing years of the nineteenth century but also substantiates his claim that he was creating a visual record of the history of his epoch. To him, such works would help future generations interpret the meaning of the past.[37]

Additionally, these group portraits, quasi-murals really, could be compared with the grandiose scale of works like Burne-Jones's *The Sleep of Arthur in Avalon* (1881–1898, Museo de Arte, Ponce, Puerto Rico) and the monumental allegorical subjects of the 1890s painted by George Frederic Watts, which, in a larger sense, are histories of the human spirit. It is more likely, however, that the colossal size of the late group portraits by Herkomer was dictated more by the fact that their scale made a visual statement that was more forceful and – perhaps more important to the artist – noticeable in the eyes of the public and the press. Furthermore, the cinematic quality of these works, in which each figure seems to emerge from a rolling film clip, calls to mind the panoramas possible in filmmaking, the creative passion of the last two years of the artist's life.

Herkomer probably began his first commissioned portrait group, *The Board of Directors* (see Figure 105) in 1891, the year of *On Strike* (see Figure 88). The self-assurance of the executives in *The Board of Directors* and in the later Krupp group (see Figure 110) celebrates confidence in the system and in the power elite – the antithesis of the questioning self-doubt expressed by the worker in the artist's *On Strike* and the pathos of his Bavarian peasant subjects.

With his usual meticulous attention to detail, for *The Board of Directors* he worked from numerous sketches and photographs, and even constructed a replica of the boardroom in his Bushey garden.[38] Praised for its modern realism and as his 'most successful work of the year' when it was shown at the Royal Academy in 1892, the painting was also seen as an attempt 'to adapt to modern times the style of the old "Regents" pictures [of] Franz Hals ...'.[39] Seventeenth-century Dutch artists such as Hals depicted mercantile achievers in an age that celebrated the middle class – an ideology that was recognized and shared by the Victorians. Hals was particularly admired by artists trained in Munich in the 1870s[40] – for his vibrant technique and consummate skill in unifying figural groups. Interest in seventeenth-century Dutch art also enjoyed a revival in France in the second half of the nineteenth century. Indeed, when Henri Fantin-Latour was painting his celebrated group portrait *An Atelier in the Batignolles* (1870; Musée d'Orsay), it was suggested that he 'would do well to study the group portraits of Rem-

took the portrait back to his Bushey studio for a few days to further refine the floral detail and to show it to his students.[36]

At the turn of the century, Herkomer also painted portraits of German royalty. Besides completing a portrait commissioned by the Kaiser (a disastrous exercise in enamel that will be discussed in Chapter 12), he also painted Prince Regent Luitpold of Bavaria (Figure 104) dressed in the historical costume of the Knights of St Hubert. The portrait, which emulates the Old-Master look favoured by Lenbach, was exhibited at the Munich Secession in 1896 and at the Royal Academy in 1899. In that year the artist presented it to Luitpold in gratitude for the Bavarian knighthood that entitled him to add the prefix 'von' to his name.

Towards the end of his career, Herkomer painted several huge group portraits within which he incorporated narrative elements (for example, in the relationships between the figures) of the kind explored earlier in such paintings as *The Last Muster* and *The Chapel of the Charterhouse*, on the one hand, with the traditional tenets of portraiture on the other. That Herkomer could equate a gathering of impoverished

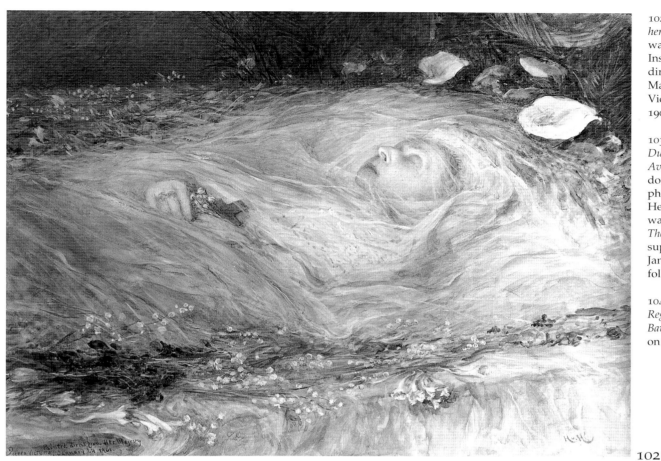

102

102 *Queen Victoria on her Death Bed*, 1901, watercolour. Inscribed 'Painted direct from her Majesty Queen Victoria January 24, 1901'

103 *H.R.H. the Late Duke of Clarence and Avondale, K.G., K.P.*, double-page photogravure of Herkomer's watercolour portrait. *The Graphic*, supplement, 23 January 1892, following p. 136

104 *H.R.H. Prince Regent Luitpold of Bavaria*, 1895–1896, oil on canvas

103

104

brandt and Hals in order to learn better how to "envelop" his figures in a common atmosphere'.[41] Herkomer gave lectures on both Hals and Rembrandt in the 1890s, and after a three-week visit to Holland in

May 1894 he offered to write articles on them for the *Magazine of Art*.[42]

While working on *The Board of Directors*, he also completed (in the summer of 1891) a 24-foot-long

105 *The Board of Directors*, 1892, oil on canvas

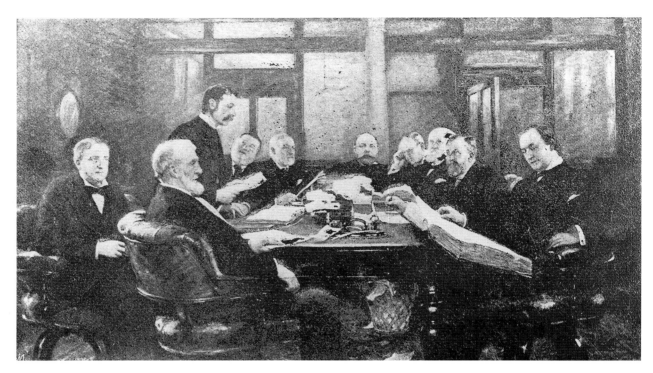

106 *The Burgermeister of Landsberg, Bavaria, with his Town Council (Die Magistratsitzung)*, 1891, oil on canvas

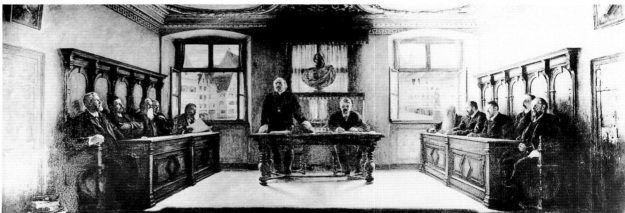

group portrait, *The Burgermeister of Landsberg, Bavaria, with his Town Council (Die Magistratsitzung)* (see Figure 106). The painting was a gift of the artist to the town of Landsberg, where he had maintained a residence since the late 1870s. Herkomer now placed primary emphasis on the 'powers of realisation', with subject matter a secondary issue,[43] thus bringing the Landsberg group portrait more into line with the aesthetic trends of the last decade of the nineteenth century. The absence of sentiment and anecdote, however, did not prevent him from seeing the work as a larger statement: 'The more reality I could put into the painting, the more it became true history painting. I had seen nothing quite like it in modern times, and consequently I felt I had something new in that direction to deal with.'[44] The novelty of this panoramic surrogate-mural probably accounts for Herkomer's being invited to exhibit it at the Munich Secession in 1893. *The Board of Directors* was shown there the following year.

The Munich Secession was a splinter group (formed in 1892) of progressive German artists who sought an alternative to the official exhibition venues that often rejected their work. Among the Secession's founders were Franz von Stuck and Fritz von Uhde, both of whom were friends of Herkomer's and whose work was well known in England.[45] The Munich Secession's exhibitions were noted for their eclecticism, and were characterized by one writer as 'little more than a convenient meeting place for irreconcilables of all sorts. All, however, being united in a distinct artistic rebellion, and not merely a revolt against the fashion of popular art, although sworn foes to the hackneyed and commonplace.'[46] Participation was by invitation only, and Herkomer showed numerous works at the Secession through the 1890s. Other British exhibitors in the Munich Secession were artists associated with the New English Art Club such as George Clausen; Newlyn School painters like Stanhope Forbes and Henry Scott Tuke, whose style shared an affinity with the German Secessionist von Uhde's scenes of humble life; and Glasgow School artists such as John Lavery.

One of the older favourites was George Frederic Watts, who found an eager reception there for his late allegorical subjects.

Despite its depiction of minor German bureaucrats, a subject presumably of little interest in England, the *Landsberg* group portrait was favourably received when it was shown at the Royal Academy in 1895, perhaps aided by its hard-to-miss panoramic size.[47] When the artist presented the painting to the citizens of Landsberg in 1896, he stipulated that it be hung in the second-floor room of the Town Hall, which is shown in the painting.[48] The picture now occupies the entire south wall. The artist was also permitted to redesign the room, now called the Herkomersaal, for which he created and added two ceramic ovens decorated with Symbolist nudes, and which contains numerous portraits by him of family members and friends. A second group portrait, *The Communal Sitting of the Burghers of Landsberg* (*Die Kumultativsitzung*), installed on the north wall of the Herkomersaal, was completed in 1903.

One of Herkomer's most intriguing and at the same time most personal group portraits, *A Zither Evening with my Students in my Studio* (Figure 107) was completed in 1901, when it was exhibited at the Royal Academy. Derived from the tradition of paintings of groups of the artists depicted in studio interiors, it belongs to a type that Continental painters, in particular, exhibited with increased frequency during the nineteenth century.[49] The painting is executed with the broad brushstrokes and bravura technique (seen earlier in the 'slash and dash' portraits of the 1880s) that was viewed at the time as imitative of the style of John Singer Sargent.[50] Yet it is also likely that Sargent was indebted to Herkomer's monumental examples (integrating large numbers of figures onto a single canvas, and so on) when he (Sargent) executed his own much later group portraits, such as *Some General Officers of the Great War* (1922; National Portrait Gallery).

Herkomer left no list of the Bushey friends and students shown in *A Zither Evening*. The scene is set on the northwest side of Herkomer's vast studio (there was also an attached glass house), which was appended to his fortress-like Bushey home, Lululaund (see Figure 118). In the background two men

107 *A Zither Evening with my Students in my Studio*, 1901, oil on canvas

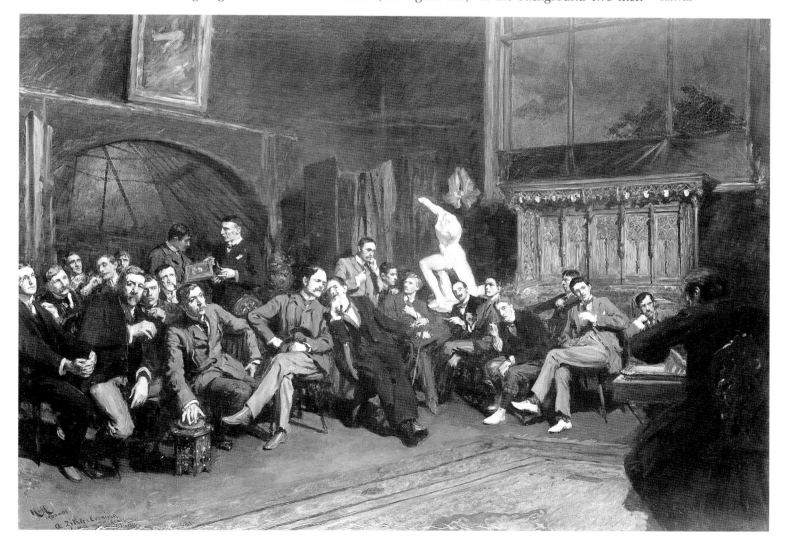

108 *A Zither Evening with my Students in my Studio*, detail 1.

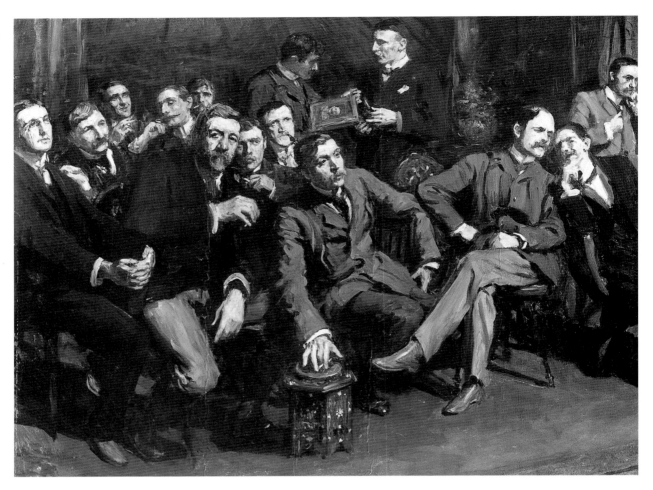

examine a small watercolour study by Herkomer of Kaiser Wilhelm II (present location unknown; see detail, Figure 108), whose full-length portrait in enamel the artist had just completed. Its inclusion underscores the artist's growing success as a portrait painter and exhibitor in Germany as well as his gratitude for the Prussian Order of Merit bestowed on him by the Kaiser in 1899.

The composition of *A Zither Evening* is more complex than in Herkomer's other group portraits. In the right foreground the figure of the artist himself, his back to the viewer, is plucking at the strings of a zither while his son Siegfried (fourth from the right) leans forward, pipe in hand, to listen (Figure 109). The painting can be interpreted as a kind of allegory: Herkomer personifies himself as Art, a singular creative force, surrounded by his students in a room of his own design that is filled with paintings and sculpture by his hand, the whole suffused by the sound of his own music. His passionate interest in the theatre is reflected in his depiction of the audience watching his performance. The wooden settle, the chair upon which Herkomer sits (carved by his father Lorenz) and even the zither itself all allude to the artist's Bavarian roots. Reaping the rewards of his phenomenal success, Herkomer's forceful character and energy seemed all-powerful at this time. 'He was the "lion" of Bushey', wrote a visitor to Lululaund:

or 'king' might be even a better name for him. Tall, with piercing eyes and greying hair, he conveyed a magnificent sense of his own importance, commanding homage from all who came in contact with him. I think I never met a stronger personality.[51]

The fashionably dressed group assembled to listen to Herkomer's music in *A Zither Evening* contrasts markedly with the assemblage of humble peasants gathered around his zither in the much earlier *Light, Life, and Melody* (see Colour plate XI), another picture with allegorical overtones, but one suffused with pathos and melancholy. The later painting, with its fusion of music and art and its specificity of time and place (Herkomer has written the title, 'A Zither Evening with my Students in my Studio', in the lower left-hand corner of the picture), remains a highly personal conflation of symbol and reality.

A second, much later, 20-foot-long group portrait, *The Council of the Royal Academy 1907* (1908; Tate Gallery), memorializes Herkomer's successful participation in the British art hierarchy[52] (he received an English knighthood from Edward VII in 1907); he presented the painting as a gift to the Tate Gallery in 1909 after exhibiting it in Berlin, Düsseldorf and the Munich International Exhibition. At a time so near the end of his life, when honours abounded but critical assessment of his work was more often negative, Herkomer

109 *A Zither Evening with my Students in my Studio*, detail 2.

joyfully wrote to the editor of the *Magazine of Art*, his friend Marion Spielmann, that his *Council* group had received 'absolute unanimity of praise' from the artists portrayed in it:

Men who seldom praise my work have gone out of their way to speak in strong terms about the picture ... I am too old to lose my head, but such praise has not come to me since the Pensioners. Praise so excessive, so unanimous, to come at my time of life, is quite a different thing, for it seems I have stood the test of time.[53]

Herkomer's last great group portrait, commissioned in 1911 by Gustav Krupp von Bohlen und Halbach, was *The Managers and Directors of the Firm Fried. Krupp, Essen, Germany (Aufsichtsrat und Direktorium der Fried. Krupp AG im Jahre 1912)* (Figure 110). It commemorates the hundredth anniversary of the founding in Essen of the huge German arms and steel manufacturing empire.[54] Herkomer was guaranteed a fee of £10 000 for the portrait, a staggering sum at the time. After critical stomach surgery in February 1912,[55] he began work on it in Bushey, with the various Krupp Directors travelling to his studio (to be painted from life) in a steady stream for nearly a year.[56] Considering the artist's weakened physical condition, it is remarkable that he was able to work at all, and there were additional commissions to fulfil. In a letter to the German poet Paul Heyse written in

1911, Herkomer noted that 'I have more than two years work fixed ahead of me – all portraiture. One is a large group of seventeen lifesize figures on one canvas – the directors of a great German firm. That is a tremendous undertaking.'[57]

The mood of his final colossal painting is serious, indeed tense, concomitant with the business at hand and endorsed by the sober palette. A portrait of the infamous 'canon-king' Alfred Krupp painted in 1887 by the German artist Carl Hertel (1837–1895) was reproduced on the background wall.[58] When the *Krupp* group was finished, Herkomer asked Gustav Krupp for permission to exhibit the painting at the 1914 Royal Academy exhibition. Considering the rancorous tension between Germany and England at this time, a decision to show it reveals the artist's extraordinary political naivety and insensitivity. Herkomer was now mortally ill, however, and perhaps too dulled by his own pain to comprehend the reality of impending war with Germany, which broke out in August 1914. His death on 31 March of that year released him from the ensuing furore over the painting:

The colossal group portrait by the late Sir Hubert von Herkomer ... might almost have been noticed in conjunction with M. Alexandre's elegy in a poulterer's shop by reason of the naive irony with which a large proportion of these forgers of lethal weapons are represented as of the most tender and lachrymose benignity. Never have we seen

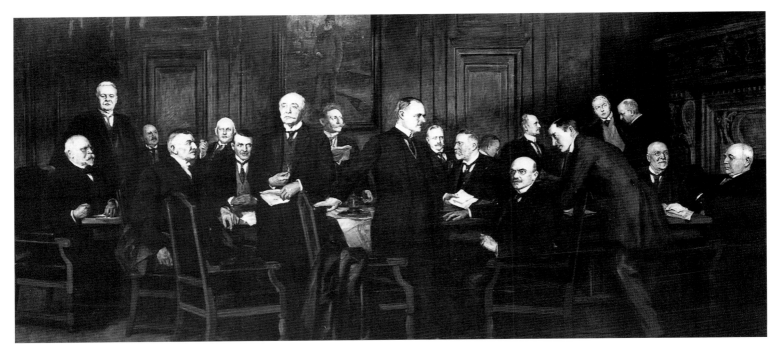

110 *The Managers and Directors of the Firm Fried. Krupp, Essen, Germany (Aufsichtrat und Direktorium der Fried. Krupp AG im Jahre 1912)*, 1913, oil on canvas

such a monument of philanthropy as in the leading figures of the organisation which sits like a nightmare on the chest of Europe . . . The result is not a fine work of art, but it commands credence for the absurdly unsuitable facts it occasionally records.[59]

While Menzel's famous painting of the interior of a Krupp factory, *The Ironworks* (1875; Staatliche Museen, Berlin), celebrates the workers as muscular heroes bathed in the light of the blast furnaces, Herkomer's Krupp group is a panoramic commemoration of

corporate power in the executive suite. An image that appears to make no judgements, it nevertheless manages to impart the spirit of the solemn, calculating men. Herkomer, in his self-appointed role as the artist of contemporary life in all its guises, who sought to depict the 'true' history of his generation, had, ironically, in his last great work memorialized those who helped bring about the destruction of the epoch he had so faithfully recorded.

Herkomer in America

Herkomer made two long visits to America in the 1880s, the first from late October 1882 to June 1883 and the second from December 1885 to May 1886. The purpose of these trips was to paint portraits. Not shy about promoting himself, the 33-year-old artist arrived in New York in 1882 with plenty of advance notice, including press releases and biographical sketches boosting his importance far beyond the status he then enjoyed in Britain and on the Continent.[1] To be sure, Americans were remarkable susceptible to the charms of 'blarsted foreigners',[2] the frenzied press coverage of Oscar Wilde on his lecture tour of America (which began in January 1882, just a few months before Herkomer's arrival) being a case in point.

A number of Herkomer's well-known *Graphic* illustrations were reproduced with their accompanying text in a reciprocal arrangement with the American magazine *Harper's Weekly*, so the artist's work was already known in America before his arrival in 1882.[3] Also, he did have close personal ties to America, having lived there for six years as a child when his parents emigrated from Bavaria to join relatives in Cleveland.

Archibald Forbes (see Figure 96), who himself was about to embark on a lecture tour of America, advised Herkomer in planning his first portrait-painting campaign. In addition, the artist obtained a commission at a dinner party in July 1882 for a portrait (present location unknown) of the United States Ambassador to Great Britain, James Russell Lowell, which also helped to spread the word about his visit.[4]

Seven portraits by Herkomer, including those of Forbes and Lowell, as well as some prints and watercolours, travelled with the artist for exhibition in November at Knoedler's Gallery in New York. Letters of introduction from, among others, Daniel Huntington, President of the National Academy of Design, further supported the young artist's aims.[5] Lecture engagements were also discussed. Knoedler's rented a studio/apartment for Herkomer in the Rembrandt Building on West 57th Street, one of several well-known studio buildings of the time.[6] In an interview several months before his arrival, he made it clear that he was most enthusiastic about reaching a new audience:

I come with appreciative feelings, having long been drawn toward America, and feel that I could do something that might prove useful to American art in its present state of rapid progression. I wish to have the art loving Americans as my friends.[7]

Herkomer arrived in New York on the evening of 30 October 1882, aboard the *SS Servia*. Accompanying him were his mistress, Lulu (his wife, Anna, who was ill in Vienna, died the following spring); his father, Lorenz; and his cousin, the painter Herman G. Herkomer (see Figure 144 and Appendix 2), who soon joined his parents at their home in Cleveland.[8] Portraits of Lorenz and Herman Herkomer were to be included in the show at Knoedler's.

In mid-November Herkomer was the guest of honour at a dinner at the Lotos Club in New York, where the works intended for the Knoedler exhibition were shown at a private reception. Two weeks later the show opened to the public at Knoedler's, accompanied by a catalogue written by the artist himself.[9] Press coverage was extensive, with lengthy descriptions of the works on display. Besides the four portraits already mentioned, the artist exhibited the watercolour portrait of John Ruskin (see Figure 94) and portraits of two famous musicians, the violinist Joseph Joachim (Oxford University) and the Wagnerian conductor Hans Richter (see Colour plate XVI). Herkomer's portrait of Ruskin was singled out by the New York press,[10] for many in the New York art world looked up to him as a heroic figure. While it was considered remarkable that Herkomer had written the text of the exhibition catalogue himself, one New York critic commented on the egotistical tone of the writing and found the self-praise and effusiveness offensive.[11] In general, however, these character traits, often mentioned during his lifetime, were better tolerated in America than in England.

Herkomer's etchings and mezzotints were as favourably regarded as the portraits. This was the time of the great etching revival, and Herkomer's visit to America coincided with that of the English artist Seymour Haden, who was Whistler's brother-in-law. Haden lectured extensively on the subject of etching and mezzotint engraving while visiting the East Coast, and his self-aggrandizing remarks got him too into hot water.[12] Aware that a rival in the art of publicity was afoot, Herkomer reported in a letter from New York to his friend Mansel Lewis that Haden's lectures were intolerable 'because of his one-sided preaching'.[13]

While in New York, Herkomer lectured at the Art Students League at the invitation of William Merritt Chase. On one occasion, after Chase finished speaking about the Impressionists, praising the works of Edgar Degas and Mary Cassatt,[14] Herkomer launched into a

lecture on Frederick Walker, who was known in America chiefly through illustrations published in *Harper's* through the 1870s.[15] Describing Walker's suggestive and poetic paintings as true Impressionism as opposed to 'a mere pretentious daub or wash or scribble' of the French Impressionists,[16] he barely managed to stay in Chase's good graces. Apparently the question-and-answer period after the lecture became rather heated, and Herkomer wrote to Mansel Lewis not long afterward that 'in New York I stirred up a hornet's nest among a clique of young painters. A furious hysterical and eccentric school exists here headed by W. M. Chase and his class of pupils at the Art Students League … I brought up that sore question of Impressionism. This has caused considerable talk ever since.'[17]

Indeed, because Herkomer frequently lectured in New York (he also lectured at the Women's Art School of the Cooper Union[18] and at the Long Island Historical Society in Brooklyn[19]), with much attendant publicity, and because his studio was open to visitors every afternoon for an hour and a half, his opinions were sought by reporters on everything from museum management[20] to the authenticity of a painting ascribed to Raphael that was being considered for purchase by the Metropolitan Museum of Art.[21]

He also acquired a number of portrait commissions, charging $2 500 a portrait, nearly twice the rate of his American counterparts, whose top price was around $1 500.[22] While in New York he painted at least six portraits, among them those of the President of the Lotos Club and *New York Herald* publisher Whitelaw Reid (Figure 111), the artist William Merritt Chase (as a gift; present location unknown) and the financier Jay Gould (Figure 112), which was completed in April 1883. Herkomer depicts this giant of capitalism as a benign, indeed sad-looking, creature, the opposite of the grasping monster seen in popular press caricatures of the time.[23] Always fascinated by money whatever the means of its acquisition, the artist was proud of this chance to meet Gould, and his portrait of him is the best of those painted on this first campaign to America.

In early January 1883, Herkomer went to Boston, where his travelling exhibition opened at the Williams and Everett Gallery to enthusiastic press coverage.[24] Whatever his success in New York, it was even greater in Boston, where he felt more at home, and he soon acquired another twelve portrait commissions.[25]

On 25 January 1883 Herkomer gave a lecture entitled 'Art Tuition' at Union Hall in Boston, which, according to one report, was attended by 'a large and very brilliant audience, embracing many of the most distinguished leaders of our art, social and literary circles'.[26] Indeed, such was the artist's success that he became something of a matinée idol: 'Mr Herkomer is getting well known here', reported one Boston newspaper. 'He appears at public receptions from time to

time and he makes friends. His appearance is rather striking – a middle-sized figure, a thoughtful and pleasant face and an intelligent head covered with black hair. Many think he is handsome … '.[27]

In late February 1883 Herkomer lectured in New Haven at the Yale School of Fine Arts, where his exhibition also travelled. By now his reputation along the East Coast was such that one of the New Haven newspaper critics encouraged his readers to avail themselves of the chance to see 'the work of one of the most distinguished artists of the English school'.[28] Questions inevitably arise about his impact, if any, on the portrait painting of his American contemporaries at this time. After all, he was exhibiting his work and lecturing in an aura of publicity and acclaim. Yet it should be remembered that Herkomer was just beginning his own career as a portraitist and that his success in that field did not peak until the 1890s.

In America his portraits tended to be admired for

111 *Whitelaw Reid*, 1883, oil on canvas

their tonal subtlety and plain, non-descriptive backgrounds or, as one Boston critic put it, 'avoiding both the pallid, lukewarm tints of the Morrisonian palette, and the vulgar extravagance of Durant and Constant'.[29] Herkomer's portrait-painting American contemporaries of the 1880s, such as Frederic Vinton, Frank Duveneck and Chase, were also influenced by European trends, most having spent years of study in Paris or Munich or both. Herkomer's comments on

the American art scene at this time, expressed to Edmund Gosse, underscore in a more personal way the difficulties that faced American artists trying to pursue their livelihood at home:

The artists who reside in New York have a hard struggle. The appreciation and sale of pictures of American artists is very limited and you can imagine how those good lads chafe against all the conditions into which they are thrown by sitting in their own country. It is a mystery to me how

they exist – the best have to teach. I have talked with so many ... The good are always expecting to run away [and] there are but imperfect opportunities for exhibition.[30]

By far the most important painting of Herkomer's 1882–1883 visit to America was *Pressing to the West: A Scene in Castle Garden, New York* (Figure 113), a social realist subject conceived in November 1882 and completed 16 months later.[31] It portrays the plight of immigrants arriving in America. Castle Garden,

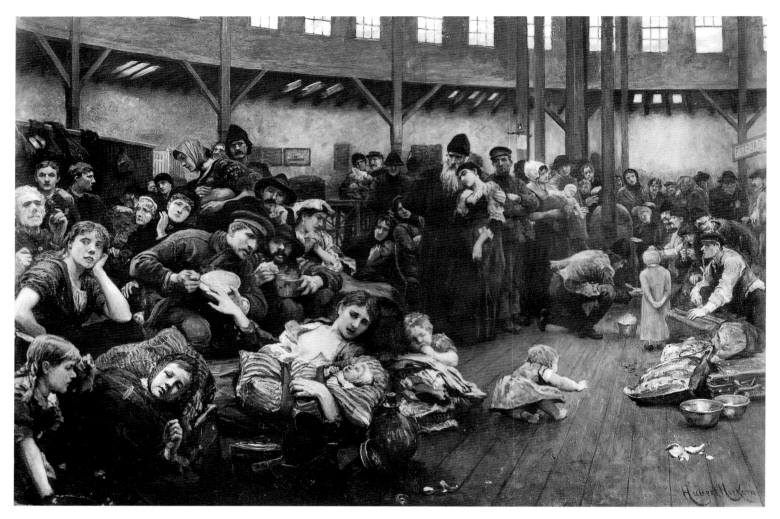

113 *Pressing to the West: A Scene in Castle Garden, New York*, 1884, oil on canvas

located at the Battery in Lower Manhattan, was the port of entry for New York and served as an immigrant station and employment hall between 1855 and 1892. Those who wished to move on to the Western states often waited many weeks at the site until jobs were found for them. It is this state of affairs that Herkomer depicts. Despite his success in America on this return visit, his memory of his family's suffering 30 years previously was revived when he observed the crowded and degrading conditions at the immigrant centre.[32]

Because his New York studio in the Rembrandt Building was open to the public each afternoon, those who wished could see the work in progress on the artist's easel. Herkomer mentioned it in a lecture at the Women's Art School at the Cooper Union in February 1883 to demonstrate his method of grouping figures and of leaving half the picture bare to suggest distance.[33] But the inevitable backlash from all the publicity soon took place. In April 1883 the following appeared in the *New-York Times*:

Papers speak of the large painting by Mr. Herkomer of a scene at Castle Garden as something new in its conception, forgetting that many such views have appeared in black and white here, while in oils also, the subject has been treated. It is so easy to accept at second hand the reputation of a painter that the disposition is to over-value an artist who

has reached fame in Europe. Mr. Herkomer is a fine draughtsman and a clever, spirited workman with the brush, but his is very far from being a genius.[34]

In his painting, Herkomer included strongly personal elements to underscore the realities of immigration. For example, his mistress Lulu posed for the figure of the young mother who pushes an offered dish of food away, her illness and exhaustion signalled by the dark circles around her eyes; Lorenz Herkomer, the artist's father, is recognizable as the white-bearded Jew supporting a younger woman in the middle ground.

The composition of *Pressing to the West* recalls the cavernous interior space, tilted perspective and prominent foreground figures of *Eventide* (see Colour plate XV). As in the earlier painting, the foreshortening accentuates the emotionally charged content. Herkomer's technique is even looser here, with rough passages of paint that amplify the harsh reality of the scene. Because he kept his progress on the painting constantly in the public's eye, it would appear that he was angling for an American buyer. According to one report in the *Boston Evening Transcript*, several men, who wanted to give the painting to the Metropolitan Museum of Art in New York, had raised a subscription fund of $12 000.[35] This tidy sum, along with the

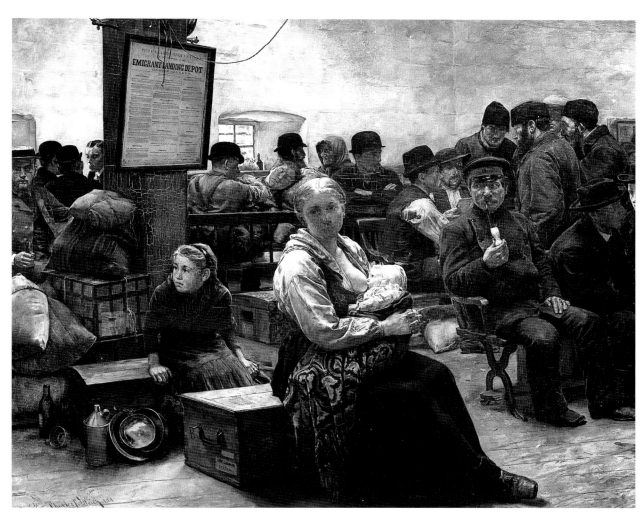

approximately $25 000 he had made from portrait commissions in just seven months, was certainly enough for Herkomer's long-planned lavish residence to become a reality.[36] The subscription scheme for the painting fell through, however, and it returned to England with the artist.

It is worth mentioning here that *Pressing to the West* probably inspired the German-born American painter Charles Ulrich's poignant immigrant scene, *In the Land of Promise – Castle Garden* (Figure 114), which was exhibited at the National Academy of Design in New York in June 1884. As in Herkomer's work, Ulrich's principal motif is a weary nursing mother and child in the immediate foreground. Ulrich, who was born in New York City, studied painting in Munich and resided again in New York between 1882 and 1886 before returning permanently to Europe.[37] Given Ulrich's background and the publicity attending Herkomer's visit, Ulrich probably saw the latter artist's work in progress. Few examples of socially aware art are found in American painting of the period,[38] and consistent documentation of immigrant conditions in America did not take place until the turn of the century, in the photographs of Jacob Riis and Lewis Hine.

Pressing to the West was first shown in London in a special exhibition at Goupil and Company in late March 1884, when *The Times* reported that 'This splendid work will add to the renown of the famous painter of *The Last Muster*.'[39] At the Royal Academy exhibition of 1884, it garnered an odd assortment of notices, the most damning being from that sometime champion of working-class causes, John Ruskin himself, who was offended that Herkomer should spend 'his best strength in painting a heap of promiscuous emigrants in the agonies of starvation'.[40]

In 1894 Herkomer exhibited *Pressing to the West* at the Munich Secession along with nine other works, including his group portrait *The Board of Directors* (Figure 105), Symbolist abstractions such as *Feinde (Hateful)* (present location unknown) and Bavarian peasant 'heads'. His emigrant subject was purchased by the Leipzig Museum from the Secession exhibition, and it remains there today. *Pressing to the West* is a work that synthesizes both realist and Symbolist elements, much in the manner of many progressive, socially aware Continental works of the last two decades of the nineteenth century. The painting goes beyond realism's literal attention to detail, instead setting up inward-turning or subjective tensions. Both the disorienting space and the disturbing human

115 Henry Hobson
Richardson, architect,
'Lululaund': Professor
Herkomer's House at
Bushey Now in Course
of Erection. The
American Architect and
Building News, 26
November 1892,
no. 883

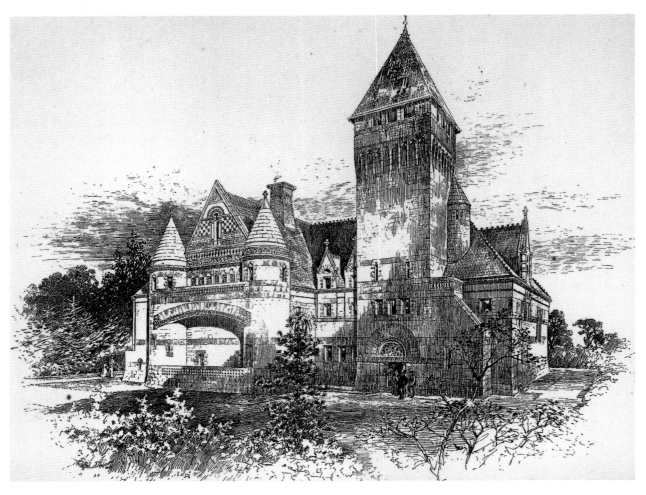

message function as metaphors for the artist's own humble beginnings.

Because of his wife's worsening health, the artist had to return to England on 13 June 1883, postponing a number of portrait commissions till his return to America in December 1885. Upon Anna Herkomer's death, the artist married his longtime mistress, Lulu, who died suddenly after 15 months of marriage just before they were to leave for a second portrait-painting campaign in America. A grief-stricken Herkomer sailed on the *Oregon* on 18 December 1885, accompanied by his father. He went straight to Boston, where a studio was again made available to him on the top floor of the Williams and Everett Gallery on Boylston Street.[41] By late January a local newspaper reported that the artist was 'at work in his Boston studio on three or four sitters a day, and has a reception every afternoon beside'.[42] The money from the lecture he delivered on 11 February at Boston's Chickering Hall was duly noted as being donated to local charities,[43] and by March he had become one of the leading social figures in Boston – the guest at countless receptions and a lionized lecturer at Harvard.[44] Portrait commissions in New York and in Providence, Rhode Island, also kept the artist on the road, and in all some 36 portraits were painted or begun during the six months of his second portrait-painting campaign.[45]

Two of the portraits are very fine. The first, begun in December 1885, was of the celebrated Boston architect Henry Hobson Richardson (1838–1886) (see Colour plate XXIII), painted by the artist as a gift in exchange for designs for exterior elevations for Lululaund (see Figure 115).[46]

The story of this commission survives in two variations. According to a contemporary account in the *American Architect and Building News*, the English version was that Herkomer, who presumably knew all the best architects in Britain, did not wish to alienate any of his friends in the profession by choosing only one of them. Therefore, he sought out an architect who lived a good distance away. The American version was that Herkomer arrived unannounced at Richardson's Brookline studio one day and informed the architect that he had come to paint his portrait. When Richardson replied that he could not possibly afford Herkomer's well-known high prices, the artist said he would paint the portrait for no fee in exchange for a Richardson-designed house. Herkomer presented his rough sketches for ground plans and Richardson, working from these and modifying them somewhat, created the final elevations.[47] The earliest drawings, however, indicate that they were made by the architect Charles Coolidge of Richardson's office, with freehand suggestions and changes filled in by Richardson himself.[48] During the actual building of

the house in Bushey (1886–1894), Herkomer further modified the elevations in order to accommodate his own needs.[49] The dramatic tower in the original Richardson plan was never built, owing to its enormous cost (see Figure 115).

Herkomer probably met Richardson through the Boston philanthropist Robert Treat Paine (see Figure 116) and his wife, Lydia Lyman Paine, when he painted their portraits on his first visit to Boston in 1883.[50] Richardson was completing a house for the Paines in Waltham, Massachusetts, and it is likely that Herkomer, admiring what he saw, decided that Richardson would be the ideal architect.

Richardson sat for his portrait in the studio

attached to his house in Brookline, Massachusetts, in two or three sittings, about nine hours in all.[51] Posed in a favourite chair, the architect is surrounded by familiar objects – including a blue vase still belonging to the family – and prints from his own collection. Also in the background is a small bronze copy of the celebrated Renaissance statue of Bartolomeo Colleoni by Andrea del Verrocchio, an appropriately heroic figure for a man who loved to surround himself with beautiful and meaningful things. Recognized as the leading American architect of his day, Richardson was 46 years old and in poor health at the time Herkomer painted him. His health problems were doubtless exacerbated by his obesity, for he weighed 370 pounds at the time. The artist obviously responded to Richardson's generous personality, however, and the portrait was a great success. In his diary, Herkomer noted that Richardson was 'as a man, as solid in his friendship as in his figure. Big-bodied, big-hearted, large-minded, full-brained, loving as he is pugnacious.'[52]

After its completion in early March, the portrait went on display in Herkomer's studio above the Williams and Everett Gallery. Visitors streamed in to see it at public viewings held between four and six each afternoon. In a long article about the painting, one Boston critic opined:

If anything, it seems to us that Mr. Herkomer has dwelt with greater stress upon H. H. Richardson, the vital human being, than upon H. H. Richardson, the brilliant and prolific artist, the greatest architect of the nineteenth century. No one can deny the immense power and originality shown, but the poetic and wonderful genius that has succeeded in creating a new and curiously beautiful architectural style, this seems hardly as evident. Nevertheless, that the portrait is H. H. Richardson through and through, penetratingly, sympathetically, this can never be denied . . .[53]

Also on special display at this time at the Museum of Fine Arts in Boston, was Herkomer's portrait *Miss Katherine Grant (The Lady in White)* (see Colour plate XXI). Acclaimed at the Royal Academy exhibition of 1885, as we have seen, it won effusive praise in Boston as well.[54] Determined to paint a pendant to this work, Herkomer observed a Miss Silsbee at a ball in Boston in early January. By late February, after introductions were arranged, the artist was well into the portrait, entranced by his sitter's beauty. 'She is beautiful in all views', he raved, 'and the artistic relish

of doing it takes off so much of the unpleasant taste connected with other work, of painting unpaintable people.'[55] The result was *The Lady in Black* (Figure 117), the other outstanding portrait of Herkomer's 1885–1886 visit to America. However, because of unpleasant gossip and rumours circulating in Boston social circles, the Silsbee family made the artist promise never to show the painting to others while he was working on it in that city,[56] and when Herkomer left America in May 1886 the picture was not quite finished. For its exhibition at the Royal Academy in 1887, it was given a quasi-Symbolist title 'Entranced in Some Diviner Mood of Self-Oblivious Solitude' and its success there as well as that of the earlier *Lady in White* assured Herkomer of another lucrative source of revenue – portrait commissions from women, usually the wives of men he painted.

The simplicity of the work's setting and dress, as well as the passive mood of the young woman, contrast markedly with the wispy complexities of Whistler and the flamboyance of John Singer Sargent. William Merritt Chase's *Lady in Black* (Metropolitan Museum of Art; New York), painted in 1888, shares certain affinities with Herkomer's *The Lady in Black*, particularly in the confrontational gaze of the sitter. Chase certainly saw Herkomer on this second visit to America,[57] though whether he was able to view Herkomer's work in progress given the restrictions imposed on it by the Silsbee family is anybody's guess.

On 13 May 1886,[58] Herkomer set sail for England, never to return to America. His diary entry on his first day back in England gives some idea of his ambivalent feelings towards the country that had brought him good fortune on the one hand, but which, on the other, reopened the painful memories of the family's mistreatment upon their arrival as impoverished immigrants so many years before.

Herkomer's work and activities continued to be discussed in American publications long after his departure from American shores. Indeed, a reproduction of *On Strike* (see Figure 88) appeared in the New-York-based periodical *Everybody's Magazine* in 1906, alongside an article entitled 'Soldiers of the Common Good' (on Switzerland and its democratic form of government), from a series by Charles Edward Russell on the rise of socialism in England and Europe.[59] By then Herkomer's paintings had become messages of history.

117 *The Lady in Black ('Entranced in Some Diviner Mood of Self-Oblivious Solitude'),* 1887, oil on canvas

Bushey: 'a sleepy picturesque village'

In 1873, Herkomer settled in Bushey, Hertfordshire, a village some 15 miles north of London. This locale became the headquarters for the many artistic ventures that engaged him, which included not only painting but also the graphic and decorative arts, theatre and film-making. Bushey's reputation as a haven for artists had been established in the early years of the nineteenth century.[1] With the founding of the Herkomer Art School, the village was further transformed, and it became the hub of a thriving art colony which survived well into the twentieth century.

Herkomer opened his art school in Bushey in November 1883.[2] It became a large and influential establishment, with more than 100 students at any given time. He closed the school in 1904, in part because it was denied a Royal Charter, but more probably because of the school's debts and the strain on his personal finances.[3] In 1905, one of Herkomer's most talented pupils, Lucy Kemp-Welch (1869–1958), reopened it as the Bushey School of Painting, but Herkomer repurchased the buildings in 1911 and they were demolished to make way for a rose garden, which still exists today.

Herkomer's well-known distaste for the traditional methods of art teaching,[4] as well as his enthusiasm for imparting to others his own formulae for success, were the guiding impulses behind the foundation of the school. He was fortunate in finding a patron, T. Eccleston Gibb of Bushey, who wanted art instruction for his ward. Gibb paid for the school's buildings, which were erected on Herkomer's Bushey estate grounds, and Herkomer served as the only principal till 1904, without fee.[5] Students did not live at the school but rather boarded in local accommodation, often found for them by Herkomer family members. Among the first group of students was an American, Edith Ashford, of Elyria, Ohio. In a letter to her family in November 1883, she reveals aspects of Herkomer's personality and casts light on the idealistic motives and austerity of the school:

I am almost the first on the soil and Mr. Herkomer's greeting is beautifully cordial . . . I have had two full afternoons in Mr. Herkomer's lovely home. The first time I went he was at work at his forge casting something . . . The workshops where engraving, printing, metal working etc., are constantly going on is no small part of the education . . . Mr. Herkomer invited me to dine with him the next evening . . . He is all on fire with enthusiasm over his Art School . . . The rules are to be very rigid, the work tremendous; but I scent the battle afar off and rush in like a war horse . . . One

term is allowed us. If before that time we do not show signs of talent we are to be sent home ignominiously.[6]

Herkomer's prospective pupils were selected from samples of their drawings; his cousin Bertha Herkomer (1858–1945) ran a separate coaching school in nearby Watford to prepare them.[7] The accepted students then entered a preliminary class and painted and drew from the live model, from casts and from the draped nude figure. Emphasis was also placed on drawing with lead pencil, a practice that Herkomer encouraged because he admired Adolph Menzel's proficiency with it.[8] The preliminary student could pass into the advanced life class immediately if his or her work met with Herkomer's approval; if after six attempts the student was unsuccessful, he or she had to leave.[9] A school magazine, The Palette, was published each month; it reproduced students' work, initially selected by a student editor but later by Herkomer himself when he took over the editorship. His numerous designs for the magazine's covers are often enchanting, employing a rich mix of nude allegorical figures to personify art and creativity.[10]

Herkomer's school was progressive by then-current English standards, for female students were allowed to work from the nude model (the male figure was partially draped), though, unlike in the French ateliers, the life classes were segregated. Herkomer felt so strongly about the life class for women that in 1891 he was responsible for the petition of female students at the Royal Academy schools that they be permitted to draw from the nude.[11] His method of teaching at Bushey, with its encouragement of the student's individuality and predominant focus on the study of the nude, approximated that in the more fashionable Paris ateliers.

The issue of art education was a subject of much debate in England during the 1880s. For example, French-trained English artists such as H. H. La Thangue and George Clausen wrote of the need for reform, advocating the French teaching style. In contrast, the conservative French critic Ernest Chesneau decried the loss of England's 'national school' as more and more of the country's artists flocked to Paris to study.[12] Herkomer achieved far-reaching influence as a teacher among a large international following of students, who came from countries such as Sweden, South Africa, America and Australia. His pupils frequently exhibited at the Royal Academy, and in some years up to 40 current and former students were

represented in London exhibitions. Some of his most prominent former pupils included George Harcourt, R.A. (1869–1947), who became a well-known portraitist; Lucy Kemp-Welch, who became celebrated for her huge subject pictures of horses; Sir William Ashton (1881–1936), an eminent Australian painter; and Sir William Nicholson (1872–1949), the portraitist and still-life painter, who loathed his experience with Herkomer and his school,[13] but whose early dark-toned portraits emulate Herkomer's style.

With his autocratic temperament Herkomer could be a harsh teacher, but he was generous with his most talented pupils, giving them money, obtaining portrait commissions for them and supervising their work. He also used them as paid copiers of his own portraits when duplicates were needed.[14] One former pupil wrote of Herkomer's charisma:

> For distinctive personality . . . since Whistler passed from this lower sphere, none could compete with Herkomer, or move so continually in the limelight. He was a school in himself, and when he settled in the village of Bushey he soon attracted to that rural spot a considerable following.[15]

Sadly, by 1908, when Herkomer published *My School and my Gospel*, his lively account of the Herkomer Art School, his once innovative methods now seemed as old-fashioned as those of the earlier academic strongholds he despised.

The focal point of Herkomer's Bushey estate grounds was Lululaund (Figure 118). Designed for him by the brilliant American architect H. H. Richardson, as we saw in Chapter 8, the house was the fulfilment of Herkomer's dream to build a residence that celebrated the craft traditions practised by his Bavarian-born ancestors.[16] Many Victorian artists built lavish residences that emulated the way of life of their afflu-

ent patrons, and in one sense Herkomer's house was an extravagant hymn to his spectacular rise from poverty to wealth. Both Luke Fildes and Frank Holl, Herkomer's colleagues at the *Graphic* magazine, who became successful portrait painters, lived in elegant houses designed by the architect Norman Shaw.

The building of a house honouring his forebears had been percolating in Herkomer's mind at least since 1882,[17] and, as one of his contemporaries noted, he 'was among the first to preach by example the necessity of the reunion of arts and crafts, to proclaim that the modern limitation of the artist to a specialty, the modern disdain of the painter for the craftsman, is a symbol of feebleness, not of power'.[18] Even though the artist owned 32 acres at his Bushey estate, the huge castle-like structure with a Romanesque exterior[19] was situated 30 yards from the public thoroughfare, at 43 Melbourne Road. The entry gates (designed by Giles Gilbert Scott) and fencing were only three feet high so that little was hidden from public view, and a carved seat on the outside of the fence afforded those who so desired a place to sit and admire. Also on the grounds were workshops for the wood carving and metal work, a generator for the electricity, a dairy, staff cottages and some art studios.

In further homage to his Bavarian roots, the soft tufa stone used in constructing the house was shipped from Herkomer's native Bavaria. The tower in the original drawing (see Figure 115) was never built, though its design may have been suggested to Richardson by Herkomer himself; his Bavarian retreat, the *Mutterturm* (see Figure 6), in Landsberg-am-Lech, which was completed in 1885 to Herkomer's design, featured a tower inspired by the mock-medieval Neuschwanstein, begun in Bavaria by Ludwig II in 1869.

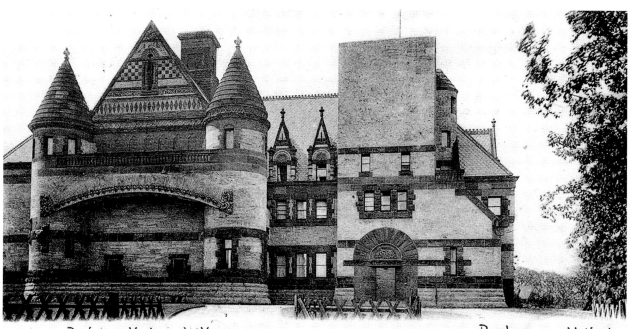

Professor Herkomer's House

Bushey near Watford

118 Photograph of Lululaund, c. 1900. Located at 43 Melbourne Road, Bushey, Hertfordshire, the house was destroyed in 1939

119 Photograph of an interior at Lululaund, c.1900

The massive exterior of Lululaund was matched by an equally grand interior that was designed entirely by Herkomer. Dimly lit by flickering electric lights, it was a magical eyrie for Herkomer's admiring guests, who were entertained by concerts of his zither music or theatrical performances. His Sunday afternoon teas were glittering affairs where theatrical personalities such as Ellen Terry and Sarah Bernhardt mingled with writers such as Thomas Hardy and Edmund Gosse as well as with industrialists and politicians whose portraits the artist had painted. While some of the guests might equate a visit to Lululaund with one to a great Gothic church, one visitor likened the interior to the fortress. Its gloomy spaces, with little natural light, created an effect the artist found restful and conducive to contemplation.[20]

The execution of Herkomer's Gothic and Art Nouveau designs was supervised by his father, Lorenz, and Uncle John (formerly Hans) Herkomer (both superb wood carvers) and their assistants (see Chapter 1, above). The latter left Cleveland, Ohio, with his family in 1883 and settled in Bushey at his nephew's request. Many of Lululaund's walls were covered with the brothers' intricate, intertwining wood carvings. Red velvet hangings with Herkomer's motto 'Propriis alis' – 'By my own wings' – and 'Lulu' woven in gold thread, were made by Herkomer's other uncle, Anton, a weaver, who remained in Long Island, New York.[21] In many respects, this quasi-utopian Arts and Crafts community echoed the ideal world of William Morris, though the Herkomers were not averse to using the most up-to-date machines when necessary. These were set up on the Bushey grounds for cutting designs into the Bavarian tufa stone that decorated the exterior of the house.

Gothic-style chairs and settles, carved in dark woods, were stiff-backed constructions that must

have been as uncomfortable as church pews (Figure 119). One of the bolder decorative elements was a plaster frieze of life-sized female figures (Figure 120), their louche nudity semi-draped with white muslin stiffened with a paste concoction invented by Herkomer's father. Entitled *Human Sympathy* – an allegory celebrating universal friendship – the frieze filled the top half of a wall in the dining room. Its design, while reminiscent of the Symbolist nudes Herkomer showed at the Munich Secession in the 1890s, recalls the similar frieze in the dining room of Franz von Stuck's elaborate *Jugendstil* Villa Stuck, built in Munich in 1897–1898. Herkomer and Stuck knew each other well,[22] and both sought to create palaces of art that encompassed the best in the decorative and fine arts. Lululaund's aesthetically unified interior was Herkomer's attempt to wed what he termed 'the modern spirit' in art with the spirit of the Gothic past.[23] This synthesis or *Gesamtkunstwerk* (a total work of art) was a theoretical tenet (via Richard Wagner) of the international Arts and Crafts Movement and its decorative offspring, Art Nouveau.[24] Like William Morris, Herkomer believed in the creation of beautiful surroundings as an antidote to the ugliness of the industrialized world, though he never shared Morris's commitment to economic reform. Rather, Herkomer's crusade tended to emphasize the spiritual role of the decorative arts in improving the circumstances of all classes.

Sadly, Herkomer's Lululaund, his 'dream realised through craft', which he envisaged as 'monumental for generations to come',[25] had a relatively short life. After the artist's death in March 1914, his widow and their daughter Gwendydd travelled to Germany in May to spend the summer at the *Mutterturm* in Landsberg. Unable to return to England when World War I broke out in August, they spent the war years in Germany. When Lady Herkomer returned to England she moved into a much smaller house near Lululaund, and her former home was neglected and vandalized. Three years after her death in 1934 the house was sold to a Watford businessman, who offered it to the Bushey Urban District Council for a museum or art gallery. The Bushey Council refused the gift in 1939, and in a wave of anti-German sentiment, Lululaund – the only H. H. Richardson-designed house in Great Britain – was torn down.[26] All that remains today is a fragment of the front entrance (Figure 121), which now serves as part of a war veterans club.

The village of Bushey was a source of inspiration for several of Herkomer's later important subject paintings, which celebrate the bucolic life he had come to enjoy there. *The First Born* (Figure 122) was shown at the Royal Academy in 1887. Its perception by one reviewer as 'a landscape'[27] is understandable, for the landscape setting fills the canvas. The figures,

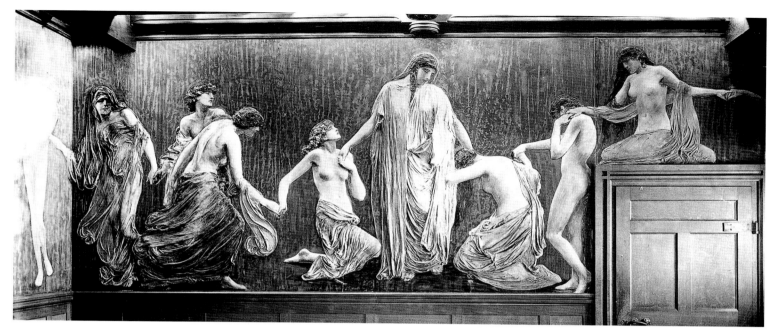

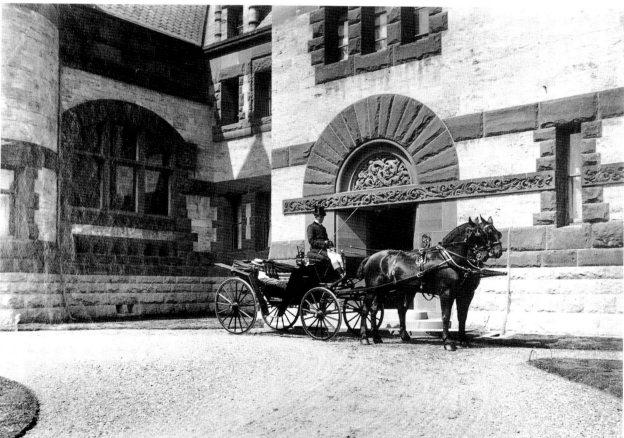

120 Photograph of the plaster frieze, *Human Sympathy*, in the dining room at Lululaund, Bushey, Hertfordshire, c.1900

121 Photograph of the front entrance of Lululaund, Bushey, Hertfordshire, c.1900. The entrance portal with its curved archway is all that survives today

diminutively scaled in contrast with his monumental Bavarian peasants, occupy their environment in much the same way that Walker and his followers envisioned the peasants' place in the rural world – as human elements in an all-encompassing nature that determined the meaning of their lives: 'True poet that he was', wrote Herkomer of Walker in 1893, 'he felt that all nature should be represented as a poem.'[28]

That *The First Born* called to mind Walker's earlier

treatments of English village life was noted by the press,[29] which two years previously had commented on Herkomer's return to a Walkerian mode in his Academy picture of 1885, *Hard Times* (see Figure 85). In contrast to the tragic elements of *Hard Times*, *The First Born* is a rustic idyll of happy domesticity set in a picturesque village lane. The leafy setting, flowering hawthorn and sunset sky advance the 'cycle of life' theme implied by the title, while the carpenter's

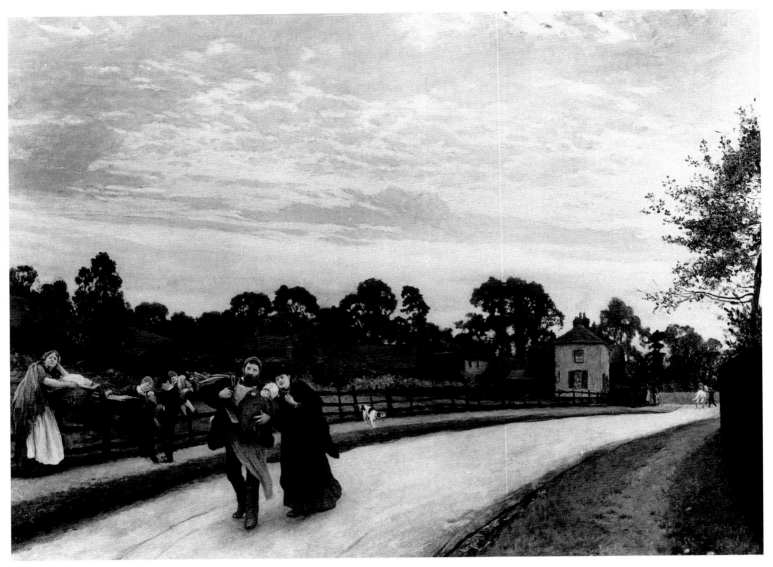

122 *The First Born*,
1887, oil on canvas

plane, an emblem of Joseph, further supports a reading of the couple as a contemporary Holy Family.

In many ways, *The First Born* affirms the artist's pleasure in the Bushey locale where he made his English home. The setting is not far from Melbourne Road, where artisans in Herkomer's employ (the model for the carpenter in *The First Born* must surely have been one of them) were building Lululaund. In 1888, Herkomer again celebrated the pleasures of Bushey in a series of watercolours commissioned by the Fine Art Society for an exhibition entitled 'Around my Home' (see Figures 50 and 51). Their humour and high-keyed colour also affirm the artist's happiness in his new marriage to Lulu's sister Margaret as well as his continuing reprise of Walker's vision of English country life. Other Bushey village scenes by Herkomer, which were shown in a special exhibition of work by Herkomer and his students at the Fine Art Society in 1892, include *Our Village Nurse* (see Colour plate XXII) (the local nurse service was contributed by the artist) and a watercolour, *A Weary Way (Bunce and Bundle)* (1891; Herkomerstiftung, Landsberg).

Herkomer's most exalted image of Bushey, however, is *Our Village* (Figure 123). For Herkomer, the picture evoked memories of his settling there in 1873 – 'it extolled the quietude of the place before cars, before trains', with 'picturesque groups of children waiting for the return of fathers and husbands'.[30] The Bushey parish church and the graveyard where the artist would be buried 25 years later appear in the background. That this microcosm of Herkomer's Bushey seems posed on a stage set reflects his absorption in *An Idyl*,[31] his theatre piece, which was first performed in June 1889, just prior to his completing the painting.

The title *Our Village* crops up in a number of related works. Walker's *Our Village – Cookham* (1873; private collection) was among the artist's watercolours exhibited at the Dunthorne Gallery in London in 1885, and George H. Boughton, a follower of Walker, exhibited his own *Our Village* (present location unknown) at the Royal Academy in 1880, a costume piece with villagers dressed in eighteenth-century style.[32] A popular collection of stories of rural life, *Our Village* by Mary Russell Mitford (1787–1855) (five volumes, 1824–1832), forms a literary counterpart to these idyllic subject pictures, much like the village tales by

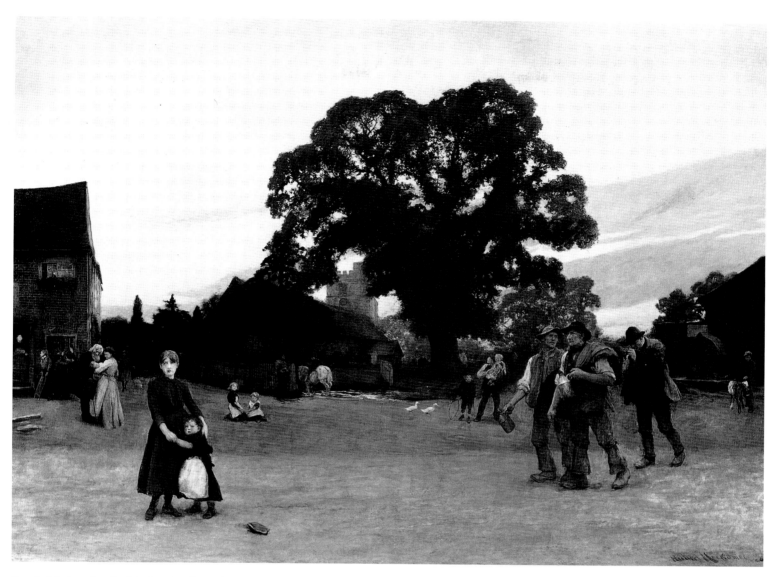

123 *Our Village*, 1889, oil on canvas

Berthold Auerbach that inspired Herkomer's German contemporaries.

Herkomer's own idyllic account of the village of Bushey as he found it when he first settled there in the 1870s[33] complements its representation in *Our Village*. But the reality of poverty and disease often rendered life an uphill battle in Bushey. According to one local contemporary,

Our principal productions are children, stinks and low fevers. Our village, standing on a steep hill, could easily be drained, so it is not done. Our churchyard, being undrained clay, is so wet that the grave digger has to empty the graves with a pail before we can bury our dead. It is not pleasant to see the remains of one's child lowered into a pit of reeking slush.[34]

By 1890, when Herkomer exhibited his picture, Bushey, only 13 miles from London's Euston Station, had become a commuter suburb serviced by frequent fast trains, though it was not yet overwhelmed by urban encroachment.

Perhaps to show his German audience, who were primarily familiar with his portraits, that he was after all an English artist, Herkomer exhibited *Our Village* in 1890 not only at the Royal Academy but also at the Munich Glaspalast, and the following year at the International Exhibition in Berlin.

The painting was generally deemed a success: 'Mr. Herkomer is almost at his best as a painter in *Our Village* ... a sort of bucolic idyl. There is something dramatic in the figures and the pathos of the landscape', reported *Athenaeum* critic F. G. Stephens.[35] Harry Quilter, however, found the poses of the figures unnatural, 'as they would appear in the studio instead of in the open air, and so have no relevancy to, nor consistency with, their landscape surroundings'[36] – thus at odds with the *plein-air* aims of the younger generation of English Naturalists.

From July to December 1891, Thomas Hardy's novel *Tess of the D'Urbervilles* was published in serial form in the *Graphic* magazine. The *Graphic's* editor, Arthur Locker, commissioned the illustrations from Herkomer,[37] which the artist shared with Joseph Sydall (fl. 1891–1904) and Ernest Borough Johnson (1867–1949), both students at the Herkomer Art School, and with Daniel Wehrschmidt (1861–1932), who came from Cleveland, Ohio, in 1883 with the

John Herkomers, to settle in Bushey and teach graphic arts and drawing at the Herkomer School. It seems that Hardy had no direct involvement in choosing the illustrators, in contrast with his earlier serialized publications.[38]

Later on, Herkomer and Hardy became good friends. Hardy regularly attended Herkomer's Sunday afternoon receptions at Lululaund, and Herkomer painted the novelist's portrait (1910; Max Gate, Dorset) in exchange for his editorial advice on the artist's two-volume memoirs, published in 1910.[39] It was in fact Hardy who suggested to Herkomer the title *The Herkomers* for the autobiography, a title inspired by Hardy's *The Dynasts*, a saga of the Bonaparte family, which Herkomer had admired when it was published in 1908.[40]

Herkomer and Hardy shared a sympathy for old rural values and customs. The tragedy of the irrevocably changed rural world described in Hardy's *Tess*, which reinforces the personal calamities of the characters in the novel, must have appealed strongly to Herkomer's own sensibilities as a master of, as one contemporary put it, 'the pathetic aspect of modern life'.[41] Herkomer made six of the illustrations for the book; Wehrschmidt did eight, Johnson six and Sydall five. The series lacks a cohesive aesthetic approach and the characters' appearances vary from one artist's illustrations to the next. Herkomer's illustrations, when compared with those of his colleagues, suggest greater richness and power in their visualization of the drama and tragedy of the novel. Indeed, in 1895 the critic and biographer of Whistler, Joseph Pennell, called Herkomer's illustrations of Hardy's *Tess* 'some of the most striking work of the last few years',[42] magnanimous praise from one who had feuded publicly with the artist in 1892.[43]

Of Herkomer's six illustrations, only one involves a pastoral setting – the scene depicting Farmer Crick and his field labourers digging crops (Figure 124). Hardy's 'Wessex', pictured in the background, is actually a recognizable part of Bushey. Herkomer duplicated the same view with the village rooftops and the path at the right in another Bushey village painting, *The Foster Mother* (1892; Bushey Museum Trust), which depicts an idyllic rural panorama encompassing the small figures of a boy and a woman carrying two lambs.[44]

Herkomer's two other outdoor scenes for the serialized *Tess* are less involved with the rural environment and more with the novel's human dimensions. In a double-page engraving depicting Tess and Alec working side by side (Figure 125), their confrontation in the firelight – his leering eyes and leaning body, her recoiling horror – makes visible the drama of his hold on her.

Perhaps the most interesting illustration in aesthetic terms is Herkomer's first for the series. A double-page illustration (Figure 126), it shows Tess about to cross the threshold into the humble Durbeyfield cottage as though emerging from the shadowy wings of a stage. Indeed, the whole box-like composition suggests a theatre set, with the action dominated both visually and in narrative terms by the arrival of the heroine, who is dressed in the elegant clothing that already sets her apart from her more shabbily dressed family. The vigorous drawing style alternates broad strokes of light and dark to add to the tension of the scene.

Herkomer gave Hardy the original drawing for this illustration, as well as that of Farmer Crick, and they are now in the Dorset County Museum in Dorchester. The illustration of Tess was repeated as an oil paint-

124

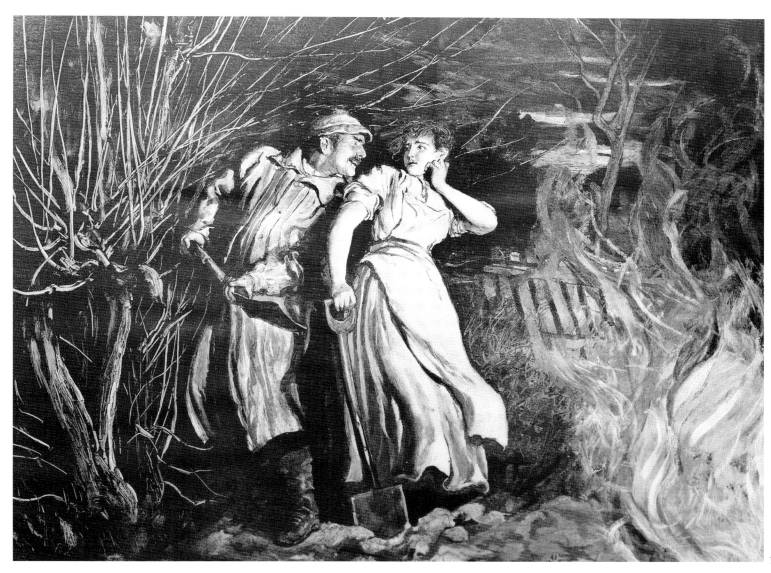

125

ing entitled *Queen of the May* (present location unknown) and exhibited with *The Foster Mother* in 1892 at the Fine Art Society exhibition of works by Herkomer and his pupils. Although he also exhibited some 40 other works in the show (see, for example, Colour plate XXII), his contributions, unlike his earlier themed exhibitions for the Fine Art Society in 1885 and 1888, seemed purposely designed to emphasize his ability to tackle a wide variety of media while forecasting the diverse styles and subject matter that marked the large-scale works of his last years.

Back to Life (Figure 127), exhibited at the Royal Academy in 1896, is Herkomer's last important rural subject. The background setting is Washford, the village in Somerset where Herkomer began to spend time from 1892 to be near the landscape painter John W. North, whom he greatly admired. By the 1890s, North's work was little known and was certainly out of fashion, though Herkomer's laudatory two-part article, published in the *Magazine of Art* in 1893, helped to bring this nearly forgotten artist increased recognition.[45] The poetic realism of North's rural sub-

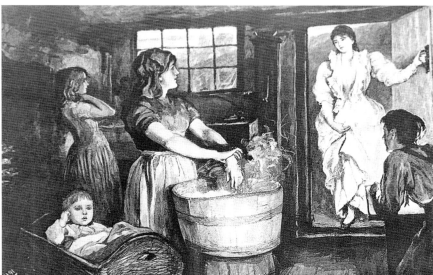

126

jects was much like that of Walker, who had been his close friend and colleague.

Herkomer chose Somerset not only for its proximity to an artist who inspired him but also for relief from his worsening health problems. The stomach ulcers

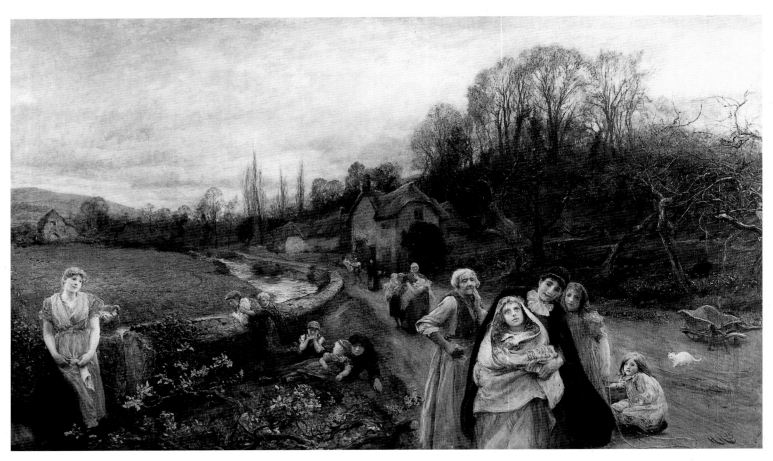

127 *Back to Life*, 1895, oil on canvas

that plagued him in his later years caused severe pain[46] and Somerset provided a quiet retreat where he could flee from portrait commissions, Royal Academy duties, lecturing and his whirlwind of other activities, when they became too oppressive. Therefore *Back to Life* is also a metaphor for his own rejuvenated spirits in this idyllic rural area.

The painting depicts a child whose restored health is indicated in her compelling facial expression. Although the village setting of *Back to Life* is authentic, the occasion that gave the painting its title was entirely imagined.[47] The luminous stare of the convalescing child in the immediate foreground was probably inspired by a painting that Herkomer had praised, Jules Bastien-Lepage's *Joan of Arc Listening to the Voices* (1879; Metropolitan Museum of Art, New York), which was exhibited at the Paris International Exhibition in 1889 and at the Grosvenor Gallery in London in 1890.[48] This work had a profound impact on English painters in the 1890s, and inspired a number of visionary images that were exhibited during the period.[49]

Herkomer's huge painting was a critical disaster, however. The *Athenaeum* took the artist to task for its 'pretentious production', 'the quantity of empty space', its 'wrong proportion and perspective' and its sloppy finish.[50] *Back to Life*, with its natural world synthesized with a mystical human element, gives a foretaste of the artist's more purely decorative and Symbolist works of the early twentieth century.

Theatre fantasies and cinema experiments

Since early childhood, Herkomer had dreamed of having a private theatre. Around 1887, when his oldest son, Siegfried, a student at Harrow, asked for Christmas theatricals when he came home from school, Herkomer decided to convert a former chapel on his Bushey grounds for use as a theatre, employing the artisans and craftsmen already at work on Lululaund.[1] As he did with all his experimental endeavours in the arts, he threw himself into the project wholeheartedly and began to develop dramatic tableaux, which he called pictorial-music-plays – visual counterparts to Wagner's music-dramas. Herkomer explained that *his* term denoted 'first the picture, then the music to attune you to the picture, and lastly the story, or the excuse for the whole thing'.[2] Herkomer himself bore the expenses for these productions, out of the huge sums he earned from portrait painting.

For Herkomer, theatre was an extension of the narrative impulse that informed his subject pictures, another way of 'picture-making', as he termed it. With a private theatre, he felt that a painter 'could experiment in scenic art, in grouping figures, and in story-telling, only changing the canvas for the stage in order to express with real objects and real people . . . the thoughts placed ordinarily upon the canvas with brush and colour'.[3]

Herkomer's technical innovations with lighting and elaborate scenic illusionism sparked great interest among set designers and theatre critics. For example, he abolished footlights, favouring electric lighting from the wings that simulated the effect of natural daylight. He cited the natural tones found in Frederick Walker's art as the inspiration for his own lighting effects.[4] His ability to create greater realism and spatial illusion onstage through the use of lighting, hanging gauzes and perspectival sets, at the same time intensifying mood to achieve harmony of mind and eye,[5] led directly to the suggestive, symbolic stage designs of Edward Gordon Craig (1872–1966), who openly acknowledged his debt to Herkomer's theatre experiments.[6]

Herkomer's first production in the little theatre (it had 150 seats) was *The Sorceress*, with music, costumes, scenery and stage direction by Herkomer, who also acted in it. The libretto consisted of selections from George Eliot's dramatic poem *The Spanish Gypsy* (1868). At least eight performances took place in April and May of 1888.[7] Other parts were played by students in the Herkomer Art School and by the artist's relatives. Margaret Griffiths, his sister-in-law and soon to be his third wife, played the title role (see Figure 128) in a costume more suggestive of Rhinemaiden than Gypsy. The production was a critical sensation – a mechanical stage moon, cleverly lit to create both magical effects and heightened realism, attracted the most attention.[8]

An Idyl (see Figure 61), Herkomer's second theatrical production, which was mounted in June 1889, was even more successful. The drama critic and musicologist William Archer asked his readers, 'Have you seen Professor Herkomer's ingenious experiments at Bushey? The Professor is doing excellent work in carrying scenic illusion to the highest power, developing its utmost possibilities.'[9] Clearly, the plot was less important – a simplistic love affair set in medieval England. Herkomer played the principal role opposite the young actress Dorothy Dene (see Figure 129), a favourite model of the Royal Academy's President, Frederic Leighton. Teachers and students from the Herkomer Art School acted other roles. Herkomer wrote the libretto and composed and scored the music. The premiere took place on 6 June 1889 and 13 performances were conducted by the Wagnerian maestro Hans Richter (see Colour plate XVI). The music for *An Idyl* shows a decidedly Wagnerian influence, in part because Herkomer taught himself orchestral scoring by studying Wagner's *Die Meistersinger*.[10] The references to Wagner were deliberate – at the time it was recognized that Herkomer's theatre experiments were a continuation in England of Wagner's vision for the drama – a *Gesamtkunstwerk* (total work of art) with dance, music, painting, architecture and stagecraft fused into a 'vast symbolico-poetic whole'.[11] Herkomer, who remained on friendly terms with Wagner and later with his widow, Cosima, after painting their portraits in the 1870s (see Figure 93), attended performances of Wagner's operas at Bayreuth through the years. Though he was enamoured of Wagner's music, he thought that the stage lighting and set designs at Bayreuth too often resulted in disastrous scenic effects.[12] William Archer looked favourably on Herkomer's Bushey Theatre experiments, encouraging his goals and giving him plenty of press coverage.

Wagner's musical themes and the sublime essence of his music were particularly favoured by the Symbolist painters at the end of the century and the work

128 Photogravure of Miss Margaret Griffiths as 'the Sorceress' in the first play at the Herkomer Theatre, Bushey, Hertfordshire, 1888

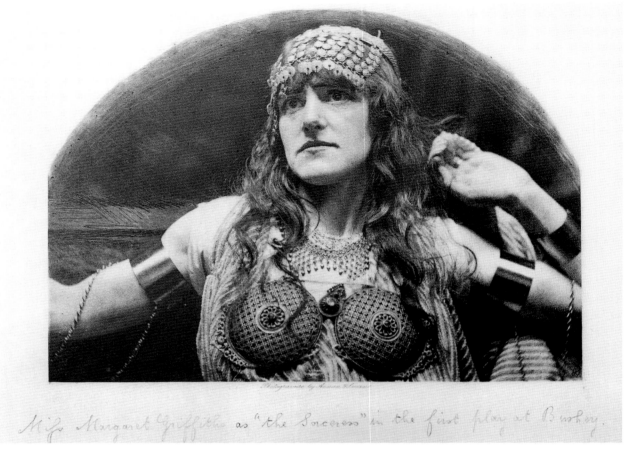

Miss Margaret Griffiths as "the Sorceress" in the first play at Bushey.

of artists such as Watts and Burne-Jones can be seen as pictorial equivalents to Wagner's soaring musical vision. Herkomer's appreciation of Wagner tended more to finding solutions to technical problems through his work and ideas – for example, learning composition and harmony from his scores and experimenting with scenic arrangements, costuming, lighting techniques and so on.

Certainly Herkomer's genius for self-promotion had found the perfect outlet. The publicity engendered by his activities in the theatre advanced not only the reputation of the Herkomer Art School but also his more general pedagogical crusade for the arts. In his lecture 'Scenic Art', which was delivered at the Avenue Theatre in London in January 1892, he made it clear that, as with his other artistic experiments, his social and artistic goals were conjunctive: the theatre was, in his view, another way to loosen traditional boundaries and a route to fusing all the arts. To Herkomer, the stage was

the medium through which the greatest truths in nature can be brought home most directly to the minds and hearts of the people and all the arts can, to their fullest capacity, be united in this most complete form of expression . . . We should not be satisfied until all the arts are placed on a single footing.[13]

While this well-publicized lecture had its detractors,[14] its message left a strong imprint on the then 20-year-old Craig, who, according to his son Edward, attended the lecture and, when it was published in

the *Magazine of Art* that same year, saved the pages in a scrapbook.[15] Craig was especially taken with Herkomer's approach to lighting as the core of 'the real magic of the art' of theatre,[16] and as a means of creating mood without naturalistic sets.[17] He incorporated some of Herkomer's ideas in his revolutionary London production of *Dido and Aeneas* in May 1900.[18] With his mother, the actress Ellen Terry, Craig attended at least two performances at the Herkomer Theatre in Bushey – *An Idyl* in 1889, when he made a backstage tour and took particular notice of the lighting techniques, and the first production in 1888, *The Sorceress*.[19]

There were only two other productions at the Herkomer Theatre: *Filippo* (an adaptation of a French play, *Le Luthier de Crémone*), performed four times in June 1890 and repeated the following year in June 1891, in which Herkomer played a hunch-backed violin-maker, and the art critic W. L. Courtney's play *Time's Revenge*, performed six times in January 1893, with Herkomer (Figure 130) playing the lead as a Breton peasant.[20] The music was composed by his cousin, the pianist Marie Wurm (later Verne).

Because of the enormous cost of producing his pictorial-music-plays (the audience attended by invitation and special trains brought them to Bushey), Herkomer decided not to continue. By 1893, his health was beginning to break down, ruined through overwork and stress. Nevertheless, his feverish activity in all other aspects of the arts continued unabated.

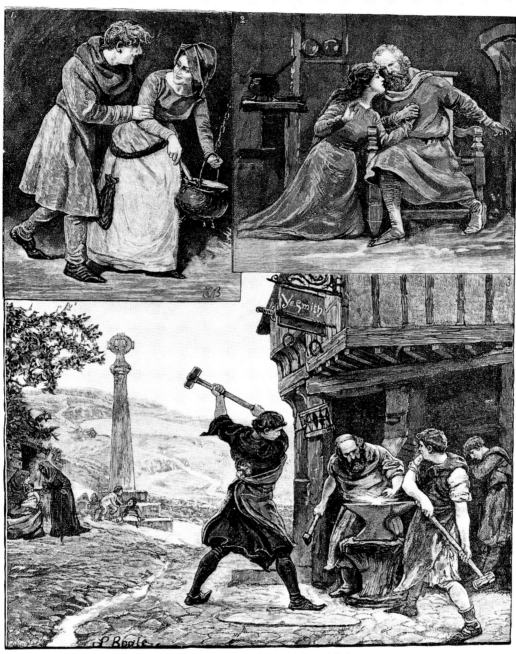

129 Cover of *The Illustrated London News*, 8 June 1889, showing scenes from *An Idyl* at the Herkomer Theatre, Bushey. At top right, Hubert Herkomer is depicted as 'John, the Smith', with the actress Dorothy Dene as 'Edith, his daughter'

In 1912, Herkomer and his son Siegfried began making films to be shown as entertainments at Lululaund.[21] Having worked for Pathé,[22] Siegfried knew something about the technical requirements of film-making: in March 1913, father and son officially formed the Herkomer Film Company (see Figure 131), a fitting conclusion to the artist's ceaseless quest to bring painterly illusion to the public. The old theatre on the Bushey estate was converted into a glass-house film studio, and a pattern of film-making,

130 Photograph of
Hubert Herkomer as
'Gaston Boissier', in
Time's Revenge by
W.L. Courtney,
produced at the
Herkomer Theatre in
1893

131 Herkomer's first
watercolour sketch
for the Herkomer
Film Company logo,
c.1913. In the final
version, the figure
was clothed

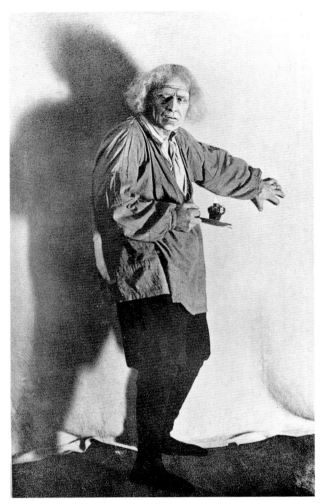

130

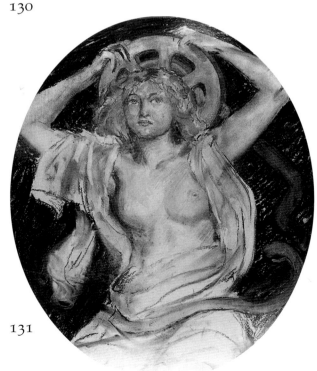

131

which still continues with other film companies, was established in Bushey. Herkomer's new artistic endeavour garnered much attention:

The announcement that Sir Hubert von Herkomer is turning his attention to cinematography has naturally aroused considerable interest from the general public as well as the Trade, for Sir Hubert, in spite of the commanding position he has acquired as a painter, has directed his genius to many other forms of art and has long been recognised as one of the most versatile men of the day.[23]

The Herkomer company made seven films; unfortunately, the negatives have not survived. The script for the first film, *The Old Wood Carver*, released in December 1913, was published, however, and its 52 still photographs give us some idea of how it looked.[24] Descriptions of the elaborate set designs and tableaux plots recall those of the earlier theatrical productions. Herkomer and family members, as well as established actors, all performed in the films, which were released commercially and played in theatres all over England. The war correspondent Archibald Forbes, whose portrait Herkomer had painted in 1881 (see Figure 96) acted in at least three of the films.[25] Two films, *The Old Wood Carver* and *A Highwayman's Honour* (see Figure 132), were sold to an American company for release in the United States.[26]

Film-making was a natural progression for Herkomer, who had been a highly skilled photographer for years. Indeed, in 1892 he invited the photographer Eadweard Muybridge to the Herkomer Art School to demonstrate to students the taking of his famous animal locomotion studies. In an interview printed in a London newspaper in 1912, Herkomer cited Muybridge's images as planting the seed of the motion picture, 'hidden though it was from the mind of man at the moment'.[27]

As early as 1879, Herkomer had travelled with a portable darkroom on his Bavarian excursions. He had become seriously involved with photography by November of that year, after being introduced to it by Mansel Lewis.[28] Herkomer and Mansel Lewis were both enthusiastic users of the *camera obscura*, exchanging ideas and equipment during the late 1870s.[29] Because Herkomer was deeply interested in the experimental and technical aspects of his craft, photography presented an exciting new challenge: he employed it to record background views and suitable models. After 1884, he relied less on photography for subject pictures but continued to use it for his portraits, finding it useful in selecting poses.[30]

Although Herkomer experimented with film-making only in the final two years of his life, the new craft underscored his didactic and social aims for the arts:

The moving picture is the thing of the future . . . A well-projected image on the screen requires so little elucidation and conveys so much more in a clearer way than the written or spoken word. And we all love pictures, don't we?[31]

132 Photograph of Hubert von Herkomer (seated) with unidentified actors in a still from the film *A Highwayman's Honour*, produced by the Herkomer Film Company and released in June 1914, three months after his death

And its use for the artist? 'The moving picture is action emphasised in pictorial form. It is nature reviv-ified, and as such it should prove of the utmost service to the art student.'[32]

The Old Wood Carver, Herkomer's one surviving film script,[33] provides a filmic parallel for the 'picture-making' of *An Idyl*, and, by extension, of his great nar-rative subject pictures of the earlier decades. A story of the triumph of an outsider and a celebration of the old craft traditions alluded to in its title, *The Old Wood* *Carver* suggests on the one hand an apotheosis of the Herkomer family itself and on the other the reconcili-ation of traditional values with new and challenging twentieth-century technical inventions. According to a modern film historian, Herkomer's films, while few in number, raised the standards of then-current British film-making with their superb innovative lighting, aesthetic superiority and slow action.[34] With Herkomer's death in March 1914, production at his film company ceased.

Herkomer as printmaker

Throughout his career, Herkomer experimented with a variety of black-and-white techniques. Indeed, he initially established his career in art with the wood engravings he designed for the *Graphic* magazine (discussed in Chapter 2, above), though he did not actually 'cut' them. This was left to skilled artisans. In 1877 he took up etching. Like many artists of the period, he was caught up in the etching revival whose best-known partisans were James McNeill Whistler and his brother-in-law Seymour Haden, both of whom Herkomer knew well.[1] Educating himself from an etching manual published in 1868 by the English artist and critic Philip Gilbert Hamerton,[2] Herkomer quickly became an expert in the craft and even travelled with a portable kit on his first landscape-painting campaign to Wales in 1879, sharing with his friend Mansel Lewis the necessary chemicals, etching plates and printing press.[3] Under cramped conditions in a wind-torn tent, he produced what he considered his best etching,[4] a self-portrait with tiny images of his children Siegfried and Elsa in the lower left corner (Figure 133). In his etchings, Herkomer strove for what he called 'a Rembrandt effect', which aimed for a softer, less line-oriented image with 'delicate half-tones and gradations of tints'.[5]

With an eye on the wider market, he sold etchings for reproduction by such firms as Goupil's, the subject matter being predominantly Bavarian themes.[6] He also etched copies of his own work – for example, his portraits of Ruskin, Tennyson and Wagner (see Figures 93 and 94; reproduction rights to these were held by the Fine Art Society) – as well as of work by other artists, notably Frederick Walker. His etchings after Walker's *The Old Gate* and *Philip in Church* (with a tiny portrait of Walker in the bottom left corner) are particularly fine; made to honour the tenth anniversary of Walker's death, they were shown at the Royal Academy in 1885. For a volume in memory of the artist Cecil Lawson, who died young in 1882, Herkomer etched Lawson's *The Hop Gardens of England* (see Figure 58), as well as a frontispiece portrait (see Figure 59), which was reproduced (alongside illustrations by Whistler) in Edmund Gosse's biography of the artist.[7]

Etchings and drypoints (which are closely related to etchings) by Herkomer were shown in 'An Exhibition of Works by Professor Herkomer and his Pupils' at the Fine Art Society in 1892. Among these was his evocative drypoint *Wild Weather* (Figure 134), which

recalls atmospheric landscape drypoints by Whistler and Haden. A year earlier, Herkomer was embroiled in an unpleasant controversy over etching. Joseph Pennell, Whistler's biographer and an expert on engraving, accused Herkomer of reproducing photogravures rather than the 16 etchings advertised in the published score of his pictorial-music-play *An Idyl*. An ugly row with charges of fraud was publicly aired in *The Times*. Herkomer eventually admitted that, although seven of the plates were produced 'entirely by my own hand', the other etchings involved a mechanical transfer.[8] Because Herkomer constantly kept himself in the public eye with announcements, lectures and special exhibitions, this taint was hard to shake off, and in an article published many years later his old friend Edmund Gosse wrote that some still thought of Herkomer as a 'charlatan'.[9] In 1892, perhaps to defuse the negative publicity of the etching episode, Herkomer published his first book, *Etching and Mezzotint Engraving*, based on a series of lecture-demonstrations given at Oxford during his tenure as Slade Professor of Art. The book explained his trial-and-error solutions in printmaking and emphasized the technical aspects of the graphic arts. While he made a number of questionable claims for originality, his revival of the use of the copper plate for mezzotint engraving, as opposed to the steel plate used by professional engravers, resulted in superb prints with wider variations of tone and softer edges.

His few works in this medium tended to be copies of well-known paintings by other artists – for example, a portrait of the actor Richard Brinsley Sheridan after Sir Joshua Reynolds, which Herkomer showed at the Royal Academy in 1881, and a portrait of Benjamin Disraeli after John Everett Millais, which he exhibited a year later at the Royal Academy. In 1882, he made a mezzotint after Millais's painting *Caller Herrin'* (Figure 136), which was published by the Fine Art Society. Millais's painting had been shown the preceding year at the Society's Bond Street galleries in a special exhibition of his work. The print is one of Herkomer's best, its deep, full tones and vaporous forms emitting a soft glow that suggests the glory days of mezzotinting in the eighteenth century. One of Herkomer's favourite devices was a dedicatory portrait annotation; in this case, he etched a tiny portrait of Millais at the lower left (a self-portrait appears at the lower right), which also signified their close friendship at this time.

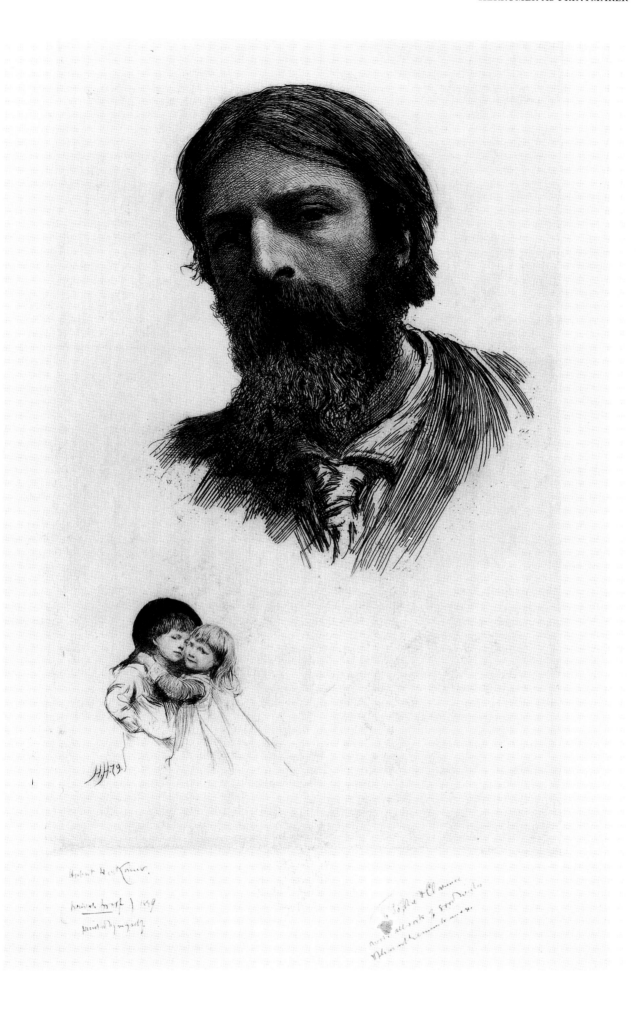

133 *Self-portrait* with
portraits of Siegfried
and Elsa Herkomer in
the lower left corner,
etching, 1879

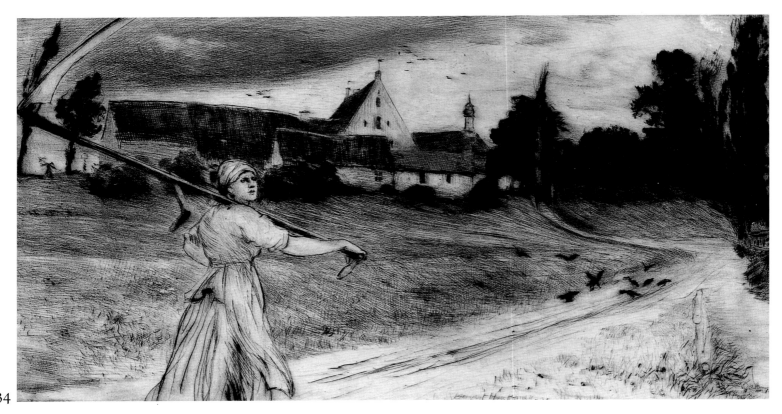

134

134 *Wild Weather*, 1891, drypoint

135 *Ivy*, c. 1896, hand-coloured herkomergravure

While mezzotint allowed Herkomer to explore a wide tonal range, he found the work slow and labour-intensive. As he explained in his book, he sought a way to produce multiple prints that were a painter's rather than an engraver's art, not requiring acid or cutting tools. The process he came up with was the 'herkomergravure' (he also called it 'spongotype'), which he patented in England and Germany.[10] This was a variation on the monotype process that the American artist William Merritt Chase had shown him during his stay in New York in 1885.[11]

The herkomergravure permitted the reproduction of multiple prints rather than the single image produced via monotype. Ink was smeared onto a copper plate and the artist designed the image with fingers or brushes. The plate was then dusted with a combination of special powders of Herkomer's invention, after which an electrotype was taken. It could then be processed in the standard manner of copperplate printing.[12] According to Marion Spielmann, the editor of the *Magazine of Art*, the resulting images combined 'the softness and warm depth of mezzotint, the strength of etching, and the charming delicacy and expression of dry-point'.[13] Herkomer exhibited 33 of his painter-engravings (herkomergravures) at the Fine Art Society in January 1896, and wrote a preface in the catalogue explaining the process.[14] In a reflection of his concern for the social significance of the arts, which was consistent in all his experimental ventures, he noted that the herkomergravure was the least costly means for 'the artist ... to reach the masses with his autographic touch'.[15] As he did in his other experimental undertakings, he perfected the

135

herkomergravure process and then abandoned it. Even so, several of his prints became very popular with collectors, especially the Symbolist female images entitled *Roses* (1896) and *Ivy* (Figure 135).

His interest in the new process may also have waned because shortly after the opening of his exhibition at the Fine Art Society a professional art printer in London questioned the originality of the herkomergravure after reading about Herkomer's claims for it in an article in *The Times*.[16] In an echo of the etching debacle with Joseph Pennell, a Mr Dallas of Dallastype Press wrote a letter that was published in *The Times* informing the public that he had held a patent for an almost identical process since 1884, that earlier experiments with results similar to Herkomer's painter-engravings had been made in Vienna as early as 1851 and that, indeed, Herkomer hadn't invented anything at all.[17] Herkomer's preface to the catalogue of the 1896 exhibition acknowledges the existence of a much earlier invention that anticipates his own, but he states that it was a failure, where his was a success. No reply by Herkomer to the London art printer's claims is known, nor is there any other mention of disputes over originality in Herkomer's writings, but by the turn of the century he had lost interest in etching, mezzotint engraving and herkomergravure, saying only that 'the joy and interest in these branches of the graphic arts left me'.[18]

In the last five years of his life his enthusiasm for printmaking returned, and in 1909 he experimented with various lithographic techniques. Looking back nearly forty years, he turned to his most famous work, *The Last Muster*, reproducing it as a lithograph and garnering fresh praise with its reappearance in a new medium. With his customary didactic zeal, he gave lecture-demonstrations of his lithographic techniques, which he published in a book, *A Certain Phase of Lithography*, in 1910.

Clearly, Herkomer had a good deal of assistance with his printmaking, given his busy schedule and his many other activities in the arts. The graphic arts formed an important part of the curriculum at the Herkomer Art School. By 1883, when the school opened, a large building on the grounds of Herkomer's Bushey property was already in use as a print workshop. According to a visiting journalist at the time, a staff of workers executed prints under Herkomer's watchful eye.[19] Printmaking was a business venture for Herkomer, and he employed the highly skilled art printer Henry Thomas Cox as his personal printmaker and assistant.[20] The printing workshops were supervised by the graphic artist

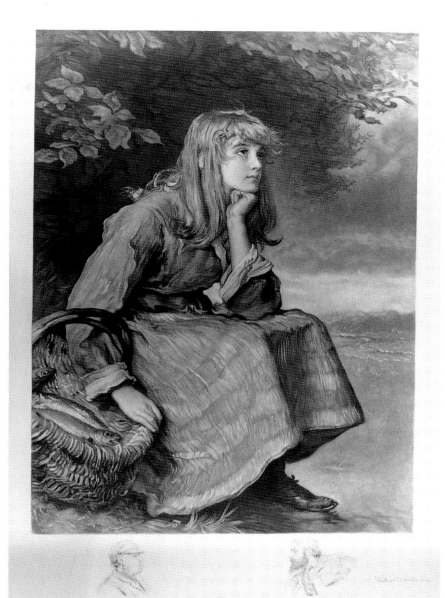

Daniel Wehrschmidt, whom Herkomer had brought from Cleveland, Ohio, specifically for that purpose. Wehrschmidt was a superb mezzotint engraver and an invaluable teacher at the school. Many of the students excelled at the difficult art of mezzotint engraving, and Bushey-trained printmakers were considered among the best in the world. When Herkomer's interest in the graphic arts declined in 1899, he sold his art printing business to Henry Cox. H. T. Cox and Sons remained among the foremost fine art printing firms in Britain until it closed in 1972.

136 *Caller Herrin'*, 1882, mezzotint, after the painting by John Everett Millais, *Caller Herrin'* (1881), with self-portrait etching lower right and etched portrait of Millais at lower left

The late years

In the last twenty years of his life, Herkomer's diversified interests and increasing celebrity in both England and Germany kept him constantly in the public eye. In addition to his attention-grabbing articles, books and lectures, Herkomer had a firm ally in Marion Spielmann, the editor of the *Magazine of Art*, with whom he maintained a lengthy and revealing correspondence.[1] At a time when the artist was reaching for inspiration and renewal, Spielmann wrote several laudatory articles about Herkomer's experimental work in the graphic arts and enamelling. But in general, reception of Herkomer's later paintings tended to be more critical as he branched out into themes such as allegorical images of the female nude that contrasted markedly with his earlier work.

There is no question that Herkomer's wide-ranging interests and activities led to a dissipation of focus on his painting, the occupation that he himself considered his 'anchor'.[2] With his publicity machine running at full bore, contemporary audiences could not fail to notice the change in his artistic interests over the years. Herkomer himself, cognizant that his diverse activities elicited unfavourable comment at times, devoted a chapter in his memoirs to the problem.[3] In his opinion, the English, as opposed to his German audience, were intolerant of versatility:

In Germany versatility is written down to the credit of the artist, as it was in the time of the Renaissance. It was a real necessity that drove me to vary my work, to give free vent to the experimental side of my nature. Had I not done so, but listened to the cry – 'Stick to your painting, and to that only!' – I should have died of inanition.[4]

Herkomer's perception of his own basic temperament impelled him to devote time to a number of activities 'to rectify', as he put it, 'a mental deficiency. I had to do many things in order to succeed in one.'[5] Whatever the reason for his constant need for diversion, the results testify to his extraordinary energy and to an ego that could confront any new challenge head on.

In March 1897 Herkomer wrote to Spielmann that he had 'at last tackled the most precious and difficult of all the arts – Enamelling'.[6] His aim was to take on what he termed 'the revivalists' in this art form,[7] that is, the Limoges School Revival of French enamellists, who utilized the old techniques and processes rediscovered by employees of the porcelain factory in Sèvres in the early nineteenth century. With modifications, Herkomer adapted the Limoges technique for

his own enamel work.[8] 'Never before in the history of the world', he wrote, 'has the decorative artist had so many beautiful materials to choose from for his art. Chemistry, metallurgy, mechanics, have put magical possibilities before him.'[9] While few painters took up enamelling (one exception was James Tissot, who made cloisonné enamel vases when he was living in London in the late 1870s), the medium had captivated a number of artisans active in the Arts and Crafts Movement in England, for example, Charles Robert Ashbee (1863–1942), who in 1888 founded the School and Guild of Handicraft in London, where craftsmen executed his elegant designs for enamel jewellery and other *objets*. For Herkomer, enamelling was an ideal extension of the Arts and Crafts aims that had inspired the building of his house Lululaund, with its neo-medieval wood carvings and weavings. He also felt that enamelling's vibrant colours would inspire greater colourism in his painting, and certainly his later works *do* display a lighter palette of brighter (though sometimes hard-edged) tones (see, for example, Colour plate XIII).

After spending a few weeks in the spring of 1894 in Somerset near the home of his friend the artist John W. North, Herkomer completed a large quasi-Symbolist painting of a female nude with the allusive title 'All Beautiful in Naked Purity' (Figure 137), which he showed at the Royal Academy that year. The bold sensuality of the naked figure – devoid of the references to classical myth or timeless legend found in the paintings of G. F. Watts or Frederic Leighton – was adversely criticized. Before exhibiting this work, Herkomer, in a rare attack of self-doubt, wrote to Spielmann that 'the press I fear will "go" for me for another departure . . . I grieve it much that you cannot see it before it goes into that all-destroying stomach – the Royal Academy walls!'[10] With its *Jugendstil* modernity, the imagery in the painting was more palatable to Continental taste, and it was shown successfully in 1895 at both the Munich Secession and the Paris Salon. Herkomer positioned a similarly posed nude female figure for the centrepiece in his great decorative enamel, a shield approximately five feet long[11] entitled *The Triumph of the Hour* (Figure 138), as well as for a smaller related enamel, *Beauty's Altar* (1900; present location unknown).

The leading figure among English art enamellers at the end of the nineteenth century was Alexander Fisher (1864–1936), whose pictorial style directly

influenced most of the art enamellers of the period, including Herkomer.[12] A prolific writer about the art of enamelling, Fisher advocated the making of unique pieces rather than the multiples manufactured by commercial enamellers. His painterly enamels, given devotional or allegorical titles (for example, *The Bridge of Life*, 1895), were small in scale and often set into elaborate frames. In contrast, Herkomer attempted to paint very large pieces that required innovative techniques of firing and mounting.

As in his experiments with printmaking, Herkomer needed a large support staff of skilled workers for enamelling. He set up an enamelling workshop on his Bushey estate grounds, where his assistants, numbering at least five, experimented with his designs and various chemical mixes.[13] In his memoirs, he devotes a long chapter to describing the technical details of the process, which at times appeared daunting;[14] the results were decidedly mixed. As many as 12 firings[15] were needed for each of the eleven panels that comprised *The Triumph of the Hour*. Herkomer kept a single example of each plate for reference,[16] several of which survive (see Colour plate XXIV). For this extraordinary object he devised a complex allegorical programme, with abstract epithets (which make little sense) concerning love, death, hope, doom and so on, assigned to the nude figures on each panel.[17] The panel titles (see caption, Colour plate XXIV) echo the moralizing sentiments of G. F. Watts's late allegorical paintings, which by the 1890s were an integral part of the international Symbolist canon. Herkomer had known Watts since the 1870s and deeply admired him;[18] in 1897, he painted a watercolour portrait of the aging artist as a gift (see Figure 95). Herkomer later asked to borrow Watts's painting of a male nude that hung in the living room of Limnerslease (Watts's residence near Guildford) so that he could duplicate the tones in one of his enamels.[19] A more overt homage is Herkomer's small enamel, *Souvenir of Watts* (Figure 139), in which the pose of the two nude figures is based on the painting that established Watts's international reputation, *Orpheus and Eurydice* (c.1879; Salar Jung Museum, Hyderabad, India).[20] By paying tribute to Watts, who was then in his eighties and at the height of his fame, Herkomer may have sought to validate his latest experiment in the arts and to justify the allegorical programme for *The Triumph of the Hour*. Whatever the reason, Spielmann's two-part article about this purely decorative piece, published in 1899 for the *Magazine of Art*, raised Herkomer's hopes for a buyer.[21] But the projected sale did not materialize, and the present whereabouts of the shield remain unknown – possibly it was destroyed in World War II.

Herkomer produced about 12 enamel pieces;[22] his studio continued to produce vases and some jewellery after he himself gave up the technique.[23] While enamelling represented to him another link in the

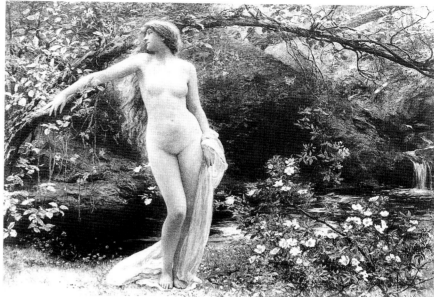

137

138

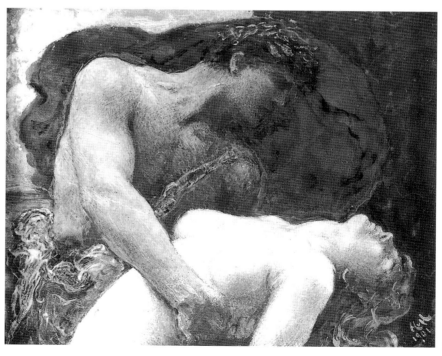

139

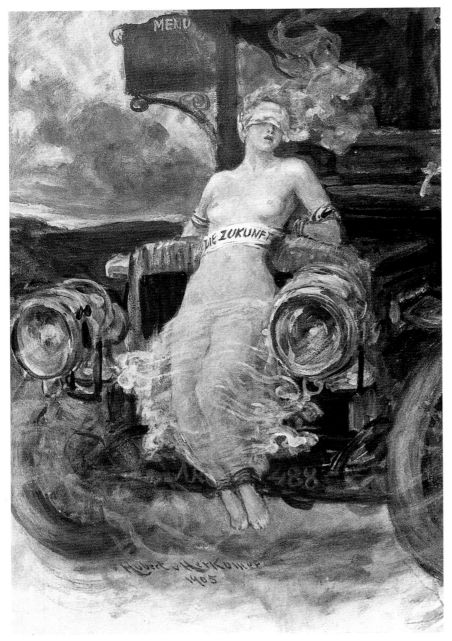

140 *Die Zukunft* (*The Future*), 1905. Coloured photogravure on menu card

the enamel portrait both for its historical significance and for the aesthetic challenge.[27]

Herkomer worked for over a year with his assistants in Bushey, completing the huge enamel piece in 1901. More than six feet high, it was fired in 12 separate panels that were joined with metal strips, much like stained glass. The joints attracted some criticism[28] and when the work was exhibited in Berlin in February 1901, it received a mixed reception.[29] More importantly, the Kaiser disliked it. The portrait was shipped back to Bushey, where it was broken up and destroyed by the artist.[30] Needless to say, this experimental chapter in Herkomer's quest for unity in all the arts was closed.

Another intriguing late work is Herkomer's gift to the citizens of his birthplace, Waal in Germany, five miles from Landsberg, where he spent his summers. Completed in 1902, the *Kriegers Denkmal* (war memorial) was dedicated to those who had fought in the Franco-Prussian War. A huge Art Nouveau stone sculpture designed in the form of a curved seat, it is decorated with groups of allegorical nude figures in relief.

In October 1905 Herkomer travelled to Spain for the first time, partly to boost his failing health. He stayed mostly in Valencia, where he painted several subject pictures of gypsy beggars, one of which, *Gypsy Mother and Children* (1905; Beaverbrook Art Gallery, Fredericton, New Brunswick, Canada) recalls the group of the mother and her children in his celebrated painting *Hard Times* of 1885. As might be expected from a man of his theatrical flair, he responded vividly to the bullfights he attended, writing enthusiastically to Mansel Lewis of the 'gorgeous dress' of the matadors.[31] These inspired two colourful bullfighter portraits, *Morenito: Toreador of Valencia* (1905–1906; Oldham Art Gallery) and *In the Arena* (1905–1906; present location unknown); the latter was shown at the Royal Academy in 1906.

chain of aesthetic unity, Herkomer feared that the word 'decorative' would be considered pejorative by English critics.[24] His enamel pieces evidently excited more interest in Germany, where he felt the audience was more receptive to decorative art.[25] For a special exhibition in Berlin in 1900 devoted to his work, Herkomer brought from England two enamel pieces – a portrait of Mandell Creighton, the Bishop of London (1899; Merton College, Oxford), and the now-lost enamel *Beauty's Altar* – in addition to portraits and subject pictures such as *Our Village* (see Figure 123). While visiting this exhibition, Kaiser Wilhelm II particularly admired the enamel of the Bishop. The artist offered to paint the Kaiser's portrait in enamel, and he asked to be portrayed in full royal regalia.[26] A preliminary watercolour of the Kaiser's face (see Figure 108) was approved and the artist, working without an official commission, decided to execute

Always fascinated by the latest technology, Herkomer embraced the automobile in the earliest stages of its use. By 1903, long before automobiles became commonplace, he had given up his carriage and horses, and he had even shipped his car across the Channel to facilitate travel between portrait-painting commissions on his yearly excursions to Germany.[32] Several drawings and illustrations from this period reveal Herkomer's love of speed, his sense of the changing concepts of time and space and his enthusiasm for the potential of modern transportation. One, a menu card designed in 1905 (Figure 140), depicts a female nude strapped to the front of an automobile, the sash across her torso inscribed with the words 'Die Zukunft' ('The Future'). Such imagery not only reflects the general current of interest in progressive technology, it also forecasts the work of the Italian Futurists, who held their first joint exhibition in Paris in 1909.

Herkomer's sponsorship between 1905 and 1907 of an automobile race, the Herkomerkonkurrenz, made his name a household word in Germany and the speed trials served as a precursor of international grand prix racing. 'Just now all Germany is excited about the Herkomerkonkurrenz', he wrote to his Uncle John. 'I find I am the most popular man ... Such a funny feeling for my name to be on every lip and every corner of the street ... I seem to have wakened the sporting element that lay dormant in the race of Germans.'[33] His Art Nouveau style design for the silver, bronze and enamel trophy (1904; Herkomerstiftung) that was awarded to the winner of the race featured nude allegorical figures representing 'the joy of speed'.[34] He sponsored racing in England as well – his youngest son, Lawrence, was a keen racing driver – and the design of his drawing *Die Zukunft* (see Figure 140) was struck as a silver medal (1908; Bushey Museum Trust), to be awarded as a trophy by the Motor Union of Great Britain and Ireland. On the sash, the German words were replaced by the English translation – 'The Future'.

Photographs of Herkomer in his Daimler (chauffeured by the electrical engineer from Lululaund) were often featured in auto magazines of the day, but the car was used for more than keeping portrait-painting appointments or speeding around the countryside. After he had critical stomach surgery in 1912, his automobile also became an essential tool for making art. Recuperating in Bournemouth for five weeks in the spring of 1912, he was chauffeured every afternoon to the New Forest where he started painting, on the spot, a series of small impressionistic oil sketches.[35] After returning to Bushey, he continued to paint landscape sketches from the car, enjoying the 'pleasurable hit or miss'[36] possibilities of working on such a small scale. Sixty of these were gathered together for what would prove to be the last exhibition of his works during his lifetime; it opened in London in May 1913 at the Leicester Galleries. He called it 'England: Lovable and Paintable', drawing the title from one of his Royal Academy lectures of 1900. For the most part, the sketches are exuberant splashes of colour and form that are a complete departure from his other late work. Paintings from the series such as *The Farmyard, Pulborough* (1912; Southampton City Art Gallery) and *The Cowboy* (1912; Beaverbrook Art Gallery, Fredericton, New Brunswick, Canada) are the artist's radiant homage to the gentle countryside of his adopted homeland.

Conclusion

While Herkomer was very much a man of his time as far as the narrative aspect of his art is concerned, his ability to reinterpret a traditional thematic repertoire with bold realism and with stylistic devices such as flattened or abstracted forms, arbitrary colours and slashing brushstrokes – all working to produce a heightened emotional intensity – reveal a vision closely in tune with forward-looking developments on the international stage. Herkomer's influence on his younger English colleagues has generally been passed over, principally because perception of their loyalty to Bastien-Lepage has been so pervasive, and partly because of Herkomer's own stylistic inconsistencies – his waffling back and forth between the delicate Idealism of Walker and his own more vigorous and assertively idiosyncratic style.

Herkomer's eagerness to explore all facets of art makes him a fascinating figure, one far ahead of his time. His enthusiasm for all that he undertook and his desire to impart the knowledge he acquired in the process is infectious and in many ways endearing, rendering him a more sympathetic personality than his contemporaries could (or wanted to) appreciate. His obsession with his own celebrity, along with the historical significance he assigned to portrait painting, permitted him to shape both his era and his own public image for transmission to later generations. His success in other creative endeavours, such as film, theatre, printmaking and the decorative arts, also places him at the cutting edge of the modern age. His fascination with new technologies seems to have been limitless. As a pioneer of the British film industry he set the highest aesthetic and technical standards. His innovative work with scenic theatrical lighting foreshadowed the spare illusionism of avant-garde drama and opera in the twentieth century. And his vision of a fast-paced future through his advocacy of the automobile, then in the earliest stages of its development, was prescient.

Herkomer's attempt in art and life to integrate Germany and England set him on a multi-cultural course of impenetrable barriers, much as he tried to break them down, and this created the tensions that ultimately bedevilled him. On the one hand his German portrait-painting colleagues perceived him as 'The English Lenbach', but, on the other, he was blackballed for the presidency of an English art organization because he was regarded as a foreigner. Ignoring such signs of disapproval, he blithely battled on, brushing aside the insults while sinking his teeth into the next art experiment with wondrous enthusiasm. Travelling back and forth between Germany and England in the decade before the Great War, he considered the burgeoning hostilities between the two nations to be a mere ploy heated up by journalists. His political naivety probably kept him sane and his death just before the outbreak of the war was a blessing. His love for both his native Germany and his adopted homeland, England, enriched his life immeasurably, but it also increased the misunderstandings and complications that ensued after his death.

Epilogue: Herkomer and Vincent van Gogh

Herkomer's animated and expressive black-and-white illustrations for the *Graphic* magazine which sparked, in turn, his most inventive subject paintings, left their mark on one of the great figures of emergent modernism, Vincent van Gogh (1853–1890).

The influence of the English illustrators on van Gogh's artistic development has been acknowledged for some time. Herkomer was the black-and-white artist whose work van Gogh admired most, and whose name is the most frequently mentioned in his voluminous correspondence.[1] As van Gogh's letters indicate, he was influenced by a complex range of sources throughout his brief career. There is no question that Herkomer's thematic, technical and even personal originality were consistently inspirational to him. But to what extent did Vincent's enthusiasm reflect widespread admiration for Herkomer? The elder artist had established a Continental reputation early in his career with the phenomenal success of *The Last Muster* (see Colour plate XVII) at the Universal Exhibition in Paris in 1878. *Eventide* (see Colour plate XV), shown the following year at the Paris Salon, was also well received. During this time several of Herkomer's Bavarian themes, such as *After the Toil of the Day* (see Colour plate VIII), *Light, Life, and Melody* (see Colour plate XI) and *Souvenir de Rembrandt* (Walker Art Gallery, Liverpool), were reproduced in the French periodical *L'Art*.[2] From 1879, Herkomer also exhibited in Germany where his work was consistently praised. In fact, French critics cited his German origins when pointing out the differences between his work and that of his English colleagues,[3] and indeed van Gogh himself, who often equated Herkomer's vision with that of Continental artists and writers,[4] specifically recognized Herkomer's German sensibility. 'The Germans have their special humour, quite different from that of the English', van Gogh wrote to his brother Theo; 'Herkomer has painted among other things a peasants' carnival . . . which has this humour very strongly' (see Figure 62).[5] At least one other Dutch artist, the Hague School painter Josef Israëls (1824–1911) admired Herkomer's work. 'Recently I passed Israëls' house', van Gogh wrote in 1883:

I have never been inside – the front door was open as the servant was scrubbing the hall. I saw things hanging in the halls and do you know what they were? The large Herkomer 'Last Muster, Sunday at Chelsea,' and the photograph of the picture by Roll, 'Grève de Charbonniers' . . .[6]

Although it has been suggested that Israëls's depressing and dark-toned images of peasant poverty provided a source for the social themes of artists at the *Graphic* like Herkomer and Holl,[7] it is apparent from the above passage that the influence worked both ways. Israëls, who began exhibiting at the Royal Academy in 1871, also kept in his studio a photogravure of Herkomer's portrait of J. Staats Forbes (Israëls's English patron), painted in 1881 (present location unknown).[8] That Herkomer's reputation on the Continent was well established by the beginning of the 1880s makes van Gogh's interest in him, manifested by 1881, less like the completely odd and isolated phenomenon it is sometimes assumed to have been.

Van Gogh derived his interpretation of Herkomer's personality and character from two written sources: his reading of 'a kind of biography' (I, T263) of Herkomer which appeared in the *Graphic* after *The Last Muster* won a medal of honour at the Paris Universal Exhibition in 1878, and Herkomer's article, 'Drawing and Engraving on Wood', published in the *Art Journal* in 1882.[9] Van Gogh had received a copy from his friend, the artist Anthon van Rappard in November 1882 (III, R17), and he was so taken with it that he mentions it at least eight times in his correspondence. 'The whole thing is thoroughly sound and honest', he wrote to his brother Theo; 'His manner of speaking impresses me the same as some of Millet's letters. To me it is an inspiration, and it does my heart good to hear someone talk this way' (I, T240). Although van Gogh expressed a strong desire for friendship with Herkomer (II, T314), their paths were never to cross, and van Gogh's plans in the spring of 1883 to pursue a career in England as an illustrator and to meet Herkomer there, were sadly aborted for lack of funds (II, T288).

Himself beset by so many career and personal frustrations, van Gogh identified his own struggle for recognition and success with what he understood to be similar difficulties for Herkomer at the beginning of his career. The information van Gogh garnered from the 'biography' about Herkomer's poverty-stricken early years sparked a sympathetic response from the younger artist, who was himself frequently near starvation. He also empathized with Herkomer's attempt to overcome the problems of his chosen craft through sheer determination and hard work. 'He is not a man who works easily', wrote Vincent:

On the contrary, ever since the beginning he has had to struggle with a kind of awkwardness, and no picture is finished without severe mental effort. I can hardly understand why, even now, many call him rough. I can hardly think of any work more profoundly sensitive than his. (I, T263)

Van Gogh began to purchase copies of the *Graphic* soon after he moved to The Hague in December 1881 (I, T169, January 1882), and by January 1883 he owned a complete run of 21 volumes dating from 1870 to 1880.[10] He removed the wood engravings from their magazine bindings and mounted them on brown or grey paper, pinning his favourites to the wall of his room (I, T169; 7 January 1882).[11] Although van Gogh lived in London for almost three years (between May 1873 and December 1876) while working as an assistant at the art dealership Goupil and Company, he purchased no English illustrations. During this period, however, he was certainly aware of the two important English illustrated weeklies, and their contents. In February 1883 van Gogh wrote to his friend van Rappard:

I assure you that the *Graphics* I have now are amazingly interesting. More than ten years ago, when I was in London, I used to go every week to the show windows of the printing offices of *The Graphic* and the *Illustrated London News* to see the new issues. The impressions I got on the spot were so strong that, notwithstanding all that has happened to me since, the drawings are clear in my mind. Sometimes it seems to me that there is no stretch of time between those days and now – at least my enthusiasm for those things is rather stronger than it was even then. (III, R20).

During the early years in The Hague, when van Gogh's aesthetic vision was relatively unformed, his primary response to imagery that inspired him, such as the English illustrations, tended to be an intellectual one. He still dwelled more on the substance of art and literature that fuelled his own humanistic sensibility than, as later on, on art informed by more purely aesthetic concerns. Thus, to him Charlotte Brontë's *Jane Eyre* was 'as beautiful as pictures by Millet or Boughton or Herkomer' (I, T148); George Eliot and Balzac were 'so astonishingly "plastic" ... that their work is just as powerful as, for instance, a drawing by Herkomer or Fildes or Israëls' (III, R8), to cite just two of van Gogh's enthusiastic responses. The following excerpt from a letter to his brother Theo is revealing:

What I appreciated in Herkomer, Fildes and Holl and the other founders of *The Graphic*, the reason why they still mean more to me than Gavarni and Daumier and will continue to, is that while the latter seems to look on society with malice, the former – as well as men like Millet, Breton, de Groux, Israëls – chose subjects which are as true as Gavarni's or Daumier's, but have something noble and a more serious sentiment. That sentiment especially must remain, I think. An artist needn't be a clergyman or a church warden, but he must certainly have a warm heart for his fellow men. (I, T240; 1 November 1882)

Van Gogh first mentions Herkomer in a letter to his brother Theo written from Brussels in April 1881 in which he discusses his admiration for Herkomer and other English artists (I, T142). Although he had not yet acquired his collection of English engravings, his knowledge of English art was up to date. He knew about the celebrated success of Herkomer's *The Last Muster*, which was modelled on his *Graphic* illustration, *Sunday at Chelsea Hospital* (see Figure 73), 'the origin', as van Gogh informed Theo, 'of a picture that has since gained the wonder and admiration of the best in Paris as well as in London' (I, T263).

The images by Herkomer that van Gogh most admired were the two published engravings (see Figures 73 and 75) of Chelsea Pensioners that inspired *The Last Muster* and their female counterpart, *Old Age: A Study in the Westminster Union* (see Figure 81), which formed the basis for *Eventide* (III, R24; I, T263). The subject matter of these works particularly appealed to him, because socially aware themes formed the basis of his own work at the time (I, T240; 1 November 1882). Such sentiments underscored his belief in the necessity that 'soul' be found at the core of a work of art. 'The soul of civilization ... What is it?' he was to write from Drenthe in September 1883; 'The eternal quality in the greatest of the great: simplicity and truth: Dupré, Daubigny, Corot, Millet, Israëls, Herkomer' (II, T339A).

Like Herkomer, who visited specific London locales for his pensioner and workhouse engravings, Vincent made numerous trips to the workhouse near his studio in The Hague and paid the 'orphan men' and 'orphan women' (local terminology for workhouse inmates) to pose for him (I, T235; October 1882). His resulting series of drawings and lithographs was directly inspired by the previously mentioned examples by Herkomer, to which Vincent ascribed his own titles such as 'Orphan Men', 'Old Mens' Almshouse' and 'The Invalids'.[12] Two drawings by Vincent, *Schweningen Woman at the Mantelpiece, Sewing* and *Old Woman Seen from Behind*, enclosed in letters to Theo a few months after he had begun to acquire his *Graphic* engravings, indicate how closely he had absorbed the poignant mood as well as the individual poses of Herkomer's workhouse illustrations.[13]

Van Gogh's lithograph *At Eternity's Gate* (Figure 141) evinces more specifically Herkomer's portrayals of the loneliness and tragedy of institutionalized old age. Modelled on a workhouse inmate with 'a queer bald head, large deaf ears and white whiskers' (I, T235), *At Eternity's Gate* has a powerful emotional impact that is accentuated by the old man's clenched fists and by the unsettling angle of the pose. With its reference to death in the title ('At Eternity's gate' is inscribed in English in the bottom left-hand corner) and pitiable tone, van Gogh's subject shares the same traits, in both its thematic and visual intent, with his favourite engravings by Herkomer. In a larger sense,

both artists' images evoke pathos and symbolize human sorrow and man's ultimate fate. A few months before his death in 1890 van Gogh painted an oil version of *At Eternity's Gate* (1890; Rijksmuseum Kröller-Muller, Otterloo), a symbolic epitaph to his own brief and tragic career.

In November 1882 van Gogh produced what he hoped would be a popular edition of prints, which included *At Eternity's Gate*. Though the series did not achieve the financial success he had anticipated (I, T249), a group of labourers did admire that print and asked the printmaker for a copy for their workshop walls (I, T245). Keeping in mind Herkomer's suggestion that art could serve as an important educational tool for all levels of society,[14] he wrote that:

No result of my work could please me better than that ordinary workshop people would hang such prints on their room ... I think what Herkomer said, it is really done for you – the public, is true. Of course a drawing must have artistic value, but in my opinion this doesn't prevent the man in the street from finding something in it. (I, T245)

Apart from his admiration of Herkomer's socially aware subject matter and commitment to art's public impact, van Gogh was also inspired by the boldness of Herkomer's technique. The 'vigorous contour' of Herkomer's illustrative style, in particular, appealed to him (III, R37; May–June 1883). The animation and vigour of van Gogh's own drawing style, later translated into the thickly loaded, expressive brush strokes of his oil paintings, suggests that Herkomer provided an early source. Herkomer's advocacy in 1882 of a drawing style that was 'free and realistic in line, which purports to show the local tone and colour as well as the light and shadow',[15] was probably what van Gogh was referring to when he compared Herkomer's technique with that of the German painter Max Liebermann. 'From your description', Vincent wrote from Drenthe in reply to a letter from Theo about Liebermann, 'I see that he, Liebermann, must work somewhat in Herkomer's manner. Especially in systematically carrying through and analyzing the patches of light and shadow ...' (I, T325; September–November 1883).

Herkomer's article of 1882 provided the focus for van Gogh's further discussion of the editorial tone of the *Graphic* after 1880. In the article, Herkomer called attention to what van Gogh termed the *Graphic*'s new focus on 'materialism instead of moral principle' (I, T252, December 1882), exemplified by its dropping its series of 'Heads of the People' (to which Herkomer had made three contributions),[16] to reproduce instead chromolithographed 'heads' of society beauties. In a possible homage to the earlier series van Gogh produced a series of drawings of 'heads of the people' at the beginning of 1883.[17] One in particular, *Fisherman with Sou'Wester, Head* (1883; Norton Simon Foundation, Los Angeles), recalls the expressive face and deep-set staring eyes of Herkomer's *The Coastguards-*

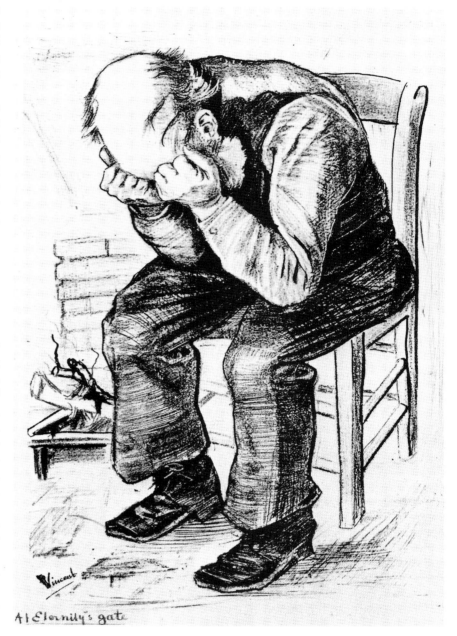

man (see Figure 31), the last of his 'heads' to be published in the *Graphic*, in 1879.

Herkomer's distinctive handling of compositional structure and space in his illustrations for the *Graphic* may also have encouraged van Gogh's artistic development. The distorted perspective that is so prominent an ingredient in many of Herkomer's engravings often sets his work apart from that of his colleagues. Since van Gogh was self-taught – like Herkomer he had little patience for formal training[18] – he resorted to mechanical aids (as had Herkomer at the outset of his career) to help him:

It is true that last winter ... I have spent more on making an instrument for studying proportion and perspective, the description of which can be found in a book by Albrecht Durer, and which the old Dutch masters also used. It makes it possible to compare the proportion of objects near by with those on a more distant plane, in cases where construction according to the rules of perspective is not possible. And

141 Vincent van Gogh, *At Eternity's Gate*, November 1882, lithograph

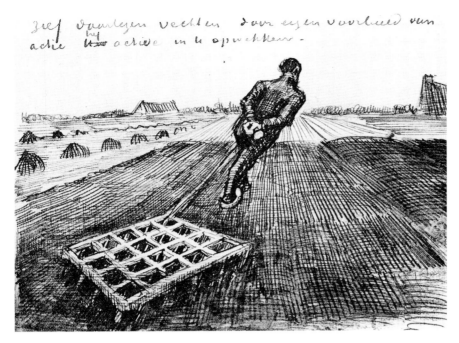

142 Vincent van Gogh, *Man Pulling a Harrow*, October 1883, sketch in letter T336

when one tries to do it with the eye alone – unless one is an expert and very far advanced – it is always hopelessly wrong.[19]

One precedent for deep perspective can be found in Dutch seventeenth-century painting and by extension, for example, the landscape paintings of van Gogh's Dutch contemporary Anton Mauve; it could thus be argued that van Gogh, as an inheritor of this Northern European tradition, was continuing a historical precedent. But his drawings such as *Road with Pollard Willows* (1881; Rijksmuseum Vincent van Gogh, Amsterdam), made at Etten in October 1881, and a drawing from Drenthe done in November 1883, *Man Pulling a Harrow* (Figure 142), which has an even more pronounced spatial distortion, go far beyond the unified space of more conventional art. Rather, these early examples suggest the nurturing force of the similar handling of space that he found in Herkomer's wood engravings. During his formative years van Gogh was still relatively isolated in an aesthetic sense from, for example, the bold structural innovations which had already taken place in Paris in the 1870s. It was not until he moved to Paris in 1886 that his work revealed a strong commitment to the innovations of contemporary French painting as well as to the formal characteristics of Japanese prints. Yet in a letter written from Arles in May 1888 van Gogh indicates that he was still unfamiliar with the work of Caillebotte whose 'manipulations of perspective to produce

overwrought sensations', according to one current scholar, 'links him to Munch, van Gogh, and later artists of expressionist bent'.[20]

Although van Gogh last mentions Herkomer in a letter written to Theo in August 1885 (II, T418), as late as 1888 he was still creating images that reflect the filtering of earlier *Graphic* sources. A painting such as *Gauguin's Chair* (Rijksmuseum Vincent van Gogh, Amsterdam) which van Gogh painted in Arles in 1888 and which he once entitled 'his empty seat' (III, T626A), is obviously derived from Luke Fildes's engraving *The Empty Chair*, published in the *Graphic* Christmas number of 1870.[21] Similarly, van Gogh's celebrated painting *The Night Café* (Yale University Art Gallery, New Haven), also painted at Arles in that year, echoes several of the fundamental elements of Herkomer's *Graphic* illustration *The 'Schuhplattl' Dance* (see Figure 39) of 1873.[22] Both are night-time tavern interiors, though van Gogh's description of his café as a place 'where one can ruin oneself, go mad, commit suicide' (III, T534) contrasts with the mood of Herkomer's more relaxed image of peasant dancers. Nevertheless, Herkomer's tilted perspective underscores the frenzied immediacy of the dancers' movements, an emotionally charged conception of space that van Gogh pushes towards an even more exaggerated dimension.

Likewise, *Dormitory in the Hospital, Arles* (Collection Oskar Reinhart, Winterthur), Vincent's portrayal of the place where he was confined for some weeks in May and June 1889, evokes parallels with Herkomer's engraving *Old Age* (see Figure 81), which is similarly set in a charitable institution. The two images share comparable thrusting spaces and looming clusters of seated foreground figures. The figures in the middle ground of Vincent's interior, who seem to be shuffling towards a dark opening crowned with a crucifix, suggest vague overtones of impending death, which is an undercurrent in Herkomer's bleaker setting as well. By the time van Gogh's Arles hospital dormitory had evolved into the similarly structured *A Passage-Way at the Asylum (St. Rémy)* (Museum of Modern Art, New York), the locale of his confinement in October 1889, the expressive space, more disorienting and stripped of humanizing elements except for one lone figure, has become a forbidding enclosure leading to a black, coffin-shaped void at the end of a corridor. Thus, in a way, van Gogh's commitment to the core of Herkomer's expressionist 'soul', remained a force in him to the end.

A catalogue of Herkomer's magazine illustrations

The Quiver

A thousand times is former woe repaid by present bliss.
(1868), 73.

Good Words for the Young

Lonely Jane (1 November 1868), 28.
Miss Jane (1 November 1869), 44.
Ursula Swayne's Troubles (1 April 1870), 333.
Jack and Jane (1 June 1870), 444.
Amy and her Doves (1 January 1871), 176.

Fun

Just So! (27 February 1869), 250.
Murder Will Out (1 May 1869), 84.
Rather like It (17 July 1869), 196.
Looking Ahead (18 December 1869), 154.
The Recent North Easters (30 April 1860), 78.

The Sunday Magazine

Diana's Portrait (1 April 1870), 400.
Diana Coverdale's Diary (1 June 1870), 536.

The Cornhill Magazine

The following three are illustrations for *The Story of the Plebiscite*:

I had grasped a pitchfork: Gredel stood behind with an axe.
(February 1872), 6.
I was beside myself with rage, and had already lifted my whip handle. (March 1872), 256.
There was Gredel in the arms of Jean Baptiste Werner. (April 1872), 476.

The following two are illustrations for *The Last Master of an Old Manor-House*:

Ah murderer! You have drawn blood from me. (September 1872), 357.
Here is a ducat. I have no more: all the rest is for my burial.
(October 1872), 475.

The Illustrated London News

Tita's Wager (13 December 1873), 572.

The Graphic Magazine

Where known, exhibited works in other media that are related to a *Graphic* engraving are noted in square brackets, along with their exhibition venue.

A Gypsy Encampment on Putney Common (18 June 1870), 680.

A 'Smoking Concert' by the Wandering Minstrels (25 June 1870), 717.
(A) *Aldershot – After a Field Day* and (B) *Aldershot – The Highland Camp* (both 16 July 1870), 69.
Anxious Times – A Sketch at Tréport, France (26 November 1870), 512. [Watercolour, *At Tréport – War News – 1870*, Dudley Gallery, 1871.]
(A) *Prussian Spies at Tours* and (B) *Count Kératry's Breton Army – Trying on Uniforms at St. Quimper* (both 3 December 1870), 549.

The Winter Campaign: Preparations for Firing (17 December 1870), 596.
The Inundation at Rome (28 January 1871), 73.
Sunday at Chelsea Hospital (18 February 1871), 152.
[Watercolour, *Chelsea Pensioners at Church*, Royal Institute of Painters in Watercolour, 1871; oil, *The Last Muster*, Royal Academy, 1875.]
A Sketch at a Concert Given to the Poor Italians in London (18 March 1871), 253.
Returning from Work, A Sketch in the Tyrol (19 August 1871), 189. [Pen and ink, *Returning from Work*, Dudley Gallery, 1872.]
A Wood Carving School in the Bavarian Alps (2 December 1871), 549.
The Sunday Trading Question – A Sketch in Petticoat Lane (6 January 1872), 1.
Divine Service for Shepherds and Herdsmen – A Study at the Berner's Hall, Islington (20 January 1872), 56–57.
Rome – On the Steps of St. Peter's – 'Per Carità, Signori' (24 February 1872), 172.
Sketches of Musical Instrument Makers at Mittenwald, Germany (A) *Zither Makers* and (B) *Violin Makers* (both 2 March 1872), 205.
A Sketch in Newgate – The Garotter's Reward (9 March 1872), 221.
Rome – In Sanctuary: A Sketch Before the Holy Water Basin at St. Peter's (6 April 1872), 320.
A Roman Cardinal and his Footman (13 April 1872), 341.
Rome – The Quack Doctor (11 May 1872), 437.
Low Lodging House at St. Giles (10 August 1872), 124.
A Mountain Cheesemaker in the Tyrol (7 September 1872), 228.
[Watercolour, *Alpine Cheesemaker*, Royal Institute, 1873.]
Night in the Guard-Room at Aldershot (21 September 1872), 277.
Charcoal Burners in the Alps (28 December 1872), 608.
Sketches in the Bavarian Alps – The 'Schuhplattl Dance' (22 March 1873), 276. [Watercolour, *In a Bavarian Tavern*, Royal Institute, 1875.]
Sketches in the Bavarian Alps – The Arrest of a Poacher (17 May 1873), 465. [Watercolour, *The Arrest of a Poacher in the Bavarian Alps*, Royal Institute, 1876.]
Carnival Time in the Bavarian Alps (18 April 1874), 368–369.
[Watercolour, *Carnival Festivities in the Alps*, Royal Institute, 1874.]

The following two are illustrations for *Ninety-Three* by Victor Hugo:

'Ninety-Three' – Danton, Robespierre and Marat in the Wine Shop (2 May 1874), 421.
'Ninety-Three' – When the Sun Rose (8 August 1874), 133.
Sketches in the Bavarian Alps – A Wirthshaus (30 January 1875), 112. [Oil, *Natural Enemies*, Royal Academy, 1883.]
Sketches in the Bavarian Alps II: 'Der Bittgang' (13 February 1875), 160. [Watercolour, *Der Bittgang*, Royal Institute, 1874; oil, *Der Bittgang*, Royal Academy, 1877.]
Sketches in the Bavarian Alps III: 'Auf der Alm' (27 March 1875), 297. [Watercolour, *Auf der Alm*, Grosvenor Gallery, 1879.]
A Visit to the Berchtesgaden Salt Mine, Bavaria I – Crossing the Lake (3 April 1875), 328.
A Visit to the Berchtesgaden Salt Mine, Bavaria II – Going Down the Slide (3 April 1875), 352.
A Visit to the Berchtesgaden Salt Mine, Bavaria III – Coming Out (24 April 1875), 400.

'The Last Muster': Sunday in the Royal Hospital, Chelsea (15 May 1875), 474–475.
Heads of the People, Drawn from Life II – The Agricultural Labourer – Sunday (9 October 1875), 360.
Heads of the People, Drawn from Life IV: The Brewer's Drayman (20 November 1875), 508.
A Dilemma (24 June 1876), 610–611. [Watercolour, A Dilemma, Royal Institute, 1875.]
'At Death's Door' from the Picture by Hubert Herkomer in the Late Exhibition of the Royal Academy (26 August 1876), 217–218. [Watercolour, At Death's Door, Royal Institute, 1877; oil, At Death's Door, Royal Academy, 1876.]
Tourists in the Bavarian Alps – The Echo (7 October 1876), 353. [Etching, Echoes in the Alps, Dudley Gallery, 1878.]
Christmas in a Workhouse (25 December 1876), 30.
Old Age – A Study in the Westminster Union (7 April 1877), 324–335. [Oil, Eventide, Royal Academy, 1878.]
A 'Kegelbahn' in the Bavarian Alps (6 April 1878), 352–353. [Watercolour, Light, Life, and Melody, Grosvenor Gallery, 1879.]
Heads of the People – The Coastguardsman (20 September 1879), 292.

The following six are illustrations for Tess of the D'Urbervilles by Thomas Hardy:

There stood her mother, amid the group of children . . . (4 July 1891), 12–13. [Oil, Queen of the May, Fine Art Society, 1892.]
'This here stooping do fairly make my back open and shut', exclaimed the dairyman. (29 August 1891), 245.
'You be going to marry him?' asked Marion. (3 October 1891), 389.
They reached the cloister . . . (17 October 1891), 449.
On going up to the fire . . . (5 December 1891): 670–671.
He lay on his back as if he had scarcely moved . . . (19 December 1891), 725.

Appendix 2

Herman Gustave Herkomer (1862–1935) and his cousin Hubert von Herkomer

Herman Herkomer (see Figure 143), who was Hubert Herkomer's first cousin, was born and raised in Cleveland, Ohio, the son of Hans (later John) (see Figure 4) and Bertha Herkomer. He too had a successful career as a portraitist in London in the 1880s and 1890s and the similarity of his initials with Hubert's has caused some confusion.

After studying at the Art Students League in New York, Herman came to England in 1881, where he joined Hubert's household in Bushey and received some instruction from his older cousin. In 1882, he pursued further studies in Munich with Franz von Lenbach and in Paris with Gustave Boulanger and Jules Lefèbvre. Success came early, helped along by his cousin's fame, and he exhibited portraits at the Royal Academy (1883–1907) and the Paris Salon (1884–1903) as well as at other venues. Though he was primarily a painter of women, his portrait of Hubert Herkomer (Figure 144) (shown wearing his Slade Professorship robes) was his most acclaimed.[1] Exhibited at the Royal Academy in 1887 and at the Paris Salon in 1888 (where it received an honourable mention), it captures well the self-confident and slightly sinister air of Hubert, who was then 38 years old.

Like Hubert, Herman was musical and had a superb singing voice. A lively ladies' man, he enjoyed society and the company of the distinguished figures he painted. By the end of the century, however, demand for his portraits had waned and a bitter feud between the cousins ensued. Herman accused Hubert of taking credit for his portraits and of discouraging the Royal Academy from promoting him to membership, while Hubert accused Herman of trading on his (Hubert's) name and of causing confusion about who had painted what.[2] In 1915 Herman left England permanently with his wife, Blanche Griffin (a half-sister of the celebrated American actress Mary Anderson), and their four sons and settled on a fruit farm in Auburn, California. The farming venture failed and Herman lived out his remaining years an embittered and tragic figure. A number of his works are in the Crocker Art Gallery, Sacramento, California. While they reveal a certain competence, there is no question that his cousin possessed the superior talent.

143 *The Young Artist (Portrait of Herman G. Herkomer)*, c. 1882, oil on canvas

144 Herman G.
Herkomer, *Hubert
Herkomer*, 1887, oil on
canvas

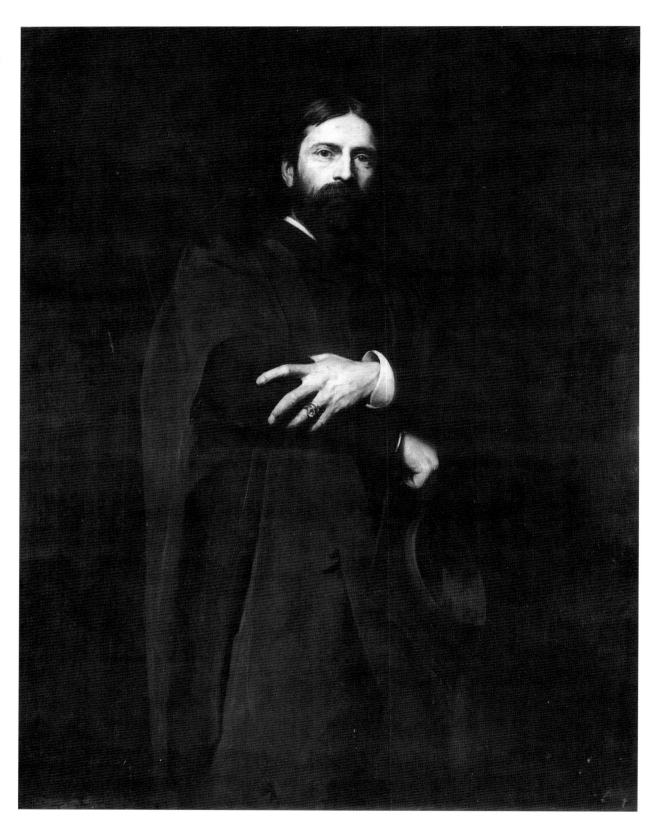

Notes

Manuscript and archival material is identified by location and collection; see 'Unpublished sources' at the beginning of the Bibliography. Page numbers for Volume 1 of the artist's autobiography *The Herkomers* (2 volumes, 1910) correspond to those in the large folio edition.

1 Herkomer's life: a path to success

1. Biographical material derives from Herkomer's own memoirs; his voluminous correspondence; his diaries and journals; the author's conversations with relatives; and contemporary interviews, articles and monographs. All are listed in the Bibliography. The early history of the Herkomers of Waal is documented in a handwritten memoir dated 20 November 1887 (New Haven, Herkomer Archive). Written by John Herkomer (Hubert's uncle) to his daughter Josephine Herrick of Cleveland, Ohio, after she enquired about the family's history, it reveals that the family was primarily of peasant stock, and the memoir gives a good account of the harshness of life in Bavaria in the late eighteenth and early nineteenth centuries. In the early years the family name was spelled 'Herkommer.'
2. Louis Engel, *From Handel to Hallé with Autobiographies by Professor Huxley and Professor Herkomer* (London, 1890), 135–137.
3. A letter dated 19 March 1824 from Mathias Herkomer to his wife in celebration of her forty-sixth birthday and their twenty-fifth anniversary is also signed by the six surviving children (New Haven, Herkomer Archive).
4. The Wurms settled in Southampton, England, soon after the Herkomers; see Engel, 142, 161. There were four Wurm sisters – Matthilde, Alice, Adele and Marie – all of whom were pianists. Marie adopted the surname Verne in 1893. Herkomer's drawing of his cousin Marie, *A Young Maiden* (1868), is in the Herkomerstiftung, Landsberg. Marie, who was a concert pianist of note, settled in Munich in 1925 and died there in 1938. Mathilde Wurm, who studied with Clara Schumann in Frankfurt (as did Marie) was successful in England from 1907 to 1936 as a renowned teacher and pianist. Her book *Chords of Remembrance* was published in London in 1936.
5. Herkomer's birthplace in Waal, marked by the two wall plaques, is now a bank building.
6. Suggested by the late Landsberg historian Professor Konrad Büglmaier, in conversation with the author, 10 June 1981.
7. Engel, *From Handel to Hallé*, 144; Hubert [von] Herkomer, *The Herkomers* (London, 1910), vol. 1, 16.
8. *Herkomers*, 1, 17–18.
9. Landsberg-am-Lech, *Herkomerstiftung*.
10. *Cleveland Plain Dealer*, undated advertisement (New Haven, Herkomer Archive).
11. J. Saxon Mills *Life and Letters of Sir Hubert Herkomer, C.V.O., R.A.: A Study in Struggle and Success* (London, 1923), 29.
12. *Herkomers* 1, 39.
13. 'Farewell Party at the Victoria Rooms', unidentified Southampton newspaper clipping inscribed in Mrs Herkomer's hand, 'December 22nd., 1874, Southampton. God bless my dear friends' (New Haven, Herkomer Archive).
14. The programme of one of Herkomer's zither recitals in Southampton, 20 April 1879, is in the *Herkomerstiftung*, Landsberg-am-Lech.
15. Engel, *From Handel to Hallé*, 176.
16. *Herkomers* 1, 26.
17. Ibid.
18. Engel, *From Handel to Hallé*, 152.
19. These are listed in the Bibliography.
20. *Catalogue of Printed Books and a Few Manuscripts: Property of Lady Herkomer and Others*, Sotheby, Wilkinson and Hodge (London, 1921).
21. See, for example, items in Herkomer's correspondence with Mansel Lewis (Llanelli, Mansel Lewis Collection).
22. 'Mein lieber Freund: Please don't be offended with me for not acknowledging sooner the kind gift of your novel. I am reading it with interest, but I read German slowly' (Herkomer to Paul Heyse, 13 February 1910; Munich, Bayerische Staatsbibliothek). On Herkomer's writing in German Bertha Herkomer wrote, 'Teresa is the housekeeper and just has to do all of Hubert's cooking and – brushes his hair before going to bed – besides helps him with his German and French letters' (to Mrs Frances Herrick, 4 May 1900 (New Haven, Herkomer Archive).
23. Interview with Hubert's first cousin once removed, the late Dr Francis Herrick, who as a child visited the artist in England (July 1982, Carmel, California).
24. 'Bilderbogen' (Engel, *From Handel to Hallé*, 154).
25. *Art Journal* (1882), 238.
26. *Herkomers* 1, 37–38.
27. Ibid., 40; Engel, *From Handel to Hallé*, 159.
28. George W. Sandell was a shipping broker with Sandell Brothers Ltd, of 6 Canute Road, Southampton. Interested in the arts, he founded an art club in Southampton and organized annual exhibitions. He often used artists trained at Herkomer's Bushey Art School to open these occasions, thus keeping Herkomer's name alive in Southampton. At Sandell's suggestion, Herkomer's widow donated the portrait of Lorenz Herkomer, the artist's father, painted by Herkomer in 1882 (see Figure 3), to the city of Southampton, where it remains today. See G. W. Sandell to C. W. Mansel Lewis, 23 September 1933, written when Sandell, who was two years younger than Herkomer, was 81 years old (Llanelli, Mansel Lewis Collection). Herkomer donated his palette in 1912. It is inscribed: 'The artist's favourite palette'.
29. Mills, *Life and Letters*, 38; *Herkomers* 1, 41.
30. Herkomer to Edmund Gosse, undated, probably 1882 (Leeds, Brotherton Collection).
31. *Herkomers* 1, 49.
32. Leibl was a student of Karl von Piloty and others at the Munich Academy from 1864–1870. See *Leibl und sein Kreis*, exhibition catalogue, Lenbachhaus (Munich, 1974).
33. For teaching methods at the Munich Academy, see Michael Quick, *Munich and American Realism in the Nineteenth Century* (Sacramento, 1978), 22–24.
34. Engel, *From Handel to Hallé*, 165.
35. *Herkomers* 1, 50.
36. This drawing is inscribed 'from life – 2 evenings – Munich' and dated '19th October, /64'. However, the same model appears in three other extant drawings, which are inscribed 'three evenings, 10-12-65; 31 Oct 65; 2 Nov 65 Munich', and are now in a private collection

in Bushey, Hertfordshire. The '64' date is evidently a mistake. Written in another hand, it may have been added later by Herkomer's father. It is most unlikely that the Herkomers were in Munich in 1864. Herkomer's memoirs clearly state that their six-month stay there occurred in 1865. See *Herkomers* 1, 48 ff.

37. *Herkomers* 1, 52.
38. Ibid., 57.
39. For example, in *Foxe's Book of Martyrs*, May and July 1866; in *Once a Week, Good Words* and the *Quiver* in 1867. See Forrest Reid, *Illustrators of the Sixties* (1928), 234–238.
40. Engel, *From Handel to Hallé*, 171. Herkomer told Edmund Gosse that the only progress he made at South Kensington was in his attempts 'to draw on wood . . . chiefly caused by the excellent drawing then appearing – of W. L. Fildes' (Herkomer to Gosse, n.d., probably 1882; Leeds, Brotherton Collection).
41. *Herkomers* 1, 57.
42. Engel, *From Handel to Hallé*, 171.
43. Hubert [von] Herkomer, 'J. W. North, A.R.A., R.W.S., Painter–Poet', *Magazine of Art* (1893), 342. The article was adapted from a lecture given by Herkomer at Oxford in 1892. North was a close friend of Walker.
44. Claude Phillips, *Frederick Walker and his Works* (London, 1894), 61.
45. M. H. Spielmann told Herkomer that the drawing was available. See Herkomer to Spielmann thanking him, 31 May 1893 (Manchester, Rylands Library). A number of sales of Walker's pictures took place in the 1890s.
46. See Rosemary Treble, 'Herkomer and Fred Walker', in *A Passion for Work: Sir Hubert von Herkomer 1849–1914* (Watford, 1982), 19; and Leonée Ormond, *George du Maurier* (London, 1969), 453.
47. 'The Institute of Painters in Watercolour', *The Times*, 24 May 1872.
48. *Herkomers* 1, 103.
49. Ibid., 83, 88.
50. See Leonée Ormond, 'The Idyllic School: Pinwell, North and Walker', in Joachim Möller ed., *Imagination on a Long Rein* (Heidelberg, 1988), 161–162.
51. See J. W. Comyns Carr, *Some Eminent Victorians* (London, 1908), 102–110.
52. *Herkomers* 1, 103.
53. German writers of the day also noticed this. For example, see G. H. Schneidek, 'Herkomers Einladungskarten', *Über Land e Meer* (1908), 159.
54. See *Herkomers* 1, 140.
55. Horace E. White, *Bushey's Painting Heritage* (Bushey, 1975), 4.
56. *Herkomers* 1, 69.
57. 'Messrs. Elliott and Fry at Baker Street', in H. Baden Pritchard, *The Photographic Studios of Europe* (London, 1881), 42–45. I am most grateful to Michael Pritchard, photographer and writer of Bushey, Hertfordshire, for mentioning this reference to me.
58. Copy of marriage certificate, Watford Record Office, 1873, p.106.
59. Herkomer to Mansel Lewis, 27 May 1883 (Llanelli, Mansel Lewis Collection).
60. Herkomer publicly acknowledged the unhappiness of his first marriage in Engel, *From Handel to Hallé*, 193.
61. Listed on marriage certificate (see n. 58, above).
62. Anna Herkomer to Mansel Lewis, 18 November 1878 (Llanelli, Mansel Lewis Collection).
63. Edmund Gosse, 'The World of Books: Herkomer', *Sunday Times* (6 May 1923). Gosse's comments appear in his review of J. Saxon Mills's biography of Herkomer.
64. 'Hubert Herkomer', *Graphic* (26 October 1878), 438.
65. Herkomer to Uncle John in Cleveland, 25 September 1876 (New Haven, Herkomer Archive); and Herkomer to Mansel Lewis, 12 October 1877 and 26 September 1878 (Llanelli, Mansel Lewis Collection).
66. 'Associates of the Royal Academy', *Illustrated London News* (1 May 1880), 429; Herkomer to Gosse, n.d., from Bushey, probably 1881 (Leeds, Brotherton Collection).
67. Fowler's lecture in Watford on 10 January 1877 was written up in the local press (New Haven, Herkomer Archive, clipping file). Phrenology is the study of a person's character as determined by the shape of the head. Fowler considered phrenological characteristics the determining factor in achieving good health. Lorenzo N. Fowler and his brother Orson S. Fowler (1809–1887) were the leading phrenologists of the Victorian era. Lorenzo spent most of his adult life in England, and founded a publishing house that specialized in phrenological literature.
68. *Herkomers* 1, opposite p.140, *Portrait of my Wife, Lulu* (1885).
69. The renaturalization papers are in the Royal Academy archives, London.
70. *Herkomers* 2, 22.
71. A typewritten memoir by a Bushey resident recounts the neglect of the two eldest children by their stepmother and asserts that neighbours often fed the children. I am grateful to Grant Longman for bringing this manuscript to my attention (Bushey, Bushey Museum Trust).
72. Herkomer's eldest son, Siegfried, married twice. The son of Siegfried's first marriage, Hubert, had mental disabilities and died in foster care in the 1950s. Siegfried had no other issue. Elsa, Herkomer's second child, also married twice. Her first husband, Dr Donald Atfield, died not long after their marriage. With her second husband, Charles MacDonald, she lived first in Egypt and then in the South of France, where she died on 25 June 1938. Their only child, Margaret, died of polio at the age of 12 and is buried in the English Cemetery in Suez. Herkomer's third child, Lawrence, although married, never had children. He died suddenly during surgery in 1922 at the age of 33 in Bushey. His widow, Louise (Lulu) Herkomer, never remarried and survived into the 1990s in Bushey. Gwendydd, Herkomer's fourth child, also died without issue, at the age of 34, in 1927. She remained in Germany during World War I when she and her mother were unable to leave Landsberg before the outbreak of hostilities. She married an eye doctor, Dr J. Rupfle, and died in Landsberg. Both she and her brother suffered from ill-health for most of their short lives.
73. See Francis Borzello, 'Art and the Problem of Poverty in Victorian England' (PhD, London University, 1979).
74. On the 1878 meeting, see Herkomer to Mansel Lewis, 8 November 1878 (Llanelli, Mansel Lewis Collection). Herkomer was appointed after Ruskin stepped down from his second professorship at Oxford; see Mills, *Life and Letters*, 110.
75. Hubert [von] Herkomer, *Five Lectures Delivered to the Students of the Royal Academy* (printed for private circulation) (London, 1900).
76. Herkomer to Baldry, 20 November 1907 (London, Victoria and Albert Museum Library).
77. See, for example Hubert [von] Herkomer, 'Drawing and Engraving on Wood', *Art Journal* (1882), 133; Hubert [von] Herkomer, 'Art Tuition', typescript lecture, 1900 (London, Victoria and Albert Museum Library).
78. For a contemporary view, see 'The New Gallery', *Illustrated London News* (7 May 1892), 559.
79. See chronological list of works in A. L. Baldry, *Hubert von Herkomer, R.A.* (London, 1901), 115–132.
80. For Paris, see Salon catalogues; for Vienna, see *Jubilaums-Kunst-Ausstellung in Kunstlerhaus, Wien* (1888). Herkomer won the gold medal with *Miss Katherine Grant (The Lady in White)*, no. 1090; for the US, see Hubert [von] Herkomer, *Descriptive Catalog of the Portraits, Etchings and Engravings Exhibited at M. Knoedler's Gallery* (New York, 1882). Herkomer won a bronze medal at the World's Columbian Exposition in Chicago in 1893.
81. The *Mutterturm* in Landsberg-am-Lech, a state museum open to the public, now houses the Herkomerstiftung collection of more than 300 works.

82. 'Notes on the International Exhibition at Munich', *Art Journal* (1879), 262.

83. Herkomer showed intermittently at the Glaspalast till 1911 (catalogues, Glaspalast-Austellung, Munich).

84. Catalogues, 'Internationalen Kunst-Austellung der Vereins Bildende Kunstler Munchens "Secession"', Munich, Staatsbibliothek.

85. On Menzel, see the Godsal Diaries (see Chapter 6, n. 17, below on these diaries of a student of Herkomer's). Herkomer lectured to his students about Menzel's work in January 1885. Menzel also lent Herkomer some drawings to hang in the Herkomer Art School Gallery, 13 January 1885. See Godsal Diaries, vol. 5. On Lenbach, see Herkomer's obituary article, 'Franz von Lenbach: An Appreciation', *Studio* (1905), 195–99; on Stuck, see Hans Faussner, *Die Rosenheimer Galerie: Max-Bram-Stiftung* (Munich, n.d.), 22.

86. Herkomer to M. H. Spielmann, 25 August 1899 (Manchester, Rylands Library).

87. Herkomer to Hofrat Adolf Paulus 7 May 1899. Included in a group of correspondence in the documentation of Lord Blanesburgh's Committee of Prominent British Artists, who exhibited in Munich. Paulus was from 1871 to 1899 Director of the Glaspalast exhibitions in Munich, which showed modern works of art from 1860 to 1930. In 1892 he became Director of the Munich Secession, where he organized a series of progressive exhibitions until 1899. I am most grateful to Dr Herbert Paulus of Erlangen, Germany, Hofrat Paulus's grandson, for sending me the above information and to Dr Maria Makela of California for her assistance on my behalf.

88. See, for example, Paul Kennedy, *The Rise of Anglo-German Antagonism 1860–1914* (London, 1980), especially pages 223–290.

89. See, for instance, 'Fine Arts: The Society of Painters in Watercolours', *Athenaeum* (9 May 1896), 624. On Herkomer posing himself as Christ, see the note on Herkomer's etching of this subject, dated 1895; the watercolour was presented by Herkomer to his friend and collaborator, the artist T. Borough Johnson, and is now in the British Museum (BM.1947.5.1.15). The inscription reads, 'For the Christ Herkomer posed himself on the Cross.' *A Rift in the Clouds* was also exhibited at the Munich Secession in 1896.

90. Herkomer to M. H. Spielmann, 31 November 1897 (Manchester, Rylands Library). The 'Society of Painters in Water Colours' was founded in 1804. It was then referred to as the Old Water-Colour Society. The Society of Painters in Water Colours received the privilege to add 'Royal' to its name in 1881, and became known as the Royal Society of Painters in Water Colours or the Royal Watercolour Society. Membership of the Royal Institute of Painters in Watercolour was a stepping-stone to membership in the Royal Watercolour Society. Herkomer resigned his associate membership (1873–1890) in the former when he became involved with the Royal Watercolour Society, to which he was elected in 1894.

91. Herkomer to M. H. Spielmann, 31 November 1897 (Manchester, Rylands Library).

92. Ibid.

93. Princess Louise was later Marquess of Lorne and then Duchess of Argyll. Herkomer knew her for years, dining with her, for example, in Boston, where both were visiting in 1882 (Mills, 136) as well as meeting with her regularly at the Royal Watercolour Society.

94. Bertha Herkomer to Jo Herrick, 7 April 1914 (New Haven, Herkomer Archive).

2 Herkomer as illustrator and the *Graphic* magazine

1. From a chronological list of Herkomer's *Graphic* illustrations, see Appendix 1.

2. For Thomas's early life, see W. L. Thomas, 'The Making of the Graphic', *Universal Review* 2 (September–December 1888), 80–93.

3. Fildes's wood engravings for Foxe's *Book of the Martyrs* (1866) were made for Thomas. See Bernard Myers, 'Studies for *Houseless and Hungry* and *The Casual Ward* by Luke Fildes, R. A.', *Apollo* (July 1892), 36.

4. Harry Quilter, 'Some *Graphic* Artists, *Universal Review* 2 (1888), 94–104.

5. See 'The Coming of Age of the *Graphic*,' *The Times* (5 December 1890).

6. Herkomer's drawing for the *Quiver* illustrates a line in a sentimental poem by Sarah Doudney, 'The Old Wound'.

7. Rossetti to William Allingham, 18 March 1855, quoted in Reid, *Illustrators*, 32.

8. Engel, *From Handel to Hallé*, 179.

9. Ibid.

10. The *Illustrated London News* cost fivepence a copy and had a circulation of 70,000 per week in the 1870s. Celina Fox and Michael Wolff 'Pictures from the Magazines', in H. J. Dyos and Michael Wolff eds., *The Victorian City: Images and Realities* (London, 1973), vol. 2, 577, fn. 5.

11. C. N. Williamson, 'Illustrated Journalism in England: Its Development, II', *Magazine of Art* (1890), 339.

12. 'The Coming of Age of the *Graphic*', *The Times* (5 December 1890).

13. For example, Richard Beard's daguerreotypes were the basis for wood engravings in Henry Mayhew's *London Labour and the London Poor* (1851–1864). Thirty-six photos of the London poor were used in John Thomas and Adolphe Smith's *Street Life in London* (London, 1877). See Beaumont Newhall, *The History of Photography* (New York, 1964), 139.

14. The term is used by Ronald Pickvance in his *English Influences on Vincent van Gogh* (Nottingham, 1974), 54.

15. See Figure 1, 'Some *Graphic* Artists', *Graphic Christmas Number*, 1882.

16. W. L. Thomas, 'The Making of the *Graphic*', 81.

17. *The Times* (19 October 1900), 9.

18. See 'The Great Depression', in Black, 91–120.

19. Pickvance, *English Influences*, 26.

20. Quoted by Edmund Gosse in 'The World of Books'.

21. *Herkomers* 1, 80.

22. Ibid., 81.

23. Herkomer, 'Drawing and Engraving on Wood', 133.

24. See Alan Woods, 'Doré's London: Art and Evidence', *Art History* I, 3 (1978), 341–359.

25. *Herkomers* 1, 80.

26. Cf. Breton's *End of the Day* (1863), illustrated in Garnet Smith, 'Jules Breton: Painter of Peasants', *Magazine of Art* (1893), 409–416. In 1863, Walker had admired the painting on display at the Palais du Luxembourg in Paris (J. G. Marks, *Life and Letters of Frederick Walker* (London, 1896), 37).

27. Herkomer, 'Drawing and Engraving on Wood', 134.

28. Ibid.

29. Kugler's *History*, published in Germany in 1842, became almost immediately available in English and French editions. Menzel's engravings numbered 400 in the 1842 edition and 200 in *Oeuvres de Frédéric Le Grand* (1843–1849). For discussion see Françoise Forster-Hahn, 'Adophe Menzel's "Daguerreotypical" Image of Frederick the Great: A Liberal Bourgeois Interpretation of German History', *Art Bulletin* 59 (June 1977), 240–261.

30. Herkomer to the Editor of the *Studio*, 11 July 1896 (London, Victoria and Albert Museum Library).

31. William Vaughan, *German Romanticism and English Art* (New Haven, 1979), 254.

32. See 'The Wandering Minstrels', *Graphic* (25 June 1870), 715.

33. Degas's picture was first exhibited in Lille in 1870–1871; see Paul-André Lemoisne, *Degas et son oeuvre* (Paris, 1946–1949), vol. 1, ill. no. 186.

34. Degas also admired Menzel; see Vaughan, 254. Some of

Degas's works, particularly scenes of dance rehearsals, were exhibited in London as early as 1872. See Theodore Reff, *Degas: The Artist's Mind* (New York, 1976), 32.

35. Engel, *From Handel to Hallé*, 176.
36. 'Our Illustrations: Sunday Morning in Petticoat Lane', *Graphic* (6 January 1872), 3.
37. 'A Visit to Newgate', *Graphic* (9 March 1872), 221.
38. Fox and Wolff, 'Pictures', 565.
39. C. N. Williamson, 'Illustrated Journalism', 393.
40. W. L. Thomas, 'The Making of the *Graphic*', 83–84.
41. The English artist William Simpson (1823–1899) made a series of 81 lithographs after his eyewitness drawings of the Crimean conflict, *The Seat of War in the East* (1855). However, he was not employed as an illustrator by the *Illustrated London News* until 1866. Edward Armitage (1817–1896) also visited the front during the war and developed several exhibited paintings from his sketches, but he was not employed by the *Illustrated London News*.
42. For example, E. J. Gregory's *Sketches from Paris by Balloon Post: The Last Lot*, *Graphic* (3 December 1870), 545.
43. *Herkomers* 1, 86.
44. W. L. Thomas, 'The Making of the *Graphic*', 84.
45. Herkomer never felt comfortable with the North German mentality; see Bertha Herkomer to Mrs Francis Herrick, 12 April 1900 (New Haven, Herkomer Archive).
46. *Herkomers* 1, 85.
47. Ibid.
48. See Appendix 1.
49. George and Edward Dalziel, *The Brothers Dalziel* (London, 1901), 207.
50. 'The Dudley Gallery: The Seventh Exhibition of Water Colour Drawings', *Art Journal* (1871), 85.
51. Other contributors to the Rome series included Sydney Hall, W. Bromley and H. Woods.
52. For example, 'Rome', *Graphic* (6 April 1872), 320.
53. 'My First Visit to Italy', in *Herkomers* 2, 53–59.
54. See 'The Peasants of Oberammergau', *Graphic* (6 August 1870), 131; 'Holiday Time in the Bavarian Alps', *Graphic* (21 April 1877), 368; and so on.
55. See Appendix 2 for a discussion of Herman Herkomer and his relationship with his cousin Hubert.
56. 'The Carnival in Bavaria', *Graphic* (18 April 1874), 359.
57. The *Graphic*'s accompanying article, 'Returning from Work' (18 August 1871), 171, identifies the background mountain in the illustration as the Zugspitze, which is in the Bavarian Tyrol.

3 English rustics and Welsh landscapes: Herkomer's early pastoral idylls

1. *Herkomers* 1, 70.
2. Ibid., 65
3. 'French and Flemish Pictures at the Pall Mall Gallery', *The Times* (7 April 1869), 4.
4. J. W. Keith, 'The Land in Victorian Literature', in G. E. Mingay ed., *The Victorian Countryside*, vol. 1, 136–149.
5. *Herkomers* 1, 104.
6. Quoted in Engel, *From Handel to Hallé*, 173.
7. 'Hubert Herkomer', *Graphic* (26 October 1878), 438.
8. Herkomer identifies them only as 'Wise and Rassal [sic]' (Engel, *From Handel to Hallé*, 177).
9. Gosse, 'The World of Books', *Sunday Times* (6 May 1923).
10. *Herkomers* 1, 77.
11. In the Landsberg photographic inventory of Herkomer's works assembled by the artist himself, 'Hoeing, woodcut from early watercolour' is the same image as the *Jack and Jane* wood engraving published in *Good Words* (Landsberg Inventory no. 389 [author's

numbers], Herkomerstiftung). The engraving illustrates 'Jack and Jane', a short story by Richard Rowe about children working in a turnip field.

12. G. and E. Dalziel, 206. The Dalziels call the watercolour 'Harvesters'; Engel, *From Handel to Hallé*, 180.
13. 'Dudley Gallery', *Art Journal* (1870), 86.
14. *Herkomers* 1, 77.
15. *Rest: Aldenham Church* is illustrated in James Dafforne, 'The Works of Hubert Herkomer A.R.A.', *Art Journal* (1880), 111.
16. *The Boy and the Apple Blossoms* is reproduced with that title in Baldry, *Herkomer*, 48. *The Idler* is a later title.
17. *Catalogue of a Collection of Drawings: Around My Home, by Professor Herkomer A.R.A.*, Fine Art Society (London, 1888).
18. 'Fine Art Gossip', *Athenaeum* (3 May 1888), 576.
19. Herkomer, 'J. W. North', 343.
20. Ibid., 345.
21. Ibid.
22. Herkomer to Mansel Lewis, 14 November 1878 and 16 December 1878 (Llanelli, Mansel Lewis Collection).
23. Hubert [von] Herkomer, 'Notes on Landscape Painting: "The Camp", Lake Idwal, North Wales, April, 1880,' *Portfolio* 11 (1880), 142–147; 174–176.
24. Herkomer, *My School and my Gospel* (London, 1908), 15; David Howard Rodee, ' "The Dreary Landscape" as a Background for Scenes of Rural Poverty in Victorian Painting', *Art Journal* 36 (1977), 307–333.
25. 'Art Notes and Reviews: The Grosvenor Gallery', *Art Journal* (1881), 189.
26. The typescript for *Found* is in Llanelli, Mansel Lewis Collection.
27. Hubert [von] Herkomer, *My School and my Gospel*, 129.
28. Renée Free, *Victorian Social Conscience* (Sydney, 1976), 43.
29. 'Society of Painters in Water Colours Thirty-Fifth Winter Exhibition', *Athenaeum* (19 December 1896), 878.
30. Herkomer to Mansel Lewis, 12 October 1877 (Llanelli, Mansel Lewis Collection).
31. I am grateful to Hartfrid Neunzert, Director of the Neues Stadtmuseum, Landsberg-am-Lech, for pointing this out to me.
32. Edmund Gosse, *Cecil Lawson: A Memoir with Illustrations by Hubert Herkomer A.R.A., J. A. McN. Whistler and Cecil Lawson* (London, 1883), 24.
33. Herkomer to Mansel Lewis, January 1877 (Llanelli, Mansel Lewis Collection).
34. Herkomer to Mansel Lewis, 15 January 1877. Lawson did not go to Bavaria with Herkomer, probably owing to his delicate health.
35. Herkomer to Gosse 11 June (July?) 1882 (Leeds, Brotherton Collection). Written from Brighton the day after Lawson's death.

4 'Romantic and paintable': Herkomer's Bavarian peasant realism

1. Robert L. Herbert, *Jean-François Millet*, exhibition catalogue, Arts Council of Great Britain (London, 1976), 14.
2. Madeleine Fidell-Beaufort, 'Peasants, Painters and Purchasers', in *The Peasant in French Nineteenth-Century Art*, exhibition catalogue, Douglas Hyde Museum (Trinity College, Dublin, 1980), 75–77.
3. Millet had large plaster casts of the Parthenon metopes in his studio (Richard Muther, *The History of Modern Painting* (London, 1896), vol. 3, 379); Walker worked from casts of the Elgin Marbles (Phillips, *Frederick Walker*, 6).
4. Harry Quilter, *Preferences in Art, Life, and Literature* (London, 1892) 179.
5. On Legros in England, see W. E. Henley, 'Alphonse Legros', *Art Journal* (1881), 290; Kenneth McConkey,

Peasantries, exhibition catalogue, Newcastle-upon-Tyne Polytechnic Art Gallery (Newcastle-upon-Tyne, 1981), 24.

6. During the 1870s, Legros taught at the Lambeth School of Art in London and at South Kensington, and in 1876 he was appointed Slade Professor at the Slade School of Art at University College, London (over the objections of those who thought an Englishman should have the job), a post he held till 1892.

7. 'The Royal Academy', *Art Journal* (1869), 168.

8. See J. Beavington Atkinson, 'The Modern German School of Art', *Art Journal* (1862), 182; 'The Present Condition of Germany in Contemporary Art', *Portfolio* (1873), 147. Atkinson also published a book, *The Schools of Modern Art in Germany* (London, 1880).

9. Engel, *From Handel to Hallé*, 181.

10. *Herkomers* 1, 89.

11. Mills, *Life and Letters*, 42

12. On Defregger, see Schneidek, 'Herkomers Einladungskarten', 159; H. Erdmann, 'Hubert von Herkomer', *Das Bayerland* 36, 13 (1925), 423. On Leibl, see Mills, *Life and Letters*, 42.

13. Herkomer to Edmund Gosse, 12 April 1884 (Leeds, Brotherton Collection).

14. Charles Blanc, *Les Beaux-Arts à l'Exposition Universelle de 1878* (Paris, 1878), 355–356.

15. Muther, *History*, vol. 2, 255–275.

16. Ibid., 256. Auerbach's *Schwarzwalder Dorfgeschichten* (*Village Tales from the Black Forest*) were published between 1843 and 1853.

17. Michael Quick, *Munich and American Realism in the Nineteenth Century* (Sacramento, 1978), 43.

18. Knaus was born in Wiesbaden but in 1856 received his art training in Düsseldorf. He also studied for a year in Paris where he was influenced by Courbet. After 1861 he settled in Berlin.

19. Helen Zimmern, 'A Painter of Children', *Magazine of Art* 8 (1885), 327–333.

20. *Ludwig Knaus*, exhibition catalogue, Museum Wiesbaden (Wiesbaden, 1979), 115.

21. Godsal Diaries, vol. 5, 13 January 1885.

22. Mills, *Life and Letters*, 67.

23. *Herkomers* 1, 88.

24. For example, Quilter, *Preferences*, 134, 305, 319; 'The Royal Academy', *The Times* (8 May 1876), 4, and so on.

25. Engel, *From Handel to Hallé*, 182.

26. Marks, 92. *The Street, Cookham* is reproduced in Marks, *Life and Letters of F. Walker*, 93.

27. Engel, *From Handel to Hallé*, 183.

28. On preservation, see Herkomer to Mansel Lewis, 1 May 1876. Large cracks appeared in subsequent years and in 1893 Herkomer did major surface repairs. Herkomer to Mansel Lewis, 7 November 1893 (Llanelli, Mansel Lewis Collection).

29. 'Exhibition of the Royal Academy', *Art Journal* (1873), 202.

30. *The Times* (19 May 1873).

31. C. W. Mansel Lewis, 'Catalogue of Oil Pictures, Watercolours, Pastels and Etchings at Stradey Castle Compiled by Me in 1916', handwritten, no pagination. incomplete. Unfortunately Mansel Lewis only made seven entries.

32. For example, see Herkomer to Mansel Lewis, 19 March 1876 (Llanelli, Mansel Lewis Collection). Mansel Lewis (1845–1931) was interested in art from an early age, and the drawings and paintings he made while a student at Eton were considered promising. He painted a number of dramatic landscapes on his camping expeditions with Herkomer at Lake Idwal in North Wales and mountain scenery remained his favourite subject. For an account of their landscape painting expeditions together, see Chapter 3. He was also a skilled portraitist as well as a lecturer on art to the local populace in his home district of Llanelli in South Wales. Etching was a favourite pursuit, and he was elected to membership in the Royal Society of Painter-Etchers. Herkomer said that his friend was 'an artist to his fingertips', but Mansel Lewis remained modest about his skills and always sought to improve on them; see the unpublished typescript by Mansel Lewis's son (Llanelli, Mansel Lewis Collection).

33. Numbers 108 and 107 respectively; see Henry Blackburn, *Pictures at the Paris Exhibition (British School)* (Paris, 1878).

34. *L'Art* 16 (1879), 129.

35. Hubert [von] Herkomer, 'The Pictorial Music-Play: *An Idyl*', *Magazine of Art* 12 (1889), 318.

36. Herman Herkomer to John Herkomer, 1 February 1882 (New Haven, Herkomer Archive).

37. See the *Graphic* (18 April 1874), 368–369.

38. Engel, *From Handel to Hallé*, 188.

39. Ludwig Pietsch, *Herkomer* (Leipzig, 1901), 20.

40. 'The Institute of Painters in Watercolours', *Art Journal* (1875), 215.

41. *Herkomers* 1, 89.

42. Engel, *From Handel to Hallé*, 192; *Herkomers* 1, 110.

43. *Herkomers* 1, 99.

44. Pietsch, *Herkomer*, 24.

45. Herkomer, 'Drawing and Engraving on Wood', 134. See also my Chapter 2, above. Herkomer particularly admired Menzel's *After the Ball* (1878; Nationalgalerie, Berlin).

46. Pietsch, *Herkomer*, 6.

47. Ibid.

48. See John Forbes Robertson, 'The International Art Exhibition at Munich', *Magazine of Art* (1880), 71; and 'Notes on the International Exhibition at Munich', *Art Journal* (1879), 262.

49. Charles Tardieu, 'La Peinture à l'Exposition universelle de 1878', *L'Art* 1 (1879), 99.

50. Quoted in Engel, *From Handel to Hallé*, 195.

51. Herkomer to Mansel Lewis, 12 October 1877 (Llanelli, Mansel Lewis Collection).

52. Ibid.

53. Herkomer to Mansel Lewis, 16 December 1878 (Llanelli, Mansel Lewis Collection).

54. Edmund Gosse, 'The World of Books'.

55. *Athenaeum* (May 1876), 641.

56. 'Royal Academy Exhibition', *Illustrated London News* (6 May 1876), 451.

57. *The Standard*, quoted in the *Graphic* (26 August 1876), 198.

58. Herkomer to Mansel Lewis, 12 October 1877 (Llanelli, Mansel Lewis Collection).

59. *Athenaeum* (May 1877), 582.

60. For example, Herkomer to Mansel Lewis, January, 1877 (Llanelli, Mansel Lewis Collection).

61. Conversation with David Mansel Lewis (grandson of Herkomer's friend), February 1982. Herkomer married Lulu in 1884 soon after his first wife Anna died, as we have seen.

62. Herkomer to Mansel Lewis, 3 December 1876 (Llanelli, Mansel Lewis Collection).

63. J. W. Comyns Carr, 'Hubert Herkomer A.R.A.', in *Modern Artists*, ed. F. G. Dumas (London, 1882–1884), 68.

64. 'Grosvenor Gallery Exhibition', *Illustrated London News* (3 May 1879), 415.

65. 'The Grosvenor Gallery', *The Times* (2 May 1879), 8.

66. For example Walter Pater's famous dictum, 'All art aspires to the condition of music', published in his essay 'The School of Giorgione', in his *Studies in the History of the Renaissance* (London, 1877).

67. Herkomer to Mansel Lewis, 15 January 1877 (Llanelli, Mansel Lewis Collection).

68. Herkomer to Mansel Lewis, 18 September 1877, and 16 December 1878 (ibid.).

69. Herkomer to Mansel Lewis, 16 December 1878 (ibid.).

70. Herkomer to Mansel Lewis, 6 October 1878 (ibid.). Mansel Lewis's painting by Herkomer *After the Toil of the Day* was exhibited at the Paris Universal Exhibition, along with *The Last Muster*.

71. 'Grosvenor Galley Exhibition', *Illustrated London News* (3 May 1879), 415.
72. Herkomer to Mansel Lewis, 18 September 1877 (Llanelli, Mansel Lewis Collection).
73. Herkomer to Edmund Gosse, n.d. (probably 1881) (Leeds, Brotherton Collection).
74. Herkomer to Mansel Lewis, 7 November 1893 (Llanelli, Mansel Lewis Collection).
75. See John Christian in *Edward Burne-Jones: Victorian Artist-Dreamer*, exhibition catalogue, Metropolitan Museum (New York, 1998), 138.
76. Herkomer to Mansel Lewis, 18 September 1877 (Llanelli, Mansel Lewis Collection).
77. *Illustrated London News* (3 May 1879).
78. 'Fine Art Gossip', *Athenaeum* (5 December 1885), 739.

5 *The Last Muster*: a planned triumph

1. Herkomer to Mansel Lewis, written from Munich, 12 October 1877 (Llanelli, Mansel Lewis Collection). Exhibitions which showed *The Last Muster* include The Royal Academy, 1875 (no. 89); Universal Exhibition, Paris 1878 (grand medal of honour); Munich International Exhibition, 1883; Whitechapel Art Gallery, London, 1885; Royal Jubilee, Manchester, 1887; Birmingham, 1887; Chicago, 1893; Guildhall, 1894; West Ham, 1897; Berlin, 1900; International Exhibition, Dublin, 1907; Franco-British Exhibition, 1908; International Exhibition, Rome, 1911; and so on. Information from an inventory file in the Lady Lever Art Gallery, courtesy Lady Lever Art Gallery, Port Sunlight.
2. Carr, 'Herkomer', 52.
3. Herkomer, 'Drawing and Engraving on Wood', 166.
4. Engel, *From Handel to Hallé*, 189.
5. *Herkomers* 1, 80–112; Mills, *Life and Letters*, 77–87; Engel, *From Handel to Hallé*, 188–193.
6. *Herkomers* 1, 109.
7. C. W. Mansel Lewis in 'Catalogue of Oil Pictures, Watercolours, Pastels, Engravings, and Etchings', compiled by Mansel Lewis in 1916, handwritten, n.p. (Llanelli, Mansel Lewis Collection).
8. Engel, *From Handel to Hallé*, 189.
9. Inventory file, Lady Lever Art Gallery, Port Sunlight.
10. *The Chapel*, Royal Hospital Guide no. 2 (London, 1976), 29.
11. Engel, *From Handel to Hallé*, 189.
12. Carr, 'Herkomer', 52.
13. Engel, *From Handel to Hallé*, 189.
14. Ibid., 188.
15. *Herkomers* 1, 111.
16. Ibid.; and Frederic Leighton to Herkomer, April 1875, quoted in Mills, *Life and Letters*, 83.
17. *The Times* (1 May 1875).
18. 'The Royal Academy Exhibition', *Art Journal* (1875), 252. Other glowing reviews were published in the *Illustrated London News* (8 May 1875), 446; and in the *Athenaeum* (June 1875), 755.
19. John Ruskin, *The Complete Works of John Ruskin*, ed. E. T. Cook and Alexander Wedderburn (London, 1904), vol. 14, 291.
20. Engel, *From Handel to Hallé*, 190.
21. *Herkomers* 1, 112.
22. 'A Sketch in the English Fine Art Court', *Graphic* (29 June 1878), 634.
23. Engel, *From Handel to Hallé*, 192; *Herkomers* 1, 110.
24. Herkomer also made an etching of the watercolour, see G. C. Williamson, xii.
25. E. Duranty, 'L'Exposition universelle: Les Ecoles Etrangers de peinture: Angleterre', *Gazette des Beaux-Arts* 18 (1878), 314.
26. Mills, *Life and Letters*, 82.
27. Quoted in J. H. Morley, *Death, Heaven and the Victorians* (London, 1971), 103. On mortality rates, see Asa Briggs, *Victorian Cities* (London, 1963), 19–20.
28. George Gissing, *In the Year of Jubilee* (London, 1895), 156.
29. Herkomer to his uncle John Herkomer in Cleveland, 2 May 1875, quoted in Mills, *Life and Letters*, 87.
30. See for example, 'The Royal Academy', *Athenaeum* (June 1875), 75.
31. *Graphic* (29 June 1878), 648.
32. Charles E. Pascoe, 'The Royal Academy', *Art Journal* (American edition) (1875), 188.
33. Treble, *Great Victorian Pictures* (London, 1978), 79.
34. 'The Royal Academy', *Art Journal* (June 1874), 1874.
35. 'The Royal Academy', *The Times* (8 May 1876), 9.
36. *Herkomers* 2, 33.
37. 'The Royal Academy', *Athenaeum* (18 May 1889), 638.
38. Included in the picture are portraits of Sir James Paget, a celebrated surgeon and pathologist; Samuel Pope QC, a prominent barrister whose full-length portrait Herkomer had exhibited at the Royal Academy in 1889. William Gladstone (Herkomer's portrait of Mrs Gladstone was also shown at the 1889 Academy exhibition), is recognizable as the face in profile against the far left pillar. The figure entering the Chapel at the right (carrying a top hat) was posed for by Simpson Noakes. A neighbour of Herkomer's in Bushey, Noakes was Chairman of the local school board and a successful stockbroker who had previously sat as the model for John Tenniel's *Punch* cartoons of 'John Bull'. Herkomer also used a literary source, and based his picture on the Founder's Day scene at Greyfriars School (Charterhouse) from Thackeray's novel *The Newcomes* (1855); see Edward T. Cook, *A Popular Handbook to the National Gallery*, vol. 2: *The British Schools including the Tate Gallery* (London, 1901), 472. *The Chapel of the Charterhouse* was accidentally destroyed when sea-water seeped into the hold of the ship returning the painting to England after its exhibition in Australia and South Africa in 1938; information courtesy of Judith Jeffries, Assistant Director, Tate Gallery, 24 March 1981.
39. *Herkomers* 2, 37.
40. See 'The Royal Academy', *Athenaeum* (8 June 1889), 733, and 'The Royal Academy', *Art Journal* (1889), 246. The quotation is from Harry Quilter, 'The Art of England', *Universal Review* (May–August 1889), 45–46.
41. Robert de la Sizeranne, *English Contemporary Art*, trans. H. M. Poynter (London, 1898), 170, quoted in Cook, *A Popular Handbook*, 472.
42. *Herkomers* 2, 36.
43. Carr, 'Herkomer', 65–66.
44. Herkomer was renaturalized a British citizen in 1897; see Chapter 1, above.
45. Mills, *Life and Letters*, 275.
46. M. H. Spielmann, 'The Royal Academy Exhibition', *Magazine of Art* (1898), 466.
47. 'The Royal Academy', *Athenaeum* (28 May 1898), 701. After Herkomer delivered the inaugural address at the opening of the Bristol Art Gallery in 1905, the tobacco millionaire H. O. Wills bought the painting and gave it to the Gallery, where it remains today.
48. From a letter by Herkomer quoted in Mills, *Life and Letters*, 273.

6 Herkomer's social realism

1. *Herkomers* 1, 72.
2. See Herkomer's letter to the editor quoted in 'Aged Women in a London Workhouse', *Graphic* 15 (7 April 1877), 326.
3. Carr, 'Herkomer', 67–68.
4. Hippolyte Taine, *Notes on England*, trans. W. F. Rowe (New York, 1873), 214.
5. Henry James, *The Princess Casamassima* (1886; rpt London, 1976), 344.

6. Carr, 'Herkomer', 69.
7. *Art Journal* (1878), 179; Blackburn, *Pictures*, 67.
8. 'The Royal Academy Exhibition', *Illustrated London News* (11 May 1878), 435.
9. 'The Royal Academy', *Athenaeum* (4 May 1878), 577.
10. Herkomer to Mansel Lewis, 12 February 1881 (Llanelli, Mansel Lewis Collection).
11. Herkomer to Mansel Lewis, 15 February 1882; 25 June 1881 (ibid.).
12. Herkomer to Mansel Lewis, 2 August 1895 (ibid.).
13. Mills, *Life and Letters*, 113. The painting was burned by the artist.
14. Herman Herkomer to his father John Herkomer in Cleveland, 1 March 1882 (New Haven, Herkomer Archive).
15. *Herkomers* 1, 136.
16. 'Then went to studio – Herk showed me what he intended with "tramp" picture and discussed it with me.' Godsal Diary, 24 January 1885 (Clwyd, Clwyd Library; see n. 17 below).
17. I am most grateful to Mr Grant Longman, Curator of the Bushey Museum, for bringing the 18-volume Godsal diaries to my attention, and to Major P. Godsal for permission to read them. The diaries are now deposited in the Clwyd County Council Library, Wales [hereafter Godsal Diary].
18. Godsal Diary, 26 March 1884 (ibid.).
19. Ibid., 3 May 1884.
20. Information courtesy of Mrs Topping of Bushey, great-granddaughter of the Quarrys (conversation, February 1981).
21. *Herkomers* 1, 136.
22. Godsal Diary, 19 January 1885 (Clwyd, Clwyd Library).
23. 'Went at 11.30 to see H. painting in his hut – the end of the road with Atkins' Farm, lovely colour'. (Godsal Diary, 6 February 1885, Clwyd, Clwyd Library).
24. Walker's *Philip in Church* is based on an illustration he made for William Thackeray's last novel, *The Adventures of Philip* (1862).
25. Godsal Diary, volume 4, 1884 (Clwyd, Clwyd Library).
26. Mills, *Life and Letters*, 153.
27. *Art Journal* (1885), 226; *Athenaeum* (June 1885), 796; *Blackwood's Magazine* 138 (July 1885), 21; J. E. Pythian, *Manchester City Art Gallery Handbook* (1905), 53.
28. See David Howard Rodee, ' "The Dreary Landscape" as a Background for Scenes of Rural Poverty in Victorian Painting', *Art Journal* 36, 4 (1977), 311.
29. *My School and my Gospel*, 3–5.
30. David Howard Rodee, 'Scenes of Rural and Urban Poverty in Victorian Painting and their Development, 1850–1890' (PhD, Columbia University, 1975), 40.
31. Treble, *Great Victorian Pictures*, 44.
32. 'We were to town and saw a great many pictures – the complete works of G. F. Watts, R.A.'; Herman Herkomer to John Herkomer, 1 March 1882 (New Haven, Herkomer Archive).
33. W. J. Laidlay, *The Origin and First Two Years of the New English Art Club* (London, 1907).
34. Herkomer painted several other works with a wayfarer motif, including *A Modern Hagar* (1893; present location unknown) and *The Nomads* (1893; present location unknown), which were shown at the Munich Secession and at the New Gallery.
35. Susan P. Casteras, *The Substance and the Shadow: Images of Victorian Womanhood* (New Haven, 1982), 46–49.
36. The strikers' leader, John Burns, is shown inciting his fellow workers to rally to the cause, which eventually did result in wage improvements. For a sympathetic contemporary view of the celebrated London dock strike of 1889, see H. H. Champion, 'The Great Dock Strike', *Universal Review* 6 (1889), 157–179.
37. Patricia Hills, *The Working American* (Washington DC, 1979), 9–10.
38. 'The Royal Academy', *The Times* (11 May 1891), 8.
39. 'The Royal Academy Exhibition', *Illustrated London News* (2 May 1891), 573.
40. *Art Journal* (1891), 197.
41. This was a variation of the *Graphic* engraving published on 17 May 1873, p.465.
42. 'The Royal Academy: Third Notice', *Illustrated London News* (16 March 1891), 648.
43. Herkomer never left any written record of his own political views.
44. Herkomer, *Five Lectures*, 25.

7 Herkomer as portraitist

1. Many of the portraits are illustrated in Herkomer's four-volume photographic inventory in the Herkomerstiftung, Landsberg.
2. *Five Lectures*, 44.
3. 'The Decline of Art: Royal Academy and Grosvenor Gallery', *Blackwood's Magazine* 138 (1885), 17.
4. 'I am most anxious to hear what your judgement is for I remember with great pleasure your encouragement of my going on with my portraits'; Herkomer to Watts, 13 January 1879 (London, Tate Gallery Library).
5. Richard Ormond, *G. F. Watts' The Hall of Fame: Portraits of his Famous Contemporaries*, exhibition catalogue, National Portrait Gallery (London, 1975), 56.
6. W. L. Courtney, 'The Life and Work of Hubert Herkomer R. A.', *Art Journal Christmas Number* (1892), 16.
7. Engel, *From Handel to Hallé*, 195.
8. Exhibited at the Royal Institute of Painters in Watercolour, 1878.
9. Herkomer to Mansel Lewis, 8 November 1878 (Llanelli, Mansel Lewis Collection).
10. See Ruskin's letter to Dean Liddell, 4 January 1879 (Cook and Wedderburn edn, vol. 37, 270). As previously mentioned, Herkomer did not become Slade Professor at Oxford till 1885.
11. Ruskin to Sara Anderson, 1 December 1879 (in Cook and Wedderburn edn, vol. 37, 303).
12. Herkomer interview, *The Star*, 4 March 1890, published in the Cook and Wedderburn edition of Ruskin, vol. 38, 210.
13. Herkomer to Mansel Lewis, 25 December 1878 (Llanelli, Mansel Lewis Collection). Herkomer vividly describes his visit to Faringford and his admiration of the poet.
14. Lady Tennyson was given a copy in June 1880; see Mills, *Life and Letters*, 102. Herkomer eventually gave his portrait of Wagner to Cosima Wagner; see Baronin von Zedlitz, 'Bei Herkomer', *Revue Deutsche* III (1893–1895), 31.
15. Others include the artists Briton Rivière (1887, untraced) and J. W. North (1893, untraced).
16. Mills, *Life and Letters*, 119.
17. Engel, *From Handel to Hallé*, 203.
18. Forbes was war correspondent for the *Daily Mail*, and covered the Franco-Prussian War, 1870–1871; the Russo-Turkish War, 1872–1875; and many of the colonial wars. He published a monograph on Kaiser Wilhelm I in 1888 and was a good friend of Herkomer.
19. Herkomer, 'Franz von Lenbach: An Appreciation', 195–199.
20. For details and the exchange of letters between Herkomer and Spencer, see Mills, *Life and Letters*, 251–261.
21. 'Royal Academy Exhibition', *Illustrated London News* (12 May 1883), 470.
22. 'Studio Notes', *Architect* (12 April 1884), 229.
23. Herkomer to Edmund Gosse, 12 April 1884 (Leeds, Brotherton Collection).
24. Harry Quilter, 'Frank Holl: In Memoriam', *Universal Review* (June–August 1888), 483.
25. Sizeranne, *English Contemporary Art*, 187, 191.
26. 'The Royal Academy', *Athenaeum* (11 May 1901), 601.

27. George Moore, 'The New Gallery', *Speaker* (7 May 1892), 556, quoted in John Stokes, *Resistible Theatres* (London, 1972), 81.
28. See *Herkomers* 1, 134–135; Mills, *Life and Letters*, 148–155.
29. *Herkomers* 1, 135.
30. See Kenneth McConkey, *Edwardian Portraits: Images of an Age of Opulence* (Suffolk, 1987), 72–73.
31. 'The Royal Academy', *Illustrated London News* (2 May 1885), 453.
32. *The Lady in White* won gold medals at the Berlin Jubilee, 1886; the Vienna Jubilee, 1888; the Paris Universal Exhibition, 1889; and the Chicago Columbian Exposition, 1893.
33. Irena Zdanowicz, 'Prints of Fortune: Hubert Herkomer's 1891–92 Etching Purchases for the National Gallery of Victoria'. *Art Bulletin of Victoria* 33 (1993), 3. I am most grateful to Dr Susan P. Casteras for bringing this article to my attention.
34. Ibid., 4–17.
35. *Royal Catalogue of Victorian Watercolours*, 461–462.
36. Ibid., 462, and Bertha Herkomer to Josephine Herrick, 29 January 1901 (New Haven, Herkomer Archive).
37. Herkomer, *Five Lectures*, 44.
38. *Herkomers* 2, 64. It is not now known what corporate body commissioned *The Board of Directors*, perhaps owing to the eventual discovery that one of the men represented was involved in an unsavoury business scandal. Herkomer himself states in his memoirs only that he received 'an unexpected commission to paint "A Board of Directors" ' and none of the figures is now identifiable (ibid.).
39. 'The Royal Academy', *Illustrated London News* (28 May 1982), 666. The painting has had a curious history. It was sold at Sotheby's in London in 1980 to a private American men's club. The picture was cut down and the heads of the club's own board members were subsequently painted in over Herkomer's portraits (information from Simon Taylor, Sotheby's London, May 1981).
40. Quick, *Munich and American Realism*, 31.
41. Douglas Druick, Michael Hoog, et al., *Fantin-Latour*, exhibition catalogue, National Gallery of Canada (Ottawa, 1983), 212.
42. Herkomer to Spielmann, 4 June 1894 (University of Manchester, Rylands Library). Spielmann, the editor of the *Magazine of Art*, turned down Herkomer's offer.
43. *Herkomers* 2, 77.
44. Ibid., 77–78.
45. On the early days of the Secession, see Spielmann, 'Munich as an Art Centre', *Magazine of Art* 18 (1894–1895), 73–75; 'G. W.', 'The Secessionists of Germany', *Studio* 4 (1894), 24–28; Keyssner, 'The Exhibition of the Munich Secession, 1899', *Studio* 17 (1899), 178–184.
46. 'G. W.', 'The Secessionists of Germany', 27.
47. M. H. Spielmann, 'The Royal Academy Exhibition', *Magazine of Art* (1895), 282.
48. Paul Winkelmayer, 'Herkomersammlung und Herkomerstiftung', in *Herkomer: Teilfonderdruck aus den Landsberger Geschichtsblätter* (Landsberg, 1939), 15.
49. For example, Fantin-Latour's artist groups; Peder Kroyer's *Artists' Lunch* (1883; Skagens Museum); and Lovis Corinth's *The Freemasons* (1889; Lenbachhaus, Munich).
50. 'The Royal Academy', *Athenaeum* (11 May 1901), 601.
51. *Responses*, quoted in Horace E. White, *Bushey's Painting Heritage* (Bushey, 1975), 28.
52. See *Tate Gallery Catalogue: British School* (London, 1936–1937), 112–113. The figures are identified left to right as Ernest Crofts, T. G. Jackson, S. J. Solomon, B. W. Leader, Seymour Lucas, J. S. Sargent, Briton Rivière, Edward Poynter, W. W. Ouless, David Murray, J. M. Swan, Hubert Herkomer, Sir T. Brock (standing) and F. A. Eaton (Secretary). Herkomer depicts the 14 members of the 'Hanging Committee' in the process of selecting the pictures for that year's Academy exhibition; behind a table at the centre Sir Edward Poynter, President of the Academy, holds a 'D' for 'doubtful', his lowered hand bearing an 'X' ('excluded').
53. Herkomer to Spielmann, 24 April 1908 (Manchester, Rylands Library).
54. See Ernst Haux, 'Bei Krupp 1890–1935' (Historisches Archiv, Fried. Krupp GMDH, Essen). Gustav Krupp von Bohlen und Halbach, who commissioned the group portrait from Herkomer, was the husband of Friedrich Krupp's great-granddaughter Bertha. He added the Krupp name after his marriage, and served as Manager of the firm from 1903.
55. Herkomer to Mansel Lewis, 6 March 1912 (Llanelli, Mansel Lewis Collection).
56. Haux, 'Bei Krupp' (see n. 54, above), 90.
57. Herkomer to Paul Heyse in Munich, 6 October 1911 (Munich, Bayerische Staatsbibliothek).
58. Herkomer to Gustav Krupp von Bohlen und Haalbach, 3 February 1913 (Essen, Krupp Archive). All the figures in the group portrait are identified. I am grateful to I. V. Köhn-Lindenlaub and I. A. Bongers, Krupp archivists at the Villa Hügel, Essen, for this information. In the preliminary sketch (1912, Villa Hügel, Essen), 17 figures are depicted. This was expanded to 19 in the finished portrait. Alfred Krupp's birthdate (1812) coincided with the founding of the Krupp works, which was a reason his portrait was painted into the background of the finished picture.
59. 'The Royal Academy', *Athenaeum* (9 May 1914), 66. During World War I, the Krupp agent in London hid the portrait and in 1919 it was shipped out of England to Essen. It is now in the Villa Hügel, the Krupp Museum in Essen. See Haux, 'Bei Krupp' (see n. 54, above), 99. Herkomer was proud of the *Krupp* group, and many celebrated guests were invited to Lululaund to see the artist working on it.

8 Herkomer in America

1. For example, see 'Hubert Herkomer's Visit to America', *New York Herald* (11 September 1882), 8; 'A Cosmopolitan Artist: Hubert Herkomer and his Works', *New York Tribune* (1 October 1882), 4 (a long biographical sketch); 'Hubert Herkomer: A Talk with Him on Leaving England', *New York Herald* (29 October 1882), 19 (interview with the artist in London, 16 October 1882).
2. 'Antique Art and Modern Critics', *New York World* (13 December 1882), 4.
3. *Harper's Weekly* 21 (28 April 1877), 328–329, which illustrated Herkomer's *The Evening of Life – A Scene in a London Workhouse* (with a different title from its English counterpart), an engraving which the artist worked up into the painting *Eventide*; see also *Harper's Weekly* (4 October 1879), which illustrated Herkomer's engraving *The Coastguardsman. The Last Muster* was also reproduced in *Harper's Weekly* in 1875.
4. See Mills, *Life and Letters*, 119, 122, 133.
5. See *New York Herald* (11 September 1882), 8; (29 October 1882), 19; (1 November 1882), 5; *New York Tribune* (1 October 1882), 4. I am grateful to American art scholar Gerald Carr, who generously sent me newspaper reports on Herkomer's first visit to America.
6. On studio buildings of the period, see Annette Blaugrund, *The Tenth Street Studio Building: Artist Entrepreneurs from the Hudson River School to the American Impressionists* (New York, 1997).
7. New York Herald (11 September 1882), 8.
8. See Appendix 2.
9. Hubert [von] Herkomer, *Descriptive Catalog of the Portraits, Etchings and Engravings Exhibited at M. Knoedler's Gallery* (New York, 1882). On the Lotos Club reception see *New York Herald* (1 November 1882), 5.

10. *New York Tribune* (27 November 1882), 5; *New York Mail and Express* (29 November 1882), 3; *New York World* (27 November 1882), 5.
11. *New York Mail and Express* (29 November 1882), 3.
12. *New York World* (18 December 1882), 2.
13. Herkomer to Mansel Lewis, New York, 6 February 1883 (Llanelli, Mansel Lewis Collection).
14. *New York Herald* (3 December 1882), 14.
15. A scrapbook of illustrations from English magazines, which included many examples by Walker, was kept at *Harper's Magazine*. See the description of this scrapbook in a letter to M. H. Spielmann from Edwin Austin Abbey (n.d.), cited in E. B. Lucas, *Edwin Austin Abbey, Royal Academician: The Record of his Life and Work* (London and New York, 1921). This information was most graciously given to me by Abbey scholar Lucy Oakley.
16. *New York World* (18 December 1882), 2. Indeed, Herkomer declared that the Impressionist School was 'on its last legs'. See *New York Herald* (24 November 1882), 10.
17. Herkomer to Mansel Lewis, New York, 6 February 1883 (Llanelli, Mansel Lewis Collection).
18. *New York Daily Tribune* (8 February 1883), 5; *New-York Times* (8 February 1883), 10.
19. *Brooklyn Daily Eagle* (16 May 1883), 1.
20. 'Art and Art Museums', *New York World* (23 December 1882), 4.
21. 'Antique Art and the Modern Critics', *New York World* (13 December 1882), 4.
22. *Boston Evening Transcript* (15 May 1883), n.p.
23. See Maury Klein, *The Life and Legend of Jay Gould* (Baltimore, 1986).
24. *Boston Evening Transcript* (16 January 1883), 6; (27 January 1883), 6.
25. *Boston Evening Transcript* (15 May 1883).
26. Ibid. (26 January 1883), 4.
27. Ibid. (27 January 1883), n.p.
28. *Palladium*, New Haven (28 February 1883). I am most grateful to Dr Susan P. Casteras for sending me newspaper clippings about Herkomer's visit to Yale in 1883.
29. *Boston Evening Transcript* (16 January 1883), 6. The reporter is referring to the French portrait painters Carolus-Duran and Benjamin Constant.
30. Herkomer to Gosse (13 March 1883), written from New York (Leeds, Brotherton Collection). On portrait painting in America, see Los Angeles County Museum of Art, *American Portraiture in the Grand Manner: 1720–1920* (Los Angeles, 1982), and Robin Simon, *The Portrait in Britain and America* (Oxford, 1987).
31. 'Fine Arts: Herkomer's Arrival and Immediate Plans', *New York Herald* (1 November 1882), 5; and Herkomer to C. W. Mansel Lewis, 29 February 1884 (Llanelli, Mansel Lewis Collection).
32. *Herkomers* 2, 133. Castle Garden was built around 1808 as a fort. The Herkomers did not go through Castle Garden when they first arrived in New York in 1851; it was still a famous concert hall, the site of the Swedish singer Jenny Lind's American debut, for example. From 1892 to 1943 Ellis Island in upper New York Bay was the official port of entry for immigrants to America.
33. *New York Daily Tribune* (8 February 1883), 5.
34. 'Notes on Art and Artists', *New-York Times* (29 April 1883), 12.
35. *Boston Evening Transcript* (6 June 1883), 3.
36. Herkomer to Hans Herkomer (24 April 1883), quoted in Mills, *Life and Letters*, 135.
37. Quick, *Munich and American Realism*, 33.
38. Patricia Hills, *The Working American*, 510.
39. 'The Herkomer Exhibition at Goupil's', *The Times* (30 March 1884).
40. Ruskin, in Cook and Wedderburn edn, vol. 33, 338.
41. *Boston Evening Transcript* (30 December 1885), 4.
42. Ibid. (23 January 1886), 4.
43. Ibid. (3 February 1886), 8.
44. Mills, *Life and Letters*, 168, and *New-York Times*, 6 March 1886, 1 for the lecture at Harvard. Herkomer is misidentified in the article as Herbert Herkomer, though he was identified as an eminent art critic, artist and Slade Professor at Oxford. The title of the lecture was 'Notoriety in Art'.
45. Mills, *Life and Letters*, 163.
46. The building of Lululaund will be discussed more fully in Chapter 9. See also *Selected Drawings: H. H. Richardson and his Office: A Centennial of his Move to Boston, 1874*, exhibition catalogue, Fogg Art Museum (Cambridge, Mass., 1974), 105–106.
47. *American Architect and Building News* (9 July 1887), 1. In a diary entry, Herkomer noted that Richardson only slightly modified the ground plans in order to design the elevation. See February 1886, quoted in Mills, 165. For discussion of the American version of how Herkomer came to paint Richardson's portrait, see John Jacob Glessner, 'The Story of my House', unpaginated typescript, March 1914, in the archives of the Glessner House, Chicago Architecture Foundation. Richardson also designed the Glessner House. I am most grateful to Mary Alice Molloy, historian, for sending me this information.
48. See *Selected Drawings* (as in n. 46, above), 105–106.
49. Jeffrey Karl Ochsner, *H. H. Richardson. Complete Architectural Works* (Boston, 1982), 414.
50. This is suggested in Ochsner, *H. H. Richardson*, 337.
51. Author's conversation with Henry Richardson III. See also 'Art Notes', *Boston Evening Transcript* (2 March 1886), 4.
52. Mills, *Life and Letters*, 164.
53. 'Art Notes', *Boston Evening Transcript*, 2 March 1886, 4.
54. Ibid.; see Chapter 7 for discussion.
55. Mills, *Life and Letters*, 166.
56. Ibid., 167. *The Lady in Black* was exhibited at the Chicago World's Columbian Exposition of 1893.
57. Ibid., 168.
58. Herkomer to Mansel Lewis, 21 April 1886 (Llanelli, Mansel Lewis Collection).
59. *Everybody's Magazine* 14 (February 1906), 146.

9 Bushey: 'a sleepy picturesque village'

1. For a discussion of Bushey as an art colony, see Chapter 1, above.
2. 'Opening of Mr. Herkomer's School of Art', *The Times* (24 November 1883).
3. 'The school and grounds will have to be sold up as there are 8000 pounds debts . . . Why it is a regular bankrupt sale', Bertha Herkomer to Josephine Herrick, 27 May 1904 (New Haven, Herkomer Archive). On the school, see Mills, *Life and Letters*, 223–229. For details of students, see Grant Longman, *The Herkomer Art School 1883–1900* (Bushey, 1976), and *The Herkomer Art School and Subsequent Developments 1901–1918* (Bushey, 1981).
4. See Chapter 1, above.
5. Herkomer, *My School and my Gospel*, 40.
6. Edith Ashford to her parents, 3 November 1883 (in a private collection). I am grateful to Marcia Goldberg of Oberlin, Ohio, for bringing this letter to my attention.
7. Flora Thomas, 'The Herkomer School', *Cornhill Magazine* (March 1926), 336. Bertha Herkomer was the sister of the painter Herman G. Herkomer and the daughter of John (Hans) Herkomer. The family settled in Bushey when Hubert asked his uncle John to come from Cleveland to supervise the carving of the furnishings and interiors for Lululaund. Bertha was also a gifted artist.
8. Herkomer to the editor, *The Studio* (11 July 1896; London, Victoria and Albert Museum Library).
9. Hubert [von] Herkomer, 'How We Teach at Bushey', *Universal Review* (Sept.–Dec. 1889), 50–55.
10. Herkomer, *My School and my Gospel*, 61.

11. Herkomer to the Royal Academy, 21 December 1891 (London, Royal Academy Archives).
12. H. H. La Thangue, 'Art Education and the Royal Academy', *Universal Review* (Sept.–Dec. 1889), 56–71; George Clausen, 'The English School in Peril: A Reply', *Magazine of Art* (1888), 222–224; Ernest Chesneau, 'The English School in Peril: A Letter from Paris', in *Magazine of Art* (1888), 25–28.
13. Nicholson was dismissed from the school in 1889 for disruptive behaviour. See Duncan Robinson, *William Nicholson*, exhibition catalogue, Arts Council of Great Britain (London, 1980), 4.
14. Herkomer, *My School and my Gospel*, 79–81.
15. Flora Thomas, 'The Herkomer School', 336.
16. *Herkomers* 2, 213.
17. Mills, *Life and Letters*, 131.
18. Courtney, 'Life and Work', *Art Journal Christmas Number* (1892), 16.
19. See Chapter 8, above, for discussion of the commission.
20. See 'Mary Bromet's Visit to Herkomer's Lululaund', 1935, in Horace E. White, *Heritage*, 28–29.
21. The 1870 census lists Anton residing in Hempstead, New York. Information kindly given by Lynn Feldshuh, Curator, Fashion Institute of New York.
22. The Munich painter Franz von Stuck (1863–1928) used to visit Herkomer at his Landsberg residence, the *Mutteturm*, during the 1890s. A photograph taken of them together on the steps of the *Mutteturm* is in the Herkomerstiftung, Landsberg-am-Lech.
23. Mills, *Life and Letters*, 214; see also a letter from Herkomer to A. L. Baldry, n.d., c.1900 (London, Victoria and Albert Museum Library).
24. In 1849 Richard Wagner published his ideas about *Gesamtkunstwerk* in his *Kunstwerk der Zukunft*, applying his concept of a synthesis of the arts to his work in the theatre.
25. Herkomer, 'Art Tuition', c.1900, lecture in typescript (London, Victoria and Albert Museum Library).
26. 'Herkomer's "Castle" Under the Pick', *Watford Post* (21 July 1939).
27. 'The Royal Academy', *Illustrated London News* (28 May 1887), 608.
28. Herkomer, 'J. W. North', 342.
29. 'The Royal Academy', *Illustrated London News* (28 May 1887), 608.
30. Herkomer, *My School and my Gospel*, 5.
31. See Chapter 10, below.
32. 'The Royal Academy Exhibition', *Illustrated London News* (May 1889), 435.
33. *Herkomers* 2, 60; *My School and my Gospel*, 6.
34. Anon., *Our Parish: How We are Governed* (London, n.d.), 4, probably between 1850 and 1890; see Grant Longman, *Bushey Then and Now: Our Village* (Bushey, 1976), 21.
35. 'The Royal Academy', *Athenaeum* (24 May 1890), 677.
36. Harry Quilter, 'The Art of England', *Universal Review* 7 (May–Aug. 1890), 36–37.
37. Arlene M. Jackson, *Illustration and the Novels of Thomas Hardy* (London, 1982).
38. Ibid., 56.
39. Herkomer to Hardy, 10 March 1908 (Dorchester, Dorset County Museum).
40. Ibid.
41. Carr, 'Herkomer', 69.
42. Joseph Pennell, *English Illustration* (London, 1895), 101, quoted in Jackson (see n. 37 above), 58.
43. See Chapter 11, below.
44. *The Foster Mother* was exhibited in a show of work by Herkomer and his students at the Fine Art Society in 1892, and at the Munich Secession in 1893.
45. Herkomer, 'J. W. North', *Magazine of Art* (1893), 297–300, 342–348.
46. *Herkomers* 2, 66–67.
47. Ibid., 97.
48. See Herkomer, 'Sight and Seeing', lecture to the students at the Royal Academy Schools (London, privately printed, 1900), 159. Referring to Bastien's *Joan of Arc*, Herkomer told his listeners that 'In that stare, so marvellously depicted, the whole story of her mind was told.'
49. Kenneth McConkey, 'Listening to the Voices: A Study of Some Aspects of Jules Bastien-Lepage's *Joan of Arc Listening to the Voices*', *Arts Magazine* (January 1982), 159.
50. 'The Royal Academy', *Athenaeum* (23 May 1896), 689.

10 Theatre fantasies and cinema experiments

1. Herkomer, *My School and my Gospel*, 135, 148, and Herkomer, *Autobiography of Hubert Herkomer* (privately printed, London, 1890), 64.
2. Herkomer, 'The Pictorial Music-Play', *Magazine of Art* 12 (1889), 316.
3. Ibid.
4. Hubert [von] Herkomer, 'Scenic Art', *Magazine of Art* 15 (1892), 262.
5. Ibid.
6. See Edward Craig, 'Gordon Craig and Hubert von Herkomer', *Theatre Research* 1 (1969), 7–16; Barnard Hewitt, 'Herkomer: The Forerunner of Gordon Craig', *Players Magazine* (May 1942), 6, 23–24.
7. Herkomer, *Autobiography*, 65.
8. 'Mr. Herkomer's "The Sorceress" ', *The Times* (26 April 1888), 12.
9. William Archer, 'The Dying Drama', *New Review* (September 1888), 388–389, quoted in Stokes, *Resistible Theatres*, 76.
10. *My School and my Gospel*, 173.
11. Archer, quoted in Stokes, *Resistible Theatres*, 76.
12. Herkomer, *My School and my Gospel*, 199.
13. Herkomer, 'Scenic Art', 261.
14. See Baldry, *Herkomer*, 39.
15. Craig, 'Gordon Craig and Hubert von Herkomer', 9–10; Herkomer, 'Scenic Art'.
16. Herkomer, 'Scenic Art', quoted in Craig, 'Craig and Herkomer', 10.
17. Herkomer also anticipated the lighting ideas of the Swiss stage theoretician Adolphe Appia (1862–1928) who, through the 1890s, wrote about the use of light in staging the operas of Wagner. See Richard Beacham, 'Adolphe Appia and the Staging of Wagnerian Opera', *Opera Quarterly* 1, 3 (1983), 121. For comparison of Appia and Herkomer, see Hewitt 'Herkomer: The Forerunner', 24.
18. Craig, 'Craig and Herkomer', 11–13.
19. Ibid., 10; on Craig and Ellen Terry attending *The Sorceress*, see Godsal Diary, vol. 7, 25 April 1888 (Clywd, Clywd Library).
20. Baldry, *Herkomer*, 39; Herkomer, *My School and my Gospel*, 212–213.
21. For a full account of Herkomer's film-making, see Michael Pritchard, *Sir Hubert von Herkomer and his Film-making in Bushey: 1912–1914* (Bushey, 1987).
22. Peter Pitt, 'The Oldest Studio', *Films and Filming* 343 (March 1983), 30.
23. ' "The Old Wood Carver": Sir Hubert von Herkomer's First Film Play', *The Bioscope* 21, 363 (2 October 1913), 57.
24. J. Saxon Mills, *The Old Wood Carver from the Cinematograph Film Conceived and Produced by Sir Hubert von Herkomer, R. A. and Siegfried Herkomer* (London, 1914).
25. Pritchard, *Herkomer and his Film-making*, 33.
26. Ibid., 30.
27. 'The Cinematograph, Sir Hubert von Herkomer's Views', *Daily Telegraph* (21 December 1912), quoted in Pritchard, *Herkomer and his Film-making*, 10.
28. Herkomer to Mansel Lewis, 16 December 1878 and 14 November 1878 (Llanelli, Mansel Lewis Collection).
29. Ibid., 29 December 1876, 13 January 1877 and 17 April 1877.
30. Herkomer, *Five Lectures*, 52–54.

31. Low Warren, interview with Herkomer in 1912, published in 'Herkomer's Last Work', *Kinematograph and Lantern Weekly* (14 May 1914), in the Bushey Library Cuttings File.
32. *Kinematograph and Lantern Weekly* (26 December 1912), quoted in Stokes, *Resistible Theatres*, 106.
33. See note 24 above.
34. Pritchard, *Herkomer and his Film-making*, 52.

11 Herkomer as printmaker

1. Haden visited Herkomer at his studio and admired a new printing press there; see Herkomer to Mansel Lewis, 25 February 1880 (Llanelli, Mansel Lewis Collection). Haden was notoriously opinionated and difficult, and Herkomer's friendship with him had broken off by the time both were in America in 1883. See Chapter 8, above.
2. Philip Gilbert Hamerton, *Etching and Etchers* (London, 1868). Herkomer mentions this book in *Herkomers* 1, 125.
3. *Herkomers* 1, 125.
4. Ibid.
5. Herkomer to Mansel Lewis, 2 February 1879 (Llanelli, Mansel Lewis Collection).
6. See Henriette Corkran, 'Painter's Etchings: Hubert Herkomer's ''Words of Comfort'' ', *Portfolio* 10 (1879), 41–42.
7. See Bibliography and Chapter 3, above.
8. See 'The Illustrations of Mr. Herkomer's ''Idyl'': To the Editor of the *Times*', 24 April 1891, 12, for Herkomer's reply to Pennell's initial accusation. Pennell answered that he had returned *An Idyl* to Novello and Company for a full refund and that 'the admissions of both the artist and the publisher satisfy me that I was fully warranted in putting my quesions to Mr. Herkomer'; see 'Professor Herkomer and ''An Idyl:'' To the Editor of the *Times*', 27 April 1891, 11.
9. Gosse, 'The World of Books', *Sunday Times*, 6 May 1923.
10. *Herkomers* 2, 168; Herkomer, *Etching and Mezzotint Engraving* (London, 1892), 104–106.
11. Herkomer, *Etching and Mezzotint Engraving*, 105. Herkomer also called his herkomergravures 'painter-engravings'.
12. Ibid., 105–107.
13. M. H. Spielmann, 'Painter-Etching', *Magazine of Art* (1892), 205.
14. 'Catalogue of New Black-and-White Art by Professor Hubert Herkomer, R. A., M. A., with a Prefatory Note by the Artist', Fine Art Society (London, 1896), 3–6.
15. Ibid., 6.
16. 'Mr. Herkomer's Portrait of Dr. Jameson', *The Times* (14 January 1896), 14. This article includes an explanation of the herkomergravure process.
17. Questioning Herkomer's invention of the herkomergravure process is a letter to the editor by Duncan C. Dallas of Dallastype Press. See 'Professor Herkomer's Process', *The Times* (5 February 1896), 14. Dallas most likely attended Herkomer's exhibition at the Fine Art Society and read the above article in *The Times*.
18. *Herkomers* 2, 168.
19. Joseph Hatton, 'Some Glimpses of Artistic London', *Harper's New Monthly Magazine* 67, 402 (1883), 850.
20. Herkomer, *Etching and Mezzotint Engraving*, 105.

12 The late years

1. The Spielmann correspondence is housed in the Rylands Library, Manchester.
2. *Herkomers* 2, 179.
3. 'Versatility – As a Medicine', *Herkomers* 2, 175–181.
4. Ibid., 176.
5. Ibid., 177.
6. Herkomer to Spielmann, 1 March 1897 (Manchester, Rylands Library).
7. Ibid.
8. M. H. Spielmann, 'Professor Herkomer as a Painter in Enamels', *Magazine of Art* (1899), 105.
9. Herkomer, 'Art Tuition', 22.
10. Herkomer to Spielmann, n.d. (probably June, 1894) (Manchester, Rylands Library). Herkomer later said that the English were too puritanical to appreciate the painting; see Mills, 207.
11. There seems to be some discrepancy about the size of *The Triumph of the Hour*. According to Spielmann, who saw the piece in the workshop, it was seven feet long. 'Professor Herkomer as a Painter in Enamels', *Magazine of Art* (1899), 163. Herkomer says it was 'some five feet from end to end' (*Herkomers* 2, 155). Mills says it was four feet wide; see *Life and Letters*, 265.
12. See Erika Speel, *Dictionary of Enamelling: History and Techniques* (Aldershot, 1998).
13. Ibid., 164.
14. *Herkomers* 2, 134–157.
15. Spielmann, 'Professor Herkomer', 165.
16. Ibid., 163.
17. A full explanation of the meaning of each panel with reproductions of the preliminary pencil sketches can be found in ibid., 107–112.
18. See Chapter 7, above.
19. Herkomer to Mrs Watts, 18 August 1901 (London, Tate Gallery Library). The originals are at the Watts Gallery, Compton, Surrey.
20. See Barbara Bryant, in *Rossetti, Burne-Jones and Watts: Symbolism in Britain, 1860–1910*, exhibition catalogue, Tate Gallery (London, 1997), 143.
21. Spielmann, 'Professor Herkomer as a Painter in Enamels', 105–112, 163–167.
22. Mills, *Life and Letters*, 264.
23. *Herkomers* 2, 157.
24. See Herkomer's notes to his biographer, A. L. Baldry, 1900 (London, Victoria and Albert Museum Library).
25. Herkomer to Spielmann, 24 January 1900 (Manchester, Rylands Library).
26. For full details of Herkomer's meeting and befriending the Kaiser, see a letter of Bertha Herkomer to her sister Josephine Herrick, 12 April 1900; and one from Herkomer to his students at the Herkomer Art School Bushey, 15 March 1900, written from Berlin (New Haven, Herkomer Archive).
27. Herkomer to his students, 15 March 1900, written from Berlin (New Haven, Herkomer Archive).
28. M. H. Spielmann, 'The Portrait in Enamel of the German Emperor, by Professor Hubert von Herkomer, R. A.', *Magazine of Art* (1901), 345–347.
29. Herkomer to Spielmann, 31 March 1901, from the Continental Hotel, Berlin (Manchester, Rylands Library).
30. Mills, *Life and Letters*, 270.
31. Herkomer to Mansel Lewis, 30 October 1905 (Llanelli, Mansel Lewis Collection).
32. Herkomer to Spielmann, 7 August 1902 (Manchester, Rylands Library).
33. Herkomer to John Herkomer, 14 August 1905, written from Landsberg (New Haven, Herkomer Archive).
34. Junius the Younger, 'The Motorist and Traveller Portraits: Hubert von Herkomer, R.A.', *Motorist and Traveller* (19 April 1905), 429.
35. Herkomer, 'Rapid Touches: The Diary of Sir Hubert von Herkomer', entry for 30 April 1912, typescript, n.p. (Bushey Museum Trust).
36. Ibid.

Epilogue: Herkomer and Vincent van Gogh

1. See Pickvance, *English Influences*; Rosemary Treble, 'Van Gogh in England', *Arts and Artists* (February 1975), 14–24; Barbican Art Gallery, *Van Gogh: Portrait of a Young Artist in England* (London, 1992). All letters quoted from here are in *The Letters of Vincent van Gogh*, 3 vols. (Boston, 1958). Letters to the artist's brother Theo have 'T' in front of the number; letters to van Rappard have 'R' in front of the number. Volume number (Roman numeral) precedes letter number.
2. *L'Art* 16 (1879), 129; 18 (1879), 180; 15 (1878), 149. *Souvenir* is a watercolour 'head' of a Bavarian peasant and it proved to be a popular etching (numerous collections).
3. For example Charles Tardieu, 'La Peinture à l'Exposition universelle de 1878', *L'Art* (1879), 99.
4. See II, T339A.
5. I, T263. Vincent is referring to Herkomer's watercolour of 1874 (Figure 62), which was reproduced as a double-page engraving, *Carnival Time in the Bavarian Alps*, in the *Graphic* (18 April 1873), 368–369.
6. II, T280. The latter picture to which van Gogh refers is Alfred Roll's *Grève de Mineurs* (*The Miners' Strike*), which after its exhibition in the Paris Salon was reproduced in the magazine *L'Illustration* (29 October 1881).
7. Rodee, 'Scenes of Rural and Urban Poverty', 75–78.
8. *The Hague School*, exhibition catalogue, Royal Academy (London, 1982), 126; fn. 9, p. 134.
9. Herkomer, 'Drawing and Engraving on Wood', 133–136; 165–168.
10. For a summary of van Gogh's collection, see Pickvance, *English Influences*, 37.
11. Van Gogh collected nearly 2 000 sheets of wood engravings culled from the *Graphic* and the *Illustrated London News*. A small number also came from *Punch*, *Harpers Weekly*, *The British Workman* and others. Approximately 1 000 items survive, and they are housed in the Rijksmuseum Vincent van Gogh, Amsterdam. Those by Herkomer in the collection number 25, though initially Vincent owned almost all of Herkomer's illustrations for the *Graphic*.
12. Other scholars have noted the relationship of van Gogh's 'Orphan Men' series and the cited illustrations by Herkomer; see Pickvance, *English Influences*, 43; Treble, 'Van Gogh in England', 18.
13. Vincent enclosed these drawings in letters T171 and T178 around March 1882.
14. Herkomer, 'Drawing and Engraving on Wood', 133.
15. Ibid., 168.
16. See Chapter 2, above.
17. For reproductions, see Jan Hulsker, *The Complete van Gogh* (New York, 1977), 74–77.
18. Vincent's brief apprenticeship with The Hague School painter Anton Mauve was not a success. See Hulsker, *Complete van Gogh*, 34.
19. I, T205. Van Gogh is referring to the winter of 1880–1881, part of which he spent in Etten before moving to The Hague in December 1881. For similar comments by Herkomer, see *Herkomers* 1, 108.
20. Kirk Varnedoe, 'Caillebotte's Space', in *Gustave Caillebotte: A Retrospective Exhibition*, Brooklyn Museum (New York, 1976), 69. Van Gogh to Theo: 'I read a notice in *L'Intransigent* that there is to be an exhibition of impressionists at Durand-Ruel's – there will be some of Caillebotte's pictures – I have never seen any of his stuff, and I want you to write me what it is like . . . ' (II, T490).
21. See Pickvance, *English Influences*, 26. In Arles, Vincent also began to reread his favourite Victorian authors, perhaps rekindling his interest in the *Graphic*.
22. Pickvance also suggests an analogy (*English Influences*, 11).

Appendix 2

1. See 'The Royal Academy', *Illustrated London News* (21 May 1887), 584.
2. I have benefited enormously from a conversation with Herman Herkomer's two sons, Leonard and Philip Herkomer (both now deceased), in Sacramento, California on 14 July 1982, with their surviving relatives and also with Hubert's cousin Agnes Platenius (also now deceased), in Englewood, Florida, over a period of years in the 1980s. Correspondence concerning the split in the family is preserved in the Herkomer Archive, New Haven (Yale Center for British Art).

Bibliography

Unpublished sources

CAMBRIDGE, Cambridge University Library: Hubert von Herkomer correspondence.

CLWYD, NORTH WALES, Clwyd County Council Library: MS diaries of Mary Godsal, 18 vols.

DORCHESTER, Dorset County Museum: Thomas Hardy correspondence.

ESSEN, Historisches Archiv Fried. Krupp GmbH: Hubert von Herkomer correspondence.

HERTFORDSHIRE
Bushey Museum Trust: Diary and archival photographs, newspaper clippings.
County Hall, Hertford, Hubert von Herkomer correspondence.
The Watford Museum, cutting files and archival material.

LANDSBERG-AM-LECH, *Herkomerstiftung*, *Mutterturm*, Landsberg: Hubert von Herkomer correspondence; newspaper clippings; recital programmes and other miscellanea; Herkomer's photographic inventory of works.

LEEDS, YORKSHIRE, University of Leeds, Brotherton Collection: Hubert von Herkomer correspondence.

LLANELLI, SOUTH WALES, Mansel Lewis Collection: Hubert von Herkomer correspondence.

LONDON
British Library: Hubert von Herkomer correspondence.
The Maas Gallery: Hubert von Herkomer correspondence.
Tate Gallery Library: Hubert von Herkomer correspondence (photocopies).
The Royal Academy Archives: Hubert von Herkomer correspondence.
Christopher Wood Gallery: Hubert von Herkomer correspondence.
Victoria and Albert Museum Library: Hubert von Herkomer correspondence and typescript of miscellaneous lectures.

MANCHESTER, John Rylands University Library: The Spielmann Collection, Hubert von Herkomer correspondence.

MUNICH, Bayerische Staatsbibliothek: Hubert von Herkomer correspondence.

NEW HAVEN, CONNECTICUT, Yale Center for British Art: Herkomer Archive: Hubert von Herkomer correspondence; newspaper clippings; photographs; drawings and miscellanea.

OXFORD, Bodleian Library: Hubert von Herkomer correspondence.

Books and articles

Altick, Richard, D, *Victorian People and Ideas*. New York, 1973.
Anon., 'Celebrities at Home: Mr. Frank Holl, R. A. at "the Three Gables" Fitzjohn's Ave.', *World* (21 December 1887), 6–7.
— 'Hubert Herkomer: A Talk with him in Leaving England – His Art School – What he will do here – Views of American Art', *New York Herald Tribune* (29 October 1882), 19.
— 'Mr Herkomer's "The Sorceress" ', *The Times* (26 April 1888).
— 'Professor Herkomer's School', *Art Journal* (1892), 289–293.
— 'Theatricals at the Herkomer School of Art', *Illustrated London News* (28 April 1888).
Art and the Industrial Revolution. Manchester: Manchester City Art Gallery, 1968.
Atkinson, J. Beavington, *The Schools of Modern Art in Germany*. London, 1880.
— 'The Modern German School of Art', *Art Journal* (1862), 182.
— 'The Present Condition of Germany in Contemporary Art', *Portfolio* (1873), 145–149.
— 'Adolph Menzel', *Art Journal* (1882), 136–140; 200–204.
Baldry, A. L., *Hubert von Herkomer, R.A.* London, 1901.
Barrell, John, *The Dark Side of the Landscape: The Rural Poor in English Painting 1730–1840*. Cambridge, 1980.
Beacham, Richard, 'Adolphe Appia and the Staging of Wagnerian Opera', *Opera Quarterly* 1, 3 (1983), 114–139.
Bell, Quentin, *Victorian Artists*. London, 1967.
Black, Clementine, *Frederick Walker*. London, n.d.
Black, Eugene E., ed., *Victorian Culture and Society*. New York, 1973.
Blackburn, Henry, *Pictures at the Paris Exhibition (British School)*. London, 1878.
Blanc, Charles, *Les Beaux-Arts à L'Exposition universelle de 1878*. Paris, 1878.
Blaugrund, Annette, *The Tenth Street Studio Building: Artist Entrepreneurs from the Hudson River School to the American Impressionists*. Exhibition catalogue, Parrish Art Museum, Southampton, New York. New York, 1997.
Blum, Jerome, *The End of the Old Order in Rural Europe*. Princeton, 1978.
— ed., *Our Forgotten Past: Seven Centuries of Life on the Land*. New York, 1982.
Borzello, Francis, 'Art and the Problem of Poverty in Victorian England.' PhD diss. University of London, 1980.
Briggs, Asa, *Victorian People*. London, 1954.
— *Victorian Cities*. London, 1963.
Brown, Ford Madox, *The Exhibition of 'Work' and Other Paintings by Ford Madox Brown at the Gallery, 191 Piccadilly*. London, 1865.
Brownell, W. C., 'Bastien-Lepage: Painter and Psychologist', *Magazine of Art* (1882), 265–271.
Browse, Lillian, *William Nicholson*. London, 1956.
Campbell, Gertrude P, 'Frank Holl and his Works', *Art Journal* (1889), 85–91.
Carr, J. W. Comyns, *Some Eminent Victorians*. London, 1908.
— 'Hubert Herkomer A.R.A.', in *Modern Artists*, ed. F. G. Dumas. London, 1882–1884, 51–72.
Casteras, Susan P., *The Substance and the Shadow: Images of Victorian Womanhood*. New Haven: Yale Center for British Art, 1982.

— and Denney, Colleen, eds., *The Grosvenor Gallery: A Palace of Art in Victorian England*. New Haven: Yale Center for British Art, 1996.

Catalogue of a Collection of Drawings: Around my Home by Professor Herkomer A.R.A., London, 1888.

Catalogue of Printed Books and a Few Manuscripts: Property of Lady Herkomer and Others. Sotheby, Wilkinson and Hodge, 25 January 1921 (London, 1921).

Caw, James L., *Scottish Painting Past and Present 1620–1908*. Edinburgh, 1908.

Champa, Kermit, *German Painting in the Nineteenth Century*. New Haven: Yale University Art Gallery, 1970.

Champion, H. H., 'The Great Dock Strike', *Universal Review* 6 (1889), 157–178.

Chapel, Jeanie, *Victorian Taste: The Complete Catalogue of Paintings at the Royal Holloway College*. London, 1982.

Chesneau, Ernest, *English Contemporary Painters*. London, 1887.

— 'The English School in Peril: A Letter from Paris', *Magazine of Art* (1888), 25–28.

Clausen, George, 'The English School in Peril: A Reply', *Magazine of Art* (1888), 222–224.

Clive, Mary, *The Day of Reckoning*. New York, 1964.

Cook, Edward T., *A Popular Handbook to the National Gallery* vol. 2: *The British Schools including the Tate Gallery*. London, 1901.

Corkran, Henriette, 'Painter's Etchings: Hubert Herkomer, "Words of Comfort" ', *Portfolio* 10 (1879), 41–42.

Courtney, W. L., 'The Life and Work of Hubert Herkomer R.A.', *Art Journal Christmas Number* (1892).

Craig, Edward, *Gordon Craig*. New York, 1968.

— 'Gordon Craig and Hubert von Herkomer', *Theatre Research* 1 (1969), 7–16.

Cundall, H. M., *Birket Foster, R.W.S.* London, 1906.

Curl, James Stevens, *The Victorian Celebration of Death*. Ann Arbor, Michigan, 1972.

Dafforne, James, 'The Works of Hubert Herkomer A.R.A.', *Art Journal* (1880), 109–112.

Dalziel, George, and Dalziel, Edward, *The Brothers Dalziel, A Record of Fifty Years Work* ... London, 1901.

Dolman, Frederick, 'Hubert Herkomer, R.A.', *Strand Magazine* (May, 1900), 43–44.

Doré, Gustave, and Blanchard Jerrold, *London: A Pilgrimage*. London, 1872; rpt New York, 1970.

Dyos, H. J., and Michael Wolff, eds., *The Victorian City: Images and Realities*. 2 vols., London, 1973.

Ebertshaüser, H. C., *Malerei im 19 Jahrhundert: Münchner Schule*. Munich, 1979.

Edelstein, Teri Jocelin, ' "But Who Shall Paint the Griefs of Those Oppress'd?": The Social Theme in Victorian Painting'. PhD, University of Pennsylvania, 1979.

Edwards, Lee M., 'Hubert von Herkomer and the Modern Life Subject', in *Sir Hubert von Herkomer 1849–1910: A Passion for Work*. Watford: Watford Museum, 1982, 32–49. Exhibition catalogue, ed. David Setford.

— 'Hubert von Herkomer and the Modern Life Subject', PhD, Columbia University, 1984.

— 'The Heroic Worker and Hubert von Herkomer's *On Strike*', *Arts Magazine* (September 1987), 29–35.

— 'Sir Hubert von Herkomer: A German or English Painter?' in *Sir Hubert von Herkomer: Zum hundertjährigen Jubilaum seines Landsberger Mutterturms*. Landsberg-am-Lech: Neues Stadtmuseum, 1988, 6–40.

— ' "Sympathy for the Old and for Suffering Mankind": Hubert von Herkomer', in Julian Treuherz, *Hard Times: Social Realism in Victorian Art*, exhibition catalogue, Manchester City Art Galleries (Manchester, 1988), 90–104.

— 'Herkomer in America', *American Art Journal* 21, 3 (1989), 49–73.

— 'From Pop to Glitz: Hubert von Herkomer at *The Graphic* and the Royal Academy', *Victorian Periodicals Review* 24, 2 (1991), 71–80.

Engel, Louis, *From Handel to Hallé: with Autobiographies by Professor Huxley and Professor Herkomer*. London, 1890.

Erdmann, H., 'Hubert von Herkomer', *Das Bayerland* 36, 13 (July 1925), 420–424.

Exhibition of Works by Professor Herkomer and his Pupils. London: Fine Art Society, 1982.

Fenn, W. W., 'Our Living Artists: Luke Fildes A.R.A.', *Magazine of Art* 3 (1880), 49–52.

Fenwick, Simon, and Greg Smith, *The Business of Watercolour: A Guide to the Archives of the Royal Watercolour Society*. Aldershot, 1997.

Ferriday, Peter, 'A Painter with a Passion for Success: Sir Hubert von Herkomer I', *Country Life* (25 January 1973), 222–224.

— 'Adventures in Lululaund: Sir Hubert von Herkomer II', *Country Life* (1 February 1973), 280–281.

Fildes, L. V., *Luke Fildes R.A.: A Victorian Painter*. London, 1968.

Forbes, Christopher, *The Royal Academy Revisited 1837–1901*. New York: Metropolitan Museum, 1973.

Forster-Hahn, Françoise, 'Adolph Menzel's "Daguerrotypical" Image of Frederick the Great: A Liberal Bourgeois Interpretation of German History', *Art Bulletin* 59 (June 1977), 240–261.

Fox, Celina, and Michael Wolff, 'Pictures from the Magazines', in H. J. Dyos and Michael Wood eds, *The Victorian City: Images and Realities*. 2 vols. London, 1973.

Free, Renée, *Victorian Social Conscience*. Sydney: Art Gallery of New South Wales, 1976.

Frith, William Powell, 'Art Education', *Magazine of Art* (1889), 101–104.

'G. W.', 'The Secessionists of Germany', *Studio* 4 (1894), 24–28.

Gogh, Vincent van, *The Complete Letters of Vincent van Gogh*. 3 vols. Boston, 1958.

Gosse, Edmund, *Cecil Lawson: A Memoir with Illustrations by Hubert Herkomer A.R.A., J. A. McN. Whistler and Cecil Lawson*. London, 1883.

— 'The World of Books: Herkomer', *Sunday Times* (6 May 1923).

Greenwood, James, *A Night in the Workhouse*. London, 1866.

Hamerton, P. G. 'Professor Herkomer on Etching and Mezzotint', *Portfolio* 23 (1892), 97–101.

Hammer, H., *Franz von Defregger*. Innsbruck, 1940.

Henley, W. E., 'Alphonse Legros', *Art Journal* (1881), 294–296.

Herbert, Robert L., *Jean-François Millet*. London: The Royal Academy, 1976.

Herkomer, Hubert [von], *Descriptive Catalog of the Portraits, Etchings and Engravings exhibited at M. Knoedler's Gallery*. New York, 1882.

— *Autobiography of Hubert Herkomer*. London, privately printed, 1890.

— *Etching and Mezzotint Engraving*. London, 1892.

— *Five Lectures Delivered to the Students of the Royal Academy*. London, 1900.

— *My School and my Gospel*. London, 1908.

— *A Certain Phase of Lithography*. London, 1910.

— *The Herkomers*. 2 vols. London, 1910–1911.

— 'Notes on Landscape Painting: "The Camp", Lake Idwal, North Wales, April, 1880', *Portfolio* 2 (1880), 142–147; 173–176.

— 'Drawing and Engraving on Wood', *Art Journal* (1882), 133–136; 165–168.

— 'How We Teach at Bushey', *Universal Review* (September–December 1889), 50–55.

— 'The Pictorial Music Play: "An Idyl" ', *Magazine of Art* (1889), 316–324.

— 'Scenic Art', *Magazine of Art* 15 (1892), 259–266; 316–321.

— 'J. W. North, A.R.A., R.W.S., Painter–Poet', *Magazine of Art* (1893), 297–300; 342–348.

— 'A Primitive Passion Play: Professor Herkomer at Waal', *Daily Graphic* (16 June 1894), 12.

— '*Strangers Within the Gate*: The Evolution of a Pictorial Composition', *Magazine of Art* (1903), 262–267.

— 'Franz von Lenbach: An Appreciation', *Studio* (1905), 195–199.

— 'Sight and Seeing', lecture to students at the Royal Academy Schools. London (privately printed), 1900.

— 'Art Tuition', c.1900, lecture in typescript. London, Victoria and Albert Museum Library.

— and Siegfried Herkomer, *The Old Wood Carver*. Film script with 52 illus. London, 1914.

Hewitt, Barnard, 'Herkomer: The Forerunner of Gordon Craig', *Players Magazine* (May 1942), 6, 23–24.

Hills, Patricia, *The Painters' America: Rural and Urban Life 1810–1910*. New York, 1974.

— *The Working American*. Washington, DC, Smithsonian Institution, 1979.

Himmelfarb, Gertrude, *The Idea of Poverty: England in the Early Industrial Age*. New York, 1983.

— *Poverty and Compassion: The Moral Imagination of the Late Victorians*. New York, 1992.

Hogarth, Paul, *Arthur Boyd Houghton*. London, 1981.

Huish, Marcus B., *British Water Colour Art*. London, 1904.

Hulsker, Jan, *The Complete van Gogh*. New York, 1977.

Huyshe, Wentworth, 'Professor Hubert von Herkomer, R.A. at Bushey', *Graphic* (12 January 1907), 35.

Huysmans, J.-K., *L'Art Moderne: Paris Salons 1879/81*. Paris, 1883.

Irvine, John H., 'Professor von Herkomer on Maxfield Parrish's Book Illustrations', *Studio* (1906), 34–43.

Jackson, Arlene M., *Illustration and the Novels of Thomas Hardy*. London, 1982.

Jackson, M. Phipps, 'Mr. Joseph Farquharson and his Works', *Art Journal* (1893), 153–157.

— 'Professor Herkomer R.A. and his Pupils', *Magazine of Art* (1896), 31–34.

Jones, Gareth Stedman, *Outcast London: A Study in the Relationship between the Classes in Victorian Society*. Oxford, 1971.

Junius the Younger, 'The Motorist and Traveller Portraits: Hubert von Herkomer R.A.', *Motorist and Traveller* (19 April 1905), 429.

Keppel, Frederick, 'Francis Seymour Haden and Hubert Herkomer', *Harper's Weekly* (18 November 1882), 732–734.

Keyssner, G., 'The Exhibition of the Munich Secession, 1899', *Studio* 17 (1899), 178–184.

Koch, Robert, 'American Influences Abroad', *Journal of the Society of Architectural Historians* 18 (1959), 66–69.

Laidlay, W. J., *The Origin and the First Two Years of the New English Art Club*. London, 1907.

Langer, Alfried, *Wilhelm Leibl*. Leipzig, 1961.

La Thangue, H. H., 'Art Education and the Royal Academy', *Universal Review* (September–December 1889), 56–61.

Laundy, Albert, 'Herkomer', *Die Zukunft* 7 (1893–1895), 319–326.

Lemoisne, Paul-André, *Degas et son oeuvre*. 4 vols. Paris, 1946–1949.

Llewellyn-Davies, J., 'The Problem of Poverty', *Universal Review* (June–August 1888), 373–385.

Longman, Grant, *Bushey Then and Now: Our Village*. Bushey, 1976.

— *The Herkomer Art School 1883–1900*. Bushey, 1976.

— *The Herkomer Art School and Subsequent Developments 1901–1918*. Bushey, 1981.

— and Monica Smith, 'Herkomer Painting Returns to Bushey', *Hertfordshire Countryside* (December 1977), 35.

Low, Rachael, *The History of the British Film*. 4 vols. London, 1948.

Lucie-Smith, Edward, and Celestine Dars, *Work and Struggle: The Painter as Witness 1870–1914*. London, 1977.

McConkey, Kenneth, *A Painter's Harvest: Works of Henry Herbert La Thangue 1859–1929*. Oldham: Oldham Art Gallery, 1978.

— *George Clausen R.A. 1852–1944*. London: Royal Academy, 1980.

— *Peasantries*. Newcastle-upon-Tyne: Newcastle-upon-Tyne Art Gallery, 1981.

— *Edwardian Portraits: Images of an Age of Opulence*. Woodbridge, Suffolk, 1987.

— 'The Bouguereau of the Naturalists: Bastien-Lepage and British Art', *Art History* 1, 3 (1978), 371–382.

— ' "Listening to the voices": A Study of Some Aspects of Jules Bastien-Lepage's *Joan of Arc Listening to the Voices*'. *Arts Magazine* (January 1982), 154–160.

Marks, J. G., *Life and Letters of Frederick Walker*. London, 1896.

Messum, David, *The Life and Work of Lucie Kemp-Welch*. Woodbridge, Suffolk, 1976.

Meynell, Alice, 'Artists' Homes: Mr. Herkomer's at Bushey, Herts', *Magazine of Art* 6 (1883), 96–101.

Meynell, Wilfred, 'Our Living Artists: Hubert Herkomer A.R.A.', *Magazine of Art* (1880), 259–263.

— 'Our Living Artists: Frank Holl A.R.A.', *Magazine of Art* (1880), 187–191.

Mills, J. Saxon, *The Old Wood Carver from the Cinematograph Film Conceived and Produced by Sir Hubert von Herkomer, R.A. and Siegfried Herkomer*. London, 1914.

— *Life and Letters of Sir Hubert Herkomer C.V.O., R.A.: A Study in Struggle and Success*. London, 1923.

Mingay, G. E., ed., *The Victorian Countryside*. 2 vols. London, 1981.

Miss E. Thompson's New Picture 'Inkermann' and her Other Battle Pieces, 'The Roll Call', 'Quatre Bras', and 'Balaclava'. London: Fine Art Society, 1876.

Morley, John, *Death, Heaven and the Victorians*. London, 1971.

Muther, Richard, *The History of Modern Painting*. 3 vols. London, 1896.

Myers, Bernard, 'Studies for *Houseless and Hungry* and *The Casual Ward* by Luke Fildes, R.A.', *Apollo* (July 1892), 36–43.

Newall, Christopher, *Victorian Watercolours*. London, 1987.

— *The Grosvenor Gallery Exhibitions: Change and Continuity in the Victorian Art World*. Cambridge, 1995.

Ormond, Leonée, 'The Idyllic School: Pinwell, North and Walker', *Imagination on a Long Rein*, ed. Joachim Möller (Heidelberg, 1988), 161–171.

Ormond, Richard, *G. F. Watts' The Hall of Fame: Portraits of his Famous Contemporaries*. London: National Portrait Gallery, 1975.

— *John Singer Sargent and the Edwardian Age*. London: National Portrait Gallery, 1979.

Phillips, Claude, *Frederick Walker and his Works*. London, 1894.

Pickvance, Ronald, *English Influences on Vincent van Gogh*. Nottingham: Nottingham Art Gallery, 1974.

Pietsch, Ludwig, *Franz Defregger*. Leipzig, 1889.

— *Herkomer*. Leipzig, 1901.

Piper, David, *The English Face*. London, 1957.

Pritchard, Michael, *Sir Hubert von Herkomer and his Film-making in Bushey: 1912–1914*. Bushey: Bushey Museum Trust, 1987.

Pythian, J. E., *Manchester City Art Gallery Handbook*. Manchester: Manchester City Art Gallery, 1905.

Quick, Michael, *Munich and American Realism in the Nineteenth Century*. Sacramento: E. B. Crocker Art Gallery, 1978.

Quilter, Harry, *Preferences in Art, Life, and Literature*. London, 1892.

— 'Frank Holl: In Memoriam', *Universal Review* 20 (June–August 1888), 478–493.

— 'Some *Graphic* Artists', *Universal Review* 21 (September–December 1888), 94–104.

— 'The Art of England', *Universal Review* (May–August 1890), 36–37.

Reid, Forrest, *Illustrators of the Sixties*. London, 1928.

Reynolds, A. M., *The Life and Work of Frank Holl*. London, 1912.

Robertson, John Forbes, 'Notes on the International Exhibition at Munich', *Art Journal* (1879), 262.

— 'The International Art Exhibition at Munich', *Magazine of Art* (1880), 71.

Rodee, David Howard, 'Scenes of Rural and Urban Poverty in Victorian Painting and their Development 1850–1890', PhD, Columbia University, 1975.

— ' "The Dreary Landscape" as a Background for Scenes of Rural Poverty in Victorian Painting', *Art Journal* 36, 4 (1977), 307–313.

Rossetti, Burne-Jones and Watts: The Age of Symbolism in Britain, 1860–1910. The Tate Gallery, London, 1997.

Ruskin, John, *The Complete Works of John Ruskin*, ed. E. T. Cook and Alexander Wedderburn. 39 vols., London, 1904.

Schmidt, Diether, 'Streik als Bildmotiv im 19 Jahrhundert', *Bildende Kunst* (1957), 172–176.

Schneidek, G. H., 'Herkomers Einladungskarten', *Über Land e Meer* (1908), 159–161.

Shepherd, Walter, 'Von Herkomer's Folly', *Country Life* (16 December 1939), 636.

Silk, Gerald, *Automobile and Culture*. New York, 1984.

Simcox, G. A., 'Mr Mason's Collected Works', *Portfolio* (1873), 40–43.

Singer, H. W., *The Drawings of A. von Menzel*. London, 1906.

Sizeranne, Robert de la, *English Contemporary Art*, trans. H. M. Poynter. London, 1898.

Smith, Garnet, 'Jules Breton: Painter of Peasants', *Magazine of Art* 1893, 409–416.

Speel, Erika, *Dictionary of Enamelling: History and Techniques*. Aldershot, 1998.

Spielmann, Marion H, 'Professor Herkomer's "Pictorial Music Play" ', *The Pall Mall Gazette* (4 June 1889), 1–2.

— 'The Chapel of the Charterhouse', *Magazine of Art* (1892), 228.

— 'Painter-Etching', *Magazine of Art* (1892), 202–205.

— 'Munich as an Art Centre', *Magazine of Art* 18 (1894–1895), 73–75.

— 'Professor Herkomer as a Painter in Enamels', *Magazine of Art* (1899), 105–112, 163–167.

— 'The Portrait in Enamel of the German Emperor by Professor Hubert von Herkomer, R.A.', *Magazine of Art* (1901), 345–347.

Staley, Allen, *The Pre-Raphaelite Landscape*. Oxford, 1975.

— et al. *The Post-Pre-Raphaelite Print: Etching, Illustration, Reproductive Engraving, and Photography in England in and around the 1860s*. New York: Wallach Art Gallery at Columbia University, 1995.

Stokes, John, *Resistible Theatres*. London, 1972.

Taine, Hippolyte, *Notes on England*, trans. W. F. Rowe. New York, 1873.

The Art and Mind of Victorian England: Paintings from the Forbes Magazine Collection. Minneapolis: University of Minnesota Art Gallery, 1974.

The Hague School: Dutch Masters of the Nineteenth Century. London: The Royal Academy, 1983.

'This Brilliant Year': Queen Victoria's Jubilee 1887. London: Royal Academy of Arts, 1977.

Thomas, David Croal, 'Josef Israëls', *Magazine of Art* (1890), 397–403.

Thomas, Flora, 'The Herkomer School', *Cornhill Magazine* (March 1926), 336–345.

Thomas, John, and Smith, Adolphe, *Street Life in London*. London, 1877.

Thomas, W. L., 'The Making of the *Graphic*', *Universal Review* 2 (September–December 1888), 80–93.

Thompson, E. P., *The Making of the Working Class*. London, 1963.

Treble, Rosemary, *Great Victorian Pictures*. London: The Royal Academy, 1978.

— 'Van Gogh in England', *Arts and Artists* (February 1975), 14–24.

Treuherz, Julian, *Hard Times: Social Realism in Victorian Art*. Manchester, 1988.

Vaughan, William, *German Romanticism and English Art*. New Haven and London, 1979.

Victorian High Renaissance. Minneapolis: Minneapolis Institute of Arts, 1979.

Vizetelly, Henry, *Glances Back Through Seventy Years*. London, 1893.

Warren, Low, 'Herkomer's Last Work', *Kinematograph and Lantern Weekly* (14 May 1914).

— *The Film Game*. Newcastle upon Tyne, 1937.

Wedmore, Frederick, 'The Rise of Naturalism in English Art', *Macmillan Magazine* (March and June, 1876).

Weisberg, Gabriel, ed., *The Realist Tradition*. Indiana, 1982.

— 'Vestiges of the Past: The Brittany Pardons of Late Nineteenth Century Painters', *Arts Magazine* (November 1980), 134–138.

White, Gleeson, *English Illustrations: The Sixties*. London, 1897.

White, Horace E., *Bushey's Painting Heritage*. Bushey, 1975.

Williamson, C. N., 'Illustrated Journalism in England: Its Development parts one and two', *Magazine of Art* (1890), 297–301; 335–340.

Williamson, George C., *George J. Pinwell and his Works*. London, 1900.

Winkelmayer, Paul, 'Der Landsberger Rathaus', *Das Bayerland* 34, 13 (1925), 404–408.

— 'Herkomersammlung und Herkomerstiftung', in *Herkomer: Teilfonderdruck aus den Landsberger Geschichtsblätter* (Landsberg, 1939), 13–22.

Wood, Bryen, *Bushey: The Archive Photographs Series*. Gloucestershire, 1997.

Wood, Christopher, *Victorian Panorama: Paintings of Victorian Life*. London, 1976.

Woods, Alan, 'Doré's London: Art and Evidence', *Art History* I, no. 3 (1978), 341–359.

Zdanowicz, Irena, 'Prints of Fortune: Hubert Herkomer's 1891–92 Etching Purchases for the National Gallery of Victoria', *Art Bulletin of Victoria* 33 (1993), 1–17.

Zedlitz, Baronin von, 'Bei Herkomer', *Revue Deutsche* (1893–1895), 26–38.

Zeller, Reimar, *Das Automobil in der Kunst: 1886–1986*. Munich, 1986.

Zimmern, Helen, 'A Painter of Children', *Magazine of Art* 8 (1885), 327–333.

— 'Hubert Herkomer', *Kunst für Alle* (October 1890), 1–13.

Index

Page references in *italic* type indicate illustrations. Works listed are by Herkomer unless otherwise indicated.